WELLINGTON
portrayed

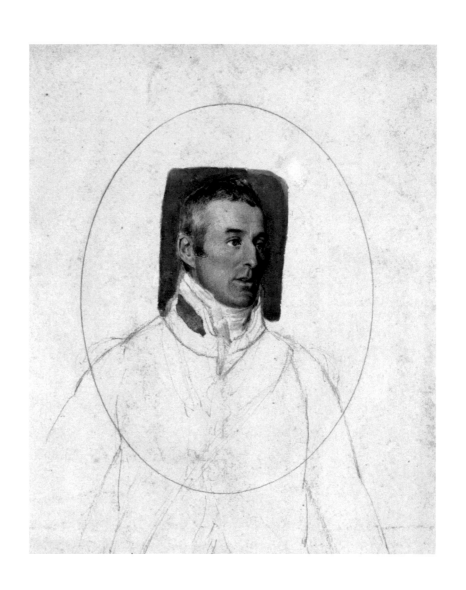

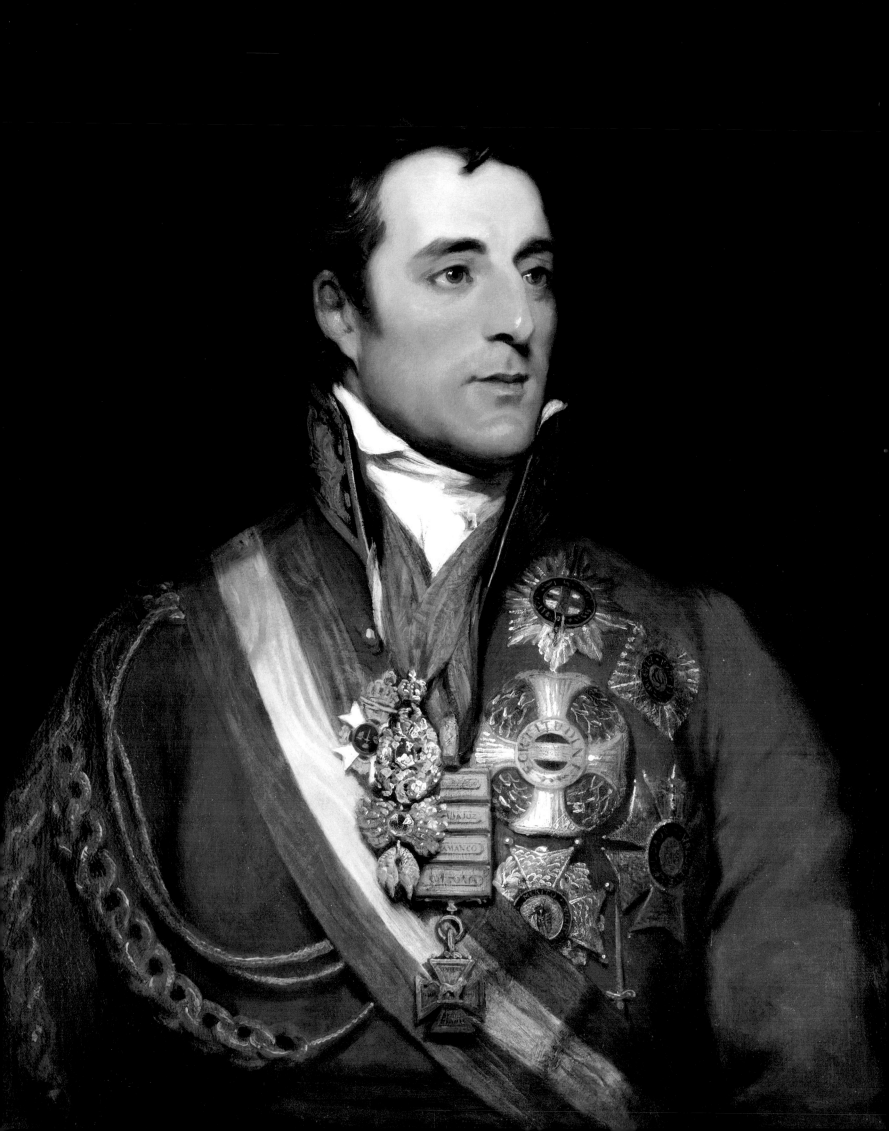

WELLINGTON
portrayed

Charles Wellesley, Marquess of Douro

with a Foreword by David Cannadine

UNICORN PRESS LTD

First published in 2014 by
Unicorn Press Ltd
66 Charlotte Street
London W1T 4QE

www.unicornpress.org

ISBN 978 1 910065 12 9

Design and layout by Mick Keates
Printed in China for Latitude Press

half-title page 1. Study in pencil and watercolour of Wellington by Thomas Heaphy, 1813.

frontispiece 2. Wellington by Thomas Phillips, 1814.

page 6 3. The Duke with Sir Robert Peel, painted by Franz Xaver Winterhalter for Queen Victoria, 1844 (detail).

To my grandfather, Gerald Wellesley, 7th Duke of Wellington,
who inspired my interest in so many things
and particularly in works of art.

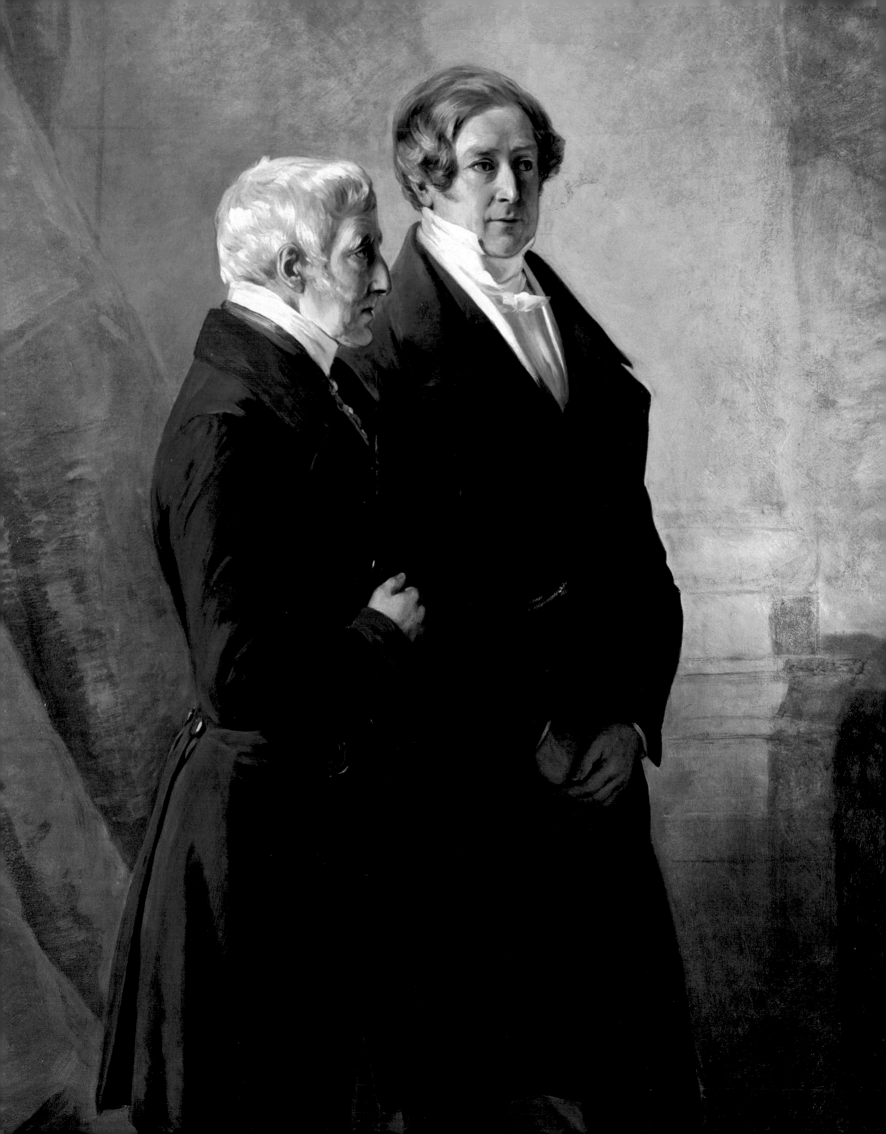

Contents

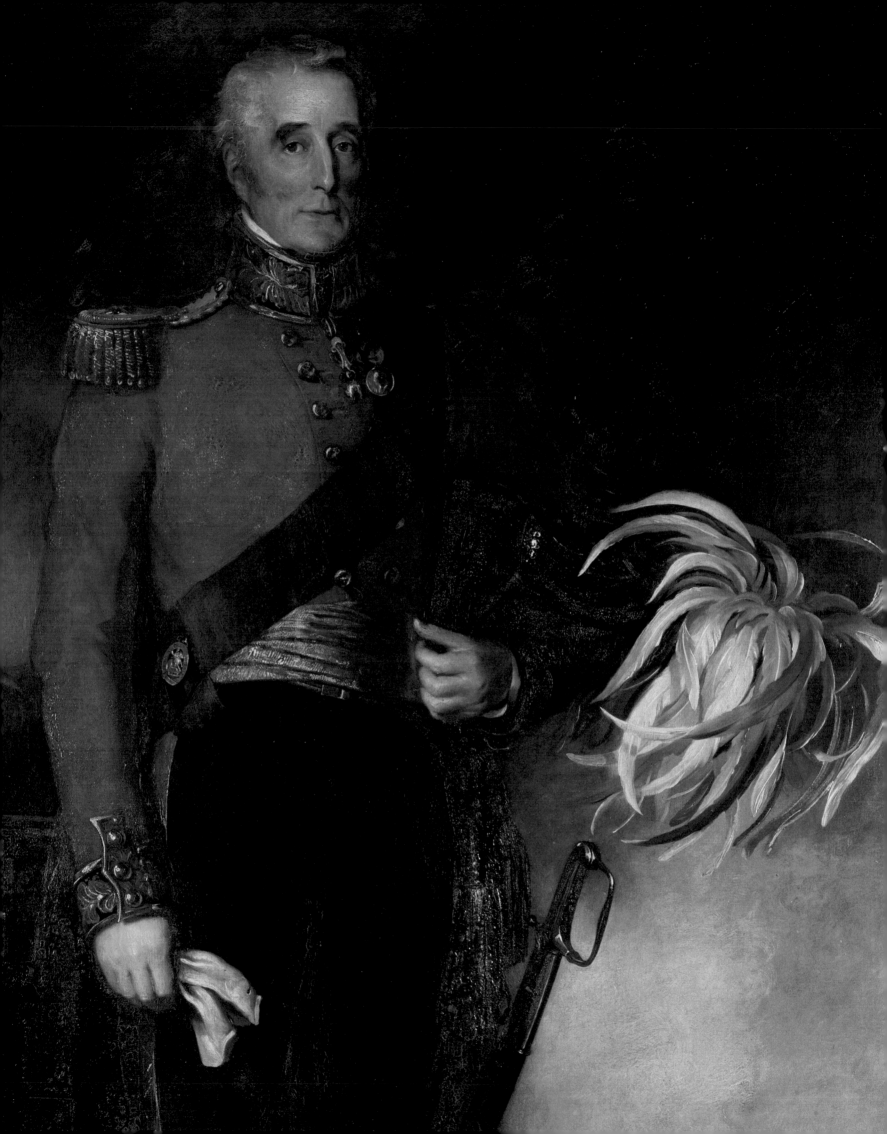

Author's Preface

There are many people I wish to thank for all the help they have given me in this small endeavour. Firstly Sir David Cannadine, who served with me as a Commissioner of English Heritage, has written a generous foreword. Her Majesty the Queen graciously allowed us to use an important number of images from the Royal Collection. Jonathan Marsden, Director of the Royal Collection, has been most supportive. Sandy Nairne, Lucy Peltz and Paul Cox at the National Portrait Gallery have given advice and encouragement. Nick Penny at the National Gallery allowed me to look at the excellent archive on their Goya portrait.

And many private owners have allowed me to publish images from their collections, including Hal Bagot, the Earl Bathurst, the Duke of Beaufort, the Duke of Bedford, the Duke of Buccleuch, Timothy Clode, Richard Cohen, the Duke of Devonshire, Michael Ethelston, Lord Hopetoun, the Marquess of Londonderry, the Duke of Northumberland, the Duke of Richmond and Gordon, the Marquess of Salisbury, the Earl of Sandwich, and the Duke of Sutherland. Teddy Clive and Liz Floyd at Christie's, David Moore-Gwyn at Sotheby's, and David Dallas at Bonhams have all very helpfully provided images of works which have gone through their sale rooms.

I thank Prince Georg von Preussen for confirming that the Behnes bust has been destroyed, and Prince Loewenstein for his help in finding the Lucas portrait given to the Prussian Army. I thank Teresa Gouveia for her help in finding the Pellegrini portrait in Lisbon. I thank Mr and Mrs Shichiro Matsukata for researching the Lawrence portrait sold to Japan in 1919. I particularly thank Manuela Mena of the Prado Museum for taking so much time to discuss with me the chronology of the Goya drawings and paintings.

Many museums and collections have allowed me to reproduce images of works for which I am very grateful. The Army and Navy Club, Ashmolean Museum, British Museum, Government Art Collection, Hermitage in St Petersburg, Institute of Directors, Metropolitan Museum of Art New York, National Gallery, National Army Museum, National Portrait Gallery, Royal Hospital Chelsea, Victoria and Albert Museum, Wallace Collection and

opposite 4. Wellington portrayed by Andrew Morton, *c.* 1837 (detail).

Wellington College have all provided images for the book. The British Museum website has been a constant source of information, as have the archives at Stratfield Saye and our archivist Jane Branfield.

I most particularly thank Alice Crossland who has done so much meticulous research and Alice Colling who has taken so many excellent photographs. Josephine Oxley, the Keeper of the Wellington Collection at Apsley House, has always been very helpful. I thank English Heritage for generously contributing to the costs of preparing the book. I thank Brian Allen for guiding me towards the publishers, Unicorn Press Ltd, who I also thank, in particular Hugh Tempest-Radford and Lord Strathcarron.

I did not imagine when I conceived the idea of doing a book of the portraits that it would take so much time and so much commitment. But I have enjoyed every minute of it.

April 2014

opposite 5. Copy after an untraced portrait by Sir William Beechey of 1814 commissioned by Lord Beresford (detail). The Duke is wearing field-marshal's uniform with the Order of the Golden Fleece, the Military Order of the Sword of Sweden, the Order of the Tower and Sword, and the Army Gold Cross with four clasps.

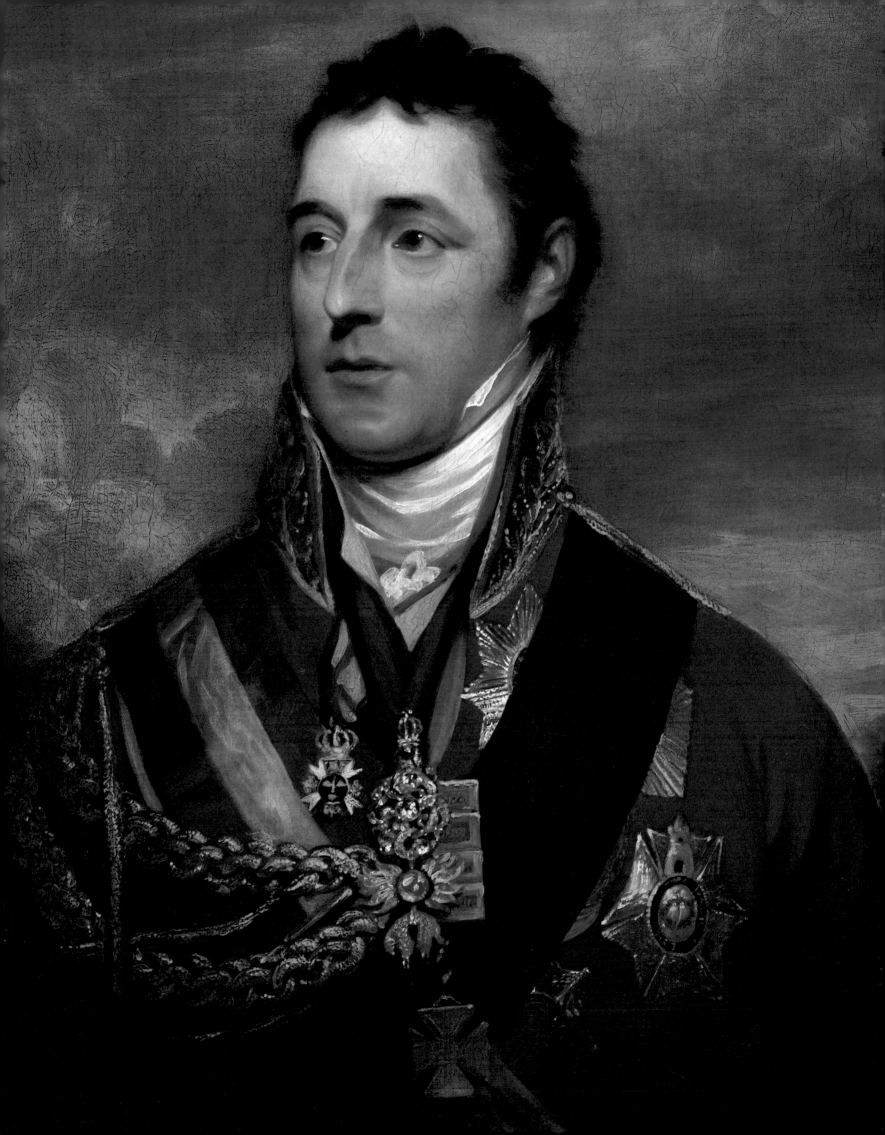

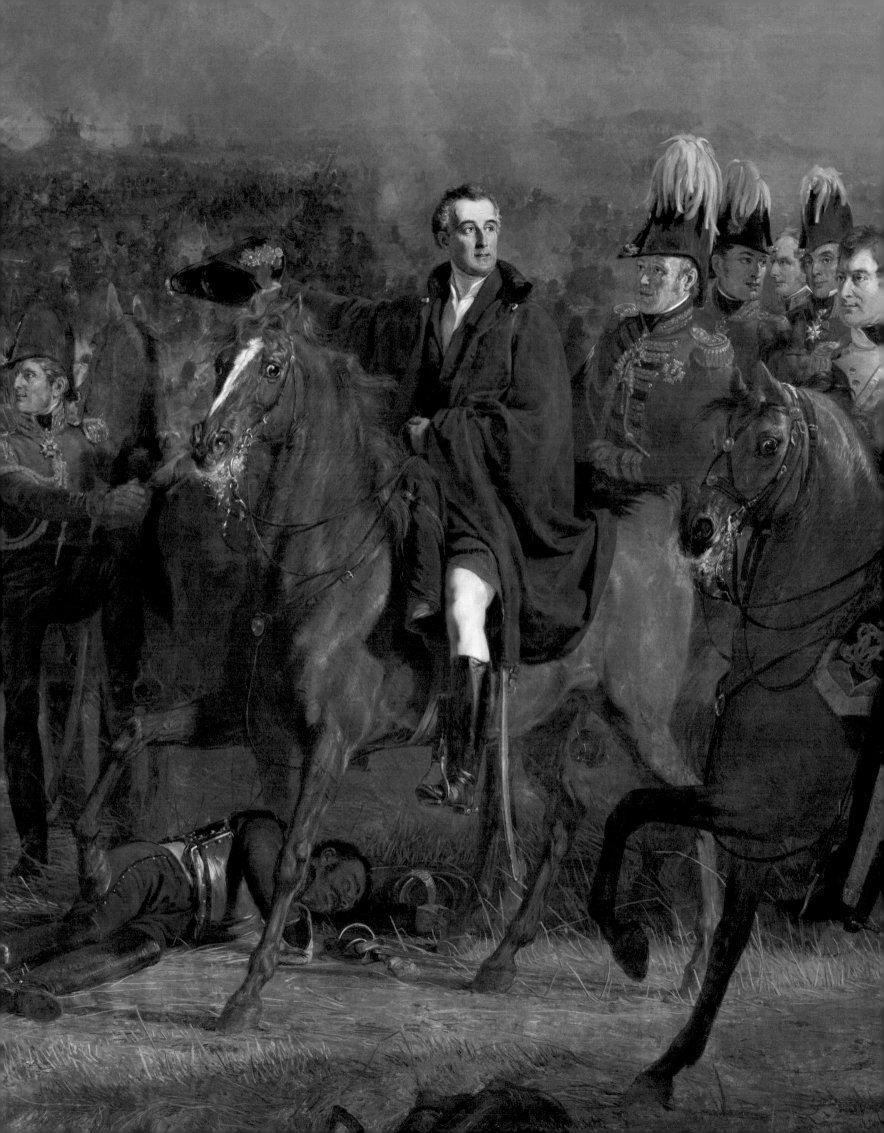

Foreword

Two hundred years on, there are many good reasons why the battle of Waterloo remains one of the most famous military engagements in European history. For decades after 1815, the United Kingdom was widely regarded as the greatest nation in the world, and for the remainder of his very long life, the Duke of Wellington was correspondingly admired as the greatest man in the world. The nineteenth century was a hero-worshipping time, and in the aftermath of Waterloo, Arthur Wellesley would become the most worshipped hero of them all. Here are some indications of his unique standing and renown. He was generally recognized as a military commander of rare and comprehensive ability, he was a dedicated and devoted servant of the state, and he was also a very remarkable human being. He held every rank in the British peerage from baron to duke, he was in addition a Netherlands prince, a Portuguese duke and a grandee of Spain, he was awarded knighthoods in virtually every major European order of chivalry, and he was a field marshal of the armies of Austria, Prussia and Russia. On his death in 1852, many people wondered if Britain could survive without him. He was accorded the most spectacular obsequies that London has ever witnessed, while Tennyson's poem in his honour has never been surpassed as a funeral ode. And in the years that followed, Wellington was commemorated in virtually every imaginable way: in streets and public houses named for him across and around the English-speaking world; in the capital city of New Zealand; in an item of footwear, a way of cooking beef, and a California redwood; in a public school that was established as a national memorial; and in a regiment in the British army, a ship in the Royal Navy, and an RAF bomber during the Second World War.

Nowadays, we no longer live in such hero-worshipping times: public figures are more likely to be derided than admired, their achievements mocked, their integrity impugned and their motives questioned; and the five minutes' fame of ephemeral celebrity (or notoriety) attracts more media attention than any claims to lasting accomplishment or enduring greatness. But this is not the only way in which the First Duke of Wellington belongs to an heroic age and an admiring world that were very different from our own times. For he was the last great

opposite 6. Detail of *The Battle of Waterloo* by Jan Willem Pieneman, 1824. Wellington is depicted on Copenhagen, at the moment when he learns of the arrival on the field of the Prussian army.

historical figure who lived most of his life before visual images became readily and instantly available to a mass, global audience: initially via photography, then through film and television, and more recently on the internet. To be sure, Louis Daguerre and Henry Fox Talbot were pioneering the first of these new forms of depiction and representation during the 1830s and 1840s; but there is only one surviving photograph of the Duke, taken in 1844. Yet as the greatest man of his generation, and a figure of unrivalled global fame, Wellington's image was widely known in his day: in part through engravings and caricatures, and in part because it was endlessly reproduced on a whole range of consumer goods, from brooches to door-stops, razors to barometers. These reproductions in turn derived from the two traditional forms of depiction and representation, namely painting and sculpture. There were many of these that could be drawn on, for even before 1815 Wellington had often been painted or sculpted; and such was his fame thereafter that the demand became insatiable, and he was depicted by virtually every major contemporary artist. Indeed, during his later decades, the requests from artists for sittings were so unrelenting as to be almost unendurable.

All this is but another way of saying that the First Duke of Wellington must have been the most painted and sculpted Briton who has ever lived: indeed, with the exception of certain religious figures, he may well be the most painted and sculpted human being who has ever lived. From one perspective, this was the direct consequence of his unrivalled heroic stature; but the constant creation of so many new images also helped entrench and consolidate his fame still further. Yet no one actually knew, and least of all the Great Duke himself, just how many painted and sculpted likenesses of him actually existed. Hence the decision of his descendant, Gerald Wellesley, later the Seventh Duke of Wellington, to compile a full list of the authentic portraits, drawings, statues and busts of his most illustrious ancestor, which he completed in collaboration with John Steegman, and published in 1935 as *The Iconography of the First Duke of Wellington*.

By turns a diplomat and soldier, an author and historian, an architect and connoisseur, Gerald Wellesley was ideally qualified to undertake this challenging and complex task; and the book appeared on the one hundred and twentieth anniversary of the Battle of Waterloo, with an elegant foreword by Philip Guedalla, the author of many works on nineteenth-century British history, who had himself written a biography of the Duke just a few years before. The *Iconography* was immediately recognised as a major work of scholarship, which opened up new ways of approaching and understanding the Great Duke; and every subsequent biographer of Wellington has been indebted to it, among them the late Elizabeth Longford, who paid a warm tribute in her acknowledgements to Gerald Wellesley as 'the generous guardian of family history and anecdote'.

But as Wellesley made plain in two appendixes to the *Iconography*, engravings were known of portraits of the Duke which could not be traced, and there were recorded portraits of him of which the current whereabouts was

unknown. So his compilation, although pioneering and path-breaking, was far from being comprehensive or complete. Since the *Iconography* was published, many new images of Wellington have been discovered, and the history and interpretation of the most famous portraits and sculptures has also been significantly deepened. And so, eighty years on, Charles Wellesley, who is Gerald Wellesley's grandson, has compiled this thoroughly updated iconography of the Great Duke, *Wellington Portrayed*. It includes many new images that have been found across the intervening decades, especially from Wellington's early years, before he was the heroic celebrity he later became after the Battle of Waterloo. It also offers new insights into the circumstances under which some of the most famous paintings were undertaken, as, for example, in the case of Goya's celebrated portrait. And to this much extended and augmented catalogue of paintings and sculptures, Charles Wellesley has also added a fascinating biographical essay on his ancestor's varied encounters and not-always-happy dealings with some of the many artists who depicted him. The result is a much more nuanced and comprehensive treatment of the many images of the Great Duke that were fashioned during his long lifetime, and this in turn helps us to appreciate, more fully than ever before, the true extent of his fame and renown. Two centuries after Waterloo, *Wellington Portrayed* is another Wellingtonian triumph.

David Cannadine
New York

1 March 2014

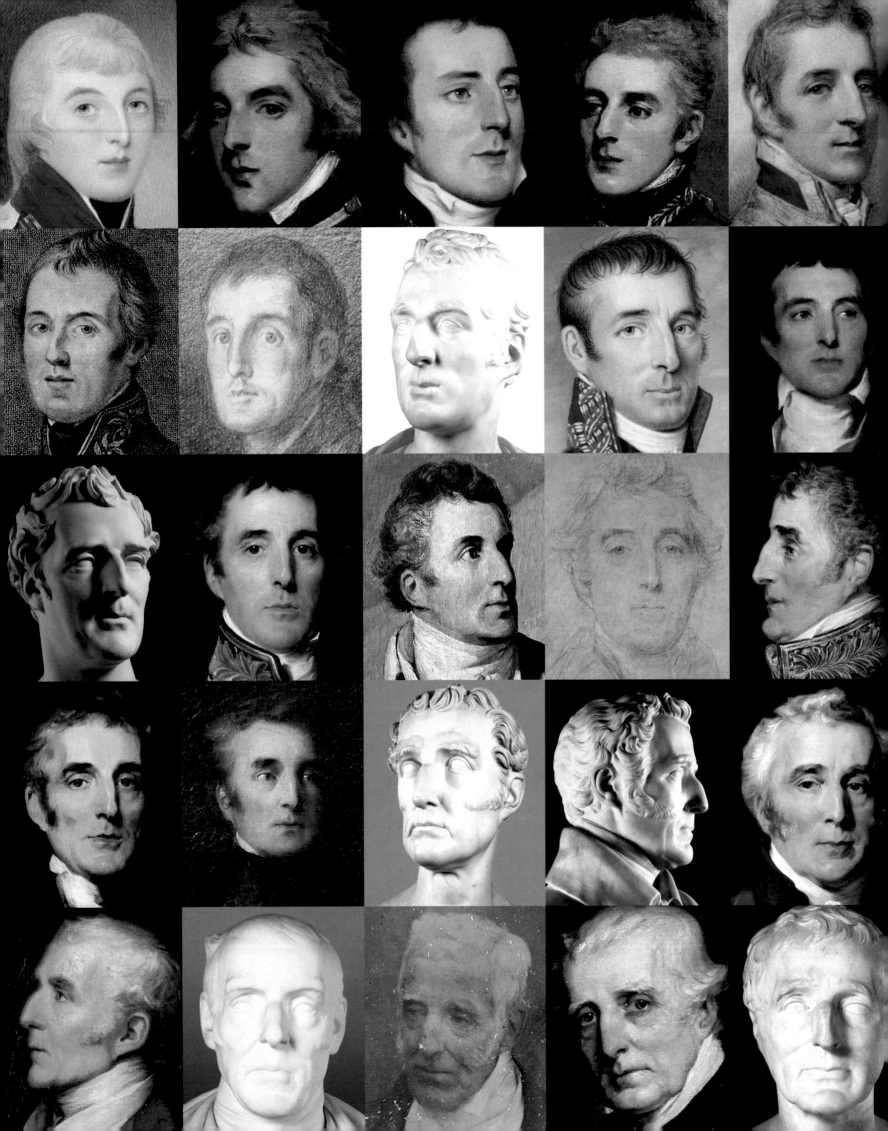

Introduction

I have spent my whole life surrounded by images of Arthur, 1st Duke of Wellington, and I am fortunate to live with my family in his two principal houses, Apsley House and Stratfield Saye. It is therefore impossible not to feel his presence and personality during my daily life.

In 1935 my grandfather, Gerald, later the 7th Duke of Wellington, published *The Iconography of the First Duke of Wellington*. It has been my Bible whenever I wanted to know about a painting or sculpture of the 1st Duke. And it has been the same for countless art historians and curators. It is a scholarly book, written with John Steegman, at the time a curator at the National Portrait Gallery.

It has for some years seemed to me that I should rewrite and update the book. Many new images have been found since the 1930s, and the new photographic technology allows reproductions of an immeasurably higher quality.

The man – who I shall normally refer to as Arthur Wellesley up until 1809 and from then on as Wellington – was probably the most painted and sculpted individual in British history (the introduction of photography after his death changed the availability of images of later well-known personalities). His image was portrayed continuously and in multiple versions. The National Portrait Gallery holds 343 images of Wellington versus 84 for Nelson, 85 for Marlborough, 91 for Henry VIII, and 125 for Queen Elizabeth I. The British Museum holds an impressive 2,362 images of the Duke.

Wellington was portrayed over and over again because he became the most admired person of his generation in the whole of Europe. From the Battle of Talavera in 1809 through the Battle of Waterloo in 1815, his appointment as Prime Minister in 1828 and his reappointment as Commander-in-Chief in 1842, there was a universal appetite for his image. Every institution, foreign court or noble house needed a portrait or a bust. His distinctive face and features became known to everyone. The caricaturists constantly drew his strong nose. And as my grandfather said, 'enamellers, painters of snuff boxes, horn pressers, pewterers, bronze-casters, medallists, fan makers and iron-workers' all wanted images of Wellington on their wares.

opposite 7. Arthur Wellesley, Duke of Wellington, through time.

top row Anonymous, *c.* 1787; by Hoppner, *c.* 1796; by Home, 1804–5; by Hoppner, *c.* 1806–7; by Cosway, 1808.

second row By Bartolozzi after Pellegrini, 1810; by Goya, 1812; by Nollekens, 1813; by Bauzil, 1814; by Lawrence, 1814.

third row By Chantrey, 1814; by Lawrence, 1817–18; by George Hayter, 1819; by Lawrence, *c.* 1820; by Ward, 1829.

fourth row By Lawrence, *c.* 1829; by Wilkie, 1832–33; by Pistrucci, 1840s, after his bust of 1832; by Campbell, *c.* 1828–36; by Briggs, 1840.

bottom row By Morton, *c.* 1840; by Marochetti, 1841; by Claudet, 1844; by Henry Weigall Jun., 1851; by Adams, 1852.

Between 1814 and 1852, the year of his death, every portrait painter and sculptor of merit and ambition implored the Duke to be given a sitting. In July 1834 he wrote to Sir John Beckett, 'I have not promised to sit for less than a score of portraits. No portrait painter will copy the picture of another, nor paint an original in under fifteen to twenty sittings, and thus I am expected to give not less than four hundred sittings.' But the result is that he was portrayed by all the best painters and sculptors of his time. Chantrey, Nollekens, Lawrence, Dawe, Wilkie and Lucas all produced portraits of enduring quality and artistic merit. In many cases there are stories and correspondence surrounding the works that are in themselves interesting to art historians.

So it has been a fascinating and rewarding experience to research and catalogue the portraits of Wellington over his long life of eighty-three years. This new iconography now lists over three hundred original paintings and sculptures.

opposite 8. *Wellington reading the Indian Dispatches*, by Thomas Jones Barker, 1846.

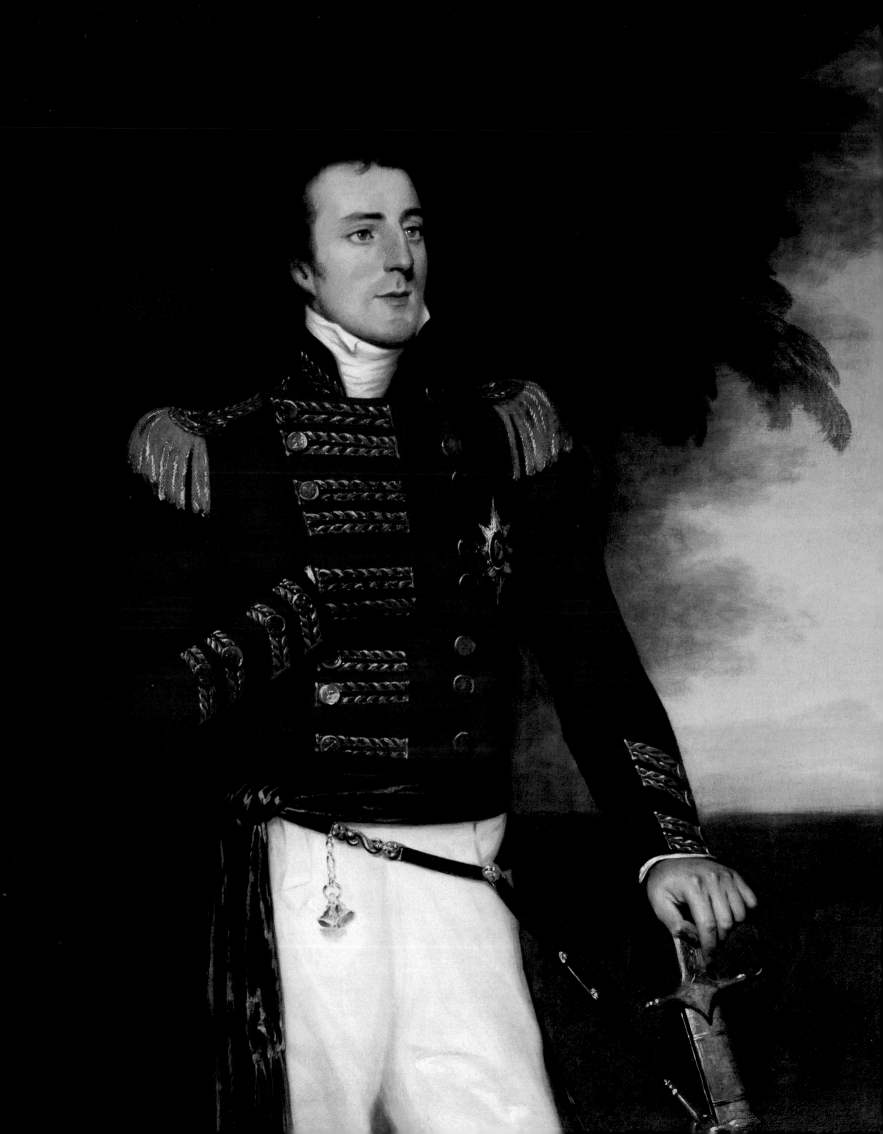

1

Early Days, India, and Marriage

The Hon. Arthur Wellesley, later 1st Duke of Wellington, was born on 1 May 1769. He was the fourth son (one older brother had died as an infant) of the Earl and Countess of Mornington, Anglo-Irish landowners in County Meath. Their country house, Dangan Castle (**10**), was about 30 miles from Dublin, and in Dublin they owned Mornington House in Merrion Street (now part of the Merrion Hotel).

Arthur's grandfather had been born Richard Colley (**11**). When he inherited from a maternal cousin the estates of the Wesley or Wellesley family he changed his name to Wesley. In 1746 he was created Baron Mornington. He was painted by William Hogarth (**12**). A man of taste, he enlarged his house and embellished the park with an ornamental lake, a temple, and two obelisks. The park was described in 1752 by Richard Pococke, Bishop of Ossory and Meath, as 'the most beautiful thing I ever saw'.

In 1758 he was succeeded by his son Garret, who was created Earl of Mornington and Viscount Wellesley of Dangan Castle in 1760. Garret Mornington was very musical and became the first Professor of Music at Trinity College Dublin, an unusual appointment for a land-owning aristocrat. Arthur and his siblings were brought up in a household full of artistic influence.

His mother, Anne, was painted several times. A romantic drawing of her as a young woman was done in 1760 by Robert Healy. (Healy was to die in 1771 from a severe cold caught while sketching Lord Mornington's cattle in Dangan Park.) She was painted by Sir William Owen in 1814 (**13**), by which time her sons had become famous. It is possible to see in this portrait where their strength of character came from. And she was portrayed by her granddaughter, Lady (Priscilla) Burghersh, later Countess of Westmorland, surrounded by the effigies of her four famous sons.

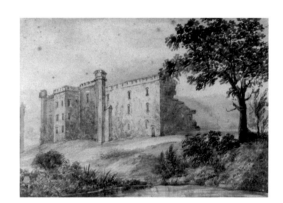

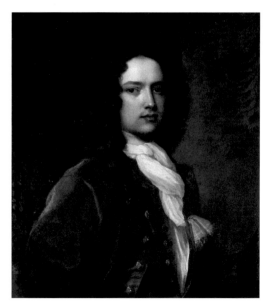

opposite 9. General Wellesley by Robert Home, 1804–5.

top 10. Dangan Castle, drawn after a fire that destroyed it in 1820.

above 11. Wellington's grandfather, Richard Colley, later Richard Wesley, *c*. 1700.

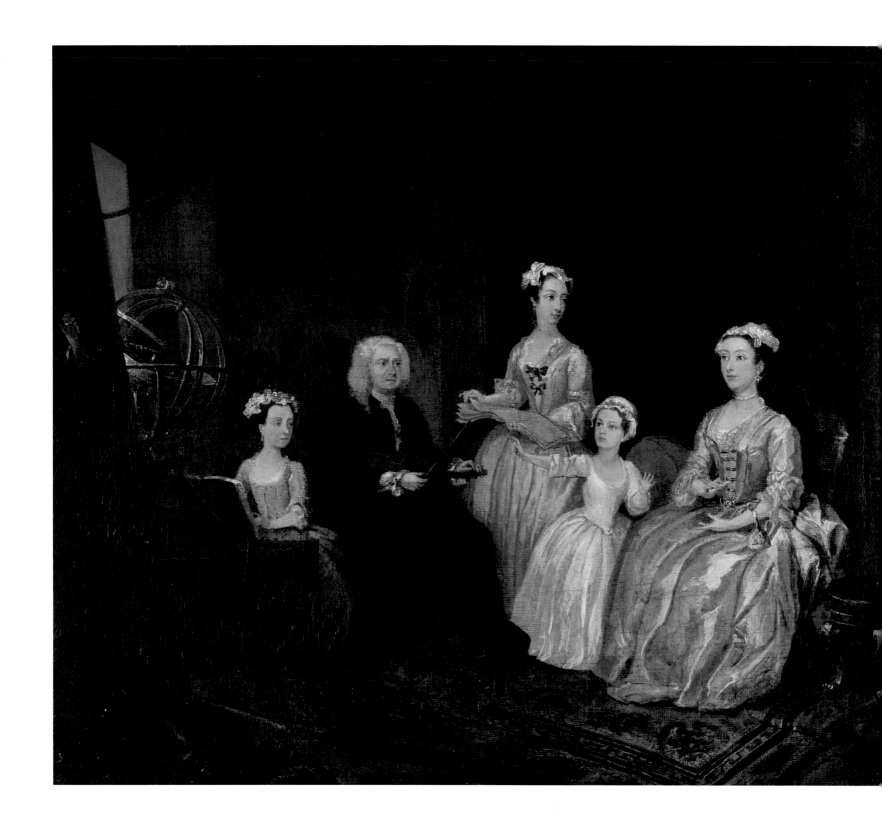

above 12. Wellington's grandfather, Richard Wesley, later Baron Mornington, portrayed by William Hogarth *c*. 1731 with his wife Elizabeth, their daughters Elizabeth and Frances, and their friend Miss Donnellan.

opposite 13. Wellington's mother, the Countess of Mornington, by Sir William Owen, 1814.

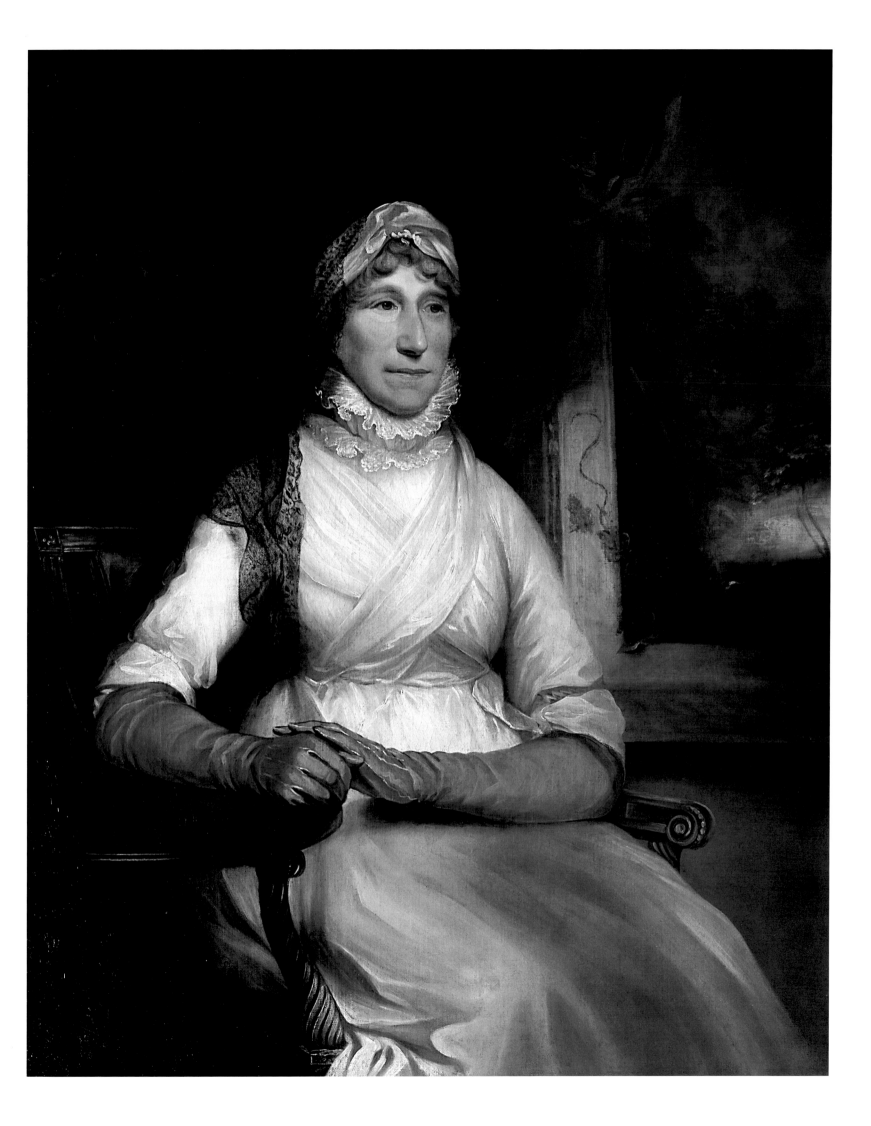

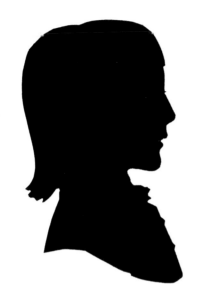

The first image we have of Arthur is a silhouette made about 1780 when he was eleven years old (**14**). What may be the earliest image of him as a young man has recently come to light, in a miniature perhaps by Walter Robertson (**15**). The features, such as the nose and earlobe, correspond to Arthur's, and he is wearing the uniform of the 76th Regiment of Foot. It has been dated to November–December 1787, when for a brief period Arthur, aged eighteen, was commissioned into this newly-formed regiment.

During the years 1787–95 Arthur mainly served as a junior aide-de-camp to the Lord Lieutenant of Ireland – first the Marquess of Buckingham and then the Earl of Westmorland. During this period he courted Kitty Pakenham, a member of another Anglo-Irish family from Westmeath, but her father, the 2nd Lord Longford, did not consider that Arthur had good enough prospects for his daughter.

In 1794 he went with his regiment, now the 33rd Regiment of Foot, to the Netherlands, where he was famously marched up to the top of the hill and down again by the Grand Old Duke of York. On returning from the Netherlands he sat to John Hoppner, the leading portrait painter of the moment (Lawrence having not yet gained his pre-eminent position) (**16**). The portrait of Lieutenant-Colonel Arthur Wesley – the family name was not changed back to Wellesley until 1797 – showing him in red uniform as an 18th-century figure with powdered hair has become iconic. Many years later, in 1841, Arthur sent the portrait to his eldest brother, Richard, who in a letter acknowledging its receipt commented, 'It is remarkable; much the best which exists of you; the likeness is perfect and conveys the true expression of your countenance.'[1] Hoppner went on to paint four of the five Wellesley brothers, and their sister Anne with her children (**17**).

In 1796 the 33rd Regiment of Foot, of which Arthur was now the commanding officer, was sent to India, where he was to acquire fame and fortune. His first serious action was against Tipu Sultan, the Tiger of Mysore, at Mallavelly on the way to Seringapatam. When Tipu was defeated and Seringapatam fell, in May 1799, Arthur was appointed Governor of Mysore. Over the following few months Thomas Hickey painted and drew many of the officers serving in the province, but any image of Arthur has disappeared. The painting of his brother Richard, Marquess Wellesley, then Governor-General of India, hangs at Apsley House, and at Stratfield Saye there are twenty-five drawings of the other officers. Four years later, the troops led by Arthur, by then a major-general, defeated a much larger force of Mahrattas at Assaye – 'the bloodiest for the numbers that I ever saw', he remembered.

While in India Arthur was painted several times by Robert Home (**9**). There are nine recorded portraits, of varying lengths, including examples at Apsley House, the National Portrait Gallery, and the Royal Collection. Some show him with the Order of the Bath, added by Home when news of the honour (gazetted in September 1804) reached India in February 1805. So Arthur became Sir Arthur Wellesley, KB. William Hickey, the diarist, records a visit to Home's studio, where he saw two portraits 'as large as life of the Marquess Wellesley

top 14. Silhouette of Arthur Wesley, *c.* 1780.

above 15. Miniature of Lieutenant Arthur Wesley, perhaps by Walter Robertson, 1787.

opposite 16. Lieutenant-Colonel Arthur Wesley by John Hoppner, *c.* 1796 (detail).

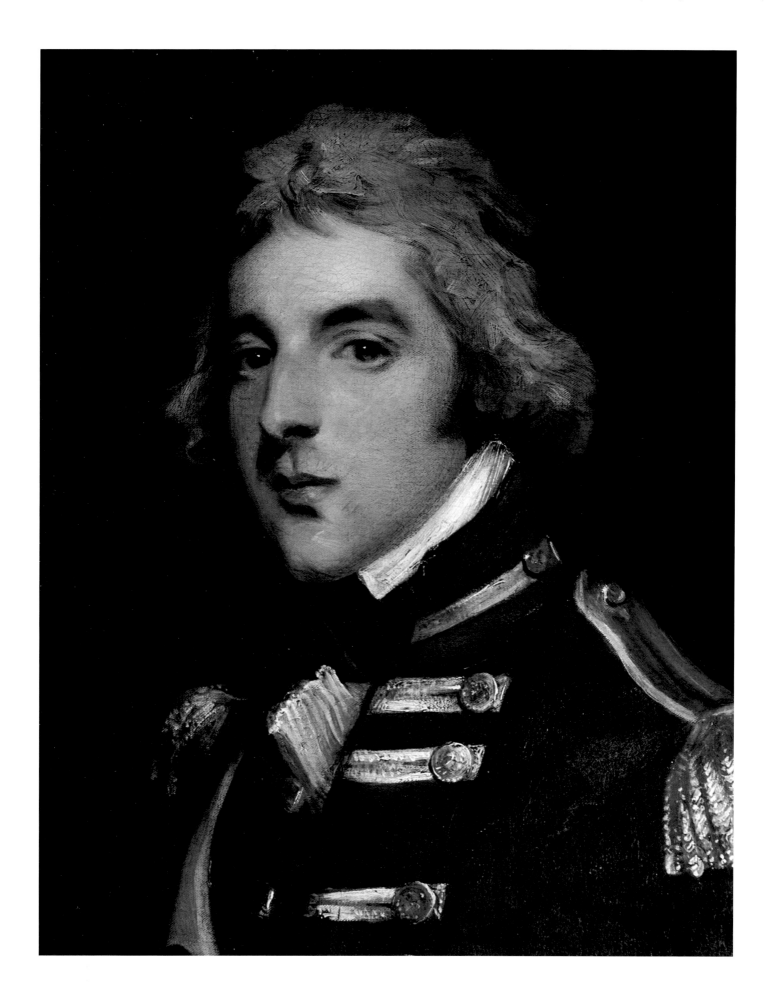

right 17. Wellington's sister, Lady Anne Wellesley, with Anne Caroline and Georgiana Frederica, the daughters of her first marriage, to the Hon. Henry Fitzroy (d. 1794), by John Hoppner.

opposite 18. The meeting of Sir Arthur Wellesley and Lord Nelson in 1805, as later imagined by John Prescott Knight.

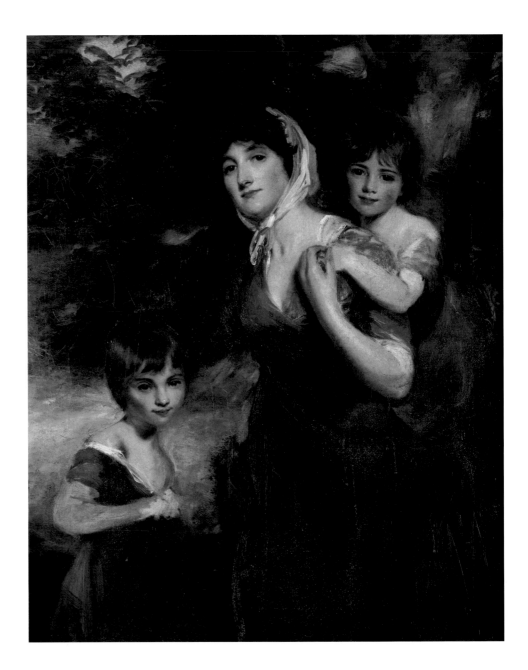

and his brother Arthur'.[2] A version of the Home portrait was engraved by Charles Turner in 1806, and when in 1809 Arthur, by then Lieutenant-General Wellesley, won the Battle of Talavera the engraving formed the basis of the images that were mass-produced to satisfy a huge demand for his likeness.

During Wellington's life a number of paintings that could not be described as portraits were done with him as the principal subject. All were engraved, adding greatly to the universal familiarity with his image. One of these, and perhaps the most poignant, depicts the meeting of Sir Arthur Wellesley and Lord Nelson on 12 September 1805 (**18**). Arthur had just arrived back in London from India, and immediately called on Lord Castlereagh, the Secretary for War and the Colonies. In the waiting room in the War Department he met a one-armed admiral with a patch over one eye. He immediately recognised

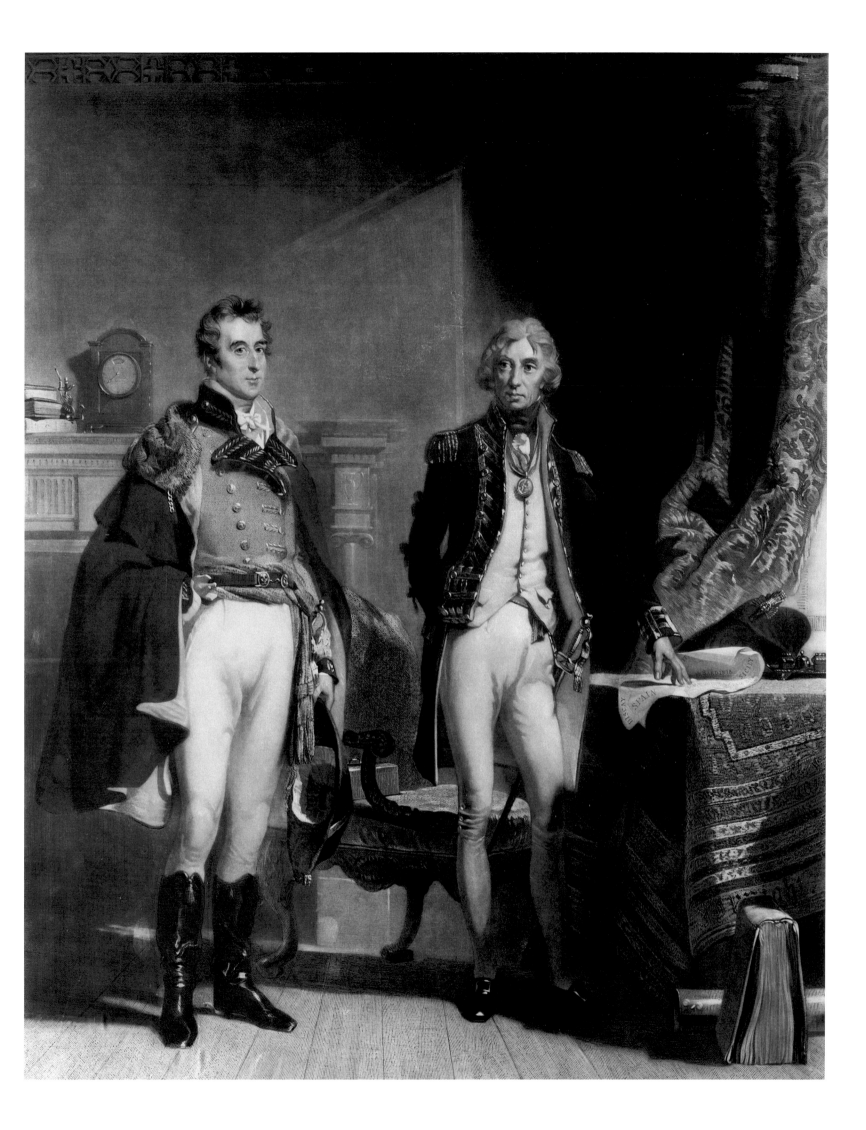

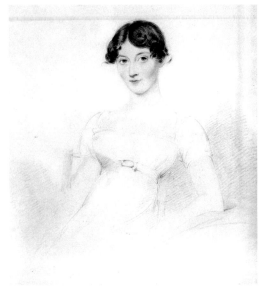

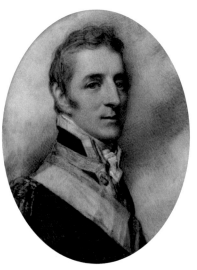

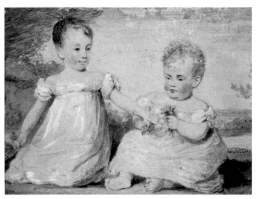

Nelson, but not vice-versa. To Arthur's annoyance 'He entered at once into conversation with me, if I can call it conversation, for it was almost all on his side, and all about himself, and, really, in a style so vain and silly as to surprise and almost disgust me.'[3] Nelson stepped out to enquire who the stranger was, and they then had a most interesting twenty-minute conversation. 'All that I thought a charlatan style had vanished, and he talked . . . with a good sense, and a knowledge of subjects both at home and abroad, that surprised me equally and more agreeably than the first part of our interview had done; in fact, he talked more like an officer and a statesman . . . I don't know if I ever had a conversation that interested me more.' Nelson died six weeks later at the Battle of Trafalgar. An image of this chance meeting was painted some years later by John Prescott Knight. The painting cannot be found, but it had been engraved, and thus the scene became well known.

Soon after his return from India Arthur renewed his suit to Kitty Pakenham (**19**), although he had not seen her for some twelve years. This time of course he was accepted by the Pakenhams, having become Sir Arthur Wellesley KB and acquired a fortune of £40,000 (probably equivalent to £4 million today) from his time in India. They were married in Dublin on 10 April 1806, and he was almost immediately made Chief Secretary for Ireland. He was described by Maria Edgeworth, a close friend of Kitty's, as 'handsome, very brown . . . and with a hooked nose'. Richard Cosway painted at least two miniatures of him around this time (**20**).

Two sons were born of the marriage, in February 1807 and January 1808. Arthur was to carry the portrait of the boys by Henry Edridge (**21**) in his travelling case all through the Peninsular War.

About this time Arthur sat again to Hoppner, for a large picture for Government House, Madras (**22**). The horse is Diomed, which he had lost at Assaye, but which had been found and bought by Sir John Malcolm, a friend. 'The old horse is in sad condition, but he shall be treated like a prince till I have the pleasure of restoring him to you.'[4] The picture was acquired by the 7th Duke from the Government of India in exchange for relics of Tipu Sultan, and it now hangs at Stratfield Saye. Engravings were published in 1808, 1810 and 1814.

In 1808 Sir Arthur was promoted to the rank of lieutenant-general – the youngest in the British Army. On 12 July he sailed from Cork with a force of nine thousand men to give support to the Portuguese people and to eject the French Army from Portugal. And thus began the Peninsular War.

top 19. Kitty, Viscountess Wellington, by Josiah Slater, 1811.

centre 20. Lieutenant-General Wellesley, miniature by Richard Cosway, 1808.

above 21. Lord Douro and Lord Charles Wellesley as small children, by Henry Edridge.

opposite 22. Major-General Wellesley with his horse Diomed, by John Hoppner, *c*. 1806–7.

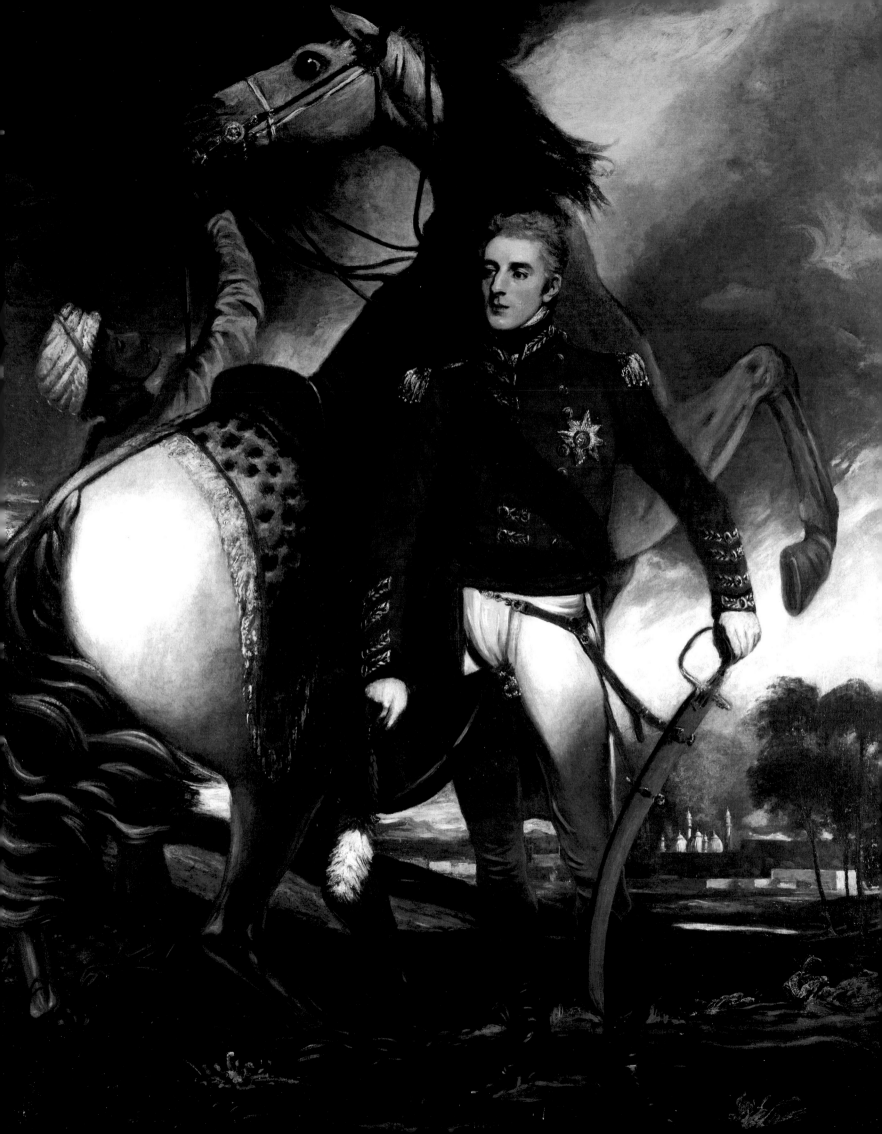

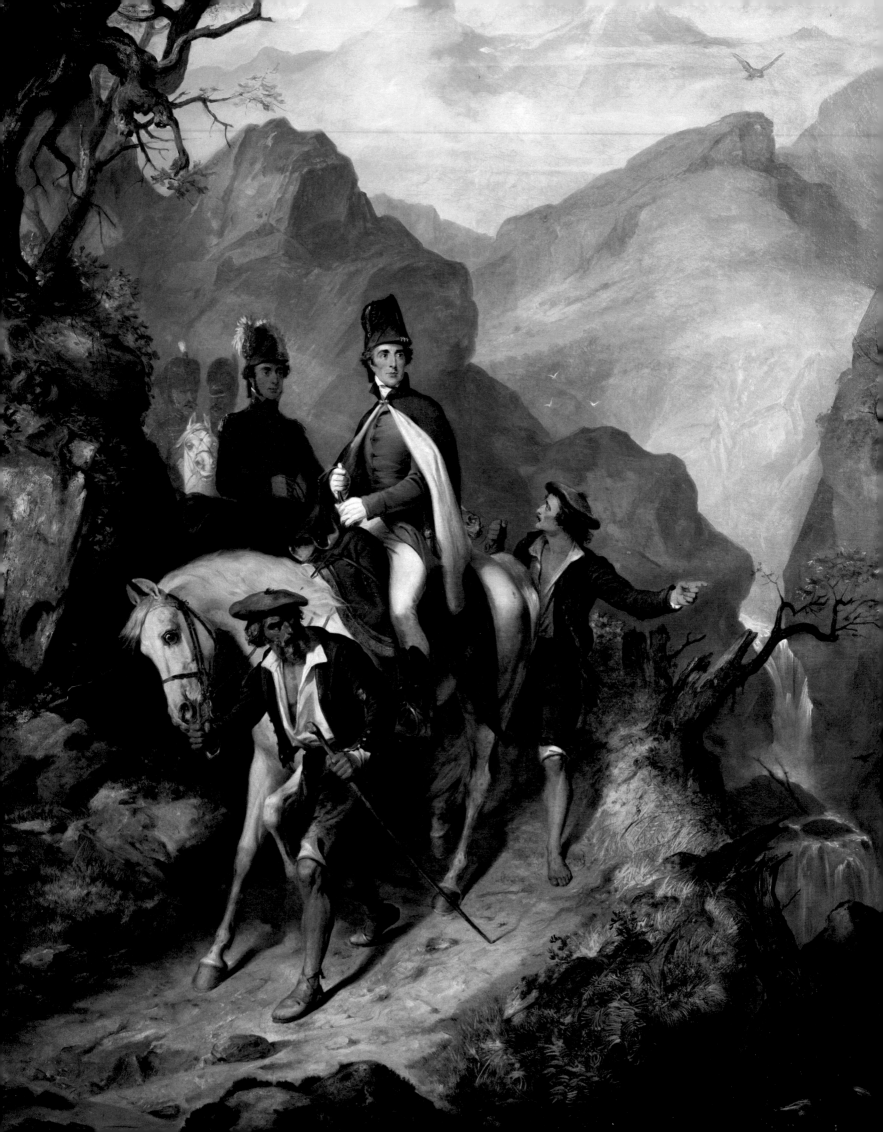

2

On Campaign for Seven Years

On 1 August 1808 Lieutenant-General Sir Arthur Wellesley landed with
his expeditionary force at Mondego Bay, some 100 miles north of Lisbon.
He moved towards Lisbon, and on 17 August won the Battle of Roliça,
followed on 20 August by the Battle of Vimeiro, in which the French General
Junot was defeated. But at the moment of victory two more senior lieutenant-
generals, Burrard and Dalrymple, arrived from England. Wellesley was
superseded, and the military advantage was not pressed. The new commanders
negotiated with Junot the excessively lenient Convention of Cintra, which
allowed the French to withdraw from Portugal with their baggage and their
booty. All three generals were recalled to London to face a Court of Inquiry at
the Royal Hospital Chelsea. Reflecting the public outrage, George Cruikshank
drew an image showing Sir Arthur paying homage to Junot (**24**). Throughout
his professional career his features were to attract the art of the caricaturists.

 In the end the three generals were cleared, but Burrard and Dalrymple
never again held command. After the death of Sir John Moore, Wellesley was
reappointed to the Iberian command. Between then and his departure in the
spring he must have sat to Joseph Nollekens, then seventy-two years old but
still the leading sculptor of the moment (**25**). His friend Lord Castlereagh had
been sculpted by Nollekens in 1808, and this may have encouraged him to give
sittings himself. After he had left England, in July Kitty recorded in her journal
going with her brother, Lord Longford, 'to see Sir Arthur's bust at Nollekens'
– it is indeed as like as possible'. The bust, which was probably plaster at that
stage, must have been seen by several artists, as it was drawn and copied by
many, including Abraham Wivell, Lawrence Gahagan and John Jackson.

 Arriving back in Portugal in April 1809, Sir Arthur would have had no time
to sit for painters. He rapidly moved north to Oporto, crossed the River Douro,

opposite 23. *Wellington at Sorauren, 27 July 1813*,
painted by Thomas Jones Barker in 1854.

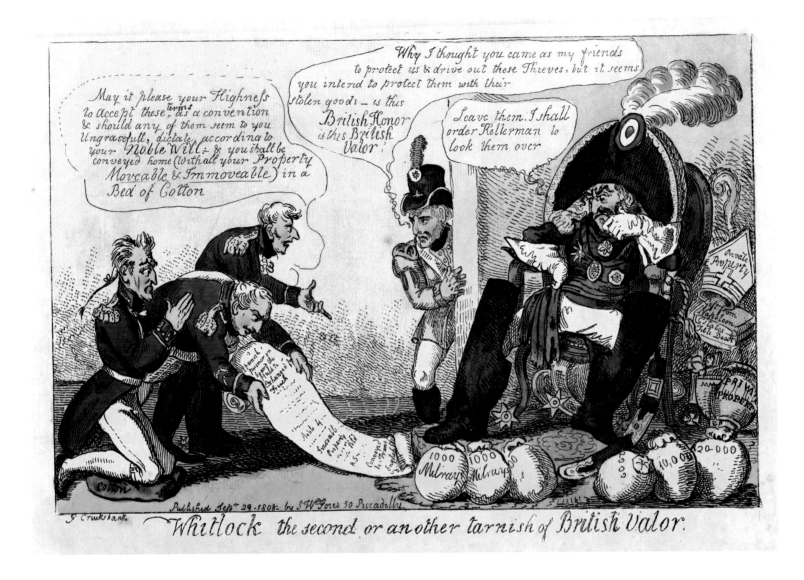

above 24. George Cruikshank's caricature, 1808.
Sir Arthur Wellesley, on the left, with Generals
Burrard and Dalrymple paying homage to Junot.

opposite 25. Marble bust by Joseph Nollekens, 1813.
Sir Arthur had sat to him in 1809.

entered Spain, and in July won the Battle of Talavera. The event was lauded
in England, and on 4 September Sir Arthur Wellesley was made a Viscount.
The College of Heralds did not want to wait to hear from Arthur, so the title
was chosen by his brother William, who wrote to him, 'after examining the map,
I at last determined upon Viscount Wellington of Talavera and of Wellington,
and Baron Douro of Welleslie in the county of Somerset – Wellington is a town
not far from Welleslie.' The family had come from Somerset before moving to
Ireland in the 12th century. Douro was chosen on account of the brilliance of
the crossing of the River Douro and the capture of Oporto in May 1809. Arthur
wrote back, 'I think you have chosen most fortunately.' From then on he was
known as Douro by the Portuguese troops. After the Battle of Talavera there
developed a widespread demand for his image, and engravings of the portraits
by Home and by Hoppner were sold in great quantities.

In August 1809 Wellington visited Lisbon for a few weeks, and it was
presumably during this time that he was painted by the Italian artist Domenico
Pellegrini, who was living there. The painting was engraved in 1810 by

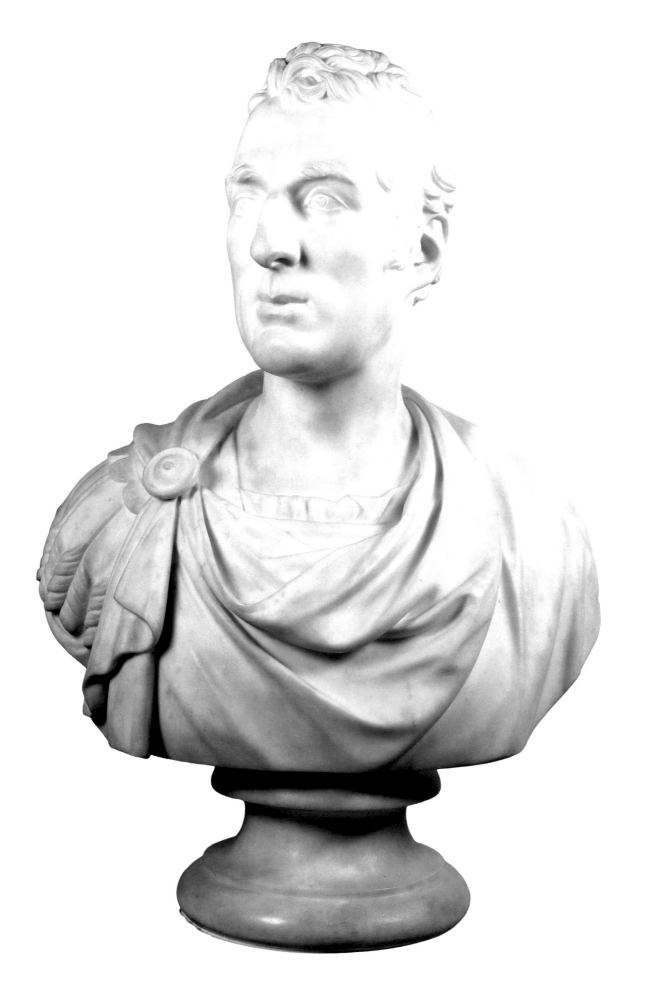

BATALHA DE ALBUERA

RESTAURAÇAŌ DO PORTO

BATALHA DO VIMEIRO

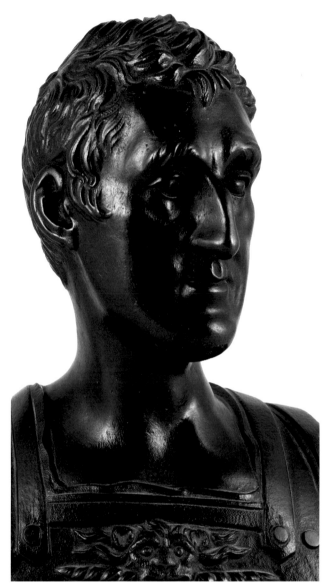

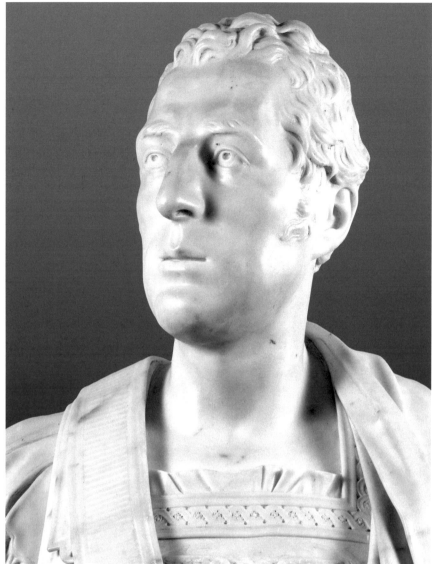

Francesco Bartolozzi, a distinguished Italian printmaker, founding member of the Royal Academy in London and then Director of the Academy of Fine Arts in Lisbon. He did two versions, a full-length (26) and a half-length. Hundreds of prints after the Pellegrini portrait were made, including versions by three other engravers. When the Duke died he left at Stratfield Saye a folder containing twenty-five copies of the full-length engraving by Bartolozzi, which he must therefore have admired.

Wellington stayed in the Iberian Peninsula from April 1809 until October 1813, when he crossed the Bidassoa into France – one of the few officers to stay the course. During these five years surprisingly few portraits were made by Spanish or Portuguese artists. In England, Lawrence Gahagan issued a small bronze bust in 1811 (27) seemingly related to the Nollekens (25), of which many examples were produced. In 1812 John Edward Carew produced a bust (28), probably based on the Nollekens and on the Home portrait (9), which was considered sufficiently good to be exhibited at the Royal Academy in 1813.

opposite 26. Viscount Wellington in Lisbon, engraved after Domenico Pellegrini by Francesco Bartolozzi, 1810.

above left 27. Bronze bust by Lawrence Gahagan, 1811.

above right 28. Marble bust by John Edward Carew, c. 1813.

overleaf, left 29. The Marquess of Wellington, painted in Madrid by Goya in 1812, with further orders added in 1814.

overleaf, right 30. Equestrian portrait of Wellington by Goya, 1812.

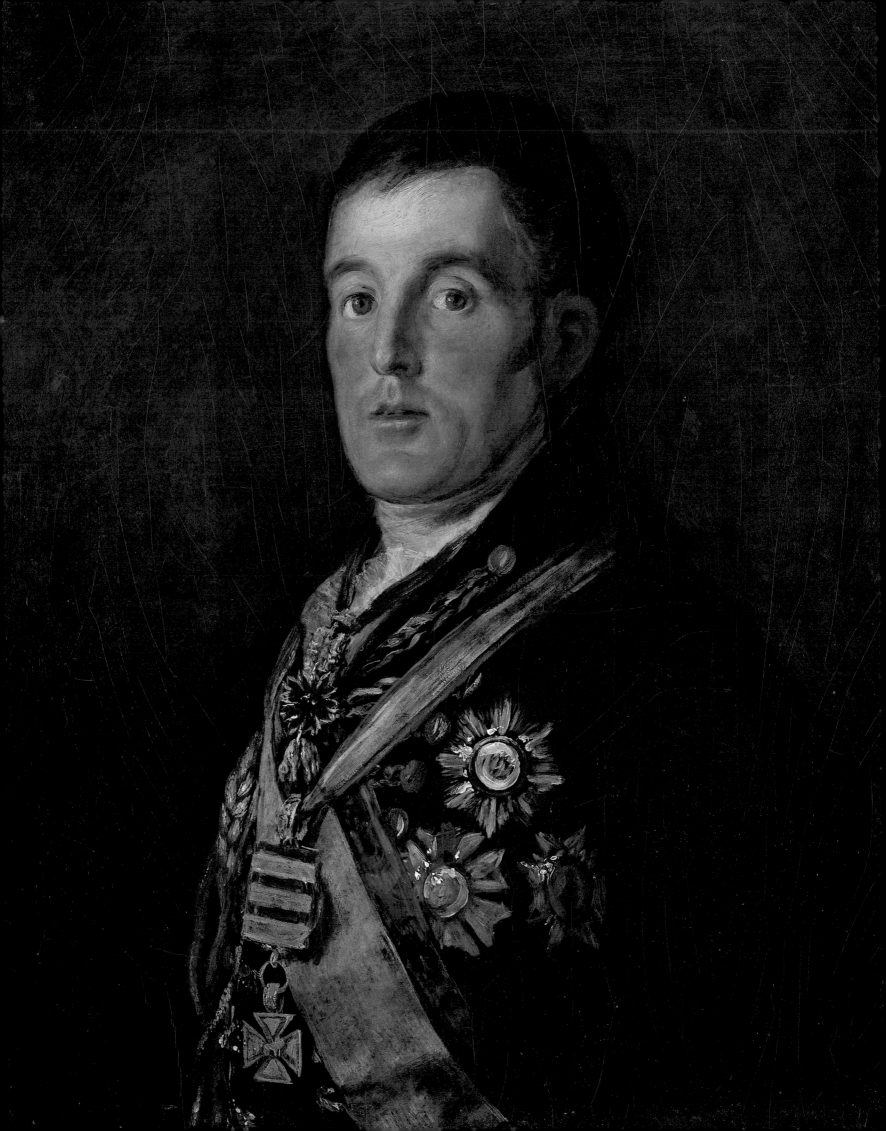

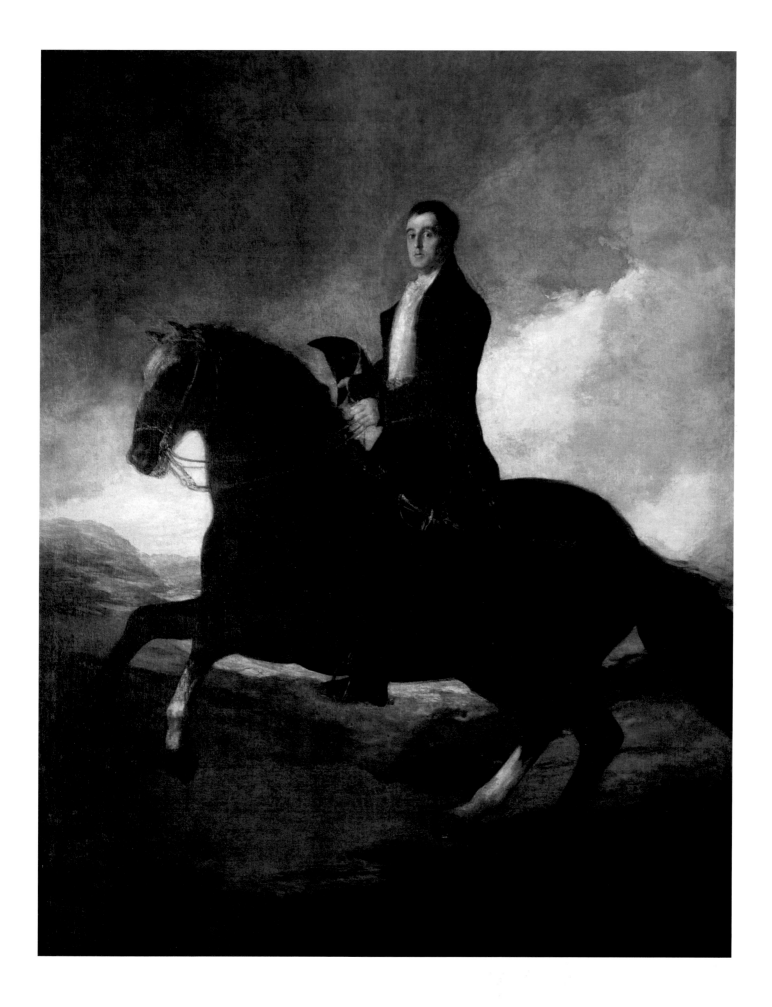

It was lost sight of in 1935 but was acquired by the 7th Duke in 1966 from John Harris and is now at Stratfield Saye. It is surprising that Carew's master, Richard Westmacott, who made several sculptures of Nelson, appears only to have sculpted Wellington many years later, for Government House in Gibraltar (now in the Botanical Gardens). He did do the statue of Achilles naked in Hyde Park, which was erected as a tribute to Wellington 'by the Ladies of England', causing much mirth and comment.

On 21 July 1812 Wellington fought and won the Battle of Salamanca, known in Spain as the Battle of Arapiles. On 12 August he entered Madrid, and immediately sat to Francisco de Goya, Spain's greatest painter of the time. Goya made an oil sketch on a mahogany board, probably taken from a Caribbean cigar packing-case (29). Manuela Mena of the Prado believes that it is the original from which all Goya's other images were made.[5] Using it, he transformed a large equestrian portrait that appears to have been of Napoleon's brother Joseph Bonaparte, then King of Spain, into a portrait of Wellington (30). That painting was seen by Wellington on 28 August at the Real Academia, and he agreed that it should go on public display on 2 September. However he then had to leave Madrid on 1 September in pursuit of the French, who were moving north towards Burgos. The large painting and the half-length remained with Goya.

The chronology of the portraits can be partially determined by reference to the various decorations depicted. While Wellington was still in Madrid, or in the months following, Goya made a very detailed red chalk drawing, seemingly in preparation for an engraving, which shows Wellington anxious and concerned (31). Fifty years later Goya's grandson suggested that it had been done on the night following the Battle of Salamanca, and that came to be the accepted view. But that almost certainly cannot be true. Goya would not have been so close to the hostilities, and it would have been difficult for him to do such a detailed drawing away from his studio. In the drawing a circular gap is left for the Large Army Gold Medal, issued in 1810 and in use until October 1813. Goya then drew a second softer portrait, in pencil, with the Large Army Gold Medal overlaid by the Order of the Golden Fleece. The Golden Fleece was granted to Wellington, the first non-Catholic ever to receive it, on 8 August 1812, by the Cortés of Cadiz. The news reached Madrid on 20 August, and on the same day Wellington wrote to Lord Bathurst seeking the Prince Regent's permission to accept the honour. Permission did not arrive until September, by which time Wellington had left Madrid. He would never have allowed himself to be drawn wearing the Order until he had received the permission.

The Army Gold Medal was superseded in October 1813 by the Army Gold Cross. Officers who had fought at four of the battles received a cross with the names of a battle on each segment. For each further battle a clasp was issued, to be worn above the cross. When the oil sketch was worked into a finished half-length (29), X-rays show that he was still wearing the Large Army Gold Medal. However, the finished painting now shows the Army Gold Cross and three clasps. Wellington's cross and three clasps, which was gazetted in October 1813,

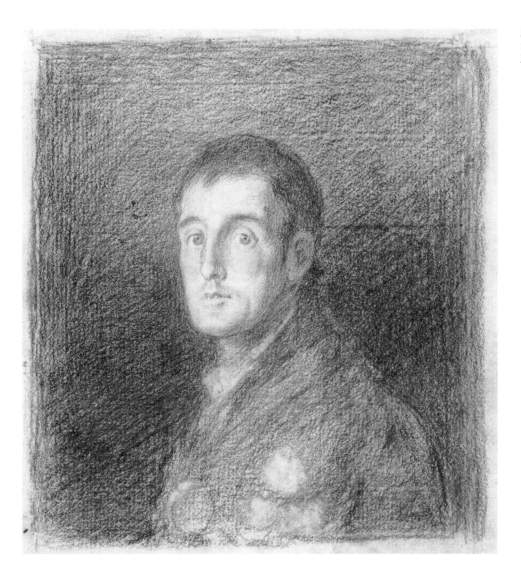

31. Wellington, drawn by Goya in Madrid, 1812. The shape of the Large Army Gold Medal (see p. 157) is indicated on the left.

would not have been received for some months, by which time Wellington was in northern Spain or southern France. He only returned to Madrid in late May 1814, and we must assume that he then lent his insignia of the Army Gold Cross and three clasps, plus his Order of the Golden Fleece, to enable Goya to add them to the picture. It is the only painting of Wellington with three clasps. The fourth clasp was issued in late March 1814, but he probably did not receive it until he returned to England on 23 June.

The oil half-length on mahogany and the large equestrian portrait were later sent to England. Wellington eventually gave the half-length to Louisa, the widow of Sir Felton Hervey-Bathurst, one of his staff officers, who had died in 1819. She was the sister of Marianne Patterson, an American lady he was very fond of (see below, pp. 53–56). Wellington allowed Louisa a house on the Stratfield Saye estate where she lived for nine years, and presumably he gave the Goya portrait to her during that time. In 1828 she married Lord Carmarthen, who in 1838 succeeded his father as Duke of Leeds. The painting descended to the 12th Duke of Leeds, who in 1961 sold it to an American, Charles Wrightsman, for

£140,000. The export was blocked and with grants from the Wolfson Foundation and the Treasury, the National Gallery acquired the picture. Eighteen days after it was put on exhibition it was stolen. Fortunately four years later it was surrendered by the thief, undamaged, and returned to the National Gallery. It remains one of the most significant portraits of Wellington ever done. There is a further portrait in the National Gallery of Art in Washington. Probably by Goya's studio, it is thought to have belonged to Miguel Álava, Wellington's trusted Spanish ADC and later Spanish Ambassador in London.

Towards the end of Wellington's time in Spain he was painted by Juan Bauzil, a Court Painter to Charles IV and Ferdinand VII. There is a small full-length watercolour in the National Portrait Gallery, and two miniatures at Stratfield Saye (**32**) and Badminton of Wellington in uniform with the Order of the Garter, which had been awarded to him in March 1813.

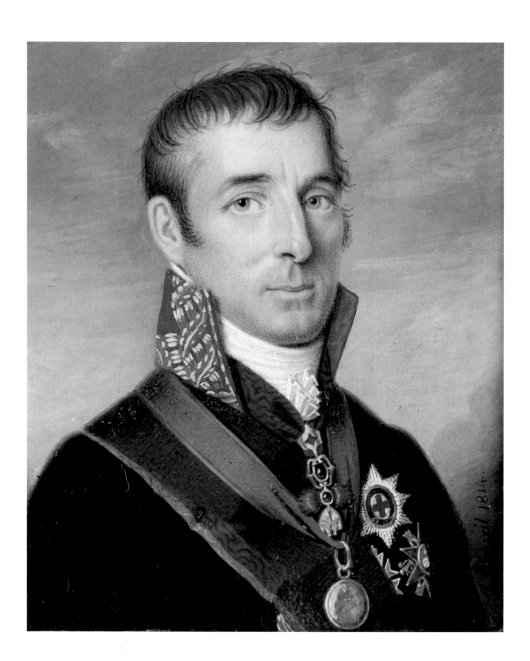

right 32. Miniature of Wellington by Juan Bauzil, 1814.

opposite 33. Miniature of Wellington by Thomas Heaphy, 1813 (detail).

On 21 June 1813 Wellington secured his most decisive victory of the Peninsular War. Joseph Bonaparte and Marshal Jourdan had gathered a substantial French Army near the Basque city of Vitoria. The Allied Army were advancing north-east in two corps, and Wellington arranged for the two columns to converge west of Vitoria. The ensuing battle was a victory so complete that over 150 French canon were captured. The French Army withdrew in such disarray that the entire baggage train was captured, including over two hundred paintings, which had been stolen from Madrid. The paintings were sent to England, and Wellington's brother William wrote to him, 'we found the Imperial to contain a most valuable collection of pictures, one which you could not have conceived'. In 1814 they were inspected by Benjamin West, President of the Royal Academy, and by William Seguier, who was to be the first Keeper of the National Gallery. After the war was over, Wellington tried several times to return them to Spain. Eventually he received a letter via the Spanish Ambassador in London, saying, 'His Majesty touched by your delicacy does not wish to deprive you of that which has come into your possession through means as just as they are honourable.' So the entire collection remained with Wellington as a gift from Spain.

After the Battle of Vitoria, the Army moved on to San Sebastian and the Pyrenees. An event during the Battle of Sorauren in late July 1813 was painted some forty years later by Thomas Jones Barker, as was a dramatic scene of Wellington crossing the Pyrenees (**23**). An engraving after the latter was published in 1858 and sold in great numbers.

On 18 September George Hennell, a volunteer in the 43rd Light Infantry, wrote that 'a painter is at Headquarters sketching a group for publication in which is a most excellent likeness of Lord Wellington'. The artist was Thomas Heaphy, Court Painter to the Princess of Wales. Larpent's *Journal* records that Heaphy was at headquarters in October and November 1813. By the middle of October he had executed twenty-six portraits of officers, for which he charged at first 40 guineas and later 50. Some of them were considered 'excessively like'.[6] Wellington sat for at least two sketches, which are now in the National Portrait Gallery (**1**, and see p. 168). On 14 January 1814 Wellington wrote to Lord Burghersh from St-Jean-de-Luz, 'if Priscilla [Burghersh's wife and Wellington's niece] is with you give my best love to her. I have sat to Mr Heaphy for a picture for her, which I suppose will be sent to her unless one of her sisters or her mother should seize it.' This picture, which in fact is a miniature, is now at Stratfield Saye (**33**).

The watercolour sketches were in preparation for a large painting of Wellington amongst his generals which Heaphy hoped to sell to the Prince Regent, and to have engraved. The engraver Anker Smith died in 1819 while still working on the plate. Heaphy had to complete the engraving, which was eventually published in 1822 (**34**). George IV died in 1830 still not having bought the painting, and Wellington, one of the King's executors, had an acrimonious correspondence with Heaphy on the subject. Heaphy demanded payment of 1,400 guineas for the painting, to which the Duke responded,

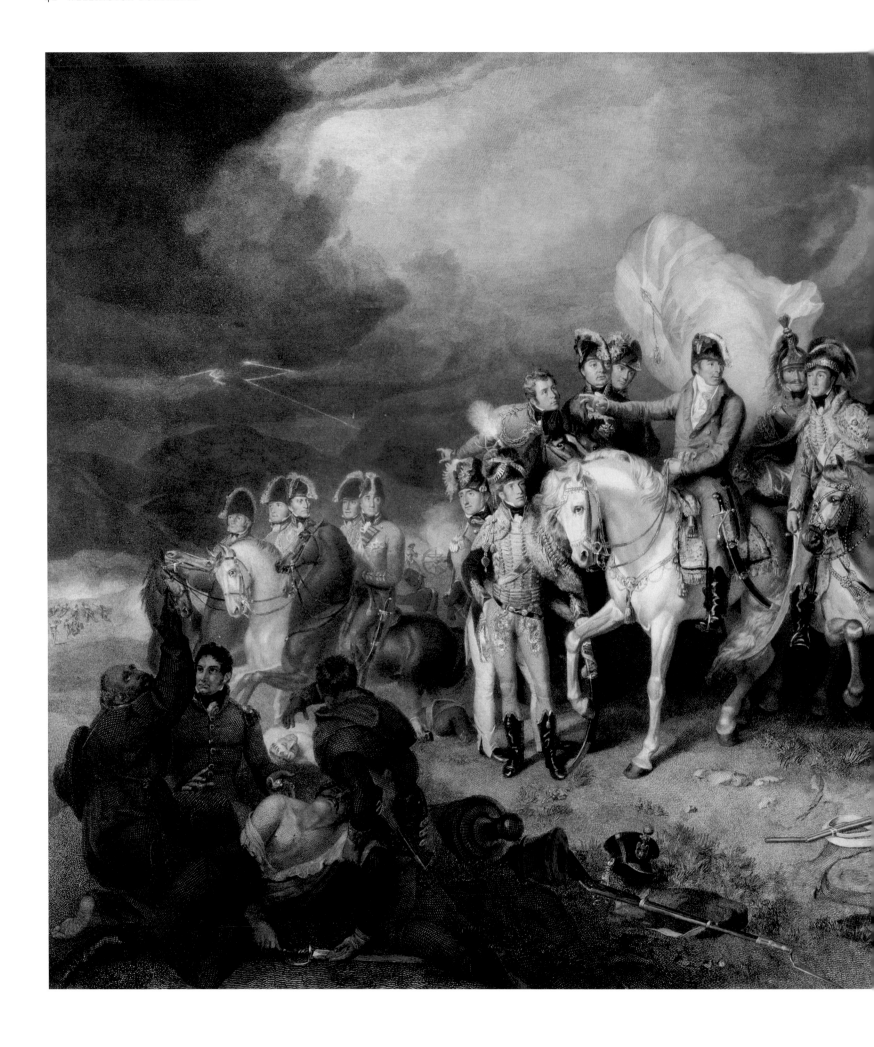

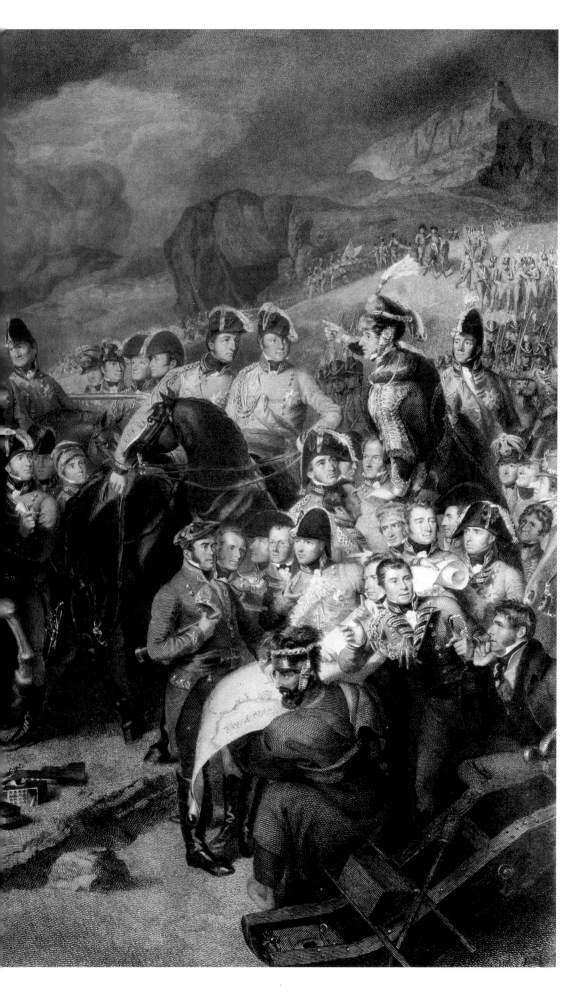

34. *Field Marshall the Duke of Wellington giving Orders to his Staff before a General Engagement*, engraving by Anker Smith and Thomas Heaphy after Heaphy, begun in 1818 and published in 1822. The painting is untraced.

'I think I recollect that he [the King] never liked it, particularly the Picture of myself.' When Heaphy died in 1835 the picture was sold with his effects, and it has not been traced. The figure of the Duke on horseback was worked up into a separate portrait, which belongs to the Duke of Buccleuch.

On 10 October Wellington and his staff crossed the Bidassoa, and entered France. He then moved east, and won a battle at Orthez on 27 February 1814. By now the Napoleonic forces were in full retreat. Napoleon abdicated on 6 April, but news did not reach southern France in time to prevent the final battle, at Toulouse, on 10 April. Three days later Castlereagh, the Foreign Secretary, wrote to offer Wellington the Embassy in Paris. He replied, 'I am very much obliged and flattered by your thinking of me for a situation for which I should never have thought myself qualified.' On 1 May he was made a duke, receiving a charming letter from the Prime Minister, Lord Liverpool, confirming that 'Your promotion to a Dukedom will appear in the "Gazette" of this night' (3 May) and then saying, 'I am most happy that you are not unwilling to accept the Embassy to Paris . . . but your acceptance of it need not preclude your coming to England for a short time to make any personal or family arrangements which you feel necessary after so long an absence.' Wellington had not been in England for over five years.

From Toulouse Wellington went in early May to Paris, but only for five days, before being asked by the Government to go to Madrid to try and persuade the King of Spain to accept a liberal constitution, in which endeavour he failed. But he did have time to see Goya again. He left Madrid on 5 June, and travelling via Bordeaux and Paris arrived in England on the 23rd. He immediately proceeded to Portsmouth, where the Prince Regent was reviewing the fleet with the Emperor of Russia and the King of Prussia.

Sir Arthur Wellesley had left England in April 1809. He now returned as Duke of Wellington, the incontrovertible hero of the nation. On 28 June 1814 he took his seat in the House of Lords as Baron, Viscount, Earl, Marquess and Duke all at the same time, a ceremony unique in history. When the Lord Chancellor had delivered the thanks of the House, Wellington replied, 'if however my merit is not great, my gratitude is unbounded. And I can only assure your Lordships that you will always find me ready to serve His Majesty to the utmost of my ability in any capacity in which my services can be at all useful to this great country.'[7] On 1 July he was invited to address the House of Commons, again an event without precedent. The Speaker in his reply included this wonderful passage:

> For the repeated thanks and grants bestowed upon you by this house,
> you have thought fit this day to offer us your acknowledgements.
> But this nation knows it is still largely your debtor . . . And when the
> will of heaven and the common destinies of our nature shall have swept
> away the present generation you will have left your great name and
> example as an imperishable monument.[8]

The Duke was only in London for six weeks, from 23 June to 8 August, but he found time to give sittings to Thomas Lawrence, Sir William Beechey, Thomas Phillips, William Grimaldi, and Francis Chantrey.

Among these, Wellington was to form a very high admiration for, and almost a friendship with, Thomas Lawrence. We believe they may have met before the start of the Peninsular War. Now the hero sat for Lawrence on 6 July 1814, the day before the big service of thanksgiving at St Paul's. Joseph Farington, a great friend of Lawrence's, wrote in his diary:

> I called on Lawrence soon after nine o'clock. At ten the Duke of Wellington came to sit for his portrait . . . He came on horseback attended by an old groom, and dressed in the plainest manner, wearing a blue coat and a round hat. Nobody was apprised of his coming and the few people who were passing had no knowledge of his being the Duke of Wellington.[9]

The full-length in civilian clothes (35) was for Lord Stewart, later Marquess of Londonderry, who had fought under Wellington in the Peninsula. It was so good that the Prince Regent tried to acquire it, but with the Duke's help Stewart and Lawrence managed to resist.[10] Twenty years later the Marchioness of Salisbury, a friend of the Duke, wrote in her diary:

> I suggested to him [the Duke] that in case Lord Londonderry, who is said to be ruined, should part with *all* his pictures, the Duke should become the purchaser of that done of himself by Lawrence, as it is really a shame his family should not possess a single good portrait of him. He promised me he would see about it.[11]

In the end the painting was not sold, and fortunately it hangs today at Apsley House, on loan from the present Lord Londonderry, the descendant of Lord Stewart. The Prince Regent then decided to commission for himself a portrait from Lawrence. It is a more heroic picture, in field-marshal's uniform and with St Paul's in the background (36). Lawrence wrote to Farington on 17 February 1815, 'I am glad to tell you that I succeeded in the completion of Lord Wellington's Portrait. From its size and necessary accomplishments it has been a great Fag to me.'[12] Lawrence was in the end paid £630 for the work,[13] and he was knighted in April. Shown at the RA in 1815, it was not considered a good likeness. Sir George Beaumont reported to Farington, 'His portrait of the Duke of Wellington I do not like so well.'[14] When the Waterloo Chamber at Windsor Castle was completed in 1831 it became a centrepiece.

During this short stay in London in 1814, the Duke also sat to the venerable Sir William Beechey. That portrait, commissioned by Lord Beresford, one of his principal lieutenants in the Peninsula, is now lost, but a good copy had been produced (5), and an engraving by William Skelton was published the same year.

overleaf, left 35. The Duke of Wellington by Thomas Lawrence, commissioned by Lord Stewart, later 3rd Marquess of Londonderry, 1814.

overleaf, right 36. Portrait by Lawrence showing Wellington holding the Sword of State, commissioned by the Prince Regent, 1814–15.

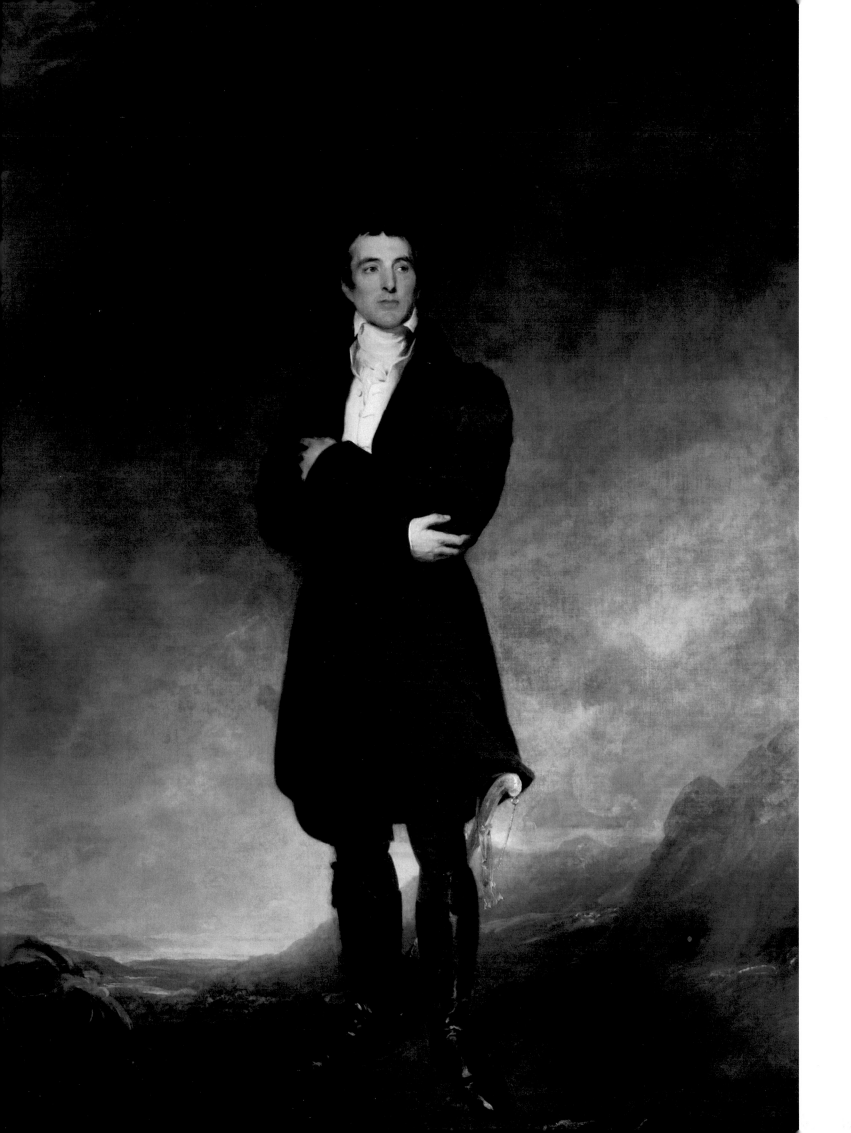

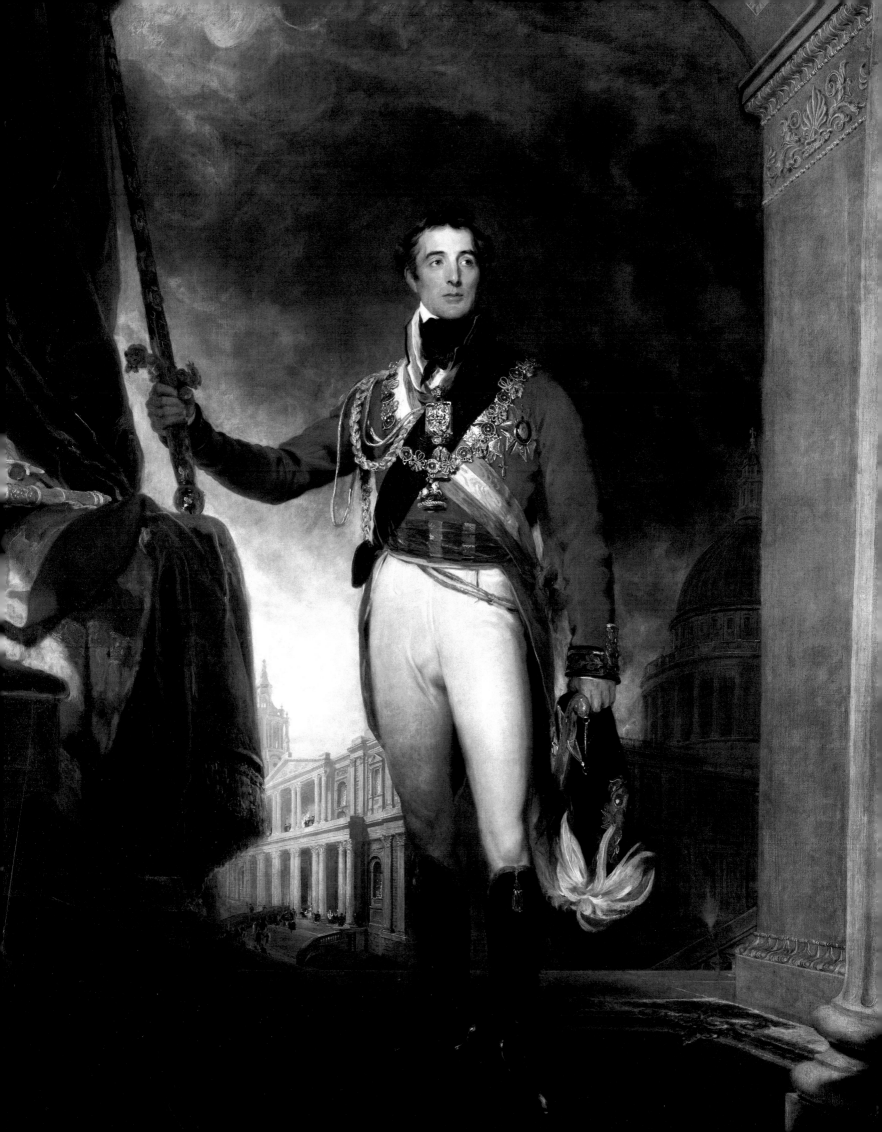

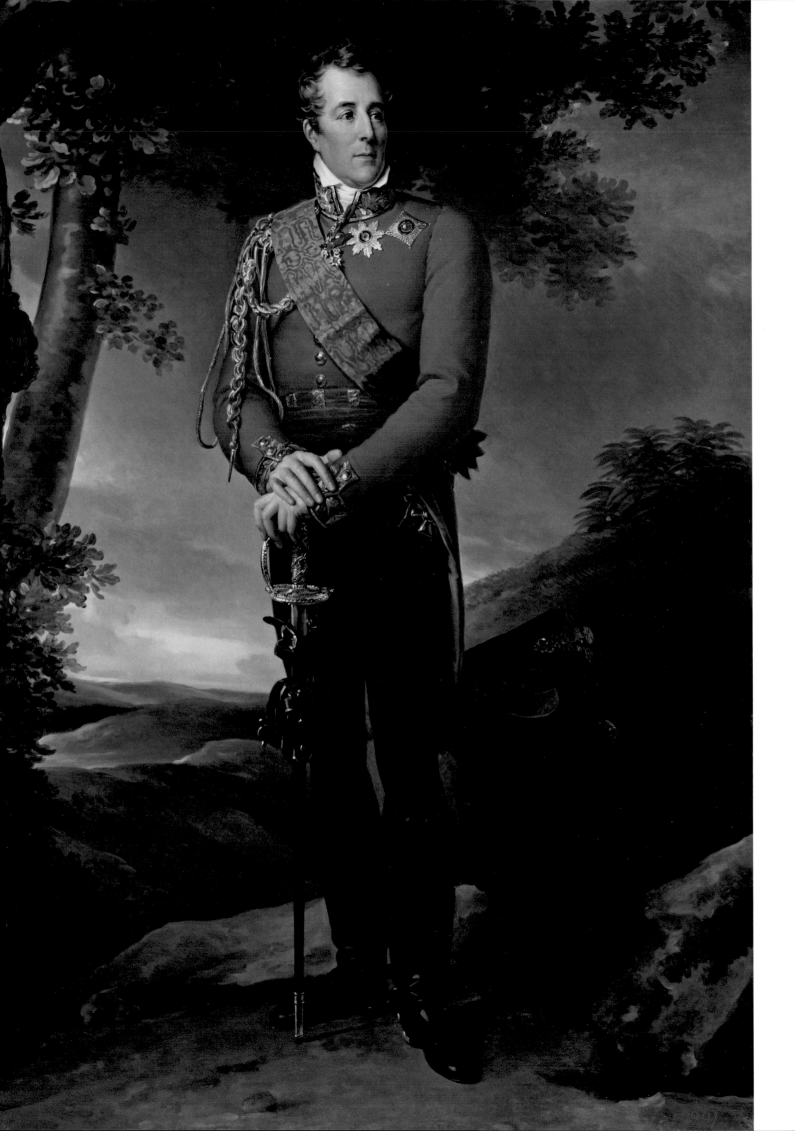

Wellington also agreed to give sittings to Thomas Phillips, who was commissioned to do a portrait for Lord Talbot, a cousin of the Prime Minister, Lord Liverpool (2). His descendant, Lord Shrewsbury, sold the picture to the 7th Duke in 1960, and it now hangs at Stratfield Saye.

He sat, too, to William Grimaldi, a miniaturist and Enamel Painter to the Prince Regent. Grimaldi had painted two very high quality *trompe-l'œil* miniatures of the Nollekens bust of 1809. Now the artist was given four sittings, and produced a miniature which being in enamel preserved an accurate record of Wellington's complexion, hair and eyes, yet it is not of the quality of other portraits of the time (see p. 159). During these busy six weeks Wellington must have sat for the first time to the sculptor Francis Chantrey. A plaster bust in the Ashmolean is dated 1814 (**38**). No marble bust of 1814 has been found, and all Chantrey busts of Wellington bear later dates (e.g. **56**).

Wellington's appointment as British Ambassador to France had been confirmed, and he left England on 8 August, arriving on the 22nd in Paris, where he presented his credentials to the restored Louis XVIII. As his residence he bought from Prince and Princess Borghese (Napoleon's sister) the Hôtel de Charost in the Rue du Faubourg St-Honoré for 870,000 francs – in today's money about £3,500,000. In justifying the price to the Foreign Office, he wrote that 'considering the size and situation of the house, the number of persons it will accommodate, and the manner in which it is furnished, the purchase is a remarkably cheap one'. It remains the British Embassy in Paris to this day, and is a further addition to his legacy.

Wellington had fought French armies for the last six years, but he was welcomed by the political elite and certainly by the Bourbon Court. Kitty, his wife, came to Paris and they entertained continuously. During the autumn, he gave sittings to François Gérard, who in the absence of Jacques-Louis David (in exile in Belgium) was the leading painter in Paris. Gérard began a full-length painting, with the Duke wearing the Garter sash, which now hangs appropriately in the British Embassy in Paris. Lady Shelley records going to Gérard's studio in July 1815 to see the portrait where it had remained unfinished during the Hundred Days:

> It is not equal to that by Lawrence. In my opinion all Gerard's portraits are bad – the one which he gave to the Duke, of Bonaparte, is the best I have seen. [That now hangs at Apsley House.] Gerard begged me to ask the Duke to dispense with all his Orders, and to have only the Order of the Garter on his breast. I delivered the message.[15]

The picture was engraved in 1818 by François Forster, a leading French engraver. Gérard produced a replica in 1817 for Tsar Alexander I, in which the Duke is depicted wearing his Russian orders (**37**).

Wellington was only in Paris as Ambassador for six months. He spent Christmas there, and his two sons and his nephew Gerald came out to join them.

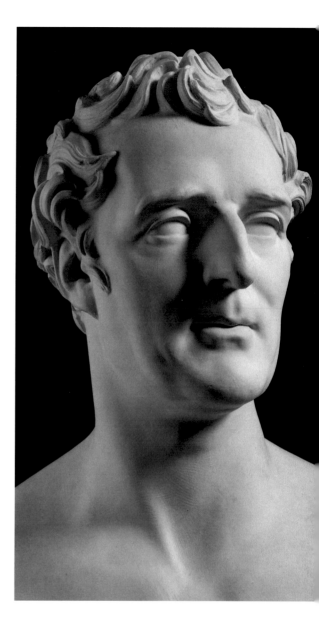

opposite 37. Wellington by François Gérard, painted for Tsar Alexander I, 1817.

above 38. Colossal plaster bust by Sir Francis Chantrey, 1814 (detail).

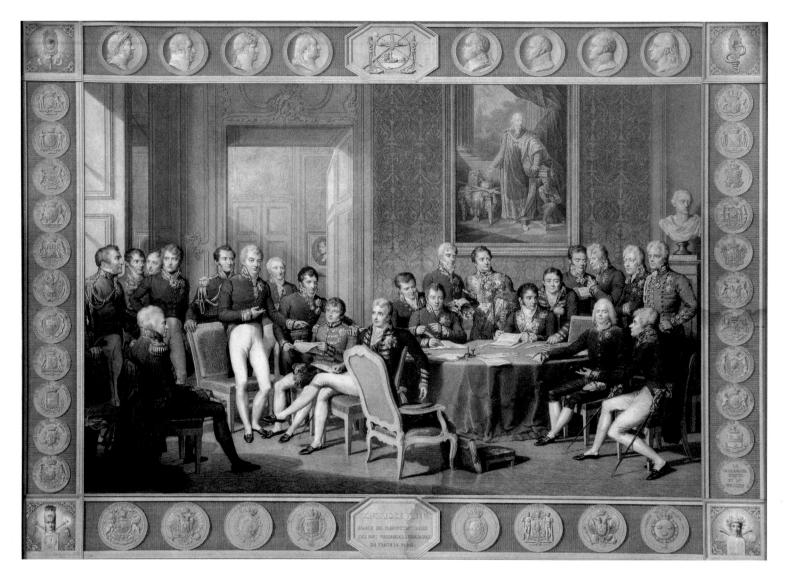

But he had to leave on 24 January 1815 to attend the Congress of Vienna as Britain's representative, because Lord Castlereagh, the Foreign Secretary, had had to return to London for a sitting of the House of Commons. The artist Jean-Baptiste Isabey went to Vienna and sketched all the participants at the Congress, in preparation for a major picture. That was not completed for some years, and is now untraced, but in 1819 an engraving after it was published (**39**), of which the Duke ordered two copies from Isabey. Isabey also painted miniature portraits of the Duke (**40**). These all date from 1816 to 1821, presumably from sittings given in Paris between 1815 and 1818, before the Duke returned to England.

While the Congress at Vienna was still in session, on 7 March 1815 the news of Napoleon's escape from Elba came, and Wellington was immediately asked to command an Allied Army to be assembled in the Low Countries. He left Vienna on 29 March, and reached Brussels on 4 April. There was much to do reassembling the army that had been disbanded a year earlier. During these weeks in Brussels, while Wellington was working with his staff officers

to plan the impending campaign, the artist Simon Jacques Rochard was given an introduction through the Duke's friend General Álava. On 13 June he spent 'à peine une heure' drawing Wellington, and produced three watercolour sketches in different poses, which he later worked into miniatures, charging Wellington 120 francs for each. One was given to Lady Georgiana Lennox, daughter of Wellington's great friend the 4th Duke of Richmond (**41**). Rochard also did a second version with the Duke wearing the dark blue sash of the Garter, versions of which are at Stratfield Saye and in the Ethelston Collection.

On 15 June 1815 Wellington attended, to her great relief, the Duchess of Richmond's Ball in Brussels. While there, news came that Napoleon had advanced into Belgium. During the course of the party, he advised many of the officers present to return, discreetly, to their regiments. He himself stayed until after midnight so as not to create alarm. He studied the Duke of Richmond's map, and then retired to his own house to write out orders.

On 16 June he moved to the village of Waterloo, and on to Quatre Bras. On the 18th he drew up his army just south of Waterloo on a site he had reconnoitred a year before when preparing a memorandum on the defence of the Netherlands. The French attacked at about 11 in the morning, but were unable to go through the squares of British infantry. In the late afternoon, when an attack by the French Imperial Guard had been repulsed, and when the Prussians were approaching from the south-east, Wellington gave the order to advance. In his own words, written to Lady Frances Wedderburn Webster at 8.30 the following morning,

> I yesterday gained a complete victory and pursued the French till after dark. They are in complete confusion. Blucher continued the pursuit all night, my soldiers being tired to death.
>
> My loss is immense . . . The finger of Providence was upon me and I escaped unhurt.[16]

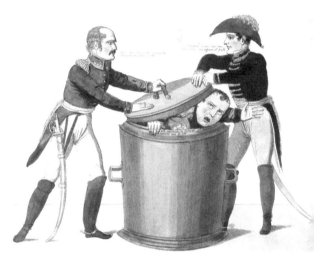

Numerous paintings of the Battle of Waterloo were produced over the succeeding years, by artists including Thomas Sidney Cooper, Sir William Allan and Alexander Sauerweid. Perhaps the best known is of the meeting of Blücher and Wellington at the end of the battle at the farmhouse of La Belle Alliance, where Napoleon had briefly established his headquarters. This moment was depicted by Thomas Jones Barker (see p. 125) and by Daniel Maclise. An engraving by Lumb Stocks was published in 1875, and it became another iconic image of Wellington.

After Waterloo caricaturists were busy too. Lacroix in France depicted Blücher and Wellington putting Napoleon in a dustbin (**42**). The Duke of Wellington had now fought his last battle.

opposite, above 39. The Congress of Vienna, engraved after Jean-Baptiste Isabey's composition of 1814 by Jean Godefroy, 1819. Wellington is shown standing at the far left.

opposite, below 40. Miniature of Wellington by Jean-Baptiste Isabey, 1818.

top 41. Miniature of Wellington by Simon Jacques Rochard, painted in Brussels in 1815.

above 42. Caricature by Lacroix of Blücher and Wellington putting Napoleon in a dustbin, 1815.

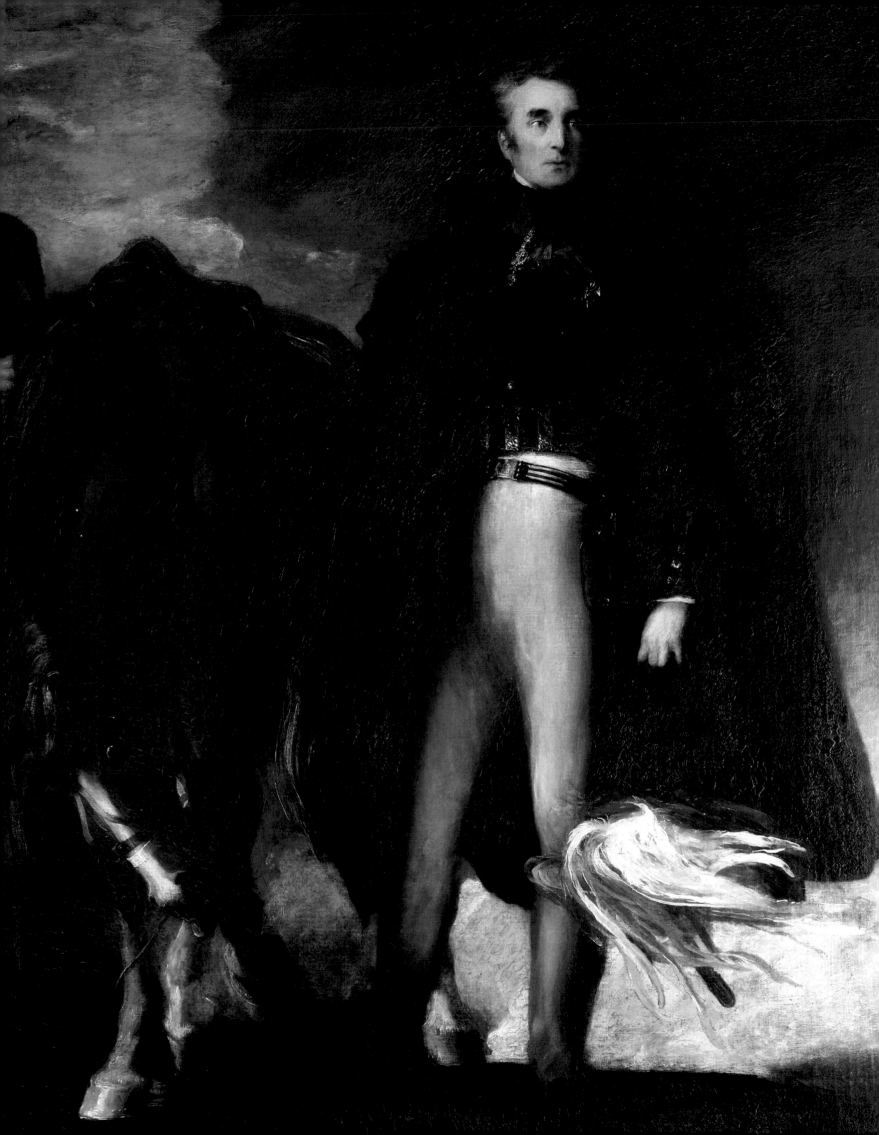

3

From Soldier to Politician

After the Battle of Waterloo, Wellington progressed towards Paris. He entered France on 21 June 1815, was in Neuilly on 5 July, and Paris on 7 July. The governments of Austria, Prussia, Russia and Britain appointed him Commander-in-Chief of an Army of Occupation, with 'autorité pleine et entière' over 150,000 men, and headquarters at Cambrai in northern France. On 18 July he was made Prince of Waterloo by King William I of the Netherlands.

For over three years Wellington divided his time between Paris and Cambrai, returning occasionally to London. In Paris he and Kitty were both painted by the Dutch King's Court Painter, the miniaturist Louis-Marie Autissier (**44**). We only recently discovered that he was also painted by Robert Lefèvre, who had portrayed several members of the Bonaparte family. Unfortunately the painting is lost, but we have an engraving (see p. 181).

In April 1817 Wellington went back to London for a short visit. He had the previous winter in Paris seen much of three American sisters who were travelling in Europe. They were granddaughters of Charles Carroll of Baltimore, a rich and distinguished American senator who had been one of the signatories of the Declaration of Independence in 1776. The eldest, Marianne, was married to Robert Patterson, whose sister had been married to Jerome Bonaparte, a younger brother of Napoleon. Wellington must have developed a strong affection for her, as he now commissioned Lawrence to paint a portrait of himself to give to Marianne (**45**) and one of her for him (**46**). On 9 May he paid 75 guineas as first payment for his picture and 50 guineas for the portrait of her.[17] In a letter to Lawrence from Cambrai dated 27 May 1817, Wellington writes, 'My dear Sir Thomas, I hope you are getting on with the Picture of Mrs Patterson. Pray don't forget that she will go in the middle of June; and then you have no chance of seeing any more of her.'[18] The second payment was made on 4 July,[19]

opposite 43. Wellington with Copenhagen, by David Wilkie, commissioned for the Worshipful Company of Merchant Taylors, 1832–33/34. He is wearing the uniform of Constable of the Tower of London.

above 44. The Duchess of Wellington by Louis-Marie Autissier, 1815.

overleaf, left 45. Wellington, painted by Thomas Lawrence for Marianne Patterson, 1817–18.

overleaf, right 46. Marianne Patterson, painted by Lawrence for Wellington, 1817–18.

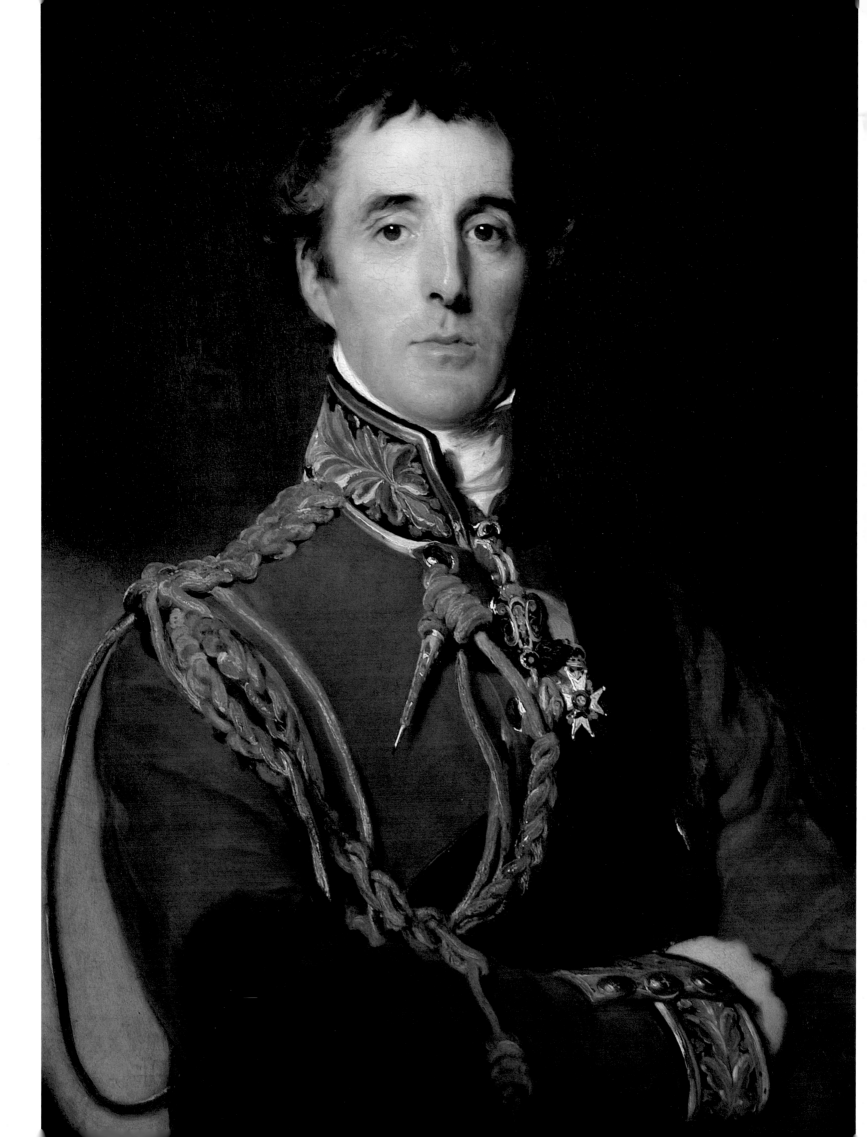

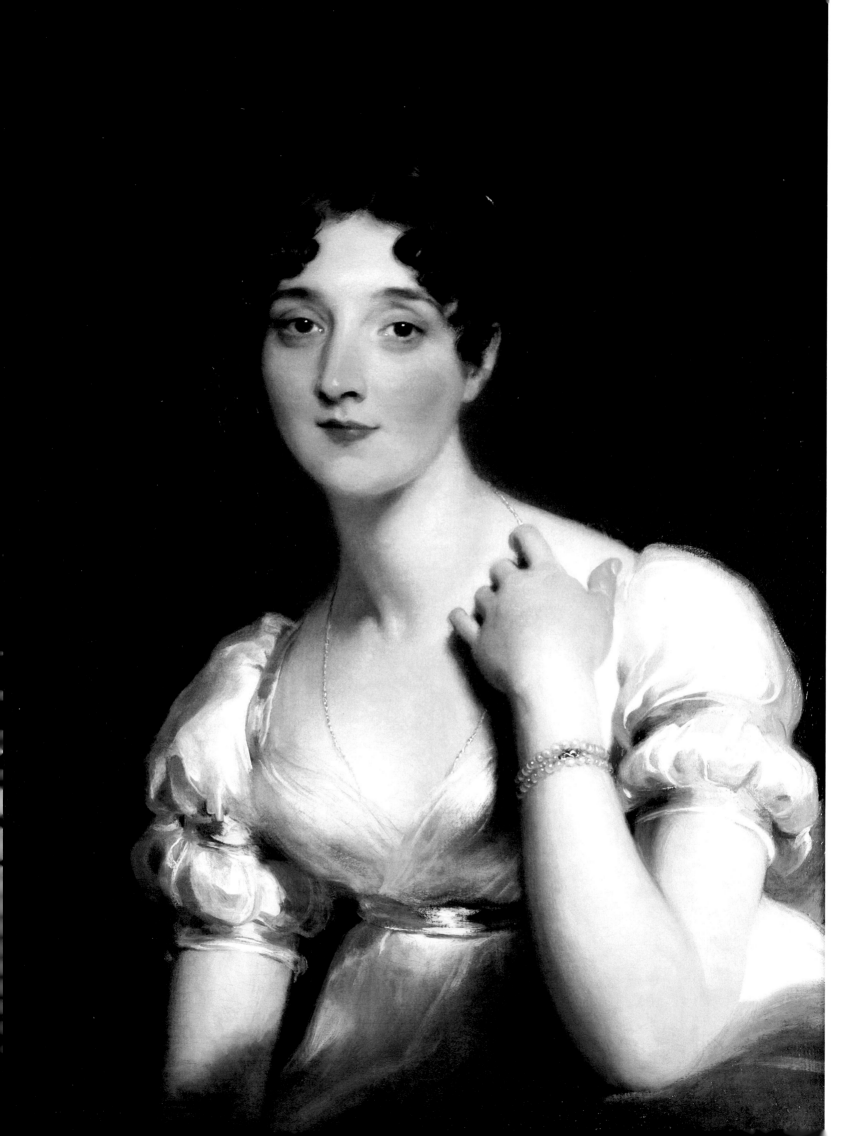

so presumably the paintings were by then finished if not varnished. As late as 8 September he wrote again, from Cambrai, 'I have had a letter from Mrs Patterson expressing great impatience to have the Pictures.'[20]

The story of these two paintings is deeply romantic. The Duke had never commissioned Lawrence, whom he admired over all other artists, to paint his wife or any other lady. The picture he commissioned of Marianne Patterson (46) hung at Stratfield Saye for the rest of his life and remains there today. He also commissioned a miniature of the painting by Marie-Victoire Jaquotot to be placed in a concealed panel in one of his Breguet watches. Marianne's husband died in America in 1819, and she returned to Europe in 1822. Kitty was still alive, and to Wellington's deep regret in 1824 Marianne married his eldest brother, Lord Wellesley. She remained however on very good terms with the whole family. She died in 1853, a year after the Duke, and bequeathed the painting of him (45) to the 2nd Duke. It now hangs at Apsley House.

Also in 1817 Lawrence was commissioned by Lord Bathurst to paint a large equestrian portrait of the Duke (48). Copenhagen was taken to Astley's Royal Amphitheatre in London and put through his paces in front of Lawrence.[21] After the painting was finished the Duchess of Wellington wrote to the artist, 'The Duke and Col. Darcy are returned quite enchanted with the last Portrait which Lord Bathurst will be so fortunate as to have. They say it is superior to Lord Stewart's [35]. I can just believe it possible.'[22] Lawrence received 800 guineas for the work.[23] This painting was considered of such quality that two copies were requested from him, both of which are now lost. One of them was for John Julius Angerstein, part of whose collection became the core of the National Gallery, founded in 1824.

Again in 1817 Wellington found time to sit to George Dawe, for a portrait commissioned by Princess Charlotte, the only child of the Prince Regent. The painting has disappeared, but a colour mezzotint was produced in 1818 (47). Dawe subsequently did a number of versions of the painting, and was also given a sitting at Cambrai. In 1819 he was commissioned by Tsar Alexander I to paint all the Russian generals, and he moved to St Petersburg for nearly ten years. While there, in addition to the Russians, he painted a full-length picture of Wellington in uniform, this time wearing his Russian orders (60).

In November 1818 the Allied Powers met at Aix-la-Chapelle, with Wellington as the British representative, and agreed to terminate the Army of Occupation in France. Wellington returned to London, where in December he was appointed Master-General of the Ordnance. His new position made him a member of the Cabinet. He became responsible for the artillery, engineers, military supplies, military transport and field hospitals. It was a position he held until 1827. In 1817 Wellington had bought Apsley House from his eldest brother, and now he and Kitty and the boys moved in. It has remained the family's London house ever since.

One of the first artists to whom he gave a sitting on his return was George Hayter, for a picture for Hayter's patron, the Duke of Bedford, showing

above 47. Colour mezzotint after a portrait of Wellington by George Dawe, 1818.

opposite 48. Wellington on Copenhagen by Lawrence, commissioned by the 3rd Earl Bathurst, 1817–18.

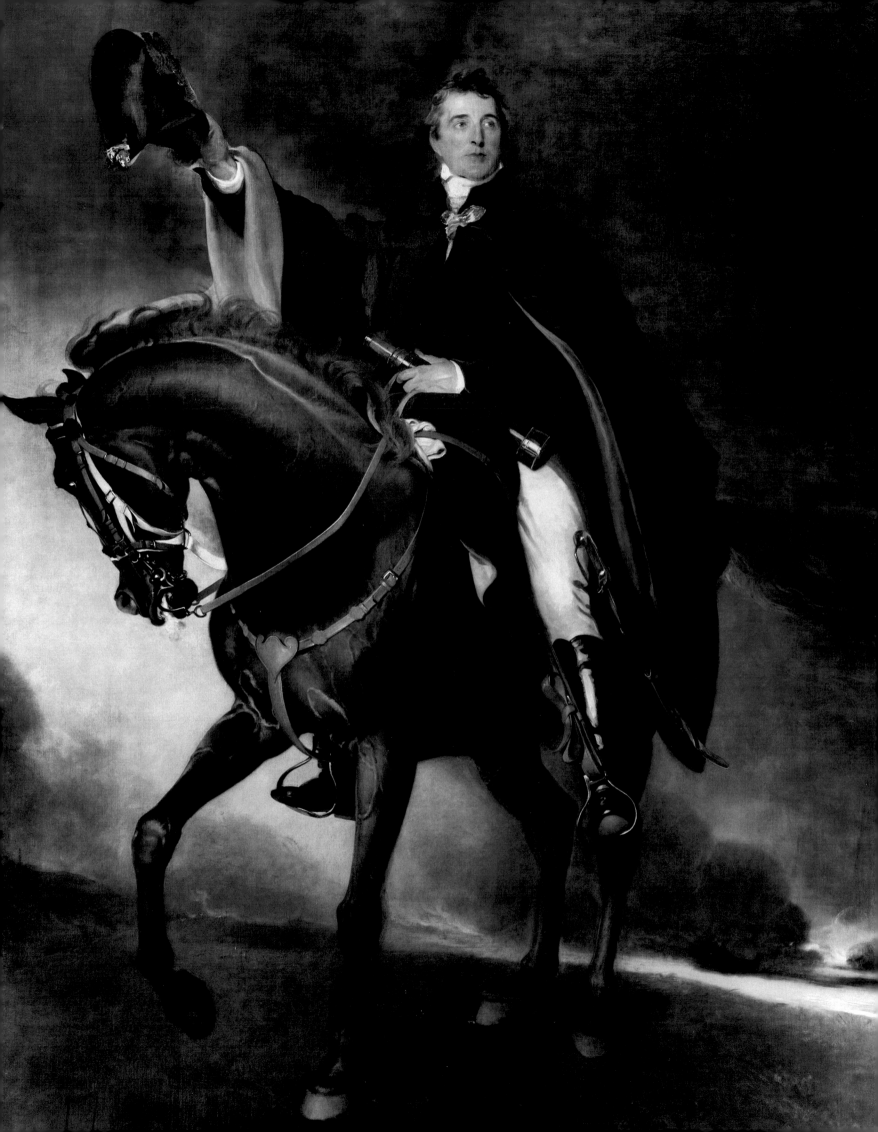

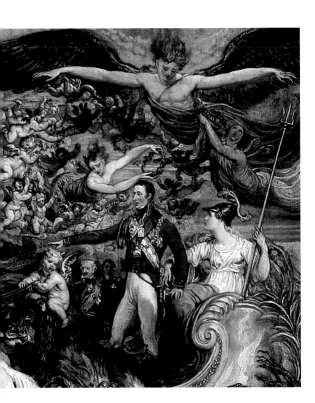

Wellington with Lord William Russell, the Duke's son, who was one of Wellington's ADCs (52). Hayter was a rising star. In 1815 Lawrence had written of him to Farington, 'A new prodigy has started up at the British Institution! Hayter the young man you must have seen at the last Exhibition . . . Many are sitting to him, and he will doubtless have their Pictures in the Exhibition.' Hayter was to paint Wellington several more times. He was knighted in 1842.

In 1819 the Duke sat to James Ward for a sketch which before the Second World War was owned by the historian Philip Guedalla but has since disappeared. Ward also produced a sketch for a large *Allegory of Waterloo* which was exhibited at the British Institution and won a prize (49). Subsequently the Directors of the British Institution commissioned an immense oil painting of the *Allegory* for the Royal Hospital Chelsea, which has disappeared. Ward was better known as a painter of animals, and in 1824 painted both Wellington's famous horse Copenhagen (51), then still alive at Stratfield Saye, and Napoleon's Marengo (50), which had been captured at Waterloo and was then standing at stud in Cambridgeshire.

Also in 1819 Lord Clancarty, the British Ambassador to the Netherlands, wrote to Wellington about a Dutch artist, Jan Willem Pieneman, who wanted to paint a picture of the Battle of Waterloo. Pieneman made three trips to London to receive sittings from the Duke and to take sketches of the other officers, and went to Stratfield Saye to paint Copenhagen. Before one of the visits, Lord Clancarty wrote, 'I have little doubt that you will generally approve of the Sketch . . . and upon the whole with Pienemans masterly execution both in design & colouring, I really believe that his picture will be as worthy, as any picture can be of such a Subject.' In 1824 the immense canvas was completed (53), and the Duke wrote to Charles Arbuthnot, his close friend and political colleague, 'the picture will be well worth seeing. He [Pieneman] cannot find a room large enough to contain it.' The finished work was exhibited in Ghent, Brussels and London before it was acquired by King William I of the Netherlands. The oil

above 49. Detail of *The Triumph of the Duke of Wellington* by James Ward, a study for the *Allegory of Waterloo*, c. 1816.

below 50. Marengo, Napoleon's horse, painted by James Ward, 1824.

below right 51. Copenhagen, Wellington's horse, by James Ward, 1824.

opposite 52. Wellington with his ADC, Lord William Russell, by George Hayter, 1819.

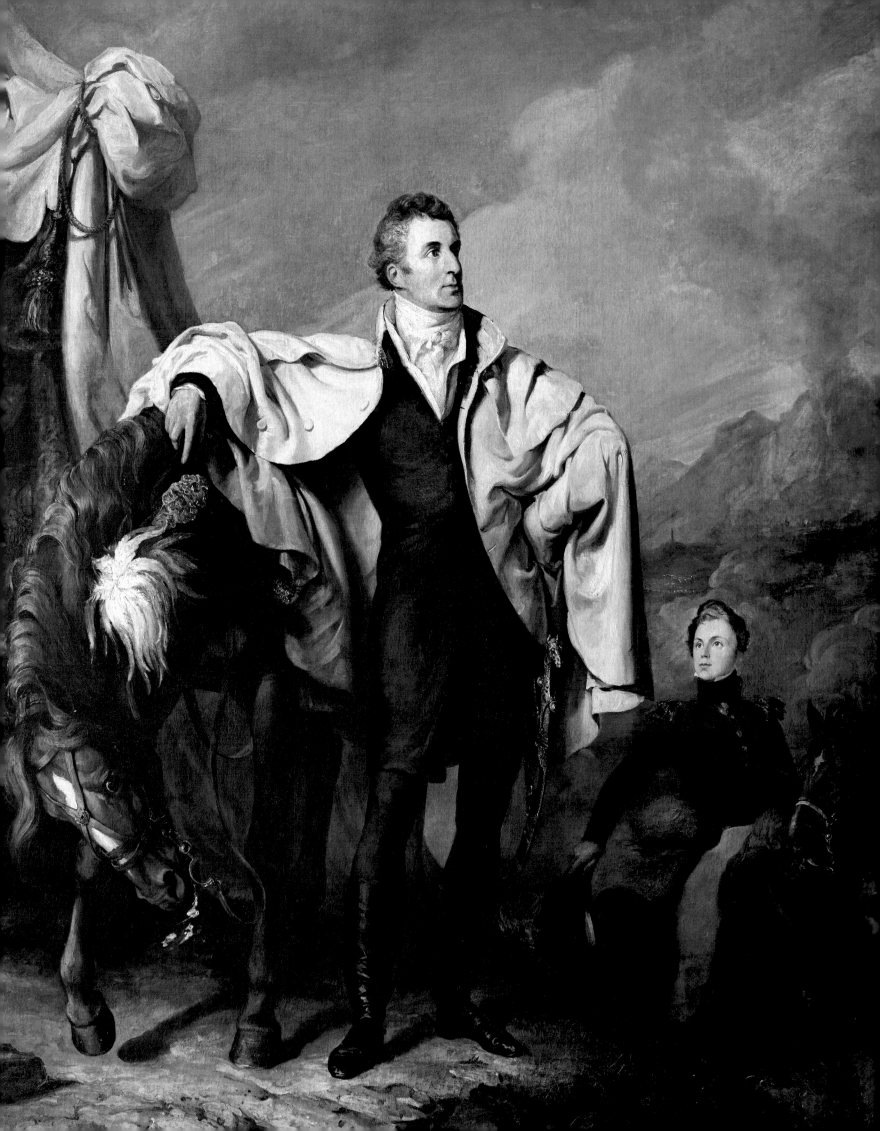

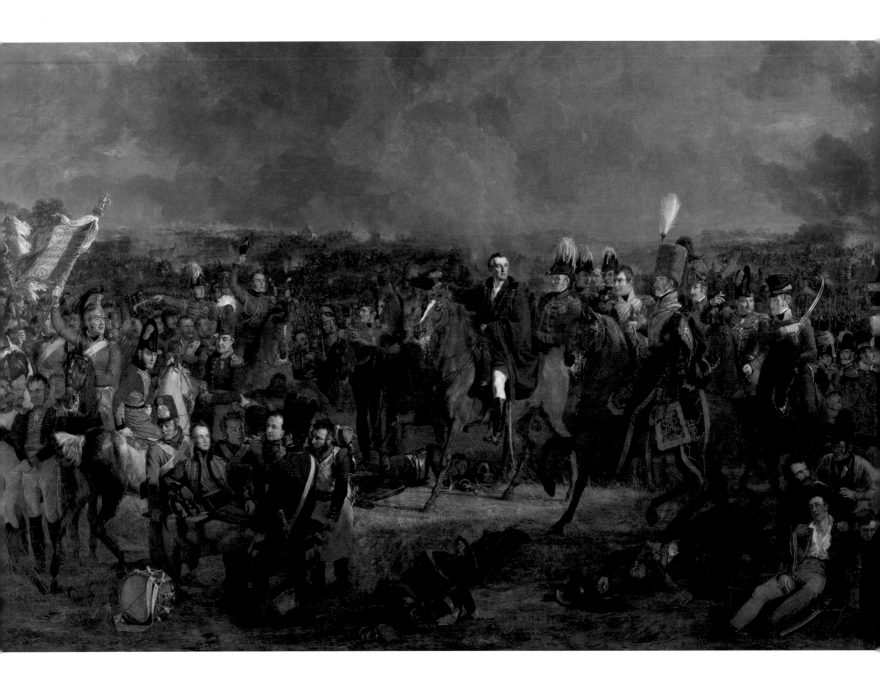

sketches of many of the officers were bought by Wellington in 1825 for 398 guineas, and now hang at Apsley House. A sketch of Wellington was given to Lord Clancarty, who wrote to the Duke on 12 January 1826, 'Your picture is arrived in excellent preservation, and been received with the utmost joy and gratitude by my whole family, – strikingly like, and does honour to Pieneman's talent as an Artist.' The large painting and the portrait are now in the Rijksmuseum in Amsterdam.

In 1820 Wellington sat again to Lawrence, this time for a picture for his great friends Charles and Harriet Arbuthnot (54). Harriet, the niece of Lord Westmorland, became an important political diarist and networker of her day. Wellington wrote no fewer than 1,488 letters to her over the next fourteen years. Now he told her, 'I have at last the pleasure of informing you that the picture is

finished and is as good as any Lawrence has ever painted.'[24] Two weeks later it had been delivered, clearly to the Arbuthnots' delight, and the Duke wrote again, 'I don't believe he [Lawrence] will ever paint me half so good. To sit for one's picture is not a very pleasant operation; but I assure you that I would repeat it to give you half the satisfaction you express with this Picture . . .'[25]

In a letter written to the Duchess of Northumberland some years later, after Lawrence's death, the Duke said:

> There is not at present a good portrait painter, possibly we shall never have such a one as Sir Thomas Lawrence. Mr. Arbuthnot's picture is one of the best if not the best that he painted. Mr. Ward [George Raphael Ward], the son of the artist who painted animals so well, has made some copies of that picture in water-colour of a diminished size, which have been thought very satisfactory likenesses.[26]

This magnificent painting was sold by the Arbuthnot family in 1878 and bought by Lord Rosebery, but sadly sold by his descendant in 1939. It is now in a private collection in Britain. Lawrence was never to better it.

Lawrence also made a drawing of Wellington about this time (55). A fine stipple engraving after it was produced some years later by Frederick Christian Lewis. Around 1820 Kitty had commissioned from Lawrence a copy of the portrait of her husband in the possession of Lord Londonderry (35). Lawrence was slow to finish the commission, and Kitty wrote to him from Stratfield Saye:

> Our Library is now complete. The room is a handsome one; the Duke has done every thing to [it] he could do to make it beautiful and comfortable, and my own ardent, earnest wish is to place in that room the Portrait of the Duke himself, that which yet remains unfinished, but which if you are so kind as *really* to undertake it, would in a very short time be completed. [27]

The Duke expressed his opinion to Kitty about having pictures of himself hanging on the walls of his houses:

> I must say that there is nothing so unpleasant to me as to have Busts and pictures of myself stuck up in every Room of my own House. It exposes me to Imputations of personal vanity among others which I do not merit; and which are very much to be attributed to the Line of Conduct which you think proper to adopt.[28]

Kitty quickly cancelled the commission, and replied to her husband:

> I did wish, and had intended to have placed the Copy of Lord Londonderry's portrait of you, which Sir Thomas Lawrence has been

opposite 53. Jan Willem Pieneman, *The Battle of Waterloo*, 1824.

overleaf, left 54. The Duke by Lawrence, painted for Charles and Harriet Arbuthnot, 1820 (detail).

overleaf, right 55. Drawing of Wellington by Lawrence, *c.* 1820.

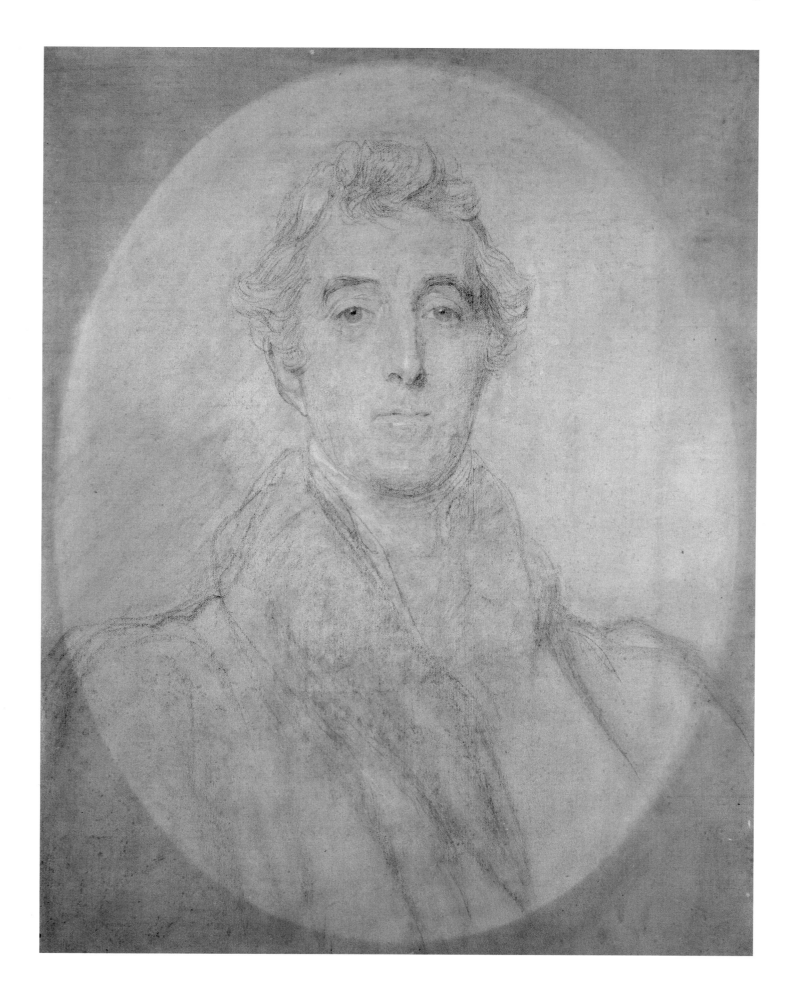

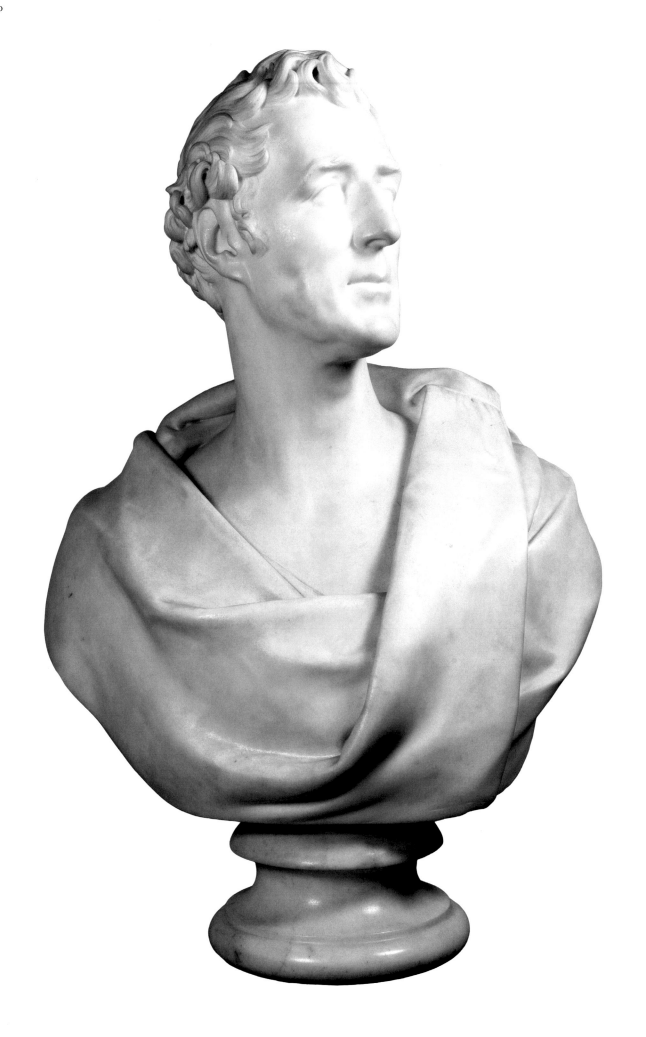

so many years finishing for me, over the fire place in the Library here, but [I will neither] do this nor any thing else when [I believe] it to be disagreeable to you.[29]

The painting was left in the studio and in the end finished by John Simpson, a pupil of Lawrence. It is now in a private collection in Ireland. Lawrence painted further portraits of the Duke. In 1824 Sir Robert Peel, Home Secretary and a close political colleague, commissioned a full-length portrait. Happily when his descendants sold the painting in 1909 it was bought by Wellington College, which had been founded in 1859 as the national memorial to the Duke.

Following the death of Napoleon on St Helena in May 1821, George IV requested the Duke to conduct him to the battlefield of Waterloo. The King expressed limited interest until he was shown where Lord Anglesey's leg was buried, when he burst into tears. The visit was recorded in a painting by Benjamin Robert Haydon many years later (86).

In early 1822 Wellington gave some more sittings to Francis Chantrey. The Prime Minister, Lord Liverpool, commissioned a bust, and Wellington ordered a replica for Charles and Harriet Arbuthnot (56). In her journal Harriet wrote:

> He is doing a bust for Lord Liverpool, of which we are to have one. It is excessively like but I do not like it so well as one done by Nollekens [25] which, tho' executed before the Duke first went to Spain, is still a most striking likeness &, what is strange, is quite as old looking as he is now. Chantrey's bust is too much in an attitude to please me.[30]

The bust was delivered to the Arbuthnots in September 1824, by which time Harriet's opinion had improved. 'We have just received a marble bust of the Duke by Chantrey. It is very like him and is a very fine work of art.'

In 1824 the Duke sat to John Jackson, the son-in-law of James Ward. Jackson painted four portraits, the first of which was for the Duke's great friend Sarah, Lady Jersey, who was an important figure in contemporary London society (57). Another of Jackson's portraits, painted around 1827, was acquired much later by the 5th Earl Stanhope for Chevening (58). Stanhope's *Notes of Conversations with the Duke of Wellington 1831–1851* were published after the death of both men. The Duke would not have been pleased, but they have given later generations another 'portrait' of the man. It is more than appropriate that there are still two portraits of Wellington at Chevening, now the Foreign Secretary's official country residence – the Jackson (58), and one by Lucas (83).

In 1825 the Duke gave a sitting to John Hayter, the younger brother of Sir George Hayter. He wrote to Lady Shelley:

> I cannot describe to you the inconvenience it is to me to sit . . . the painters take up the only time I should have . . . to transact business of any kind, or to read anything.

opposite 56. Marble bust of Wellington by Francis Chantrey, 1823.

above 57. Sarah, Countess of Jersey, by Richard Cosway.

I should not mind attending a good artist. But really, to sit as a
'Study' to a young one who will never paint a picture as long as he
breathes; and to pass three hours with him, and to have even one's own
reflections interrupted by his *impertinence* during that time, is more than
human patience, *even mine*, can bear.

However, I have promised him one more sitting, and he shall have it.
But mind, that will make the tenth for this picture – viz. six at Maresfield
and four in London; and I know that, after all, it will not be worth
a pin![31]

Just over a month later, he wrote, 'I have completed my sittings with Mr. Hayter;
but I don't believe he has completed the picture. He now wants my clothes,
which Sir Thomas Lawrence has got! The fact is, that I have neither time nor
cloaths [*sic*] enough for all the calls upon them.'[32] The painting (59) was
exhibited at the RA in 1826 and a hundred years later was bought by Lord
Curzon, former Viceroy of India, for the Victoria Memorial Hall in Calcutta
(now Kolkata). A sketch of the Duke's head by John Hayter was later engraved
by William Henry Mote.

In January 1826 the Duke was asked to represent Britain at the funeral of
Alexander I, Emperor of all Russia. He travelled to St Petersburg, stopping for

a few days in Berlin. On this journey he acquired busts by Rauch of the two Tsars, Alexander and his brother Nicholas, of the King of Prussia, and of Prince Blücher, his ally at Waterloo. In St Petersburg he bought many prints, including a large set after George Dawe's paintings of Russian generals. His stay there convinced him of the efficacy of central heating, which he installed at Stratfield Saye on his return. While in St Petersburg he probably sat again to Dawe. In the Hermitage there is a full-length of the Duke wearing Russian orders (**60**). When Dawe left Russia and died in England in 1829 there was in his studio in St Petersburg an unfinished portrait of Wellington. It was finished by Dawe's assistants, and now hangs at Goodwood.

In December 1826 the Duke was made Constable of the Tower of London. Surprisingly, the Tower never commissioned a portrait, but a portrait of Wellington in the uniform of the Constable was later commissioned from David Wilkie for the Worshipful Company of Merchant Taylors.

Throughout most of Wellington's military career, the Commander-in-Chief of the Army had been the Duke of York, George IV's brother. When York died in January 1827, Wellington was appointed Commander-in-Chief. The Prime Minister, Lord Liverpool, suffered a stroke only three months later and had to resign. As his successor the King appointed George Canning. Wellington was not a supporter of Canning, and resigned. By a further twist of fate, Canning died after 119 days in office. At this point the King appointed Lord Goderich as Prime Minister, and wrote to Wellington 'for the purpose of again offering to You the Command of my Army, and I sincerely hope that the Time is arriv'd, when the Country will no longer be depriv'd of the Benefit of your high Talents.' Then in January 1828 Goderich found himself unable to continue, and Wellington was appointed Prime Minister. With great reluctance he had to give up the position of Commander-in-Chief, as it was generally agreed that not even he could hold both positions.

Wellington had always been irresistibly interesting to caricaturists, and the best of the hundreds of caricatures were done during the nearly three years that he was Prime Minister. By then George Cruikshank (**24**) was mainly doing illustrations, and the leading caricaturist practitioner of the art at the moment was William Heath, who also used the pseudonym Paul Pry. In one of his many inventions, 'The Prime Lobster' of January 1828 (**61**), when Wellington had just become Prime Minister, he shows the Duke wearing the gown of a Treasury minister, having laid aside his martial hat and sword – to the amazement of the little symbol of Paul Pry, bottom left, who has dropped his umbrella in astonishment. The paper on the ground is 'The Soldier Tired of Wars', a song from Thomas Arne's *Artaxerxes*.

In January 1829 the Duke was appointed Lord Warden of the Cinque Ports, with a residence at Walmer Castle in Kent. In later years this was to become the setting of a great many sittings given to painters and sculptors. Already in his first year as Prime Minister a number of new portraits were made. James Ward was commissioned to paint a picture for the Royal Female Orphanage in Surrey,

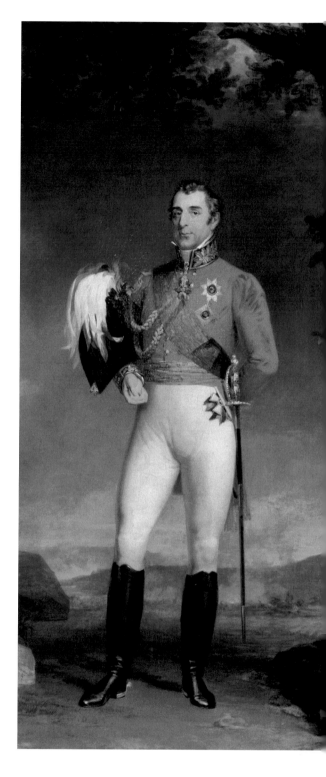

opposite, left 58. The Duke by John Jackson, *c.* 1827 (detail).

opposite, right 59. The Duke by John Hayter, 1825 (detail).

above 60. The Duke with Russian orders, painted by George Dawe for Tsar Alexander I, 1829 (detail).

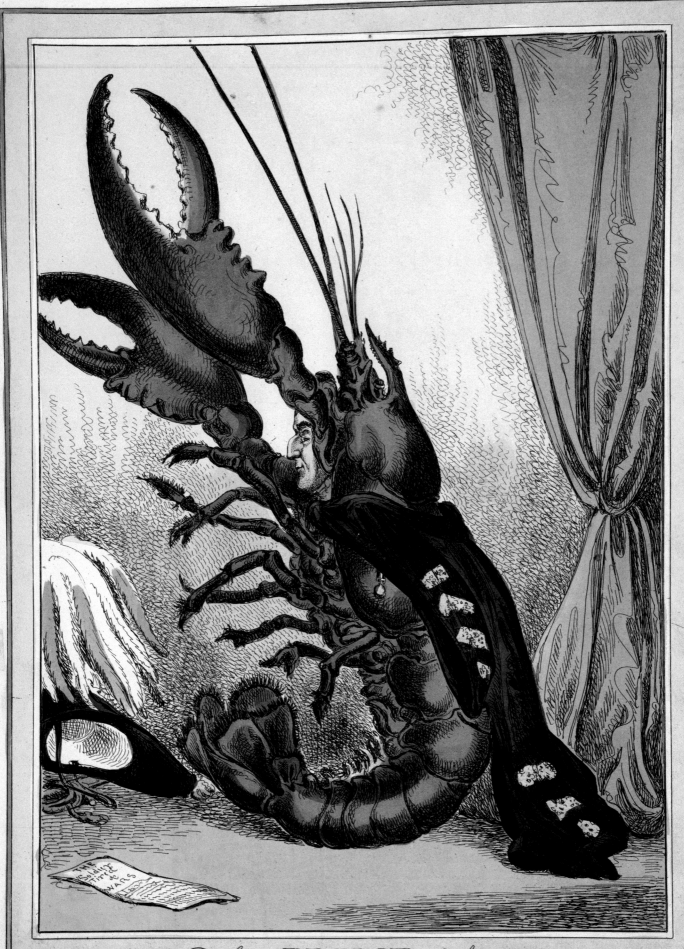

The PRIME Lobster

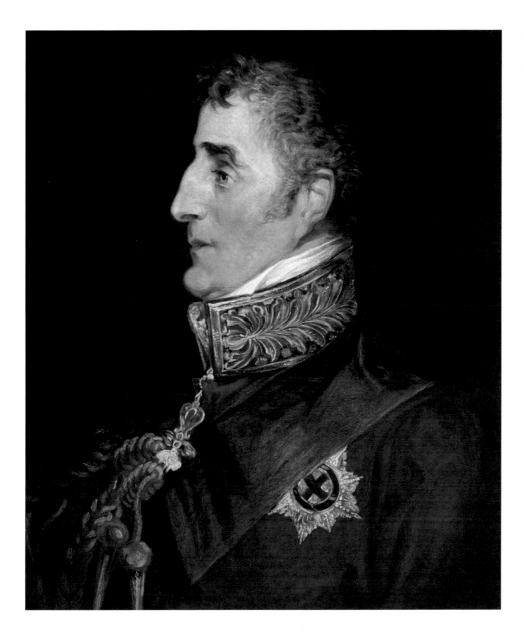

opposite 61. The Duke as 'The Prime Lobster' by William Heath (Paul Pry), 1828.

left 62. The Duke by James Ward, 1829.

of which the Duke was patron (**62**). The picture was eventually bought by the 7th Duke, and now hangs on loan at 10 Downing Street. It would appear that it was also in this year that Thomas Heaphy painted another version of a small full-length watercolour of the Duke, originally painted in northern Spain around 1813 (**63**, cf. p. 169). It was eventually owned by Sir Winston and Lady Churchill, and when the 7th Duke had lunch one day with the Churchills at Hyde Park Gate, Sir Winston pointed at it and said, 'the greatest man of action that ever lived'. Again in 1829, James Northcote produced a painting of the Duke on a white horse that now hangs in the Exeter Guildhall, and a small bronze bust of the Duke by Henry Weigall Senior was 'published' by J. Blashfield.

Around then also, David Wilkie began working on a picture that was to be exhibited at the Royal Academy in 1836, wrongly described as 'Portrait of the Duke, representing his Grace writing to the King of France on the night

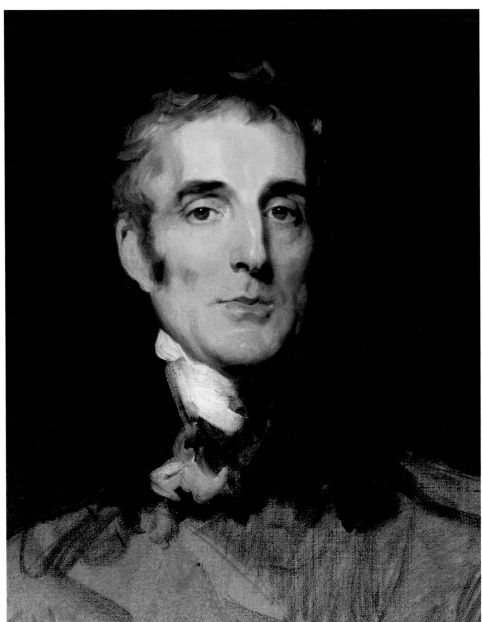

before the Battle of Waterloo' (**65**). One of the sketches is dated 1829. In fact Wellington did not write to the King himself, but to the King's nephew, the Duc de Berri, and that was at 3 a.m. on the day of the battle. Both the sketch and the main picture are in the Aberdeen Art Gallery and Museum.

Sir Thomas Lawrence died in January 1830, leaving a considerable number of unfinished canvases in the studio. Several of these were of the Duke. Harriet Arbuthnot wrote in her journal on 25 March, 'I walked a few days ago with the Duke to see poor Sir Thos Lawrence's pictures, some, I dare say, 20 years old, still unfinished. The Duke wanted to find some belonging to him. He had paid Sir Thos 1500£ for pictures & had not got one.'[33] Lady Jersey had commissioned a half-length of the Duke, and would not allow it to be finished by any of the pupils (**64**).

In 1830 the sculptor John Francis, who had been a pupil of Samuel Joseph and of Chantrey, executed two busts – one less than life-size, which is at Woburn Abbey (**66**), and one for Lady Jersey. He did further busts which were exhibited at the Royal Academy in 1832 and 1838. In 1832 he also made a replica of the Nollekens 1809 bust of the Duke.

In November 1830, after nearly three years as Prime Minister, and after the general election caused by the death of George IV, Wellington resigned. For the next few years he led the opposition to reform and became for the only time in his life very unpopular with the public.

In 1831 the United Service Club commissioned William Robinson, a former pupil of Lawrence, to paint a full-length portrait of the Duke (**67**). Knowing how often the Duke was asked to give sittings and not wanting to ask the favour, the Committee instructed Robinson to copy a Lawrence portrait, but also wrote to the Duke asking if Robinson could borrow a sword, a cloak and a telescope. To their surprise, the Duke replied that 'he would give as many sittings as might be necessary to make the picture an original'. The cloak was sent, but the sword could not be found. It had been borrowed by Lawrence for an earlier picture. As Robinson still knew the late artist's servant, he went round to Lawrence's studio, and they eventually found the sword, unmarked and about to be sold. So the sword was painted into the picture and returned to the Duke, who was especially pleased to have it back. The sword is now on display at Apsley House.

After Lawrence's death George IV had appointed David Wilkie as Painter-in-Ordinary. In 1832 he was commissioned to paint a large picture of Wellington with his horse Copenhagen for the Merchant Taylors. In October and November he travelled to Stratfield Saye to paint the Duke and Copenhagen (**43**). This may have been the last time the horse was painted, as he died in 1836, and was buried at Stratfield Saye with full military honours. The picture was completed in late 1833 or early 1834. In that year the Duke was installed as Chancellor of Oxford University, and in the British Museum there is a Wilkie sketch showing him in academic robes, but as far as we know Wilkie never painted a portrait in oils of him as Chancellor.

The Great Reform Bill became an Act on 4 June 1832, after the Duke with reluctance but with realism led the House of Lords to allow the legislation to pass. When Wellington rode to the Tower on 18 June 1832, Waterloo Day, to give a sitting to Benedetto Pistrucci, the Italian Chief Medallist at the Royal Mint, he was still suffering a certain unpopularity on account of his former opposition to the Bill. On leaving the Mint he was surrounded by a mob which followed him all the way to Apsley House. Two Chelsea pensioners, who had served under him, appeared and walked on either side of his horse, and when he passed Lincoln's Inn the lawyers came out in their gowns and wigs to protect him. When he reached St James's the gentlemen in the clubs saw him riding up the street with a set face, looking straight ahead. On arriving at Apsley House with Lord St Germains, who had joined him, his only comment was 'An odd day to choose.'[34] The resulting bust, more than life-size, was bought by the Duke

opposite 66. Marble bust of Wellington by John Francis, 1830 (detail).

left 67. Wellington by William Robinson, 1831 (detail).

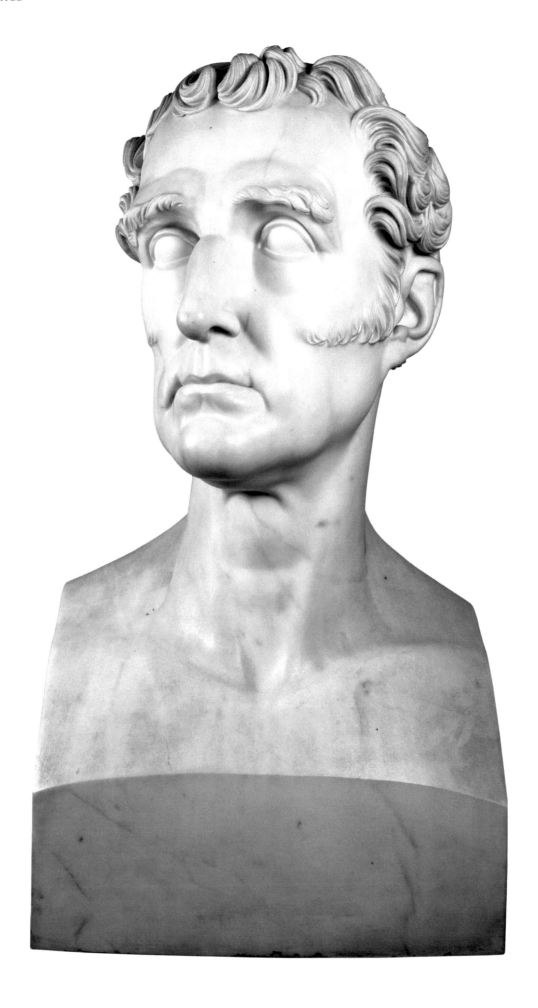

from the artist for 100 guineas in 1835. In the 1840s he commissioned another version, this time life-size, to give to his new daughter-in-law, Lady Douro (**68**). This bust is at Stratfield Saye, while the monumental version is at Apsley House.

Pistrucci's connections with the Wellesley family had started much earlier, in 1816, when Wellington's brother William Wellesley Pole was Master of the Mint. In 1817 he was appointed Chief Engraver. It had been decided to produce a special Waterloo Medal to be given to 'each of the sovereigns in alliance with the Prince Regent, to their ministers and generals', and Pistrucci won the competition, over John Flaxman. Unfortunately the size – some 15 cm in diameter – and the complexity of the design, combined with difficulties between Pistrucci and the Mint, meant that it took more than thirty years to complete, by which time all the intended recipients except Wellington were dead (**69**).

In 1833, Andrew Morton wrote to the Duke about a picture he had been commissioned to paint for the Royal Naval Club. The Duke gave him some sittings at Walmer and at Stratfield Saye, and the painting was exhibited at the Royal Academy in 1835, but both the painting and the club have disappeared.

In the same year Wilkie was commissioned to do a portrait for the Duke's friends Lord and Lady Salisbury, which hangs still at Hatfield (**70**). It met with criticism initially, however. The Marchioness of Salisbury wrote in her diary on 19 May 1835 after seeing the painting at the Academy, where portraits of Wellington by Morton and Pickersgill were also on show:

> I am afraid that I cannot change the opinion I formed the first moment
> I saw Wilkie's picture of him, that it is a decided failure in likeness.
> He thought so himself, and that it was too large about the body.
> The colouring, though, is good, and it is far superior to the two other
> portraits of him – that by Pickersgill [in the Oriental Club (**71**)] is like a
> drunken undertaker, and that by Morton [that of the Royal Naval Club]
> made of wood. To these two criticisms Lord Aberdeen adds a third, that
> Wilkie's is like a Spanish beggarman.[35]

In July 1834 Sir John Beckett, who had served as Judge Advocate General in Wellington's Government in the 1820s, asked the Duke if he would sit to John Simpson, who had been Lawrence's pupil, for a full-length portrait. It was to this request that the Duke replied bemoaning how many artists he was being asked to sit for (above, p. 19). We are not sure he ever agreed to sit. The painting at Apsley House which has been associated with this commission is not full-length and is almost identical in composition to Lady Jersey's unfinished portrait by Lawrence (see pp. 180, 181). It is not at all like Simpson's other portraits of the Duke, and it is now thought to be an unfinished studio copy.

In 1834 and again in 1835 the Duke gave some sittings to Henry William Pickersgill for a full-length portrait for Lord Hill, who had served under him in the Peninsula and at Waterloo. A similar picture was also painted for the Oriental Club, of which the Duke was the first and only President (**71**). The portrait for

opposite 68. Marble bust of Wellington by Benedetto Pistrucci, 1840s.

above 69. Reverse of the Waterloo Medal by Pistrucci, 1817–49, showing the Prince Regent, Franz I of Austria, Alexander I of Russia, and Friedrich Wilhelm III of Prussia, surrounded by emblems of peace.

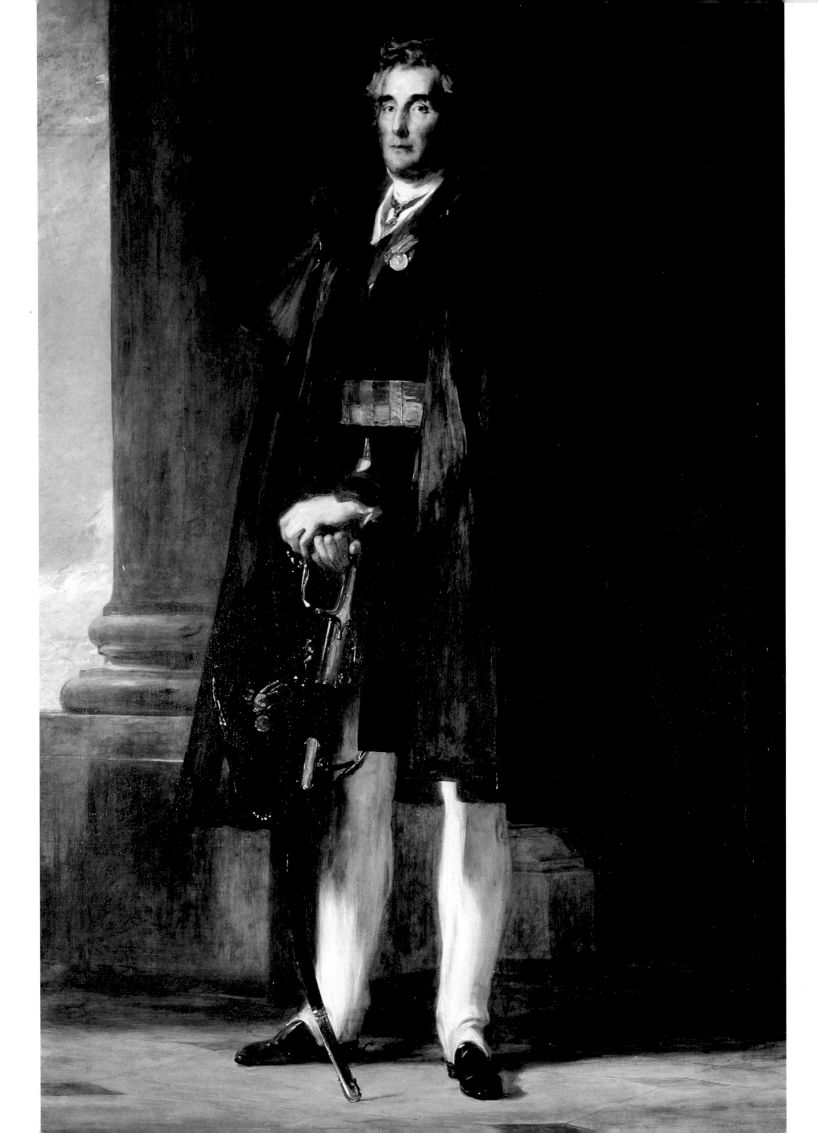

Lord Hill is now lost, and that for the Club was unfortunately later cut down, but its original composition is recorded in a print published in 1841 (see p. 198).

Also in 1834 the Duke was asked by Lord Wharncliffe to sit for a commission given to Henry Perronet Briggs by the inhabitants of Barnsley. The Duke replied from Stratfield Saye:

> I am Bankrupt on Portraits of myself. I have at this moment demands upon me for five and I cant find time to sit for them. The truth is that a good Painter requires five or six sittings at least each of three Hours, take those 15 or 18 Hours out of the disposable time that any publick Man has in a morning in London and it will be found impossible to allot the portion of time that the Painter requires. For observe that you must attend him between ten o'clock in the morning and four in the Afternoon and while sitting to him you must do nothing else . . . I therefore have adopted another mode of sitting for my Picture. I brought Wilkie down here three times last year and I think that I did not give him less than between thirty and forty sittings not of the Duration of three Hours which was Lawrence's time, but of from an Hour to an Hour and a half; and I have no objection to do the same by any other Gentleman who will do me the Honor of passing his time here.[36]

It took some time for Briggs to be allowed his sittings. On 19 August 1836 he wrote again to Lord Wharncliffe, asking him to intervene with the Duke, and adding, 'I am afraid the Duke has been so much persecuted in this way & to so little purpose that he will be heartedly tired of sitting – but I hope to produce such a picture as shall supersede the necessity of any more.'[37] On 4 May 1839 James Cocker wrote on behalf of the town, 'The portrait, which your Grace condescended to sit for, at the intercession of Lord Wharncliffe, is deposited in the public buildings of Barnsley; and a provision is made in the title deeds that the trustees are to hold it as the property of the town.'[38] Unfortunately it is now lost.

In November 1834 the Whig Government under Lord Melbourne fell. Wellington was invited by William IV to become Prime Minister again. He advised the King to send for Robert Peel instead, but Peel was abroad and uncontactable, so for a few weeks Wellington acted as caretaker Prime Minister. He occupied all the main offices of state, including First Lord of the Treasury, Foreign Secretary, Home Secretary, Secretary for War and the Colonies, and Leader of the House of Lords. He spent every day moving from one department to another, taking decisions and signing papers. It was again as if he was commanding an army at war. Fortunately, Peel was found in Rome and returned to London in December. The Duke became Foreign Secretary in Peel's new government.

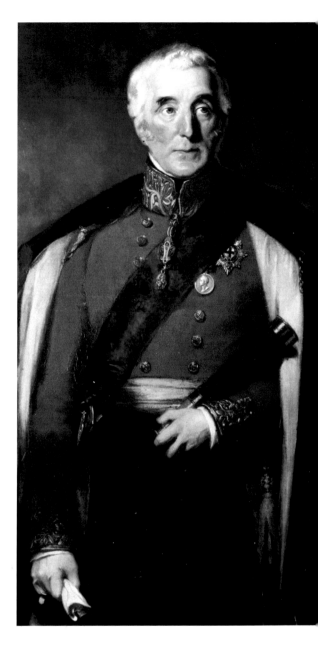

opposite 70. The Duke by David Wilkie, 1833–35.

above 71. Portrait of the Duke commissioned from Henry William Pickersgill for the Oriental Club, *c.* 1834–35 (detail).

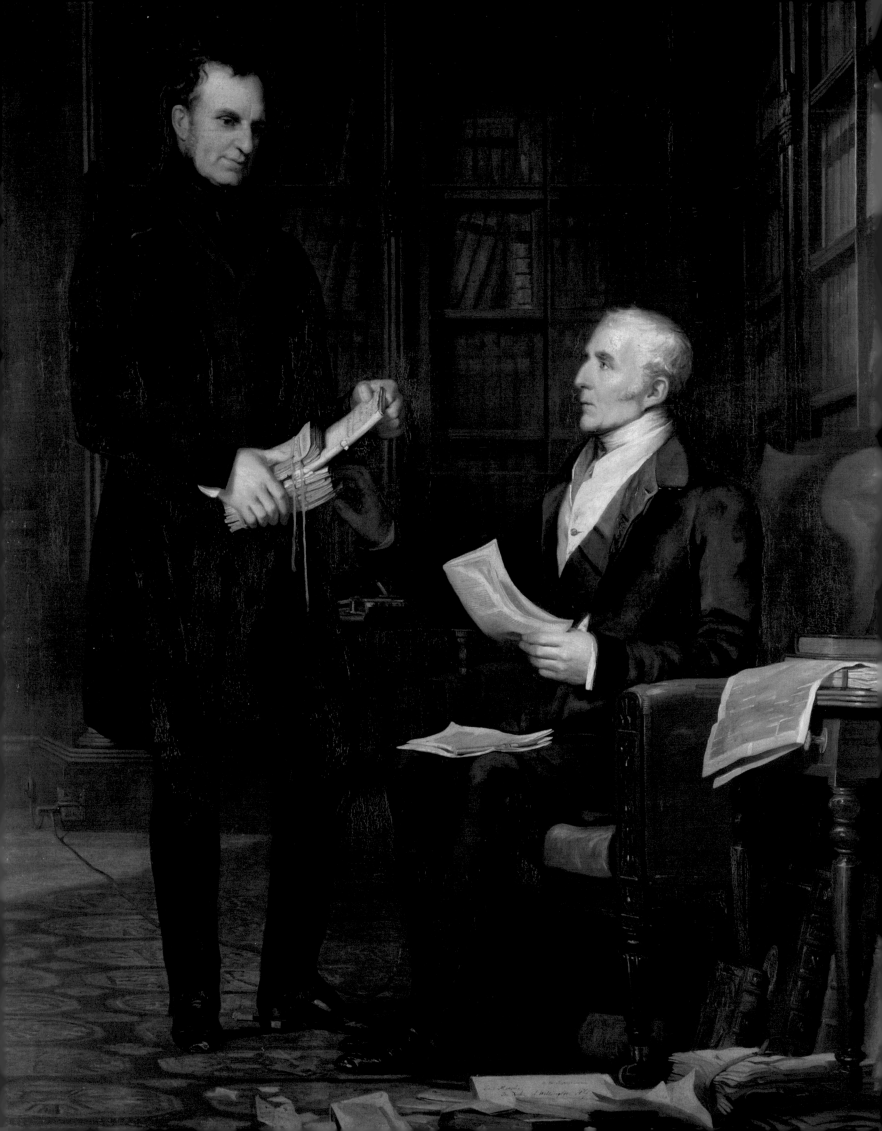

4

The Pillar of the State and Portrait Painters' Prey

In January 1835 the Duke was Foreign Secretary and Leader of the House of Lords. The printseller Thomas Boys, who had bought the copyright of Benjamin Robert Haydon's painting of Napoleon musing on St Helena, commissioned Haydon to do a picture of Wellington musing on the field of Waterloo. Haydon wrote a series of letters asking for sittings, but the Duke repeatedly rejected the request, saying among other things, 'I on the field of Waterloo am not exactly in the same situation as Napoleon on the rock of St Helena.' Haydon replied, 'it is because your Grace is in a different situation . . . that the public and the army will glory in seeing you there.'[39] At this point Haydon committed an inexcusable (in the Duke's opinion) intrusion. He called at Apsley House and persuaded the steward, Mugford, to lend him the Duke's coat so that he might paint it. When the Duke discovered what had happened he was outraged. Haydon had to abandon the painting, but there was a happier outcome in 1839 (85).

Later in 1835, the Junior United Service Club commissioned John Simpson to do a full-length portrait. The Club has disappeared and with it the painting, but it is known from an engraving, published in 1835 (p. 206). In the same year, Joseph Towne showed a marble statue of the Duke at the Royal Academy. The statue is lost, but we know that it was from life as there is a letter at Stratfield Saye offering 'a model which Mr Towne has made from a sketch the Duke kindly allowed him an opportunity of taking'. Towne, better known as the sculptor of the vast collection of anatomical wax models at Guy's Hospital, also exhibited a bust at the 1838 Summer Exhibition, but that too is now lost.

opposite 72. Wellington with Colonel John Gurwood, his private secretary, by Andrew Morton, *c.* 1840.

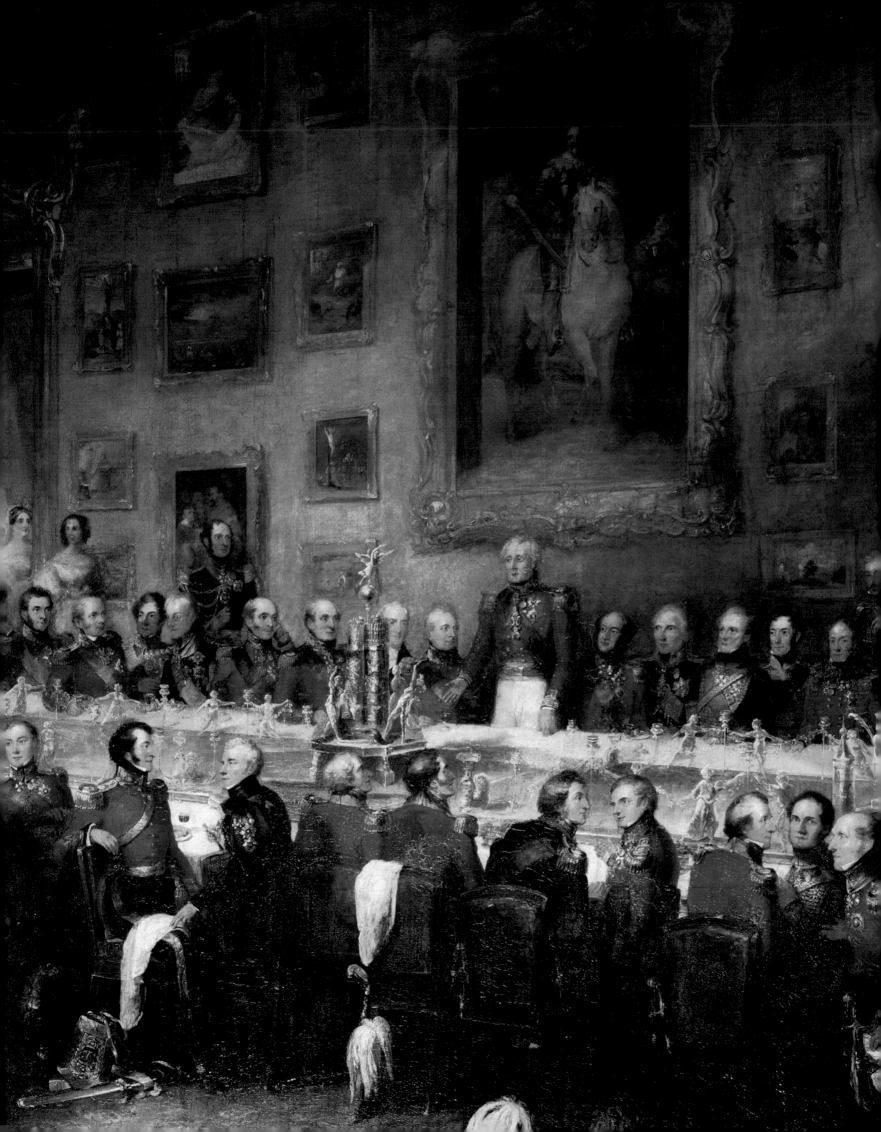

On 18 June 1836 the young William Salter, who had been a pupil of Northcote, was riding in Hyde Park and saw through the windows of Apsley House the Duke's Waterloo Banquet in progress. Salter's patron was Priscilla Burghersh, the Duke's niece, and through her he asked permission to paint the banquet. The Duke agreed, despite his doubts about the immaturity of the artist. Salter began work making studies of the individual officers. The painting that has become the most iconic image of the banquets was eventually completed in 1840 and exhibited in several places in London in 1841 (**73**). An engraving by William Greatbach published in 1846 proved extremely popular. The painting, which is over 4 metres wide, now hangs at Apsley House.

In 1836 further portraits were painted. John Lilley was commissioned by the Mayor and Corporation of Dover to paint a full-length of the Duke in his uniform as Lord Warden of the Cinque Ports (**74**). He wrote to Wellington in October:

> I have today received a communication from Mr. Thompson on the part of the Corporation of Dover, mentioning that your Grace has kindly condescended to allow me the favour of a sitting, for the Portrait of your Grace, which the Corporation are so anxious to place in the new Town Hall.
>
> I have My Lord Duke, to express my most grateful feelings for this act of kindness and condescension, and to say, that I shall be ready to wait upon your Grace, on any day, and at any hour, which may be most convenient to your Grace.[40]

This picture was exhibited at the Royal Academy in 1837 and engraved by James Scott, which engraving made his name (p. 186). A sketch for the Dover painting, at Stratfield Saye (**75**), is in some ways finer than the finished portrait – particularly now, since very sadly the Corporation of Dover decided in 1973 to cut the canvas down to head-and-shoulders, in order to save on the cost of restoration.

Wellington did not rate Lilley's work. In November he wrote to Lady Burghersh from Stratfield Saye, 'I don't think that he is going on well. He has genius, and he is a dashing fellow with a brush in hand; but he is not steady to anything.'[41] He continued the following week:

> Mr. Lilley has been here since last Monday; and has had nine sittings; eighteen at Walmer makes twenty-seven. This really is too much. After painting the head at Walmer, he was to come here to sketch in the figure, the cloak, &c. He has in fact commenced a new picture altogether. The figure, cloak &c., are done. But the head is in my opinion not so good as the other. I can positively sit no longer. I do think that having to pass every leisure hour that one has by daylight in sitting for one's picture is too bad. No man ever submitted to such a bore: and I positively will not sit any longer.[42]

opposite 73. *The Waterloo Banquet at Apsley House*, 1836, by William Salter, completed in 1840 (detail).

below 74. The Duke as Lord Warden of the Cinque Ports, painted by John Lilley for the Mayor and Corporation of Dover, 1836–37 (detail).

bottom 75. Wellington by Lilley, sketch for the Dover painting, 1836.

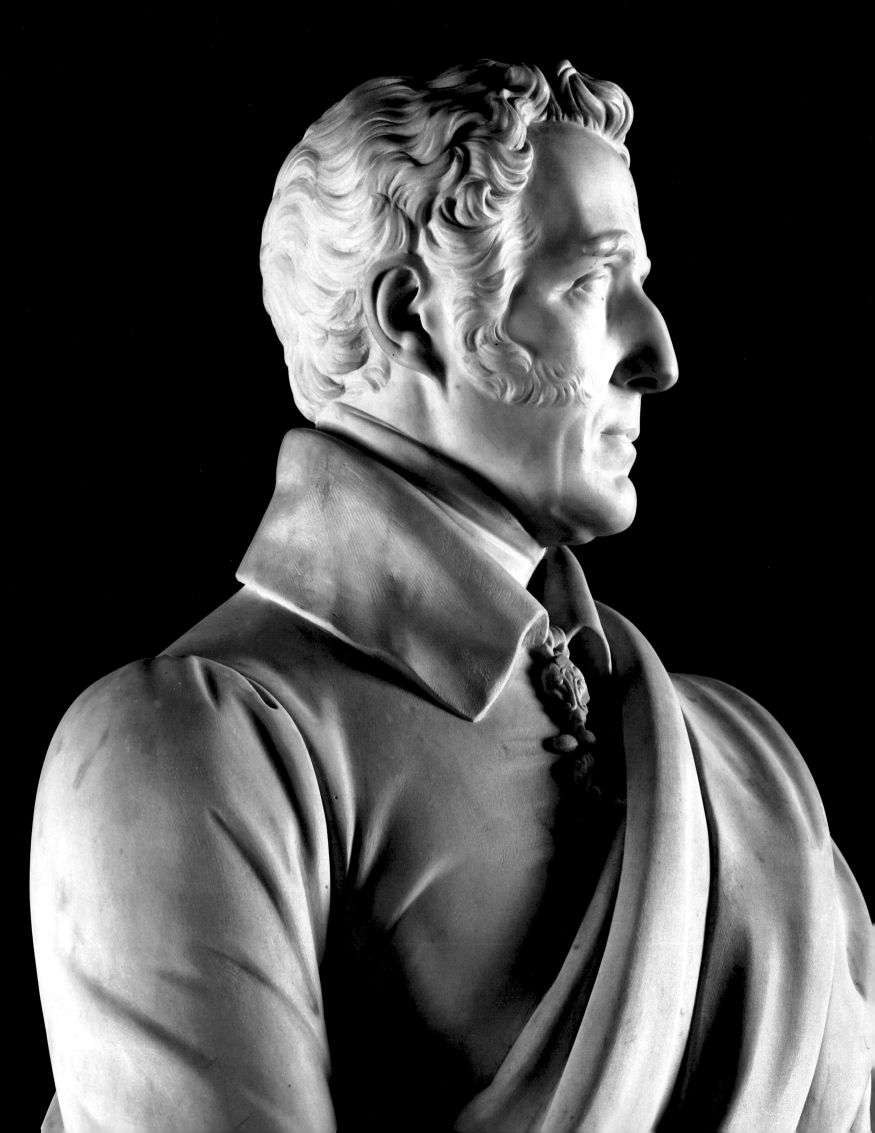

It appears that Lilley left Stratfield Saye without finishing the portrait:

> Mr. Lilley went away and carried away his picture very suddenly last
> Sunday. He did not stay to dine. I told him that he was attempting that
> which was impossible, that is to paint over in nine sittings a head which
> had taken him eighteen sittings at Walmer Castle. That I could sit no
> more, having given in the whole not less than twenty-seven sittings in
> less than three weeks.
>
> He was not pleased, however, it is obvious; and this is what one gets
> for making oneself a slave of these gentlemen artists.[43]

Throughout the rest of 1836 painters and sculptors preyed on him and consumed
his free time. Lady Salisbury wrote in her diary on 7 November:

> The Duke has had four artists at Walmer, a sculptor, and three painters
> employed by Lord Carrington, the Duke of Buccleuch etc. . . . to take his
> likeness. They occupy him the whole of the daylight with the exception of
> half an hour for breakfast, and the intervals during which their apparatus is
> changed and which he employs in walking up and down the beach for
> exercise.[44]

The sculptor was Thomas Campbell, working on a commission for a statue from
the Duke of Buccleuch (**76**). Some years earlier he had done a bust of the Duke
for Lord Ellesmere and for other Scottish families including Lord Hopetoun and
Lord Lauderdale. He also some years later did a bust for the King of Hanover.

The painter employed by Lord Carrington was Andrew Morton, to whom
the Duke duly sat at Walmer in October and November. Other artists are
mentioned in a letter from Wellington to Lady Burghersh of 3 November: John
Lilley, whose picture 'is getting on, but very slowly', Henry Perronet Briggs, and
'Mr. Hall who is acting as draftsman to Mr. Campbell. I sit to three at the same
time.'[45] James Hall wrote that he made

> six or seven slight Camera Sketches this morning from the Duke's figure
> . . . First we (Campbell and I) got him to stand without his cloak for several
> attitudes, then several with his cloak: after which he sat down and Campbell
> worked with the bust while I retouched a profile made in London from C's
> bust, which drawing is thus made of peculiar value.[46]

He also took a cast of the Duke's hands (see p. 161). Then, as an independent
artist, he produced a painting, based on the drawings he had made at Walmer,
for Colonel John Gurwood, the Duke's private secretary (**77**).

The portrait that Henry Perronet Briggs was working on at Walmer had been
commissioned by the Charterhouse in London, then still the home of the boys'
school, of which the Duke was a Governor (**78**). The painting was shown at the

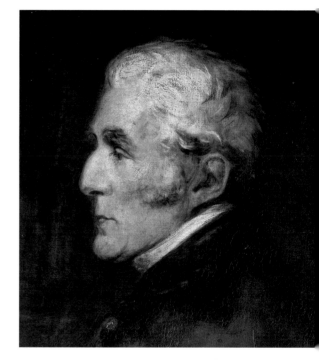

opposite 76. Marble statue of Wellington by Thomas
Campbell for the Duke of Buccleuch, *c.* 1828–36
(detail).

below 77. Wellington by James Hall, painted for
Colonel John Gurwood, 1836 (detail).

bottom 78. Wellington by Henry Perronet Briggs,
painted for the Charterhouse, *c.* 1837 (detail).

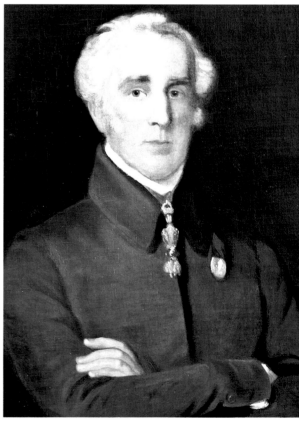

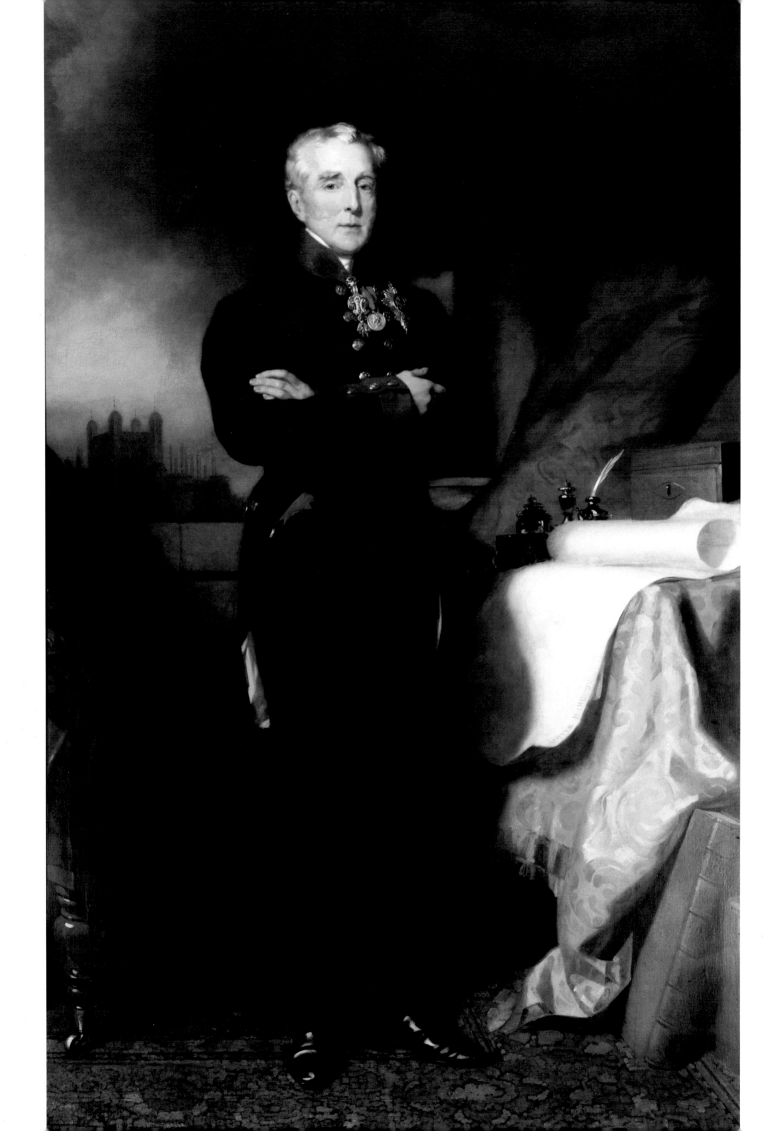

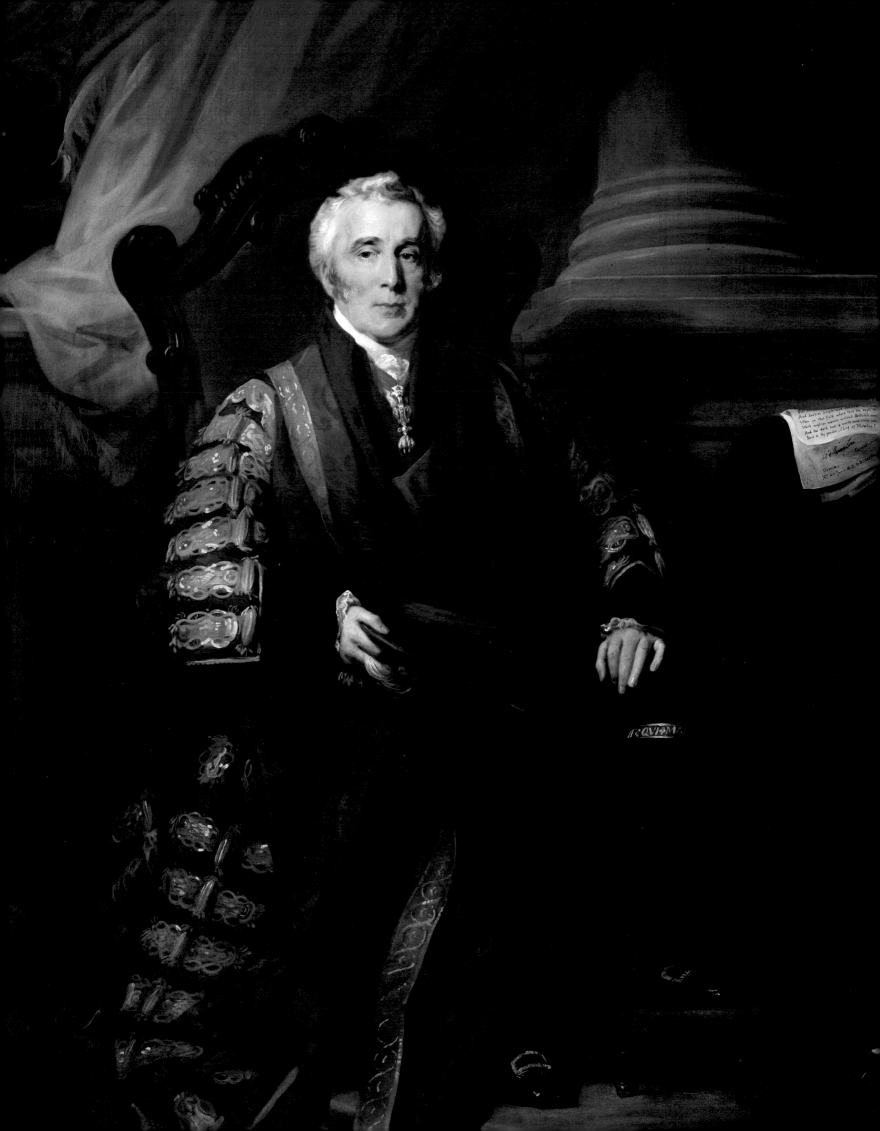

Royal Academy in 1837. Many versions were produced, including those in the Houses of Parliament, the British Embassy in Brussels, and the Beaverbrook Art Gallery in Canada.

In 1830, while still Prime Minister, Wellington had been elected an Elder Brother of Trinity House, the organization founded in 1514 to look after the safety of shipping and seafarers. In 1837 he became the Master, and Trinity House commissioned John Lucas to do a full-length portrait of him in his uniform, with orders (**79**).

Lucas also painted a portrait of the Duke in his robes of office as Chancellor of the University of Oxford. It had been requested by the University in 1835. In March 1839 Wellington wrote to his niece Priscilla that Lucas had been at Stratfield Saye, and the painting was delivered later that year, at the Duke's charge, for 200 guineas. It was engraved in 1841 by the eminent Samuel Cousins (p. 188). Another portrait of the Duke in his robes as Chancellor was commissioned in 1838 by Lord Eldon, who was High Steward of the University. It was painted by Henry Perronet Briggs, and completed in 1840 (**80**). The 7th Duke acquired the painting from Lord Eldon's descendant and it hangs at Stratfield Saye.

The greatest of all depictions of Wellington, in terms of size, had its origin in 1837 when a committee was formed under the chairmanship of the Duke of Rutland to raise money to erect a memorial to the Duke:

> At a Meeting of Noblemen and Gentlemen of the United Kingdom of Great Britain, held on Monday the 19th June, 1837 (the Anniversary of the Battle of Waterloo falling on Sunday), it was Resolved That, as there is no great National Memorial to record the splendid Military Achievements of the Duke of Wellington, it is proposed, to erect, by general Subscription, and in an appropriate situation, in the Metropolis, such a Testimonial as may be worthy of those Services, and of a Nation's Gratitude.[47]

The commission for a monumental equestrian statue was given to Matthew Cotes Wyatt (son of James Wyatt and brother of Benjamin Dean Wyatt, architects who had variously remodelled Apsley House). It was to be placed over the arch designed by Decimus Burton, to the south of his screen adjacent to Apsley House (**81, 103**). The whole had been intended by George IV to commemorate the victories in the Napoleonic Wars. The Duke sat to Wyatt in 1839. Copenhagen the horse was dead and a substitute was used, which later aroused some criticism.

The work was undertaken at Wyatt's workshop in the Harrow Road and his son James did much of the modelling. The statue was cast in bronze, some of it from French cannon captured at Waterloo, in eight pieces, the legs of the horse being solid to take the weight. When completed in 1846 it was 30 feet long and 22 feet tall (some 9 by 7 metres) and weighed forty tons (**82**). It was taken from

previous pages, left 79. Wellington as Master of Trinity House, by John Lucas, 1839.

previous pages, right 80. Wellington as Chancellor of the University of Oxford, by Henry Perronet Briggs, 1840.

opposite 81. The Wellington Arch with Matthew Cotes Wyatt's statue in position before 1882, looking north towards the Hyde Park Screen. Apsley House is partly visible on the right.

below 82. Bronze equestrian statue of Wellington by Matthew Cotes Wyatt, 1846, now at Aldershot.

the workshop to Hyde Park Corner on a low carriage made at Woolwich with wheels 10 feet (some 3 metres) in diameter. The carriage was pulled by a hundred men from the Scots Fusiliers. When finally hoisted onto the Arch the statue immediately seemed too large, and even before the scaffolding had been taken down there were calls for its removal.

The Duke had stood aside from the matter, but eventually he wrote to the Queen suggesting that the removal of the statue would be interpreted as a hostile gesture by the Whig government towards him personally. The Queen replied on 12 July 1847:

> The Queen has been informed by Lord John Russell [the Prime Minister] that the Duke of Wellington is apprehensive that the removal of His Statue from the Arch to another Pedestal might be construed as a mark of displeasure on her part . . . although she had thought that another Pedestal would have been more suitable for this Statue and that the Arch might have been more becomingly ornamented in honour of the Duke than by the Statue now upon it, she has given immediate instructions that the Statue should remain in its present situation . . .[48]

The Duke responded the same day:

> he submits to Your Majesty the expression of his sorrow and shame; that Your Majesty should be troubled for a moment by any thing so insignificant as a Statue of himself.
>
> He rejoices sincerely that your Majesty has been most graciously pleased to countermand the order of the removal of the Statue.[49]

In the end it remained in place until 1882, when the Arch was moved to its present position at the apex of Constitution Hill. The statue was taken to Aldershot in 1885 and installed behind the Royal Garrison Church (82).

In the autumn of 1838 the Duke was still under pressure from artists. Lord Mahon (later Lord Stanhope) was a regular visitor to Walmer. He records that both Chantrey and Lucas were there. The latter was working on the picture for Trinity House (79), and Lord Mahon commissioned Lucas to do another painting of the Duke for himself, in field-marshal's uniform this time (83). The picture still hangs at Chevening.

The Duke had by now become accustomed to spending the autumn at Walmer. In October 1839, Lucas returned to paint him as Lord Lieutenant of Hampshire for the City of Winchester. Benjamin Robert Haydon was now allowed some sittings.[50] Haydon's first commission for an image of the Duke 'musing on the field of Waterloo' had ended badly (above, p. 79). On 7 May 1839, however, 'the gentlemen of Liverpool' had written to Wellington asking him to sit for the same composition. This time the Duke responded, 'I will, with great pleasure, see Haydon.' Haydon explored the site of Waterloo in

opposite 83. The Duke, painted by John Lucas for Lord Mahon, later 5th Earl Stanhope, 1839–40 (detail).

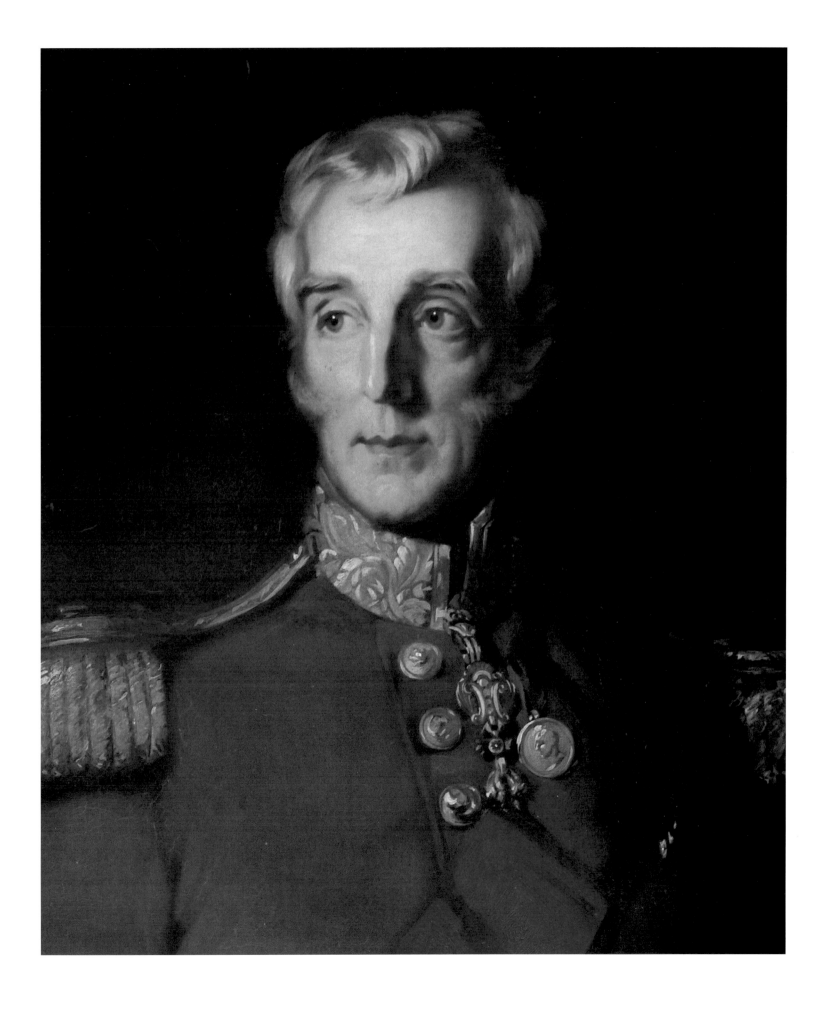

right 84. Study of Wellington by Benjamin Robert Haydon, painted at Walmer in October 1839.

opposite 85. *Wellington on the Field of Waterloo,* by Haydon, 1839.

August, and at Walmer he was given several sittings. He noted, 'I studied his fine head intensely. . . . his conversation powerful, humorous, witty, argumentative, sound, moral.'

He also made quick sketches of the Duke's 'back, his hands, legs, etc.' The resulting oil sketch was considered so good by Priscilla Burghersh and Charles Arbuthnot, who were both staying in the house, that nothing was changed (**84**). 'They thought I had hit the expression.' This oil sketch so admired by his contemporaries now hangs at Stratfield Saye, as does Haydon's fine painting of Copenhagen, which he copied from Ward's image (**51**) as Copenhagen had died in 1836. The final picture of Wellington musing at Waterloo hangs today in the Walker Art Gallery in Liverpool (**85**). Haydon also painted a detail of the Duke on a window shutter at Chatsworth.

Haydon again had to rely on Ward's image of Copenhagen when in 1840 he painted the scene of King George IV being shown the battlefield of Waterloo by the Duke (86), an event that had taken place in September 1821 (see above, p. 65).

Although Lady Salisbury had considered Andrew Morton's earlier painting wooden (see p. 75), he was again given a sitting in early 1840, this time at Apsley House. The Duke was painted in his chair in the Library, discussing documents with his private secretary, Colonel John Gurwood (72). Gurwood was a hero of the storming of Ciudad Rodrigo in 1812, and had begun to edit the Duke's dispatches in 1832. The furniture and bookcases are very accurately painted, and they are all there to this day. The painting or a variant was exhibited at the Royal Academy in 1840. A few years later it was acquired by the 4th Marquess of Hertford, and it hangs today in the Wallace Collection.

above 86. *The Duke of Wellington describing the Field of Waterloo to George IV*, an event that took place in 1821, by Benjamin Robert Haydon, 1840.

opposite 87. Portrait commissioned from John Lucas by Wellington for the 1st Marquess of Anglesey, 1841–42.

In the 1840s William Essex, who in 1839 had become Enamel Painter to the Queen, produced a number of miniatures in enamel on copper after the Arbuthnot Lawrence (p. 150). They are of very high quality, but as far as we know Essex never had a sitting.

In December 1840 Wellington decided to commission from John Lucas a full-length portrait to give to his former subordinate Lord Uxbridge, now Marquess of Anglesey (87). In 1810 Uxbridge had run off with Charlotte Wellesley, then married to the Duke's brother Henry. For many years relations between Wellington and Anglesey had been strained, but the Duke now wished to send him a present, having received this letter: 'I am most anxious to possess a full length Portrait of you. This is not a new desire, for I have had it for many years, and was on the eve of making the request, when certain political events which have long passed, and are forgotten, disabled me from naming the subject to you.'[51] The Duke replied:

> I am much flattered by your desire to possess a Portrait of me and you may rely upon every exertion on my Part that you should have the best that can be painted at present.
>
> I sat to Lawrence several times for a full length Portrait for you [this painting is not known], which was not finished and I believe that in the confusion which followed his sudden death, it was sold by auction, to whom I cannot tell.
>
> I am not aware of any one of Lawrence's now to be sold.
>
> There is a Painter now in London who has painted some very good Pictures of me, very little inferior to those by Lawrence. His Name is Lucas . . . He is certainly the Painter who has made the best Portraits of me since Lawrence.[52]

Lucas had done a number of portraits of the Duke, who now wrote to him, 'I beg you to recollect . . . how desirable it is to attend to the size of the Head . . . the Head of all those you have painted, even that in the Robes of the Chancellor of Oxford [p. 188], is too large. I always thought so, and you may rely upon it that I am right.'[53] Like the Oxford picture, this one cost the Duke 200 guineas, but it gave greater satisfaction. On 5 November he wrote to Lady Burghersh, 'I think that the best picture painted by Lucas is the last intended for Lord Anglesey. It is, moreover, in the Field-Marshal's uniform.'[54]

In April 1840 the Duke was approached by 'a Deputation from the Citizens of Glasgow and the Noblemen and Gentlemen of Counties in the West of Scotland', who considered that

> the eminent services of His Grace the Duke of Wellington . . . ought to be Commemorated by a suitable Memorial, erected in this city . . . the erection of an Equestrian statue is the most suitable mode of perpetuating the Sentiments of this meeting. [The petitioners wished to] Solicit Your Grace's

opposite 88. Bronze equestrian statue of Wellington by Carlo Marochetti in Royal Exchange Square, Glasgow, 1844.

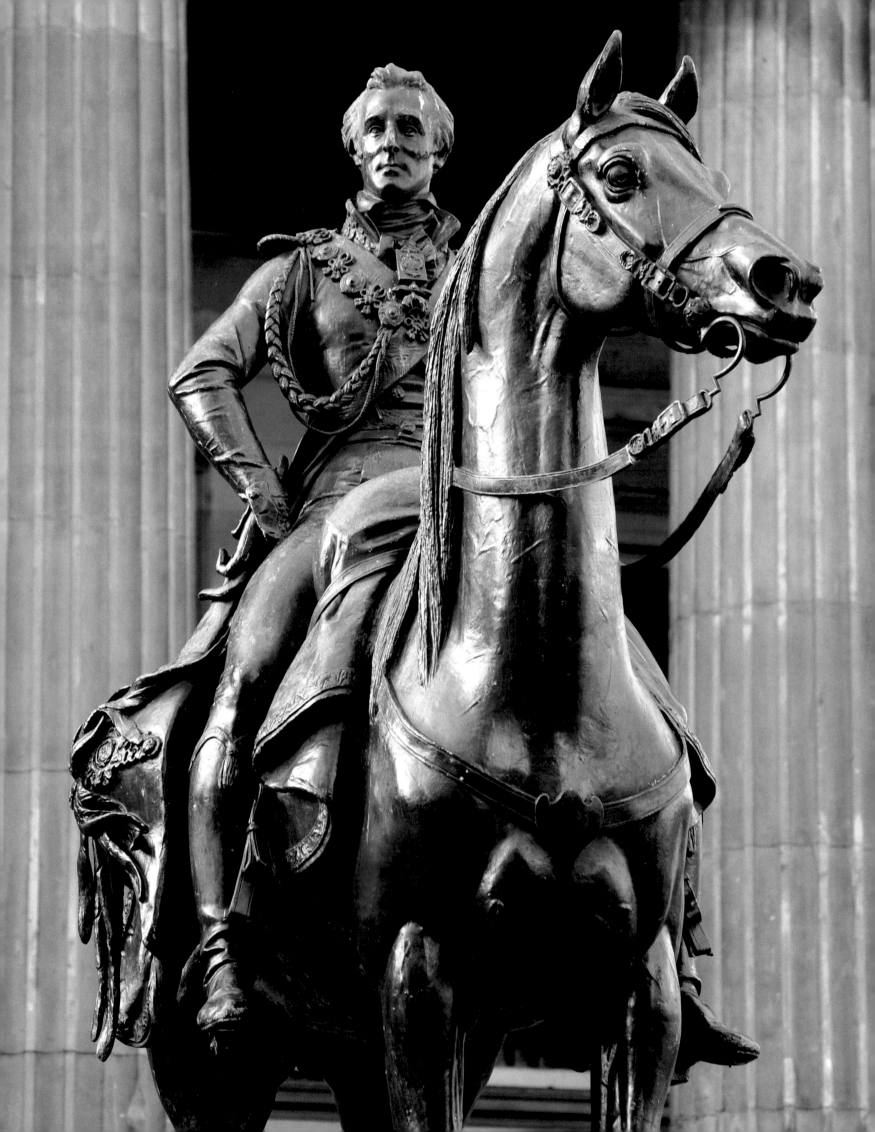

kind permission that the Artist who may be Selected . . . should have an opportunity of waiting on Your Grace, at such times as may best suit Your Grace's personal convenience.[55]

The petition was signed by the Lord Provost Henry Dunlop and by the Duke of Argyll. The fund became by far the largest and most speedily gathered for any monument in Glasgow in the 19th century. John Steell, John Gibson, Richard Westmacott and Carlo Marochetti all submitted designs. The Committee gave the commission to Marochetti (88) – an unpopular decision, because he was a foreigner. The Duke agreed to give Marochetti some sittings, and he stayed at Stratfield Saye in late May 1841. It was not a happy experience. The Duke wrote to Lady Wilton, 'I lament the fate of passing my manhood acquiring celebrity; and having to pass my old age in sitting for busts and pictures to artists so that they may profit by it.' His irritation is further reflected in a letter to the Convener of the Glasgow Monument Committee:

> The Duke has done everything in his power for Mr. Marochetti. He received him at his house in Hants – sat in a room and on horseback for him; and he took drawings and Moulds of all he required. The Duke has no clothes but those which he wears daily – He does not carry about with him horse appointments. He really thinks that at least during the session of Par[liamen]t Artists might leave him unmolested! He does not recollect to have left any letter from Mr. Marochetti unanswered. He declines to allow his Clothes to be taken from his house by an Artist.[56]

At the statue's unveiling in 1844 crowds gathered and were impressed, as was Queen Victoria when she visited Glasgow in 1849. After the studies made at Stratfield Saye, Marochetti also sculpted a bust, which his grandson sold to the 7th Duke and is now at Stratfield Saye.

Another portrait of this period was a full-length commissioned for the Cutlers' Hall in Sheffield from Henry Perronet Briggs. Two prints were published after it.

Having led the opposition in the House of Lords since Peel's government resigned in April 1835, the Duke joined the Cabinet again in 1841 as Leader of the House of Lords, but at his own request without a ministerial position (he was seventy-two, and had had a minor stroke in 1839). In that year an American artist established in London, Charles Robert Leslie, wrote to Wellington asking for a sitting for a painting which the Queen had commissioned of the christening of the Princess Royal. Leslie had already painted Wellington for his picture of Queen Victoria taking the sacrament at the Coronation (for both paintings, see p. 183).

Also in 1841, the National Wellington Testimonial Committee in Scotland approached the Duke through Lord Dalhousie, the son of his companion in arms in the Peninsula, hoping that he would give sittings to John Steell, a leading Scottish sculptor, for an equestrian statue in Edinburgh. The Duke retorted:

I am now 72 years of Age, I have served the Publick for above 50 years
and I now devote as much time to their Service as I can take from the
Rest which is necessary for all Animals to take. In the Course of my Life
I have sat for hundreds of Pictures and Busts, there are hundreds of both
in this Town by the first Artists in the World. Yet at my Age I am required
at the very moment that there is a prospect of a little Relaxation from
publick business to fix a time for sitting for additional Pictures & Busts
instead of seeking for relaxation or at least Repose, as every other animal
in the Creation is occasionally allowed to do.[57]

Lord Dalhousie clearly felt very guilty about having asked the favour:

I am so fully sensible of the hardship to which your Grace is subjected,
in having your retirement perpetually disturbed by the intrusion of artists;
and I am so perfectly conscious that this fresh demand from Edinburgh,
at such a time, must give you intolerable annoyance, that I really feel it
due to myself to write to your Grace privately, begging you to acquit me
personally of having any share whatsoever in fixing this infliction upon
you.[58]

In a further letter to Dalhousie the Duke responded:

I had four at S. Saye when I was there for the Whitsun Holidays.
I generally have six here [at Walmer]. But I cannot pretend to find
Time to sit to Artists in London. I came here on Thursday as I told you
I should & I shall be happy to receive Mr Steel whenever he will come.[59]

Many of Wellington's friends sympathised. Charles Arbuthnot wrote on 1 June
that year, 'I cannot imagine much greater annoyance than the having to live
with artists and to waste all your time in sitting to them. It is one of the many
sacrifices which are exacted from you and so I fear it will be to your life's end.'[60]

Based on the sittings given in 1841, Steell sculpted a bust for Lord Bathurst
in 1843 (**89**). A second bust made in the same year was given to Lord Dalhousie
by the City of Edinburgh to thank him for persuading the Duke to give the
sittings to Steell. These busts were considered sufficiently good by the Duke that
he ordered another one to give to Eton College. Finally in 1848 Steell completed
the iconic statue that stands at the east end of Princes Street in Edinburgh. It was
cast in 1852, and unveiled on 18 June. It soon became known as 'the Iron Duke
in bronze by Steell' (**90**).

When William IV died in 1837 he was succeeded as King of Hanover by his
younger brother Ernest, Duke of Cumberland and Teviotdale. In 1842 the new
King asked the Duke to send him an equestrian portrait by John Lucas (p. 189).
The Duke wrote to Priscilla Burghersh on 27 March 1843, 'I saw Lucas'
equestrian picture before it went to Hanover. It appeared to me to be very good.'[61]

89. Marble bust of Wellington by John Steell, 1843.

90. Equestrian statue of the Duke by John Steell outside Register House in Edinburgh, 1848, cast in 1852.

The picture hung at Herrenhausen Castle until the Second World War, when the castle was destroyed. There is no record of the painting after that time.

In August 1842 Lord Hill, who had been appointed Commander-in-Chief in 1828 when Wellington became Prime Minister, decided to resign, and the Duke was appointed to be again Commander-in Chief. He was reluctant to remain in the Cabinet, but Peel needed him and he stayed. Two years later the Duke agreed to be portrayed in the new medium, photography, invented by Louis Daguerre. A silver iodide plate was exposed to the sitter and an image 'etched' on to the plate. Antoine Claudet was one of the few people licensed to make daguerreotypes in Britain, and the Duke sat to him on his seventy-fifth birthday, 1 May (**91**). Claudet's is the only photograph ever taken of the Duke, and it is one of the most important images we have, for being a photograph it is free of an artist's interpretation. It was engraved by H. T. Ryall and published

one year later. In 1852 Claudet was appointed the first Photographer-in-Ordinary to the Queen.

In 1844 Benjamin Robert Haydon was again at Walmer, as was Edward Hodges Baily, the sculptor. Haydon noted in his diary that Baily had been commissioned by Storr and Mortimer to produce an equestrian statuette of Wellington. During the sittings the Duke became rather exasperated. He asked Baily why artists could not be content with what they had done already. But then he got up on the horse, and Baily modelled away.[62]

One of the more unusual people who painted the Duke was Alfred, Count d'Orsay. He was the son of one of Napoleon's generals, and his mother was an illegitimate daughter of the Duke of Württemberg. In the 1820s he had met Lord and Lady Blessington, and became Lady Blessington's lover. He was at

91. Daguerreotype plate of Wellington by Antoine Claudet, 1 May 1844.

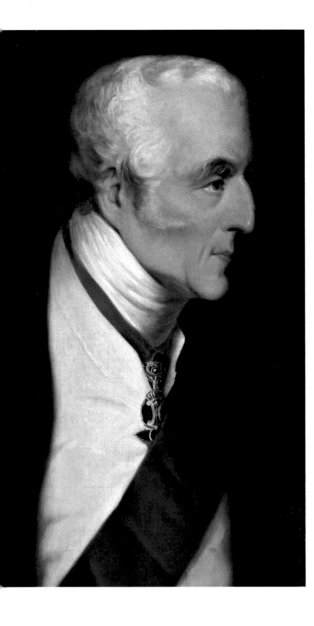

above 92. Wellington by Count D'Orsay, 1845 (detail).

opposite 93. Silver-gilt equestrian statuette of the Duke by Count D'Orsay, made by Hunt & Roskell, 1845.

various moments a friend of Lord Byron and of Disraeli. The National Portrait Gallery hold a large number of portrait drawings of his contemporaries and friends done by him in the 1830s and 1840s. Eventually he met the Duke. A portrait dated 1845 was sold at Lady Blessington's sale in 1849 (**92**). It now belongs to the National Portrait Gallery, and is appropriately on loan to King's College London, of which the Duke was co-founder with George IV. It is probably the original of a number of versions, one of which hangs today in the British Embassy in Paris.

The Duke also agreed to an equestrian statuette being modelled by D'Orsay (**93**). The artist wrote to Henry Bulwer in March 1845, 'I have just made a statuette of the Duke of Wellington on horseback . . . The Duke declares it is the finest thing he has ever seen and the only portrait by which he would wish to be known by posterity.'[63] Made up in silver gilt by Hunt & Roskell, it and one of Napoleon also by D'Orsay were displayed in the Duke's lifetime on the sideboard in the Dining Room at Apsley House.

In 1845 the Worshipful Company of Salters commissioned John Lilley to paint a monumental equestrian portrait of the Duke. Very sadly the Salters' Hall was bombed in the Second World War, and the painting was destroyed. Fortunately it had been recorded in an engraving (p. 186). Around the same time, Pickersgill produced an equestrian portrait of which two versions exist (p. 199). One is at the City of London Club, of which the Duke had been a founding member in 1832. The other was bought by subscription in 1852 for the Army and Navy Club, of which the Duke became a patron on condition that it include officers from the Royal Navy and Royal Marines as well as just the Army.

In 1847, shortly before his death, Robert Vernon, who had made his fortune from selling horses to the British Army during the Napoleonic Wars, commissioned Edwin Landseer to paint a picture of the Duke, leaving to the artist the choice of composition. Landseer chose to represent the old Duke visiting the battlefield of Waterloo incognito with his daughter-in-law, Lady Douro. It is not known whether Wellington gave him a sitting, but it is very possible, as in 1848 they were corresponding about the purchase by the Duke of another painting by Landseer. Vernon died before the picture was finished but it was included in his large bequest and is now in the Tate. An engraving after it became one of the best known images of the Duke. A reduced copy of the painting is in the Family Collection (**94**).

In 1848 the Duke sat to Henry Weigall for a marble bust, exhibited at the Royal Academy in 1849. It is now at Stratfield Saye, having been owned by Rupert Gunnis (compiler of the *Dictionary of British Sculptors*) and willed to the 7th Duke when Gunnis died at Stratfield Saye in 1965.

In 1846 Angela Burdett-Coutts, the owner of Coutts Bank, the wealthiest woman in England and a major Victorian philanthropist, began to believe that she was in love with the Duke of Wellington, and in February 1847 she proposed to him. He was seventy-eight and she was thirty-three. But he wrote back, 'I have passed every Moment of the Evening and Night since I quitted you in reflecting

above 94. Wellington returning to the field of Waterloo with Lady Douro, a copy after Sir Edwin Landseer's *A Dialogue at Waterloo* of 1837–50.

opposite 95. Wellington with Lady Douro at Buckingham Palace, by Charles Robert Leslie, *c*. 1848.

upon our conversation of yesterday . . . You are Young, my Dearest! . . . I entreat you again in this way, not to throw yourself away upon a Man old enough to be your Grandfather.'[64] However they remained very good friends for the rest of his life, and she was considered by the 2nd Duke to be an honorary member of the family. At a party given by Angela Burdett-Coutts about 1848, Charles Robert Leslie painted two scenes of the Duke looking at busts of Napoleon and of Washington. Leslie also painted the Duke and Lady Douro, coming down the steps at Buckingham Palace (**95**), and a charming small watercolour of the Duke in evening dress, no doubt from life.

In 1849 the Duke decided to give 'Kitcat' portraits by Lucas of himself to Prince Metternich, to the Austrian Army, and to the Prussian Army for the Military School in Berlin (p. 190). He paid 60 guineas for each and 4 guineas for the frames.

In 1851, the penultimate year of the Duke's life, he was still giving sittings.
Angela Burdett-Coutts commissioned Robert Thorburn, father of the famous
bird painter, to paint the Duke in the Library at Stratfield Saye with his
grandchildren. This composition was completely in keeping with Wellington's
great interest and good way with children. Frances, Marchioness of Salisbury,
had written in her journal in 1838, 'We have now eight children in the house
[Stratfield Saye] . . . and the rush of delight they make when the Duke enters the
room and the way they surround his chair is quite touchant.'[65] The resulting
picture painted on ivory became another iconic image of the Duke (**97**). Angela
Burdett-Coutts was made a Baroness in 1871 and died in 1906. There was a
major sale of her effects in 1922 where the 7th Duke bought the Thorburn
painting.

Sir George Hayter also received a sitting from the Duke in 1851. This was for 'a picture in which His Grace is shown contemplating the Effigy and relics of Napoleon at Madame Tussaud's in Baker Street'.[66] The painting was commissioned by Madame Tussaud, who had seen Wellington visiting the effigy and been 'struck by the circumstance'.[67] Luckily a mezzotint was published in in 1854 (96), as the original painting was destroyed by a fire at Madame Tussaud's in 1925.

The Duke's last sitting to a sculptor was given on 18 November 1851, to Henry Weigall Senior, who produced a bronze bust (p. 214). When the Duke died the following year, Weigall published versions in bronze and in plaster which sold widely. The sculptor had brought with him to the sitting his son Henry, a painter. Henry Weigall Junior painted a full-length portrait which now hangs in the Foreign Office on loan from the family (100), and several miniatures, one of which was incorporated in a bracelet given to the Duke's granddaughter Victoria (98). He eventually married Wellington's great-niece, Priscilla Burghersh's daughter, Lady Rose Fane.

Probably the last painting of the Duke was done by an American, James Glass. Entitled *His Last Return from Duty*, it shows the Duke, still Commander-in-Chief, leaving Horse Guards Parade accompanied by his groom, John Mears (99). After an introduction by the American minister in London, Glass was given some sittings in the Library at Apsley House. On 26 July 1852 he showed an oil sketch to the Duke, who is said to have commented, 'You had better take your sittings now as I may not be here in the spring.' Glass framed the oil sketch, noting on the frame 'The Duke saw this sketch on July 26 and seemed pleased'. The sketch was acquired by Lord Charles Wellesley, the Duke's second

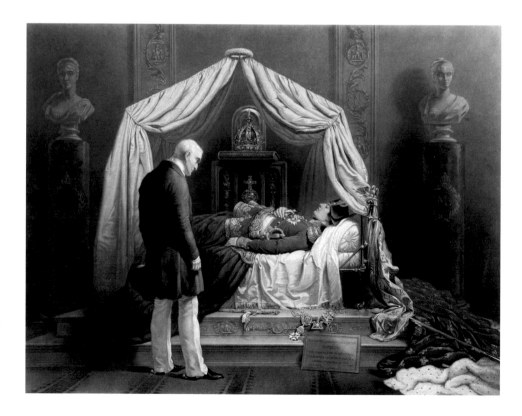

right 96. Mezzotint after Sir George Hayter, showing the Duke leaning over an effigy of Napoleon in Madame Tussaud's wax museum.

opposite, above 97. A large miniature on ivory by Robert Thorburn, 1852, showing Wellington with Henry, Mary, Arthur and Victoria, the children of Lord Charles Wellesley, in the Library at Stratfield Saye.

opposite, below 98. Miniature by Henry Weigall Junior, 1851, set in a bracelet given to the Duke's granddaughter Victoria.

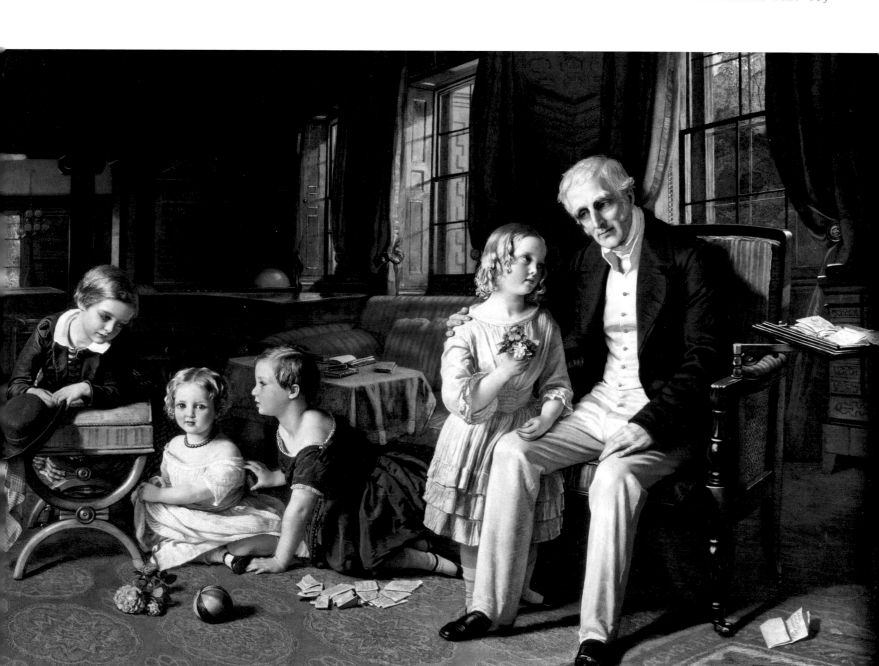

son. The Duke was to die six weeks later. Glass painted a picture of the groom and the horse riderless, and then painted the finished picture, which now hangs at Apsley House. The image was engraved in 1855 and many copies were sold.

As was his normal practice, the Duke left London in early August 1852 for Walmer, where he received a visit from Prince Albert on 10 August when the Queen and the Prince Consort were on their way to Belgium. After a few uneventful but happy weeks by the sea the Duke died suddenly on 14 September. Lady Charles Wellesley, his daughter-in-law, wrote to Lady Salisbury to announce his death:

The poor Duke seemed yesterday as well as usual, this morning he was seized with violent sickness, & soon after with fits, & lost all consciousness,

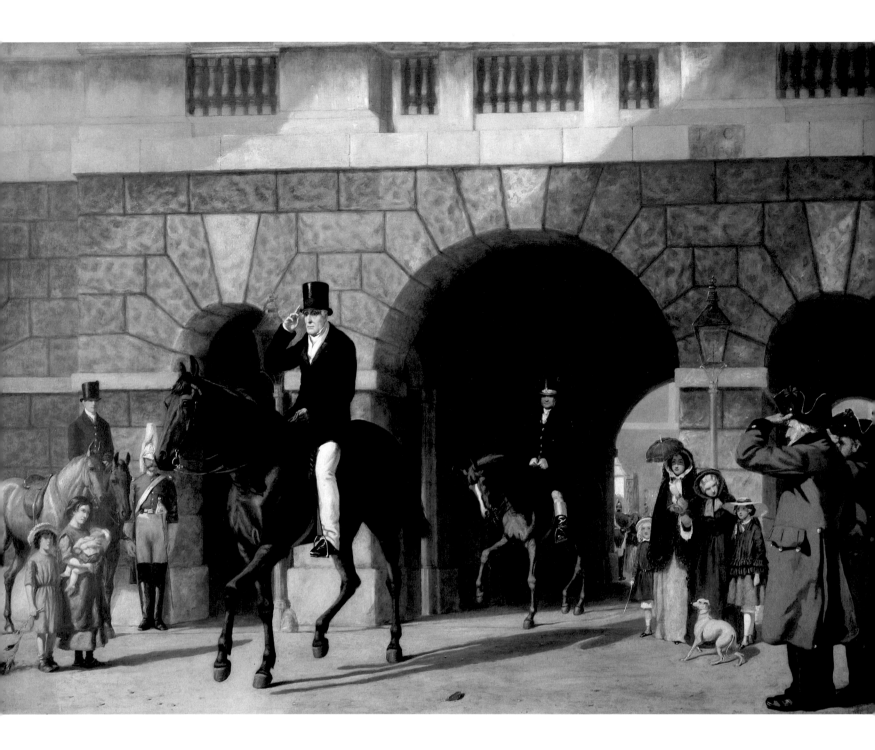

at intervals there appeared to be a slight amendment, but for a few
moments only, & alas! he gradually sank until at ½ past 3 all was over.

I can hardly realise it yet, so few short hours ago he was well &
amongst us. But it is mercifully ordained he was spared bodily suffering
& lingering illness.[68]

With the Great Duke's death the long history of him sitting to artists came to
an end. From the silhouette of him as a boy in Ireland (**14**) to the Commander-
in-Chief riding back to Apsley House from Horse Guards, it is impossible to
calculate how many hours of his life he had given to painters and sculptors.

The style of painting had moved from Hoppner to Lawrence, to Wilkie and
to Lucas. It is difficult to comprehend fully the extent to which the Great Duke
became such an icon. The arts of engraving and modelling developed so that
many households had an image of Wellington on some piece of furniture or
equipment. He was not vain, and found this constant demand for yet another
portrait to be surprising and disconcerting. At his death it is estimated that there
were left more images than of any other person who had not been a reigning
monarch. The catalogue of these images constitutes a major element of his
extraordinary legacy.

99. *His Last Return from Duty*, by James Glass,
1853.

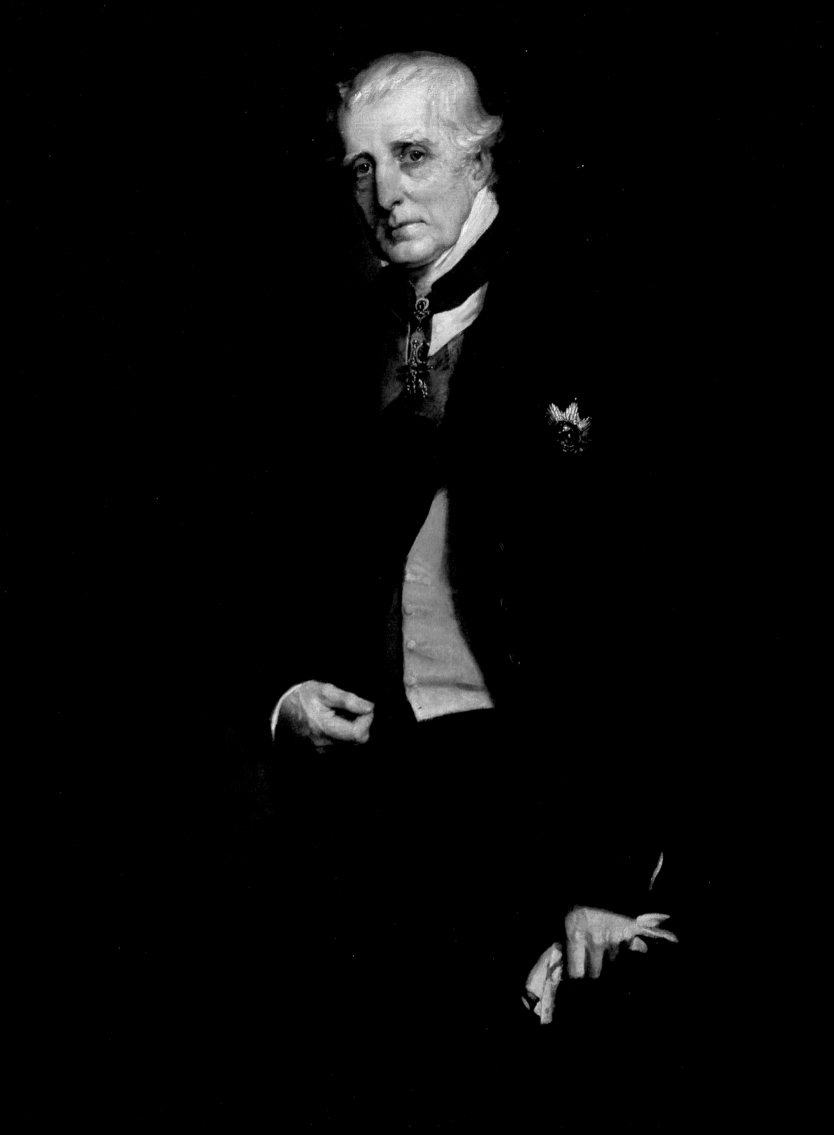

Epilogue

When the Duke died, his younger son, Lord Charles Wellesley, and Lord Charles's wife, Sophia, were staying with him, but Lord and Lady Douro were abroad in Germany and took four days to return. An image of the scene of death by Sir John Gilbert was published in the *Illustrated London News* (**101**). The Queen wrote to Lord Charles from Balmoral on 16 September, 'The Queen can not let anyone but herself express to Lord Charles her deep grief, her unfeigned sorrow at the immense loss the whole nation and herself have experienced in the death of his dear, revered and great father, the greatest man the country ever produced.' Two days later she wrote a more personal note to Lady Douro, 'My dearest Bessie, I really hardly know how to express half of what I feel on the sad event which has plunged us and the whole nation into sorrow. It is impossible to think of this country without the Duke.'

Three days after the Duke died, George Gammon Adams made a death mask, which shows the Duke's distinctive face but sadly with sunken mouth, the false teeth having been taken out (see p. 120). From the death mask Adams rapidly made a bust. Charles Dickens, who had met the Duke through their mutual friend Angela Burdett-Coutts, was asked to advise Adams on it. He found 'according to my eye, the mouth much too tight, and a general want there about of a suggestion of flexibility'.[69] His comments were accepted and alterations made. Adams must have worked fast, for on 16 November, two days before the state funeral, the 2nd Duke wrote that he considered the bust (**102**) 'by far the best that has appeared. We are very much obliged to you for thus making a likeness which hereafter will be considered as authentic.'[70] It became an enduring image, reproduced in marble and bronze in multiple editions and in different sizes.

Preparations now began for the most elaborate state funeral ever. The Duke's body was placed in a pine shell made by the carpenter at Walmer. This was then placed in three further layers of coffin brought from London – first thick lead,

opposite 100. Wellington by Henry Weigall Junior, painted from sittings given in August and November 1851 (detail).

above 101. The scene of the Duke's death as imagined by Sir John Gilbert, engraved by Joseph Lionel Williams for the *Illustrated London News*, 1852.

then oak, and finally mahogany, covered in red velvet. The funeral carriage was conceived under the supervision of Henry Cole by the Government School of Design, the forerunner of the Royal College of Art. It was made in eighteen days and weighed over eighteen tons.

The state funeral was held on 18 November 1852 (**103**). The procession was made up of eight squadrons of cavalry, six battalions of infantry, sixteen regimental bands, and one captain, one subaltern, one sergeant, one corporal and six men from every regiment in the British Army. It began at Whitehall, moved up the Mall, passed Buckingham Palace, and then Apsley House. Along

opposite 102. Marble bust by George Gammon Adams, based on the death mask he had taken (p. 120), 1852.

above 103. The procession of the state funeral, shown by Louis Hague at Hyde Park Corner between Apsley House (on the left) and the Wellington Arch with the Duke's statue in position, published as a lithograph by Ackermann (detail).

Piccadilly, it turned down St James's Street and left into Pall Mall, crossed Trafalgar Square and processed along the Strand, Fleet Street, and up Ludgate Hill to St Paul's Cathedral, where the Duke was buried. Louis Hague painted a series of watercolours of the event, which were lithographed and published by Ackermann a few months later (103).

In the weeks following the state funeral, a number of cities which did not yet have statues of Wellington moved to rectify the gap. Manchester commissioned Matthew Noble, Leeds commissioned Carlo Marochetti, and Norwich commissioned George Gammon Adams. When the gigantic equestrian statue that Matthew Cotes Wyatt had made in 1846 for the Wellington Arch was moved to Aldershot, a smaller statue to replace it was commissioned from Joseph Boehm. Placed on Hyde Park Corner facing the portico of Apsley House, it was unveiled in 1888.

For the Royal Gallery in the new Palace of Westminster a giant mural was commissioned from the artist Daniel Maclise, depicting Wellington meeting Blücher at the end of the Battle of Waterloo. The cartoon was shown to the Prince Consort in June 1858. The mural, some 3.5 metres high and 14.5 metres long, was displayed to the public in March 1862. It was and is considered a masterful image of the aftermath of the Battle of Waterloo.

After the Duke's death, the tenants and labourers at Stratfield Saye subscribed to a memorial to be placed at the east lodges of the Park, and addressed the 2nd Duke:

> We represent the Tenants, Farmers, Servants, and Labourers, and School Children, most of whom have passed the greater portion of our lives on your Grace's property, and, under God's blessing, have participated in the advantages afforded to us by a great, liberal, and just landlord and master. We are desirous of handing down to posterity a Testimonial of our admiration and gratitude.

The 2nd Duke replied:

> While history records those glorious deeds to which the country is indebted for imperishable renown . . . this Monument will attest that we are each individually suffering under a personal loss . . . you have lost a friend who brought into the relations of domestic life the breeding of a politer age . . . you can give a denial to the adage that 'No man is a hero to his servant.'[71]

The monument took the form of a bronze statue by Marochetti of the Duke in military uniform, raised up on a Corinthian column (104, 105). The work was completed in 1863.

In 1856 a competition was held for a monument of the Duke to be placed on the north side of the nave in St Paul's Cathedral. Those who took part

above and opposite 104, 105. The bronze statue by Carlo Marochetti on a column at Stratfield Saye, 'Erected by Arthur Second Duke of Wellington and by the servants and labourers on the estates of his father as a token of their affection and respect 1863'.

opposite 106. The monument to the Duke of Wellington in the nave of St Paul's Cathedral.

included John Bell, John Henry Foley, John Gibson, William Calder Marshall, Matthew Noble, Edgar George Papworth, John Thomas and William Frederick Woodington. The winner was Calder Marshall and the runner-up Woodington, but the Commissioners gave the contract to Alfred Stevens, with a cost limited to £20,000. He conceived a monument based on a tall white marble triumphal arch, sheltering a bronze figure of Wellington on a sarcophagus, with allegorical figures, and topped by a bronze equestrian statue of the Duke. The sum proved to be inadequate, and Stevens died in 1875 leaving the monument unfinished. It was completed by a pupil, Hugh Stannus, and the equestrian statue was realised by John Tweed. The completed memorial was finally installed in 1912, sixty years after the Duke's death.

In 1852, before the funeral, Tennyson, the poet Laureate, wrote the moving and fitting epitaph, of which these are extracts:

> BURY the Great Duke
> With an empire's lamentation,
> Let us bury the Great Duke
> To the noise of the mourning of a mighty nation
> . . .
> And let the mourning martial music blow;
> The last great Englishman is low.
> . . .
> No more in soldier fashion will he greet
> With lifted hand the gazer in the street.
> . . .
> Our greatest yet with least pretence,
> Great in council and great in war,
> Foremost captain of his time,
> Rich in saving common-sense
> . . .
> Such was he whom we deplore.
> The long self-sacrifice of life is o'er.
> The great World-victor's victor will be seen no more.
> . . .
> Truth-lover was our English Duke
> . . .
> Him who cares not to be great,
> But as he saves or serves the state.
> Not once or twice in our rough island-story,
> The path of duty was the way to glory
> . . .
> But speak no more of his renown,
> Lay your earthly fancies down,
> And in the vast cathedral leave him . . .

Notes

[1] Lord Wellesley to the Duke of Wellington, 20 March 1841. Stratfield Saye Archive.

[2] William Hickey, *Memoirs*, ed. A. Spencer, IV (London 1925), pp. 304–5.

[3] J. W. Croker, *The Croker Papers*, II (London 1884), p. 233, 1 October 1834.

[4] Letter from Sir John Malcolm to Sir Arthur Wellesley, 3 February 1804. BL, Add. Ms. 13747, f. 32.

[5] For the chronology of the Goya portraits of Wellington I am endebted to Manuela Mena, Chief Curator of 18th-Century Art and Goya at the Prado, Madrid.

[6] *The Private Journal of Judge-Advocate Larpent: attached to the Head-quarters of Lord Wellington during the Peninsular War, from 1812 to its close*, ed. Sir G. Larpent (London 1854), p. 278. 'Lord Wellington and all his staff lost their way, and were five hours exploring two leagues home in the rain and dark, after various perils. It was a tremendous night. Mr. Heaphy, the artist, who is now here, was nearly being involved in my scrape, and it is said he has, in consequence of these risks, added ten guineas to the price of his likenesses, and made them fifty guineas instead of forty guineas. This is too much for a little water colour whole length; but he has, I hear, now taken twenty-six, and some excessively like.'

[7] *The Dispatches of Field Marshal the Duke of Wellington During his Various Campaigns in India, Denmark, Portugal, Spain, the Low Countries, and France*, ed. John Gurwood, XII (London 1838), p. 66.

[8] ibid., p. 69.

[9] *The Diary of Joseph Farington*, ed. K. Cave, VII (London 1982), p. 263, 6 July 1814.

[10] ibid., XIII (London 1984), p. 4563, 23 July 1814. 'Col. McMahon had called on Lawrence and represented the propriety of the Prince Regent having the portrait of the Duke ... claimed by Lord Stewart, but Lawrence got over this difficulty.'

[11] C. Oman, *The Gascoyne Heiress: The Life and Diaries of Frances Mary Gascoyne-Cecil, 1802–39* (London 1968), p. 109, entry of 22 January 1834.

[12] *Sir Thomas Lawrence's Letter-Bag*, ed. G. S. Layard (London 1906), p. 99.

[13] W. R. A. Geo. 266421, as read in O. Millar, *The Later Georgian Pictures in the Collection of Her Majesty the Queen* (London 1969), pp. 77–78.

[14] *The Diary of Joseph Farington*, cit. at n. 9, VIII, p. 5.

[15] *The Diary of Frances, Lady Shelley, 1787–1817*, ed. R. Edgcumbe, I (London 1912), p. 117.

[16] *Supplementary Despatches and Memoranda of Field-Marshal Arthur Duke of Wellington, K.G.*, ed. the 2nd Duke of Wellington, X, March–July 1815 (London 1863), p. 531.

[17] Copy of a memorandum from the Duke, 9 May 1817. *A Selection from the Private Correspondence of the First Duke of Wellington*, ed. the 7th Duke of Wellington (London 1952), p. 158.

[18] Royal Academy Archive, LAW/2/201.

[19] *A Selection from the Private Correspondence of the First Duke of Wellington*, cit. at n. 17, p. 158.

[20] Royal Academy Archive, LAW/2/307.

[21] Letter from Lawrence to John Julius Angerstein, 6 August 1818, quoted in J. T. Whitley, *Art In England* (New York 1973), p. 288.

[22] Letter from the Duchess to Lawrence, Mont St Martin, 8 July 1817. Royal Academy Archive, LAW/2/211.

[23] *The Diary of Joseph Farington*, cit. at n. 9, VIII, p. 173.

[24] Letter from the Duke to Mrs Harriet Arbuthnot, 18 November 1820 (letter 59). Stratfield Saye Archive.

[25] ibid., 15 December 1820 (letter 64). Stratfield Saye Archive.

[26] Letter from the Duke to the Duchess of Northumberland, 13 May 1837. Stratfield Saye Archive. A miniature by George Raphael Ward was recently acquired for the Family Collection at the Raglan Collection sale, Christies, 22 May 2014, lot 77 (see Ill. 106).

[27] Letter from the Duchess to Lawrence, 9 October 9 1822. Stratfield Saye Archive.

[28] Letter from the Duke to the Duchess, 17 March [1824]. Stratfield Saye Archive.

[29] Letter from the Duchess to the Duke, 18 March 1824. Stratfield Saye Archive.

[30] *The Journal of Mrs. Arbuthnot 1820–1832*, ed. F. Bamford and the 7th Duke of Wellington, I, February 1820–December 1825 (London 1950), p. 156.

[31] Letter from the Duke to Lady Shelley, 1 March 1825. *The Diary of Frances, Lady Shelley*, cit. at n. 15, II, pp. 124–25.

[32] Letter from the Duke to Lady Shelley, 7 April 1825. Ibid., p. 125.

[33] *The Journal of Mrs. Arbuthnot*, cit. at n. 30, II, p. 347.

[34] An account is in *The Richmond Papers, from the Correspondence and Manuscripts of George Richmond, R.A., and his Son Sir William Richmond, R.A., K.C.B.*, ed. A. M. W. Stirling (London 1926), 5 March 1845.

[35] Oman, *The Gascoyne Heiress*, cit. at n. 11, pp. 165–66.

[36] The Duke to James Stuart-Wortley-Mackenzie, 1st Lord Wharncliffe, 14 February 1834. Stratfield Saye Archive.

[37] Letter from Henry Perronet Briggs to Lord Wharncliffe, 19 August 1836. Stratfield Saye Archive.

[38] Letter from James Cocker to the Duke, Barnsley, 4 May 1839. Stratfield Saye Archive.

[39] Haydon, *The Autobiography and Memoirs of Benjamin Robert Haydon*, ed. T. Taylor (London 1926), p. 581.

[40] Letter from John Lilley to the Duke, 4 October 1836. Stratfield Saye Archive.

[41] Letter from the Duke to Priscilla, Lady Burghersh, 30 November 1836. *Correspondence of Lady Burghersh with the Duke of Wellington*, ed. Lady Rose Weigall (London 1903), p. 83.

[42] ibid., 4 December 1836, p. 84.

[43] ibid., 8 December 1836, p. 85.

[44] Oman, *The Gascoyne Heiress*, cit. at n. 11, pp. 165–66, 218.

[45] Letter from the Duke at Walmer Castle to Lady Burghersh, 3 November 1836. *Correspondence of Lady Burghersh*, cit. at n. 41, p. 80.

[46] Quoted in a letter from Basil Hall, James Hall's brother, to Cadell, 17 May 1830. National Library of Scotland, MS 21007, f. 200. See also S. Smailes, 'Thomas Campbell and the "camera lucida": the Buccleuch statue of the 1st Duke of Wellington', *Burlington Magazine*, vol. 129, no. 1016 (November 1987), p. 713.

[47] *The Wellington Military Memorial, Memorial of the Military Achievements of His Grace the Duke of Wellington*, 1837, bound book with list of all subscribers, with amounts given. Family Collection.

[48] Letter from Queen Victoria to the Duke, Buckingham Palace, 12 July 1847. Stratfield Saye Archive.

[49] Letter from the Duke to Queen Victoria, London, 12 July 1847. Stratfield Saye Archive.

[50] For Haydon's account, see Haydon, *Autobiography*, cit. at n. 39, p. 659. Haydn arrived at Walmer on 11 October.

[51] Letter from the Marquess of Anglesey to the Duke, Beau Desert, 27 November 1840. Stratfield Saye Archive.

[52] Letter from the Duke to Lord Anglesey, Stratfield Saye, 8 December 1840. Stratfield Saye Archive.

[53] Letter from the Duke to Lucas, Stratfield Saye, 20 December 1840. Stratfield Saye Archive.

[54] *Correspondence of Lady Burghersh with the Duke of Wellington*, cit. at n. 41, p. 141.

[55] Petition to the Duke from the Committee for the Glasgow statue, 4 April 1840. Stratfield Saye Archive.

[56] Letter from the Duke to Mr Dalglish, Convener [*sic*] of the Glasgow Monument Committee, 3 May 1842. Stratfield Saye Archive.

[57] Letter from the Duke to Lord Dalhousie, 28 June 1841. Stratfield Saye Archive.

[58] Letter from Lord Dalhousie to the Duke, 2 July 1841. Stratfield Saye Archive.

[59] Letter from the Duke to Lord Dalhousie, 6 July 1841. Stratfield Saye Archive.

[60] Letter from Charles Arbuthnot to the Duke, Woodford, 1 June 1841. Stratfield Saye Archive

[61] *Correspondence of Lady Burghersh with the Duke of Wellington*, cit. at n. 41, p. 148.

[62] Haydon, *Autobiography*, cit. at n. 39, pp. 770–71.

[63] M. Sadleir, *Blessington D'Orsay* (Bristol 1833). See also Gerald Wellesley and John Steegmann, *The Iconography of the First Duke of Wellington* (London 1935), p. 9.

[64] Letter from the Duke to Angela Burdett-Coutts, 8 February 1847. Stratfield Saye Archive.

[65] Oman, *The Gascoyne Heiress*, cit. at n. 11, p. 280.

[66] Letter from Angelo C. Hayter to the 3rd Duchess of Wellington, 1 June 1897. Stratfield Saye Archive.

[67] ibid.

[68] Letter from Lady Charles Wellesley to Lady Salisbury, 14 September 1852. Stratfield Saye Archive.

[69] E. Healey, *Lady Unknown: The Life of Angela Burdett-Coutts* (London 1978), p. 113.

[70] Letter from Adams's daughter to the 3rd Duchess of Wellington. Stratfield Saye Archive.

[71] From a transcription of the Deputation presented by a Mr Porcher, 3 March 1853, and the 2nd Duke's reply. Family Collection.

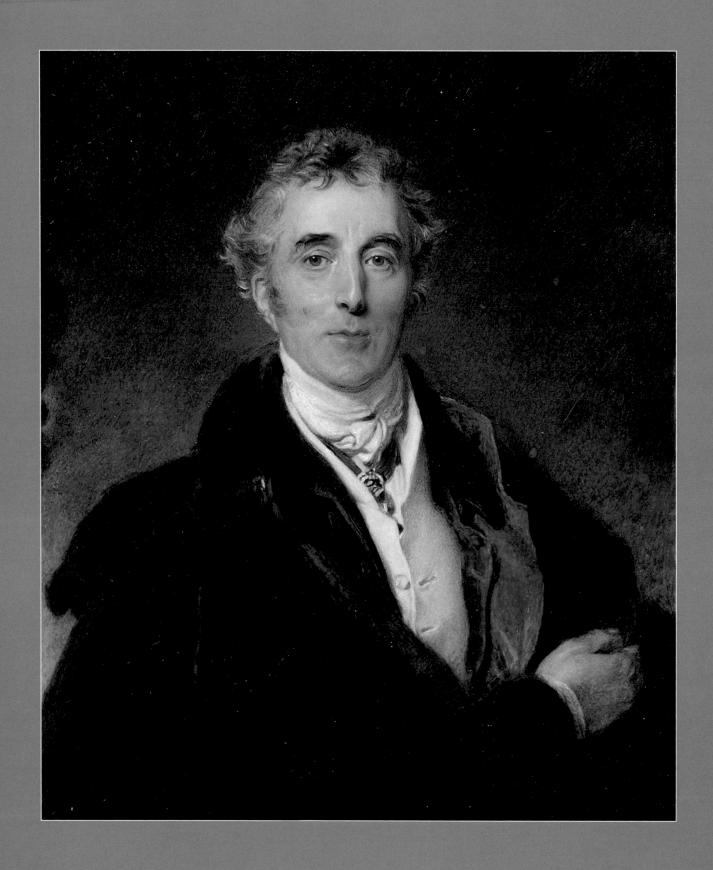

CATALOGUE

Artists appear in alphabetical sequence, and within the entries works are arranged chronologically. Date, medium, and dimensions are given where known. Unless otherwise stated, the medium is oil on canvas, and drawings and prints are on paper. 'Present whereabouts unknown' indicates that it has not been possible to trace a work since its inclusion in the *Iconography*. 'Family Collection' indicates works that belong to the family. 'Wellington Collection, Apsley House' signals works gifted to the nation in 1947 by Gerald Wellesley, 7th Duke of Wellington.

The letters R and L indicate directions in relation to the spectator.
d. = diameter, h. = height, FL= full-length, HL= half-length, TQL= three-quarter-length.

ARA	Associate of the Royal Academy
BM	British Museum, London
BI	British Institution
GAC	Government Art Collection
RA	Royal Academy of Arts, Royal Academician
RCT	Royal Collection Trust
RI	Royal Institution
RSA	Royal Scottish Academy
NPG	National Portrait Gallery, London
NGL	National Gallery, London
SBA	Society of British Artists
V&A	Victoria and Albert Museum, London

107. Miniature of Wellington by George Raphael Ward, 1828, after a portrait by Lawrence (see p. 179).

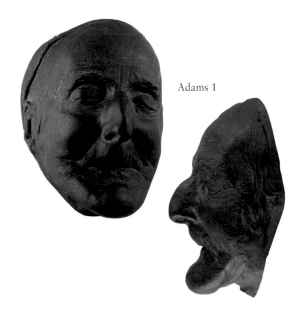

Adams 1

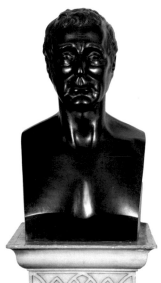

Adams 3

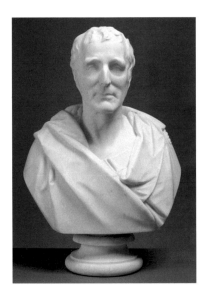

Adams 4

ADAMS, GEORGE GAMMON
1821–98

Studied at the RA Schools from 1840 as both sculptor and medallist.
His work was shown at the Great Exhibition in 1851.

1. Family Collection

Bronze, 1852, 25.5 × 17 cm. From the death mask made three days after the
Duke's death, after his false teeth had been removed. There are several replicas in
bronze and plaster of the death mask. A version was presented to the RI by
the 2nd Duke of Wellington on 18 June 1860 and another cast was sold at
Sotheby's on 22 July 1988.

2. Family Collection, on loan to London District, Horse Guards

Marble bust, signed and dated 'G. G. Adams, Sc., London, 1852', h. 67.5 cm.
Full-face, neck and chest bare. Executed from the death-mask taken by the
sculptor (No. 1).

Examples of this bust with bare chest are in the RCT (bought by Queen
Victoria and Prince Albert in 1853), in Burghley House, and in the V&A. A
further example, inscribed 'The gift of the Duke of Wellington to Lt. Gen. Sir
Thomas Brotherton, August 22nd 1857', belongs to Hampshire County Council.

A smaller version, signed and dated, is also in the Family Collection.

3. Family Collection

Bronze bust, signed, life-size. Taken from the original bust (No. 2). Another
bronze is in the V&A.

4. British Embassy, Brussels (Government Art Collection)

Marble bust, 1852, h. 75 cm. Shoulders draped. Purchased by the GAC in 1950.
This or another was formerly in the collection of the Earl of Ellesmere.

5. The Close, Norwich

Bronze statue, 1854, life-size. FL, standing, with cloak. On a plinth decorated
with regimental colours and coat of arms. Inscribed on the base 'WELLINGTON'.

6. Wellington Collection, Apsley House, London

Marble bust, 1859, h. 77.5 cm. Head turned slightly to the L, shoulders draped.
There is a replica in the GAC. Other replicas were sold at Sotheby's,
28 November 1973, lot 208, and Christie's, 14–16 May 1997, lot 47.

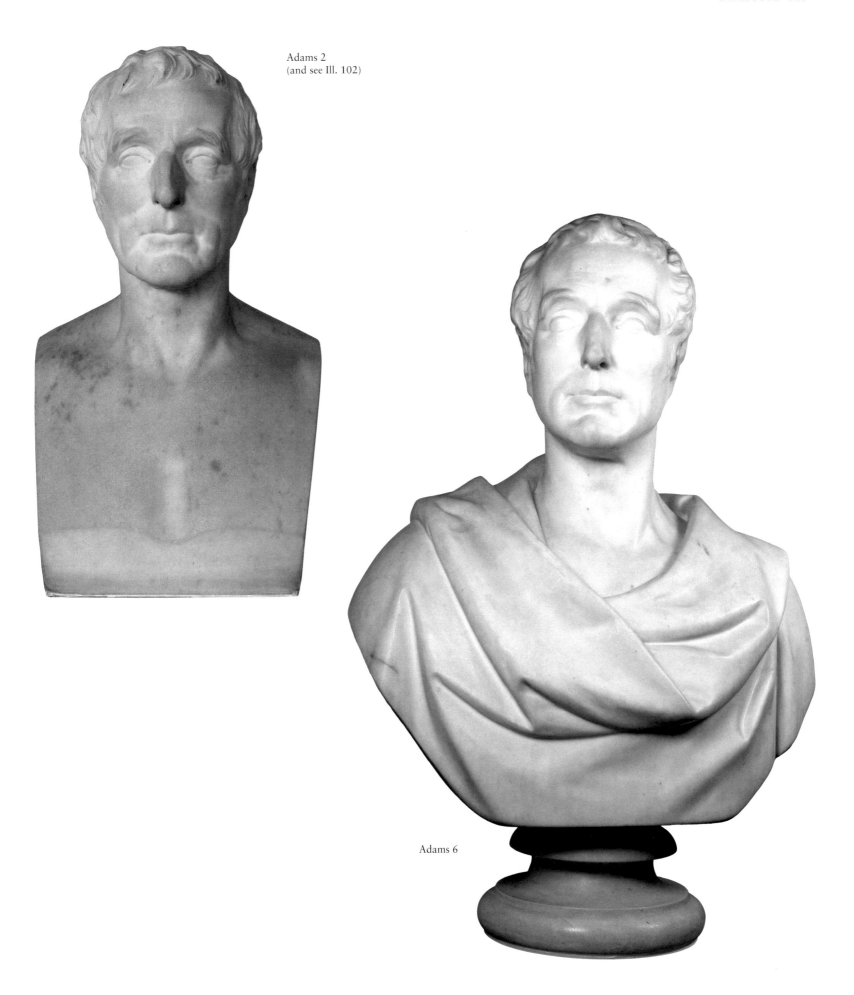

Adams 2
(and see Ill. 102)

Adams 6

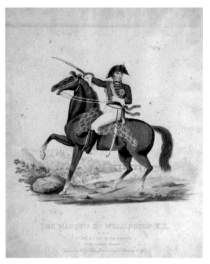

Aglio 1

Amatucci 1

Amatucci 2

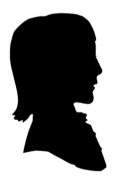

Anonymous 1
(and see Ill. 14)

AGLIO, AGOSTINO
1777–1857

Born in Cremona, studied at the Brera Academy, and travelled to Rome.
He came to England in 1803 to assist the architect William Wilkins,
and painted decorations for many theatres, churches and country houses.
Between 1820 and 1830 he published several books on art.

1. Family Collection

Engraving after Aglio by H. S. Minasi, published in 1812. FL, equestrian,
riding to the L, in military uniform with Order of the Bath, sword in his
right hand.

Another engraving, by J. Quilley, was published in 1813.

AMATUCCI, CARLO
fl. 1804–14, d. 1819

An Italian medallist working mainly in Lisbon, but Wellington sat to him in Spain.

1. Family Collection

Wax relief, signed 'Carlo Amatucci fecit', c. 1812, d. 5.7 cm. In profile to the L.
Order of the Golden Fleece and other orders. This miniature served as a model
for multiple likenesses of the Duke. Bought by the 7th Duke of Wellington.
There is another version in the Metropolitan Museum of Art, New York.

Engraved by Samuel Freeman and by Charles Middlemist in 1814.
An impression of the Freeman engraving is in the Family Collection.

2. Family Collection

Wax relief, 1813, d. 7.5 cm. In profile to the R. With the Order of the Golden
Fleece and a sash of another order. Inscribed 'PENINSULAE UNIONIS INVICTUS
DEFENSOR 1813' (The unvanquished defender of the union of the Peninsula).

ANONYMOUS
1. Family Collection

Silhouette on paper, c. 1780, 5 × 3 cm. Head in profile to the R. Inscribed
on the back in handwriting believed to be that of Anne, Countess of
Mornington: 'Arthur, now Duke of Wellington', with an illegible date.
Also, in the handwriting of Lady Charles Wellesley, 'Arthur Wellesley, 1st Duke
of Wellington'.

2. Family Collection

Miniature, 1787, h. 7 cm. HL, to the R, in the uniform of the 76th Regiment of Foot. This could be by Walter Robertson, an Irish portraitist (*c.* 1750–1802).

3. Family Collection

71 × 57 cm. HL, to the L, in military uniform with right hand in jacket. Wearing sash and Grand Cross of the Order of the Bath, Order of the Garter, and Army Gold Cross, no clasps. An inscription on the reverse reads 'Un tableau buste de Milord Duc de Wellington Paris 20 Août, 1816'.

4. Family Collection

Multiple edition bronze bust, 1840, h. 23 cm. Produced by Berens, Blumbery & Co., who sent this example to the Duke on 18 June 1840.

AUTISSIER, LOUIS-MARIE
1772–1830

French-born Belgian portrait miniaturist, considered by many to be the founder of the Belgian school of miniature painting. Court Painter to King William I of the Netherlands. He painted Wellington and his wife in Paris. By the time the artist died he had painted over 250 miniatures. A miniature of the Duke by Autissier was exhibited at the Ghent Salon in 1824, no. 107.

1. Formerly the Hon. Mrs Dudley Ward, London.
Present whereabouts unknown

Miniature on ivory, signed and dated 1816. Head and shoulders slightly to the L. The 7th Duke had seen this, and described the subject as being in scarlet uniform. The star of the Order of the Garter, Order of the Bath, and badge of the Order of the Golden Fleece are seen. The Hon. Mrs Dudley Ward was the step-granddaughter of Colonel Gurwood, the Duke's private secretary (see Morton, No. 5).

Another version, signed and dated 1818, h. 6.5 cm, was sold at Sotheby's, 24 November 1983, lot 363. Present whereabouts unknown.

2. Formerly Mme David (née Charrier), Vannes, Morbihan.
Present whereabouts unknown

Miniature on ivory, *c.* 1816. Head and shoulders slightly to the L, in uniform with the star of the Order of the Garter, the Order of the Golden Fleece and badge of Knight of the Bath. In the background a curtain and the base of a column. Exh. Brussels Salon 1816, no. 1, as 'Portrait d'un illustre Général'. Reproduced in Lucien Lemaire, *Autissier miniaturiste* (Lille 1912), p. 75.

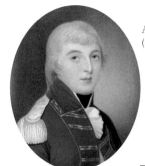

Anonymous 2 (and see Ill. 15)

Anonymous 3

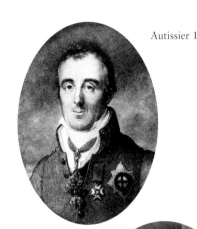

Anonymous 4

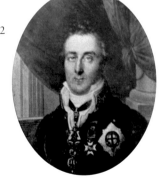

Autissier 1

Autissier 2

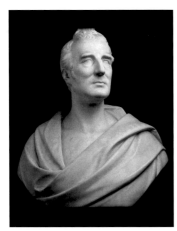

Baily 1

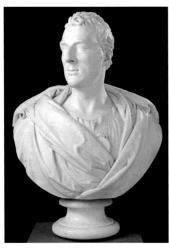

Baily 2

Baily 3

BAILY, EDWARD HODGES, RA
1788–1867

Sculptor, born in Bristol. From 1804 he spent seven years in John Flaxman's studio, working with him on designs for goldsmiths' work and monuments. In 1809 he entered the RA Schools. In 1817 he became ARA and in 1820 RA. He produced busts and statues of major figures of his day.

1. The Parliamentary Art Collection
Marble bust, signed 'E. H. Baily, R.A.', 1829–30, h. 79 cm. Head turned to the R, in Classical dress. Bought by the 7th Duke in 1954 and presented to the House of Lords in 1964.

2. Tate Britain, London
Marble bust, *c.* 1828–30, h. 79 cm. After the Nollekens of 1809 (q.v.).

3. Family Collection
Bronze statuette, 1844, h. 52.5 cm. FL, equestrian, in long overcoat with top hat in his right hand. Another version was sold at Sotheby's, 20 November 1997, lot 120.

BARKER, THOMAS JONES
1815–82

Son of the painter Thomas Barker ('Barker of Bath'). He trained first under his father, then moved to Paris in 1834 to train under Horace Vernet. In Paris he exhibited frequently at the Salon between 1835 and 1845, and painted several portraits for Louis-Philippe. In 1845 he returned to England and became a regular contributor to the RA.

1. Family Collection
The Bridge at Sorauren, signed, 87.5 × 105 cm. Wellington, accompanied by Lord Fitzroy Somerset, is shown composing orders. This commemorates an incident when he was nearly captured by French dragoons at the Battle of Sorauren. Acquired by the 2nd Duke. Exhibited at the NPG in 1866.

2. National Army Museum, London
Wellington at Sorauren, 27 July 1813, *c.* 1853, 129 × 99 cm. Wellington is depicted on horseback being led through a mountain pass to the village of Sorauren by two local guides. He is followed by Lord Fitzroy Somerset and members of his staff.

A larger version of this work (234 × 297 cm), signed and dated 'T. Jones Barker / 1854', is in the Family Collection (2a).

An engraving, with figures by William Greatbach and landscape by Robert Wallis, was published in 1858.

3. Family Collection

Study for *An Incident at the Battle of Waterloo*, 52.8 × 42.5 cm. FL, equestrian, in blue coat and cloak, hat extended. The finished painting is now in a private collection.

4. Private Collection

The Meeting of the Duke of Wellington and Field-Marshal Blücher on the Evening of the Victory of Waterloo at the Belle Alliance.

An engraving by Charles E. Lewis is in the Family Collection (4a).

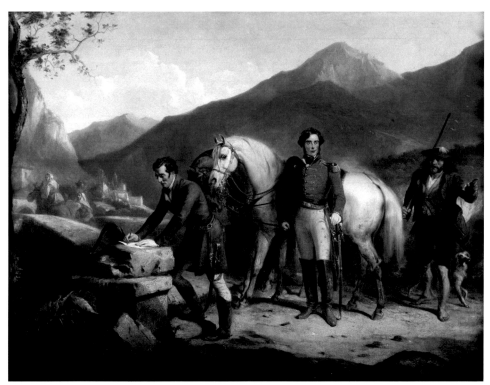

Barker 1

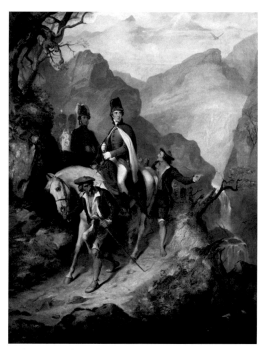

Barker 2a (and see Ill. 23)

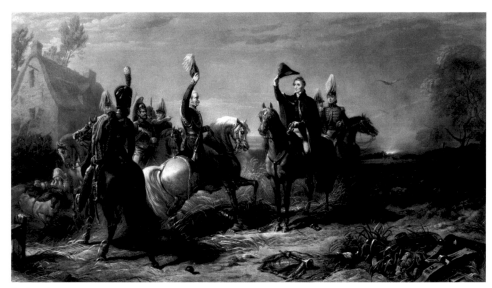

Barker 4a

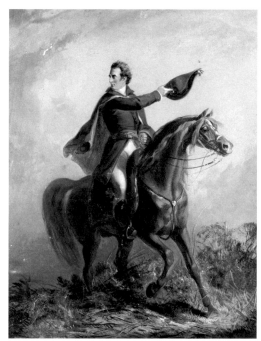

Barker 3

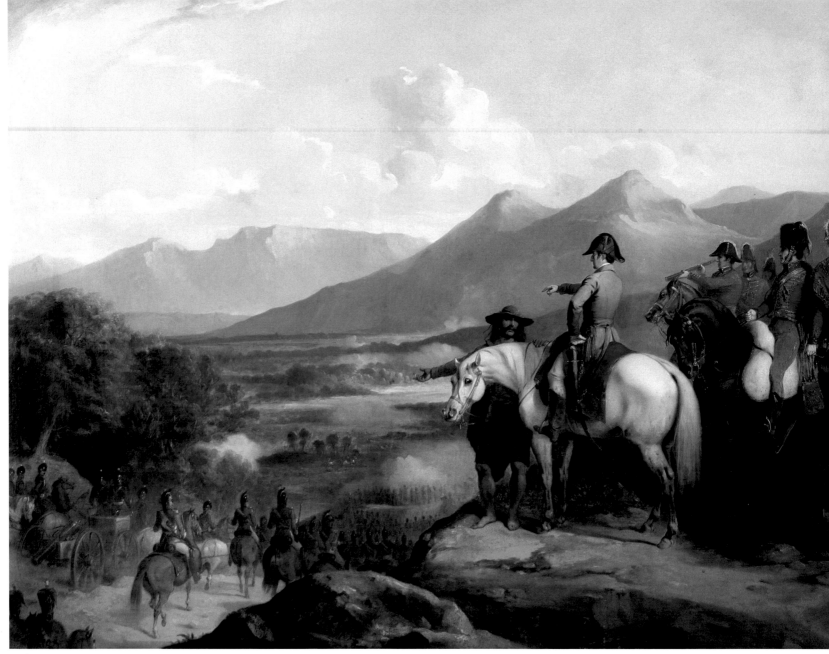

Barker 5

Barker 6 (and see Ill. 8)

5. Joint Services Command and Staff College, Shrivenham
The Battle of Vitoria 21 June 1813, 100.2 × 134 cm. Wellington
is shown, in blue coat and hat, accompanied by his staff overlooking the
battlefield.

6. Family Collection
Wellington Reading the Indian Dispatches, 1846, 44.5 × 33.5 cm. The Duke
is shown in old age in the Library at Apsley House, seated and bespectacled.
A portrait of Napoleon can be seen behind on the R. The Duke must have given
a sitting, as the chair, made from the 'Waterloo Elm', is accurately painted, as is
the desk.

An engraving by Frederick Bacon was published in 1854.

BAUZIL, JUAN
1766–1820

Born in Mallorca, he came to Madrid in 1797. He was Court Painter to the Spanish kings Charles IV and Ferdinand VII.

1. Formerly W. R. C. Stowe, New Zealand. Present whereabouts unknown
Miniature on ivory, signed and dated 1812, 7 × 5 cm. Head and shoulders to the R, wearing the uniform of a Spanish captain-general, with the Order of the Golden Fleece and other orders. Exh. Chelsea Military Exhibition 1890, no. 847a, and Guelph Exhibition 1891, no. 1193. Listed in Richard Walker, *Regency Portraits*, I, p. 527, as being in the Wellington Club in New Zealand, but no longer there.

2. National Portrait Gallery, London
Watercolour, *c*. 1812–16, 33 × 24.8 cm. FL, standing, to the R, wearing a dark blue civilian greatcoat and grey breeches, bareheaded. Landscape background. Presented to the gallery in 1870.
 Engraved by Charles Turner, 1816. An impression is in the Family Collection.

3. Family Collection
Miniature on ivory, signed and dated 'J. Bauzil 1814', 7 × 6.3 cm. Head and shoulders, slightly to the R, in a blue coat with embroidered red collar, wearing the Order of the Golden Fleece, star of the Order of the Garter, and Large Army Gold Medal.

4. Duke of Beaufort, Badminton
Miniature, 1816, 8.3 × 7.6 cm. HL, similar to No. 3 but without the Large Army Gold Medal. There is a copy on porcelain in the Family Collection, given to Lady Shelley when she stayed at Stratfield Saye in December 1836.

5. Original painting untraced. Prints in the British Museum, London, and in the Family Collection (5a)
Mezzotint after Bauzil by Charles Turner, 1816, 55.7 × 40.4 cm. TQL to the R, in dark coat, holding the hilt of his sword in his left hand. Inscribed 'From an original Picture by Bauzil, Painter to His Catholic Majesty. Madrid . . .'

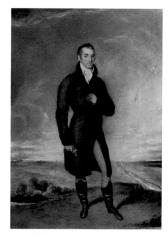
Bauzil 2

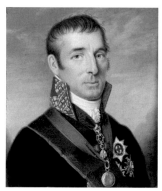
Bauzil 3 (and see Ill. 32)

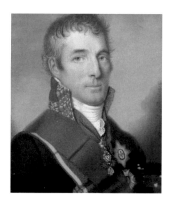
Bauzil 4

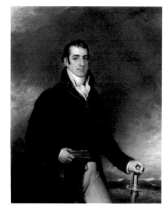
Bauzil 5a

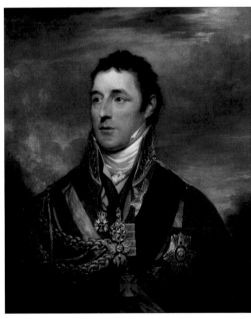

Beechey 1a

Beechey 1b (and see Ill. 5)

BEECHEY, SIR WILLIAM, RA
1753–1839

Painter. He entered the RA Schools in 1774. In 1793 he was elected ARA and became Portrait Painter to Queen Charlotte. In 1798 he painted *George III and the Prince of Wales Reviewing Troops*, for which he was made RA and was knighted. That was the only painting to be destroyed in the 1992 fire at Windsor Castle.

1. Original painting untraced

1814. Nearly HL, head to the L, wearing field-marshal's uniform with the Order of the Golden Fleece, the Military Order of the Sword of Sweden, the Order of the Tower and Sword, and the Army Gold Cross with four clasps. The painting was commissioned by Lord Beresford and recorded in Beechey's account book. It was at Bedgebury Park in Kent until the house and contents were sold in 1919. It appeared for sale at Christie's in April 1928, but has since disappeared.

The BM has a preparatory drawing as well as two impressions of the engraving by William Skelton, published in 1814 (1a). The portrait was also engraved by H. Meyer in 1817, after a drawing by John Jackson.

A high quality copy is in the Heckscher Museum of Art, Huntington, N.Y. (76.2 × 63.5 cm) (1b).

BEHNES, WILLIAM
1795–1864

Sculptor. Born in London, he spent his early life in Dublin, and trained in the Academy there. Returning to London, he enrolled in the RA Schools in 1813, and exhibited at the RA from 1815 onwards. In 1837 he became Sculptor in Ordinary to Queen Victoria. Behnes is said to have helped D'Orsay (q.v.) with his bust and equestrian statuette of the Duke. Rupert Gunnis also notes busts shown at the RA in 1853, no. 1364, and 1855, no. 1520, both untraced (Gunnis, *Dictionary of British Sculptors*, p. 96).

1. Formerly the King of Prussia, Schloss Charlottenburg, Berlin. Destroyed

Monumental marble bust, executed in 1851 for the King of Prussia. There is no evidence that it was *ad vivum*. The *Spectator* on 1 November 1851 signalled its display in London before its dispatch: 'A truly admirable head of the Duke, whether considered as a likeness or as a work of art, has been recently completed by Mr. Behnes . . . We know of no work, whether pictorial or in sculpture, which, without sacrifice of individual truth, conveys so elevated, accurate, and complete a notion of the Duke as he is. The King of Prussia may well congratulate himself on his acquisition.' It was moved to the depot of Schloss Charlottenburg in 1910. The depot was hit by Allied bombs in 1943, and no trace of the bust has been found since that time.

2. Castle Complex, Hampshire County Council, Winchester

Marble bust. Facing front, bare-chested. Formerly in the County Buildings.

BONE, HENRY, RA
1755–1834

Enamel painter, employed continuously by George III, George IV and William IV. His early career was in porcelain and jewellery painting. From 1780 he exhibited large-scale, often historical, enamel miniatures at the RA. He was elected ARA in 1801 and RA ten years later. One of his sons was fatally wounded at the Battle of Toulouse in 1814.

1. The Ethelston Collection

Enamel miniature, after Hoppner (q.v., No. 1). HL, to the L, in the uniform of a lieutenant-colonel of the 33rd Regiment. Inscribed on the back 'HS', and traditionally thought to have been given by Arthur to Henrietta Smith, whom he met on the voyage to India, but it seems more likely that it was made at a later date.

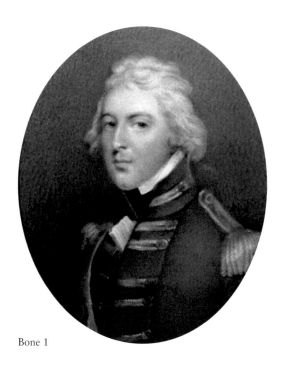

Bone 1

BRIGGS, HENRY PERRONET, RA
1793–1844

Pupil at the RA Schools in 1811, and contributor to the Summer Exhibitions from 1814 until his death. Elected ARA in 1811 and RA in 1832. Thereafter he focused on portraiture rather than history painting.

1. Charterhouse, London

c. 1837, 106.7 × 81.3 cm. TQL, slightly to the R, arms folded. Wearing a dark blue uniform, with Order of the Golden Fleece and Waterloo Medal. Exh. RA 1837.

Versions are in the Palace of Westminster, the Cavalry and Guards Club in London, Wellington College, the National Galleries of Scotland, the British Embassy in Brussels, and the Beaverbrook Art Gallery at Fredericton, New Brunswick. A number of other versions are recorded, but are now untraced. One was sold at Sotheby's on 12 June 2003. That version, commissioned by Winthrop Praed (a political supporter of the Duke), includes a table in the background with an inkstand and a fragment of a letter with the Duke's signature pasted onto the canvas. One was formerly in the collection of the 1st Earl Cowley. One was commissioned by Lord Wharncliffe and completed just before Briggs's death in 1846, appearing in the posthumous sale of his works. Formerly at Wortley Hall, Sheffield, it was sold at Lawrence's Auctioneers, 22 February 1996, lot 5. Lord Wharncliffe also commissioned a version on behalf of Barnsley. It is known that this was hanging in the Town Hall in 1839 and had been registered as 'the property of the town', but it cannot now be found.

A further example of this type, but without the Waterloo Medal, 91.4 × 71.1, was in the possession of Mr Millet of Leicester in 1935.

There are copies in the GAC and in the Guernsey Museums and Galleries.

Engraved by H. T. Ryall and by J. J. Wedgewood, 1841.

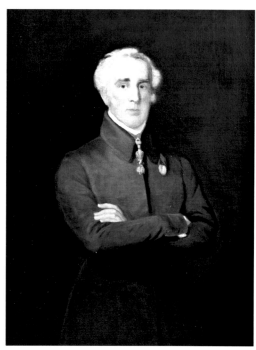

Briggs 1 (and see Ill. 78)

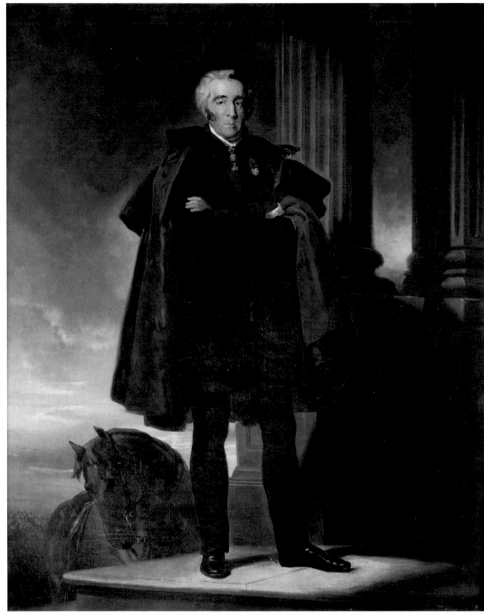

Briggs 2 (and see Ill. 80)

Briggs 3a

2. Family Collection

1840, 178 × 127 cm. Commissioned by the Earl of Eldon. FL, seated, to the R, in robes of Chancellor of the University of Oxford. In the background a column, and a scroll with a poem and Wellington's signature. The poem is by Joseph Arnould, who won the Newdigate Prize for English verse in 1834. On 11 June that year he read out his poem at the inauguration of the Duke as Chancellor. Purchased by the 7th Duke in 1947 at the Lord Winchilsea sale. A copy is in the RCT.

Engraved by George Henry Phillips, 1840. An impression is in the Family Collection.

3. Cutlers' Hall, Sheffield

c. 1840, 84 × 60 cm. FL, to the R, standing on the steps of a building with columns to the R and a horse in the mid-ground. Wearing military cloak, with Order of the Golden Fleece, his arms folded. Placed in Cutlers' Hall in 1842/43. A small copy is in the Family Collection (3a).

A mezzotint by Thomas Goff Lupton was published on 12 August 1840, of which an impression is in the NPG. An engraving by H. T. Ryall, Engraver to the Queen, was published in 1842.

BUCK, ADAM
1759–1833

Irish painter, born in Cork. He began painting portraits at a young age. He settled in London in 1795, and showed as many as 171 pictures at the RA during his lifetime. He also exhibited at the BI and the SBA. He focused on portraiture in watercolour, but also painted larger works in oil. Many of his portraits were reproduced as stipple engravings.

1. National Portrait Gallery, London

Etching, published in April 1829, 25.1 × 21.6 cm (plate). HL, seated, to the L, his right hand on a rolled document inscribed 'Catholic Relief Bill'. This is attributed to Buck from its close resemblance to a series of political portraits drawn from life and published by him.

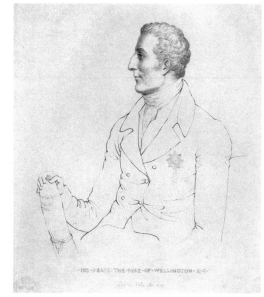

Buck 1

BURGES (or BURGESS)
No details known

In November 1844 the Duke, writing to his niece Priscilla, by then Lady Westmorland, said: 'The best bust of me was done by a man named Burges [*sic*] who is employed on the Edinburgh statue [presumably the equestrian portrait by Steell, q.v.]. But I saw only the original made in clay. He has not yet cut even one in marble, notwithstanding that I ordered one long ago for Eton College, and a second for the University of Oxford' (*Correspondence of Lady Burghersh with the Duke of Wellington*, p. 156).

There is no bust of the Duke by Burges at Eton College. If the Duke's spelling of the name is correct, the sculptor may have been related to the architect William Burges. Gunnis does not note a Burges or Burgess having sculpted the Duke.

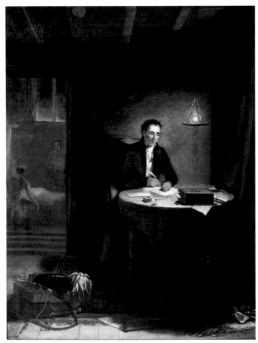

Burghersh 1

BURGHERSH, LADY (PRISCILLA), LATER COUNTESS OF WESTMORLAND
1793–1879

The fourth child of Wellington's brother William Wellesley Pole, later 1st Baron Maryborough. Corresponded regularly with the Duke, who encouraged her artistic talents. In 1811 she married John Fane, Lord Burghersh, who became Earl of Westmorland in 1841. She studied under William Salter and exhibited at the BI. Her painting of her grandmother, Lady Mornington, surrounded by effigies of her four famous sons, now hangs in the Library at Apsley House.

1. Family Collection
1840, 90 × 69.2 cm. Wellington is seated writing a dispatch on the night of 18 June 1815, after the battle of Waterloo. Lieutenant-Colonel Sir Alexander Gordon, fatally injured, lies in the back room, attended by two soldiers. Hat, sword, telescope and map are on the ground.

Engraved by William Bromley, with the inscription, 'Dedicated by permission To The Most Noble Richard Marquis Wellesley K.G.'

BURNET, JOHN
1781/84–1868

Scottish engraver and painter. He trained as an engraver under Robert Scott and studied at the Trustees Academy in Edinburgh. He moved to London in 1806. Between 1802 and 1862 he was a regular contributor to the RA, and also exhibited at the BI and the SBA. He engraved Sir David Wilkie's famous picture of the Chelsea Pensioners in 1831.

1. Family Collection
The Despatch, His Grace the Duke of Wellington, K.G. &c. &c., During the Peninsular War, mixed-method engraving, published in 1839, 73.6 × 55.5 cm (plate). Wellington is depicted FL, standing, writing a dispatch while a messenger with a donkey waits. A captured city burns in the distance to the R. To the L a servant tends a fire, and in the background are two officers. Another impression is in the NPG.

Burnet 1

BURNEY, EDWARD FRANCESCO
1760–1848

Painter, best known for his illustrations. Nephew of the musician Dr Charles Burney and cousin of the novelist Fanny Burney. He entered the RA Schools in 1777, and was influenced by Fuseli and Reynolds. He exhibited at the RA between 1780 and 1803.

1. Private Collection, New York
Miniature in grisaille on paper, *c.* 1814, h. 8.6 cm. In profile to the L, in major-general's uniform. Inscribed on the back: 'Duke of Wellington / by / E. F. Burney'. Sold at Christie's, 9 December 2008, lot 59.

Engravings were produced by James Heath in August 1814, and of a second composition by H. Meyer in 1815.

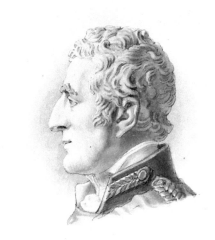

Burney 1

CAMPBELL, THOMAS
1790–1858

Sculptor. Born in Edinburgh, he was apprenticed to a marble cutter there, then studied at the RA Schools in London, and was tutored by Nollekens. In 1818 he moved to Rome, and set up his own studio. He returned periodically to London to undertake commissions. His patrons were the 6th Duke of Devonshire and the 5th Duke of Buccleuch. He moved back to England in 1829 or 1830, and employed James Hall (q.v.) as his assistant. He used a *camera lucida* to obtain likenesses of his sitters.

1. Family Collection
Marble bust, inscribed on the back 'Thos. Campbell, 1827', life-size. To the L, shoulders draped and pinned with a brooch at the right shoulder. Formerly in the collection of the Earl of Ellesmere at Bridgewater House, bought by the 7th Duke in April 1950. The bust proved to be enormously popular. Several versions are known, including those in the Hopetoun Collection and at Thirlestane Castle in Berwickshire.

2. The Duke of Buccleuch, Dalkeith Palace, Edinburgh
Marble statue, *c.* 1828–36, h. 219 cm. Head to the R, arms folded over the hilt of a sword, in military cloak, with the Order of the Golden Fleece visible.

3. Present whereabouts unknown
Bronze bust, *c.* 1831, exh. RA 1831.

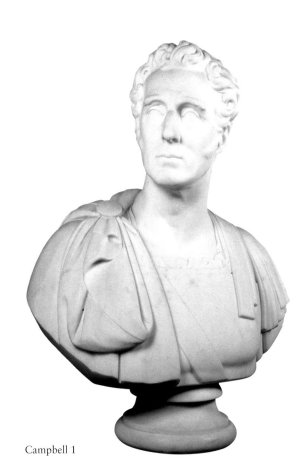

Campbell 1

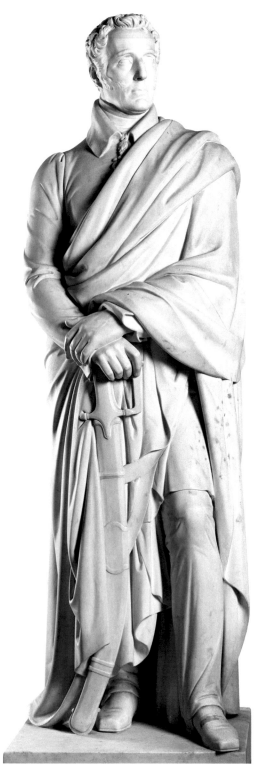

Campbell 2 (and see Ill. 76)

4. Formerly the Earl of Westmorland. Present whereabouts unknown
Marble bust, probably 1845, life-size. In Roman dress. The Duke in a letter of 1 November 1844 to his niece Lady Westmorland promises to sit to Campbell for a bust for her (*Correspondence of Lady Burghersh with the Duke of Wellington*, p. 156).

CAREW, JOHN EDWARD
c. 1785–1868

Irish sculptor, son of a sculptor. He was an assistant to Sir Richard Westmacott from 1809 to 1825 and also kept his own studio. From 1831 to 1837 he worked for Lord Egremont at Petworth. When Lord Egremont died in 1837 Carew became bankrupt and moved back to London.

1. Family Collection
Marble bust, *c.* 1813, h. 71 cm. Head to the L, in Roman dress. Not believed to be *ad vivum*. Exh. RA 1813, no. 895. Acquired by the 7th Duke in December 1966 from John Harris by exchange.

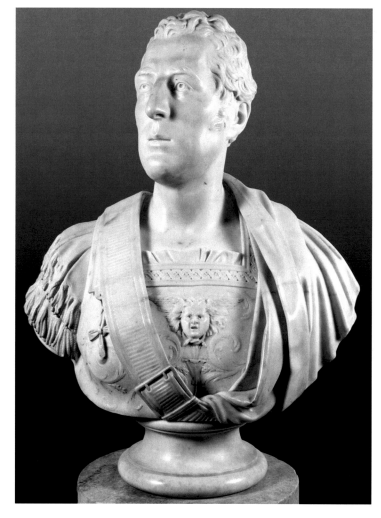

Carew 1
(and see Ill. 28)

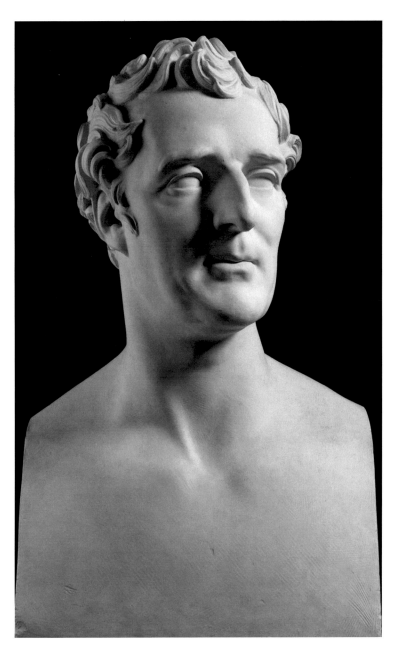

Chantrey 1
(and see Ill. 38)

CHANTREY, SIR FRANCIS LEGATT, RA
1781–1841

Originally apprenticed to a woodcarver, Chantrey studied stone carving and oil
painting at the RA Schools from 1802. In 1815 he became ARA and in 1818 RA.
One of the greatest sculptors of his day, he was knighted by William IV in 1835.
He died suddenly in 1842, leaving a fortune of £15,000, which mostly went to
the RA to form the Chantrey Bequest.

1. Ashmolean Museum, Oxford

Colossal plaster bust, 1814, h. 83.5 cm. One of a collection of 154 casts of
the original models of busts and statues by Chantrey presented to the University
of Oxford by his widow in 1842. No marble bust of this date has been traced.

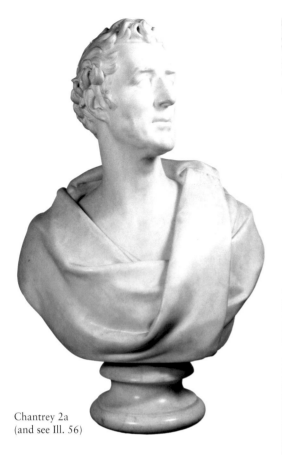

Chantrey 2a
(and see Ill. 56)

Chantrey 2b, 2c

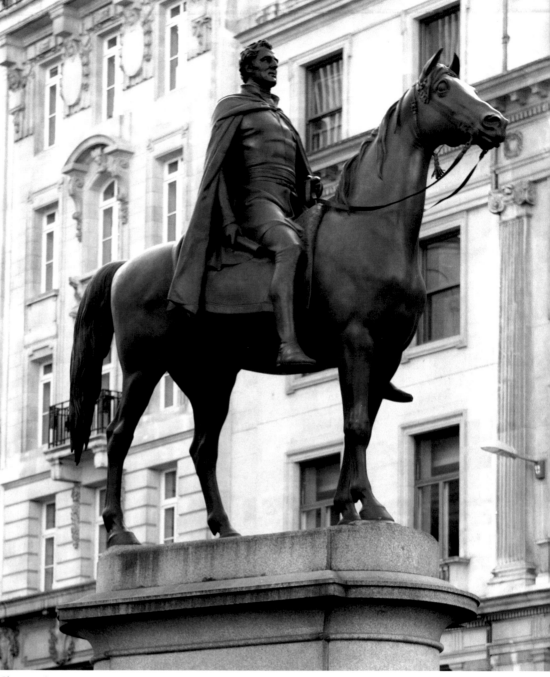

Chantrey 3

2. Metropolitan Museum of Art, New York

Marble bust, inscribed 'CHANTREY. SC. 1823', h. 77 cm. Head to the R, shoulders draped. Bought at Christie's 5 July 1994, lot 99. This is the first version, commissioned by the Earl of Liverpool in 1821 or 1822, when Wellington was a member of his cabinet. At Apsley House there is a second version, also of 1823, which was commissioned by the Duke for Charles and Harriet Arbuthnot, and was probably returned some years later by Mr Arbuthnot (2a).

Further examples are at Petworth House (1828) and Belton House (1838).

There are three in the RCT (1828, 1835 and 1837), and one in the Examination Halls at the University of Oxford (1841).

A plaster cast of the model is in the Ashmolean Museum, Oxford (cf. No. 1). An engraving by E. Finden after a drawing of the bust by Henry Corbould was published in 1830.

Two pencil studies for the bust are in the Family Collection. They were bought by the 7th Duke in 1941 (2b, 2c).

3. Royal Exchange, London

Bronze statue, erected in 1844, life-size. FL, equestrian. The Duke is represented bareheaded, riding without stirrups. Commissioned by the Corporation of the City of London. Completed after Chantrey's death by Henry Weekes.

Two plaster models are in the Family Collection. Ten drawings for the figure, horse and plinth, dated 1838, are in the NPG.

CLAUDET, ANTOINE FRANÇOIS JEAN
1797–1867

A student of Louis Daguerre in France, the first to practise and popularise the daguerreotype photographic method in England. He improved the process, greatly reducing the time needed to develop the image. He also introduced the use of painted backdrops in the studio. In 1852 he was appointed Photographer in Ordinary to Queen Victoria.

1. Family Collection

Daguerreotype, 1844, 6.7 × 5.2 cm. Nearly HL, slightly to the L, in black coat with white shirt and stock. Taken on the occasion of the Duke's 75th birthday, at the Adelaide Gallery Studio in London. Being a daguerreotype, it shows the sitter in reverse. Another daguerreotype plate from the collection of a descendant of the Duke's sister, Lady Anne Wellesley, was sold at Sotheby's on 26 October 1984.

An engraving by H. T. Ryall was published in large editions in 1845 and in 1849. Paintings after the daguerreotype are numerous and of varying quality. The Family Collection includes one by William Essex (No. 2), one by A. Soloman, and an oval version by R. Clothier. A miniature by John Haslam is in the Ashmolean Museum, Oxford. Another, signed and dated 1852, was sold at Christie's, 20 March 1989, lot 190.

Claudet 1 (and see Ill. 91)

Copley 1

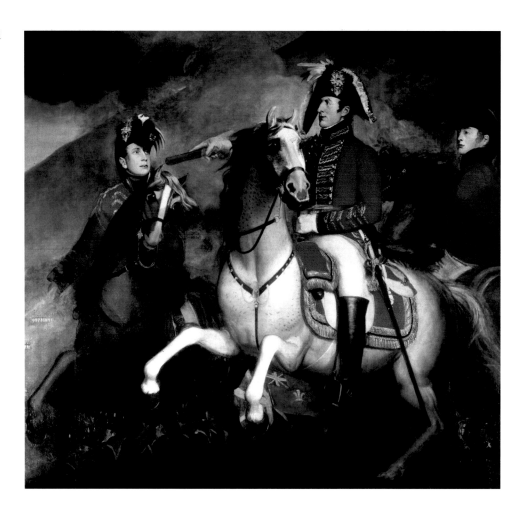

COPLEY, JOHN SINGLETON, RA
1738–1815

Painter. Born in Massachusetts, he was taught to engrave and paint by his stepfather, Peter Pelham. He travelled around Europe, studying in Italy for a year, before settling in London in 1775. In 1776 he was elected ARA, and in 1779 RA. Copley's group portrait of the Duke of Wellington was the last portrait he produced before his death.

1. Private Collection, England
The Battle of the Pyrenees, 1814, 216 × 198 cm. Grand FL equestrian portrait, depicting from L to R the Prince of Orange (later King William II of the Netherlands), Wellington – who sat for Copley in 1814 – and the Duke's ADC and Assistant Military Secretary the Earl of March, later 5th Duke of Richmond. In military uniform with troops flying a flag in the background. Sold by Copley's son in 1864, and after passing through various private hands it was then bought by the present owner, a descendant of Copley.

COSWAY, RICHARD, RA
1742–1821

Chiefly a miniaturist. He entered the RA Schools in 1769, and exhibited there from the following year. He was made ARA in 1770, RA in 1771. In 1785 he was appointed Principal Painter to the Prince of Wales, for whom he also built up a great collection of art and books. He exhibited 45 miniatures at the RA between 1770 and 1806.

1. Victoria and Albert Museum, London

Watercolour miniature on ivory, 1808, h. 7.1 cm. Head and shoulders to the R, wearing scarlet uniform with ribbon of the Order of the Bath. Inscribed 'Rdus Cosway / R.A. et F.S.A. / Primarius Pictor / Serenissimi Walliæ / Princip[is] Pinxit / 1808'. Gifted to the museum by Mrs Emma Joseph in 1941, from a collection put together by her late husband, Samuel Solomon Joseph, who died in 1894.

An identical miniature was owned by Lady Rose Weigall, great-niece of the Duke, who was the wife of the artist Henry Weigall Jun. It is now lost.

One version was shown at the Guelph Exhibition in 1891, no. 1187.

CŒURÉ, SÉBASTIEN
b. 1778

French painter, engraver and draughtsman. He exhibited at the Paris Salon from 1810 to 1831.

1. Original painting untraced. Print in the National Portrait Gallery, London

Aquatint after Cœuré by Jean-Baptiste Alix, *c.* 1813, 42.4 × 30.3 cm (plate). FL, standing, in military uniform with Order of the Golden Fleece and sash and star of the Order of the Bath. Leaning on a cannon with telescope in his right hand and sword in his left. Accoutrements of battle on the ground and troops in the background. Inscribed 'Le Duc de Vellington, / Généralissime des Armées Angloises'.

D'AGUILAR, MANOEL, MARQUÉS
1767–1817

Engraver, born in Oporto. He worked in London in the studio of Thomas Milton in the 1790s. In 1796 he returned to Portugal, where among other subjects he engraved portraits of members of the Portuguese royal family.

1. British Museum, London

Engraving after and by D'Aguilar, 1814, 44.7 × 34.5 cm. Head and shoulders to the R, wearing field-marshal's uniform, with badge and collar of the Order of the Golden Fleece and other orders. Surrounded by the words 'Arthur Wellesley, Pro Duque da Victoria' and 'Hoc vera forma est'. Engraved in Lisbon.

Cosway 1
(and see Ill. 20)

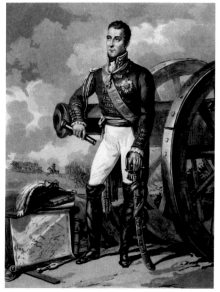

Cœuré 1

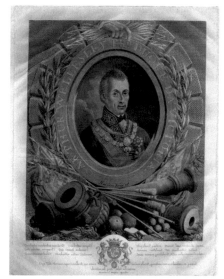

D'Aguilar 1

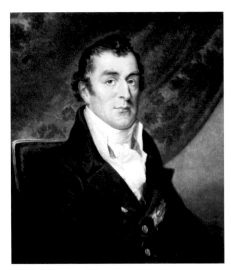

Dawe 1 (and see Ill. 47)

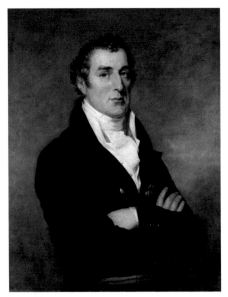

Dawe 2

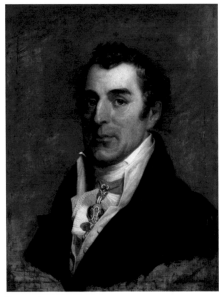

Dawe 4

DAWE, GEORGE, RA
1781–1829

Painter, son of a successful mezzotint engraver. Made RA in 1814. He became a popular portrait painter for both the British and Russian royal families. His main body of work was produced for the Russian Imperial court from 1819 onwards.

1. Original painting formerly in the collection of Princess Charlotte, untraced. Print in the Family Collection
Colour mezzotint after Dawe, 1818. Head and shoulders, to the R, wearing civilian dress with star of the Order of the Garter.

2. Family Collection
1818, 91.4 × 71 cm. HL, to the R, arms folded, in civilian dress with star of the Order of the Garter faintly outlined. Presented by the Duke to the Markham family. Purchased from MacDougall's, 7 July 2011, lot 22.

3. Family Collection
Signed and dated 'Geo Dawe R.A., Pinct 1818', 68.5 × 66.5 cm. HL, to the L, arms folded, in field-marshal's uniform, with Order of the Golden Fleece, the Waterloo Medal, ribbon and star of the Order of the Garter, and Order of the Bath. Presented to the 7th Duke in 1957 by C. W. R. Hill of Queen Hoo Hall, Tewin. Thought to have been given to Mr Hill's ancestor, General Rowland Hill, by the Duke himself.

An identical painting was formerly in the collection of Mrs Banks at Winstanley Hall, Lancashire. An almost identical picture is in the NAM, signed and dated 1818, painted for John Bissett, Commissary-General in the Peninsula.

4. The Duke of Northumberland, Alnwick Castle, Northumberland
Signed, 1818, 58.4 × 45.7 cm. Head and shoulders to the L in black coat and white stock, with Order of the Golden Fleece. Unfinished. Purchased by the 4th Duke of Northumberland as a pendant to the portrait he owned of Napoleon.

5. Cheltenham Art Collection, Cheltenham
Signed and dated 'Cambrai, 1818', 87.5 × 70 cm. HL, to the L, arms folded, in blue coat and white stock, with Order of the Golden Fleece. Cambrai was the Duke's headquarters as Commander-in-Chief of the Army of Occupation in France.

Another version, dated 1819, is in the Gatchina State Museum (Reserve), Russia.

6. Private Collection, New Zealand
86 × 68.6 cm. HL, slightly to the L, in field-marshal's uniform with the Order of the Golden Fleece, and holding a plumed hat. Unfinished. Presented to the collection by Sir James Prendergast, the artist's nephew.

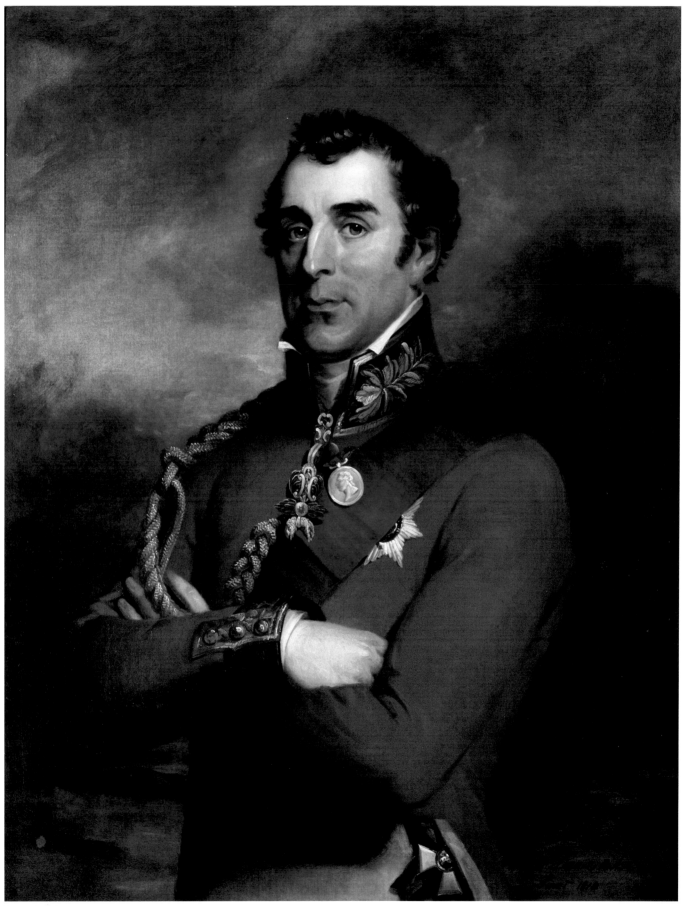

Dawe 3

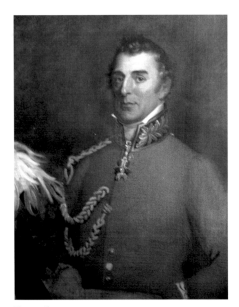

Dawe 6

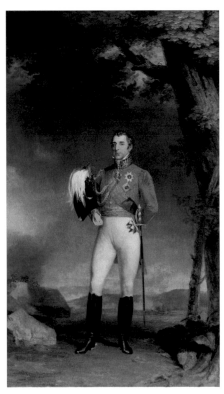

Dawe 7 (and see Ill. 60)

7. Hermitage Museum, St Petersburg

1829, 317 x 185 cm. FL, standing, in field-marshal's uniform, left arm behind his back and plumed hat tucked under his right arm. Decorated with the Order of the Golden Fleece and with Russian orders: the sash and star of the Order of St Andrew, and star of the Order of St George 1st class at his left hip. Formerly in the collection of the Emperor of Russia.

8. The Duke of Richmond and Gordon, Goodwood House

c. 1829, *c.* 95 × 60 cm. FL, pose as in No. 7. Finished by Dawe's assistants after the artist's death in 1829. It was evidently produced around the same time as No. 7. The badge of the Russian Order of St George is evident at his left hip. The original sash (now barely visible) would have been that of the Russian Order of St Andrew. A sash from the left shoulder was added at a later date, perhaps after the painting came into possession of the Duke of Richmond, in which case it might be that of the Order of the Garter. The star of neither order is shown. This painting first appeared in the Goodwood Collection in 1877.

9. Formerly Viscount Hill, Hawkstone. Present whereabouts unknown

Very similar to Nos 7 and 8. In the possession of Sir Clement Hill by descent, until his widow sold it at Christie's on 18 April 1939.

Dawe 8

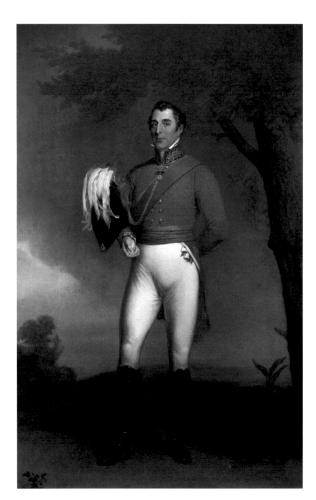

10. Formerly Viscount Chelmsford, London. Present whereabouts unknown
64.8 × 55.9 cm. Head and shoulders, to the L, dark blue coat with white stock, with star of the Russian Order of St Andrew.

De Daubrawa 1

11. Formerly Mrs H. A. May, Pittsburgh, Pa., USA.
Present whereabouts unknown
1818. HL, to the L, in dark coat with white stock, Order of the Golden Fleece and another order visible. A note on the frame reads 'Wellington / (Painted from Life) / At Aix La Chapelle in 1818 / By G. Dawe Esq R.A.'

12. Formerly Sir Philip Grey Egerton, Bt, Oulton Park, Cheshire.
Present whereabouts unknown
1820, 91 × 68.6 cm. HL, to the L, arms folded, bareheaded, in a scarlet tunic with Order of the Garter and Order of the Golden Fleece. Painted for Major-General Egerton (1766–1825). Oulton Park was damaged by fire in 1926 and bombed in 1940, and there is no record of the work after that time.

DE DAUBRAWA, WILLIAM HENRY
c. 1807–*c.* 1881

Painter of military subjects from around 1840, after a short career in the army. From 1842 he worked in London and exhibited works at the RA, BI and SBA. His name usually appears in records as Henry de Daubrawa.

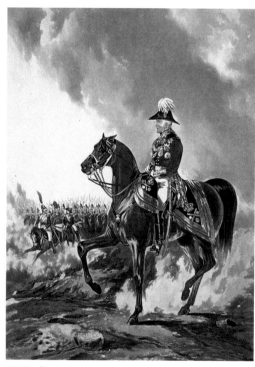

De Daubrawa 2a

1. Family Collection
A View in Hyde Park, signed and dated 1844, 51 × 41.5 cm. FL, equestrian, to the L. The elderly Duke in long black coat and top hat, riding past the Wellington Monument in Hyde Park, saluting with his right hand. Groom on horseback far R.

Engraved by John Harris in 1844 and published again in Randolph Ackermann's *Eclipse Sporting Gallery*, 26 March 1845.

2. National Army Museum, London
The Duke of Wellington at the Grand Review in Windsor Great Park on 5 June, 1844, 1844, 30.5 × 22.8 cm. FL, equestrian, riding to the L, in field-marshal's uniform with various orders and decorations. Tsar Nicholas I, Emperor of Russia, seen in dark green uniform, behind, followed by the 17th Light Dragoons.

There is a print in the Family Collection (2a).

De Daubrawa 3

3. Family Collection

Signed, 90 × 69 cm. FL, as an old man, walking to the L, in long black coat and top hat. Landscape background. Inscribed in the bottom left-hand corner 'aetatis suae 84'. Sent for exhibition at the Royal Hibernian Academy as 'Portrait of the Duke of Wellington in his 84th year'.

DERBY, WILLIAM
1786–1847

Painter and miniaturist. In 1825 he succeeded William Hilton in producing the drawings for Edmund Lodge's engraved *Portraits of Illustrious Personages of Great Britain*. One of his most important patrons was the Earl of Derby. Between 1811 and 1842 he exhibited chiefly at the RA, but also showed works at the BI and SBA.

1. Wallace Collection, London

Watercolour on card, 1834, 18.2 × 14.2 cm. TQL, slightly to the R, in scarlet military uniform with dark cloak over his right shoulder. One of a series of watercolours made for Lodge's *Portraits*, published in a second edition in 1835. An inscription on the back says that it was painted from two sources – the head from a chalk drawing by Sir Thomas Lawrence, and the body from a copy of Lawrence by William Evans at Eton College.

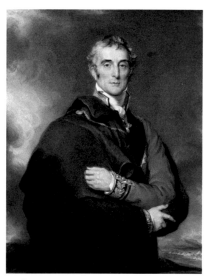

Derby 1

DIGHTON, DENIS
1792–1827

Painter and printmaker, son of Robert Dighton Sen., who ran a successful caricature print studio in London. Brother of Richard and Robert Dighton Jun. Entered the RA Schools in 1807. Appointed military draughtsman to the Prince Regent in 1815, and became specially known for military subjects. Exhibited at the RA between 1811 and 1825.

1. Royal Collection Trust

Watercolour, *c.* 1814, 35 × 25.5 cm. FL, equestrian, to the L, in blue coat and hat, looking to the R. To the R a tree, possibly the 'Waterloo Elm'. British troops advancing on the French to the L.

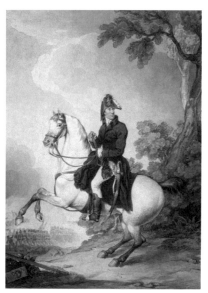

Dighton, D. 1

DIGHTON, RICHARD
1795–1880

Son of Robert Dighton Sen., brother of Denis and Robert Dighton Jun. He began by producing etchings of well-known personalities. After 1828 he turned to watercolours and aquatints. He was particularly fond of profile figures.

1. Family Collection

The Master General of the Ordinance, drawn and etched by Dighton, 1819, 28.5 × 19.2 cm. FL, standing, in profile to the L, in military coat and field-marshal's hat. Pointing with his right hand and holding a sword in his left. Published by T. McLean.

Dighton, R. 1

DIGHTON, ROBERT (JUNIOR)
1786–1865

Son of Robert Dighton Sen., brother of Denis and Richard Dighton.
He produced etchings of military figures between 1800 and 1809 before
carving out a career as a professional soldier.

1. Present whereabouts unknown
Watercolour, signed 'R. Dighton, 38th Regt.', *c.* 1811, 48.3 × 35.6 cm. FL, nearly
in profile to the L, wearing cocked hat, scarlet uniform coat, with the Order of
the Tower and Sword, which was awarded in August 1811.

An engraving with variations, inscribed 'Drawn from the life at Elvas
by an officer of the 38th Regiment', was published in 1814.

D'Orsay 1 (and see Ill. 92)

D'ORSAY, ALFRED GUILLAUME GABRIEL, COUNT
1801–52

A French officer, son of an officer, he moved to London in 1830. Despite receiving
no formal training, he proved to be a talented portrait painter and sculptor,
receiving commissions from members of the aristocracy and the royal family. More
than 125 sketches of his contemporaries were engraved by Mitchell of Bond Street.
He was appointed Director of the Ecole des Beaux-Arts in Paris just before
his death.

**1. National Portrait Gallery, London
(currently on display at King's College, London)**
Signed and dated 1845, 135.3 × 104 cm. TQL, to the R, face in profile, wearing
evening dress with white cravat, the Order of the Golden Fleece and ribbon of the
Order of the Garter, hat under his left arm and right hand resting on a carved table.
Formerly Countess of Blessington, Gore House, bought at her sale in 1849 by Mr
C. Vickers of Newbury, who bequeathed it to the NPG in 1875. Replicas are in the
Travellers' Club in London, at Eton College, and in the British Embassy in Paris.
The latter belonged to Wellington's nephew, Lord Cowley, who was ambassador.
It was bought from his descendant by the 7th Duke, and sold on by him to the
GAC for the Embassy. Another replica was in the Burdett-Coutts collection.
Engraved by C. E. Wagstaff, 1846.

2. Family Collection
Silver-gilt statuette made by Hunt & Roskell, 1845, h. 96 cm. The Duke, looking
straight ahead, is shown astride Copenhagen in coat and hat, his right hand
holding a telescope, sword at his left side. There is a companion statuette of
Napoleon in the Family Collection.

This model was much reproduced in smaller formats in bronze.

It has been suggested that Thomas Henry Nicholson and William Behnes
helped D'Orsay with much of his sculpted work.

D'Orsay 2
(and see Ill. 93)

D'Orsay 3

3. Wellington College, Berkshire

c. 1846, 92 × 51 cm. FL. As in No. 1, his right hand on a carved table. In the background, the silhouette of the Matthew Cotes Wyatt equestrian statue (erected on 28 September 1846), a column with Classical figures, and drapery. Originally in the collection of Sir Edward Sherlock Gooch, one of the Duke's godsons. Sold at the Gooch sale through Sotheby's at Benacre Hall, 9–11 May 2000, lot 555. Acquired by the Old Wellingtonians at Lyon and Turnbull, Edinburgh, November 2011, lot 243.

DOWNMAN, LIEUTENANT

1. Present whereabouts unknown

Engraving, *c.* 1809. Head and shoulders in profile to the L, wearing uniform with star of the Order of the Bath and large cocked hat. A rare engraving, undated, inscribed with the title: 'Field-Marshal the Duke of Wellington, &c. &c. &c. Etch'd from a Sketch by Lieu.ᵗ Downman R.A.ʸ [Royal Horse Artillery] made at Badajos'. Wellington spent the winter of 1809–10 in cantonments at Badajoz, and it seems probable that this sketch was made then rather than during the siege and capture of the fortress in 1812.

The original drawing has not been traced, neither has the artist been identified. Thomas Downman (1776–1852), nephew of the artist John Downman, served in the Peninsula where he was mentioned by Wellington for gallantry, and is known to have drawn portraits from life, but he had been promoted to captain in 1802. Formerly in the possession of Lieutenant-General Sir Gerald Ellison.

Downman 1

DOYLE, JOHN, 'H.B.'
1797–1868

Originally from Dublin, Doyle had some success working as a portraitist in London, exhibiting at the RA in 1825. He became a well-known caricaturist, and much of his work was published by Thomas McLean.

1. British Museum, London
Black chalk touched with white. FL, equestrian, riding to the R, bareheaded, baton in his right hand.

2. Family Collection
Ancient Concerts – A Rehearsal. Engraving, signed 'HB', 1838, 37 × 26 cm. Wellington FL in profile to the L, conducting an orchestra. Published by McLean on 14 May 1838.

3. British Museum, London
Tinted lithograph, 1842. FL, equestrian, riding to the L, in dark coat and top hat. Inscribed 'Sketched on his Birthday, May 1st, 1842'. Published by McLean.

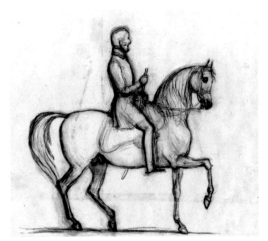

Doyle 1

Doyle 3

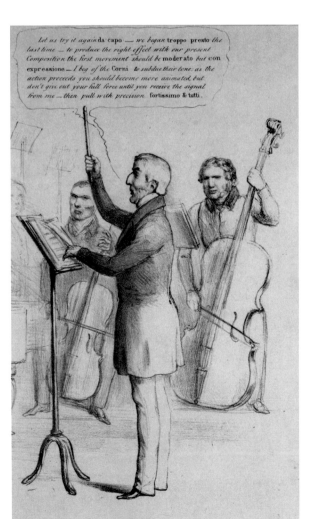

Doyle 2 (detail)

EDRIDGE, HENRY
1769–1821

Apprenticed to the mezzotint engraver and landscape painter William Pether. He became a student at the RA in 1784, winning the Silver Medal two years later. Elected ARA in 1820. He mainly produced watercolours, of subjects including Lord Nelson and William Pitt. Reynolds greatly admired his work.

1. Present whereabouts unknown
Pen and wash, signed and dated 1797. FL, in long coat with braids and epaulettes. Landscape with mountains in background. Formerly Francis Wellesley, sold at Sotheby's, June 1920, lot 263. Bought by G. W. Panter of Foxrock, Co. Dublin, but lost sight of since Mr Panter's death in 1929.

ENGLEHEART, JOHN COX DILLMAN
1783–1862

Nephew of the miniature painter George Engleheart. He achieved great success with his work, sending no fewer than 157 paintings to the RA from 1801. He was forced to give up his profession at an early age due to ill health.

Engleheart 1

1. Formerly Lieutenant-Colonel E. L. Engleheart.
Present whereabouts unknown
Miniature on ivory, *c.* 1820, 9.5 × 9.1 cm. Head and shoulders, slightly to the R, wearing a civilian greatcoat with fur collar. Inscribed on the back 'J. C. D. Engleheart pnxt, after Sir Thomas Lawrence'. It does not however accord with any of the known portraits of the Duke by Lawrence. Sold at Sotheby's, 28 April 1981, lot 185.

ESSEX, WILLIAM
1784?–1869

Specialist in large-scale enamel miniatures, following Henry Bone, who made the medium popular. He exhibited at the RA between 1818 and 1864, and also at the BI. He became Enamel Painter to Princess Augusta of Cambridge, to Queen Victoria, and finally to Albert, Prince Consort.

1. Family Collection
Enamel miniature, signed and dated 1841, 25 × 20.5 cm. HL, slightly to the R, in black coat with white stock. After Lawrence, No. 6. Inscribed 'Wellington / After Sir T. Lawrence R.A. / Painted by W. Essex 1841 / Enamel painter in Ordinary to / Her Majesty'. A second version is in the Family Collection, 14 × 11 cm. Two miniatures of this type are in the collection of the Duke of Northumberland at Alnwick Castle.

Essex 1

Essex 2

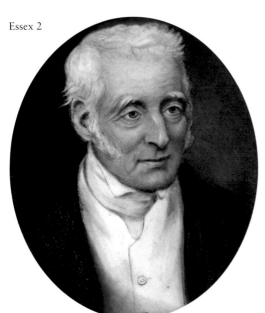

A smaller version, head and shoulders, is on loan to the Scottish National Galleries, and another was sold at Christie's, 7 November 1988, lot 86. A version was exhibited at the RA in 1844, described as '39 W. Essex – enamel after Lawrence 1821, in possession of the Rt Hon. Charles Arbuthnot'. A head-and-shoulders version, enamel on copper, signed lower L 'W.E.', 1846, 11.5 × 7.3 cm, is in the St Louis Art Museum, St Louis, Mo., USA. A miniature very similar to the St Louis version, signed and dated 1846, h. 9 cm, was sold on 5 November 1985, lot 177.

2. Family Collection
Enamel miniature after the daguerreotype by Claudet (q.v.), reversed to have the correct orientation, inscribed 'Wellington / By W. Essex / Enl. painter to / Her Majesty 1852'. Head and shoulders to the R, in blue coat and white stock.

FORREST, ROBERT
1790–1852

A stonemason, self-taught, who became a successful sculptor of monumental works. In 1830 in Edinburgh he exhibited large stone statues of the Duke of Wellington, the Duke of Marlborough and Queen Mary, which proved to be a popular attraction for some twenty years.

1. Family Collection
Stone statue, *c.* 1836, life-size. FL, standing, in military uniform with cloak over his shoulders, hat in his left hand, in his right hand the reins of a horse, whose head is seen lowered on the L. Formerly at Falcon Hall, Edinburgh, demolished in 1909, then moved to Lennel House, Coldstream, Berwickshire. Bought by the family at Christie's, 14 October 1992, lot 1143.

2. Newmarket Street, Falkirk
Stone statue. Pose similar to that in No. 1, but with the full figure of a horse behind.

Forrest 1

Forrest 2

Francis 1 (and see Ill. 66)

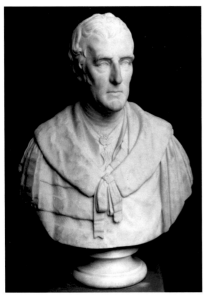

Francis 3

FRANCIS, JOHN
1780–1861

Sculptor. He studied under Samuel Joseph and Sir Francis Chantrey, and enjoyed the patronage of the Duke of Sussex, George IV and Queen Victoria. He exhibited at the RA on a regular basis between 1820 and 1857, and showed busts of the Duke there in 1832 and 1838.

1. The Duke of Bedford, Woburn Abbey
Marble bust, signed 'J. Francis, Sc. 1830', h. 78.5 cm. To the R, with shoulders draped. Exh. RA 1830.

2. Formerly the Earl of Jersey, Middleton Park, Oxfordshire.
Present whereabouts unknown
Marble bust, signed and dated 1830, h. 38 cm. Middleton Park was demolished in 1934 and the contents sold. This work was not included in the sale catalogue.

3. Private Collection, England
Marble bust, inscribed 'J FRANCIS / SC / 1830', h. 30.5 cm. Head turned to the L, in Classical robes pinned over his right shoulder.

4. National Portrait Gallery, London
Marble bust, inscribed at the back 'J. Francis, sc, London 1852', h. 79 cm. Wearing peer's robes, with ribbon of the Garter and badge and ribbon of the Order of the Golden Fleece. Exh. RA 1853. Purchased 1866.

FRY, WILLIAM THOMAS
1789–1843

Engraver. Working mainly in stipple engraving, he was one of the first to experiment with steel plates. Between 1824 and 1830 he exhibited at the SBA, and engraved eight plates for Edmund Lodge's *Portraits of Illustrious Personages of Great Britain*.

1. Present whereabouts unknown
Sepia on vellum, signed and dated 1815, 28 × 21.6 cm. HL, head to the R, wearing uniform and orders. Francis Wellesley sale, Sotheby's, June 1920, lot 364.

Francis 4

GAHAGAN, LAWRENCE
c. 1735–1820

The first known member of a family of sculptors. In 1777 he won first prize at the Society of Arts. He exhibited busts at the RA between 1798 and 1817. Two of his sons, Lucius and Sebastian, became sculptors. The full extent of Gahagan's output is confused by both Lawrence and Lucius signing their works 'L. Gahagan'.

1. Family Collection

Bronze bust, inscribed 'Wellington. L. Gahagan fecit and pubd. June 12, 1811', h. 30 cm. To the R, in Classical military uniform. This little bust is interesting as it is the earliest dated image of Wellington in the round hitherto traced. He was in the Peninsula at the time. It seems hardly possible that the bust was made from prints or pictures. The face bears a close resemblance to the Nollekens type (q.v.). Lawrence Gahagan's son Sebastian worked for Nollekens, and he may have done so too. Two of these busts were sold at Christie's, 7 July 1992, lot 138, and 12 December 2001, lot 139. One of these is the version in the Family Collection.

> Engraved by Andrea Freschi in 1812 and by Adam Buck.

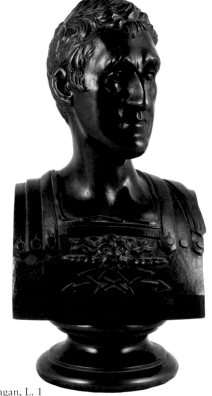

Gahagan, L. 1
(and see Ill. 27)

GAHAGAN, SEBASTIAN
fl. 1800–1838

Son of the sculptor Lawrence Gahagan, he became an assistant to Joseph Nollekens. In 1816 he won the commission to produce the funerary monument to Sir Thomas Picton, who had died at the Battle of Waterloo. He was a regular contributor to the RA between 1802 and 1835, as well as to the BI.

1. Formerly J. E. Waldy. Present whereabouts unknown

Marble bust. Exh. Guelph Exhibition 1891, no. 1615, by the Rev. J. E. Waldy, in whose possession it remained until his death in 1896.

> Engraved by Freschi, 1812. An impression is in the BM (1a).

Gahagan, S. 1a

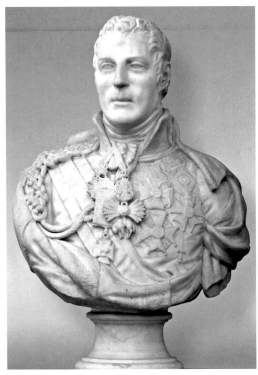

Garrard 3

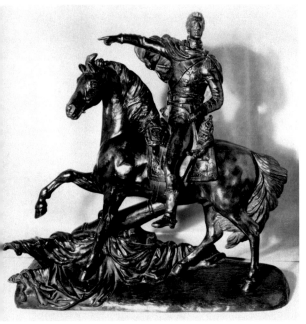

Garrard 4

GARRARD, GEORGE
1760–1826

A painter of animals and then a sculptor. After studies under Sawrey Gilpin he entered the RA Schools in 1778, first exhibiting there three years later. In 1800 he became ARA. He exhibited 215 works at the RA, as well as examples at the BI and SBA. A marble bust of Wellington exh. RA 1820, No. 1056, is untraced. Garrard was involved in an unsuccessful proposal to erect an equestrian statue of the Duke in Parliament Square.

1. Formerly Earl Spencer, Althorp House. Present whereabouts unknown
Plaster bust, signed 'G. Garrard, ARA', dated 19 December 1814. In uniform, with orders. Not considered to be a good likeness by the 7th Earl Spencer, who intended to have it painted to resemble terracotta.

2. Formerly the Queen's Apartment, Windsor Castle.
Present whereabouts unknown
Marble bust, 1815.

3. Southill Park, Bedfordshire
Marble bust, inscribed '1 Jany 1816. G. Garrard, A.R.A.', h. 63.5 cm. Exh. RA 1816, No. 947.

4. Birmingham Museum and Art Gallery
(on display at the Museum Collections Centre)
Bronze statuette, 1818, h. 60.4 cm. FL, equestrian. Study for a large monument, not executed. The Duke is depicted in military uniform, his right arm extended. Captured flags on the ground under the horse's hooves.

GEDDES, ANDREW
1783–1844

Portrait painter and etcher. Trained at the RA Schools and exhibited there from 1806. He became a close friend of Sir David Wilkie, of whom he produced his best-known portrait. After working in Edinburgh, he settled in London in 1831 and became ARA in 1832. His grandson was the writer Wilkie Collins.

1. Present whereabouts unknown
Canvas, small FL. Geddes sale, Christie's, 8 April 1845, lot 528.

GÉRARD, FRANÇOIS PASCAL SIMON, BARON
1770–1837

A French artist, born in Rome where his father was a diplomat. He studied in Paris under the sculptor Augustin Pajou and the painter Jacques-Louis David. He exhibited regularly at the Salon. He was one of the first to be made a Knight of the Legion of Honour, and was made a baron by Louis XVIII.

1. British Embassy, Paris (Government Art Collection)
1815, 245 × 160 cm. FL, standing, head to the R, wearing field-marshal's uniform with ribbon and star of the Order of the Garter, the Order of the Golden Fleece, and the Grand Cross of the Order of the Bath, hands resting on his sword hilt, bareheaded. Painted for the Duke in 1815 at a cost of 12,000 francs. The artist's widow offered the Duke a copy in 1840, which was refused. Bought by the GAC in July 1953. A reduced version of this work, 31.8 × 24.2 cm, was shown at Burlington House in 1932 (*French Art*, no. 300), and is now in the Musée de Versailles.

Engraved by François Forster in 1818.

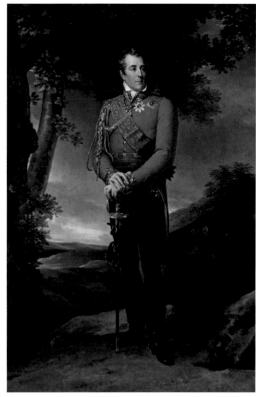

Gérard 2 (and see Ill. 37)

2. Hermitage Museum, St Petersburg
A replica of No. 1, painted in 1817 for Tsar Alexander I, 244 × 162 cm. The Duke is wearing, instead of the Order of the Garter, two Russian orders – the ribbon and star of St Andrew and the star of St George. He was to receive the baton of a marshal of Russia in January 1820.

GLASS, JAMES WILLIAM
1825–57

Painter, born in Cadiz, son of the British Consul. He studied in New York before coming to London in 1847. There he exhibited at the RA eight times. In 1856 he returned to New York, where he later committed suicide.

Glass 2 (and see Ill. 99)

1. Private Collection, Scotland
1852, 76.2 × 63.5 cm. FL, seated to the L, in the study at Apsley House, with his secretary, Algernon Greville. Exh. RA 1853, described in the catalogue as painted from sittings given in July 1852 (the Duke died in September). Formerly at Bridgewater House.

2. Wellington Collection, Apsley House
His Last Return from Duty, signed 'JW' (Glass's monogram), 1853, 81.3 × 123 cm. The Duke is shown on horseback, riding away from the Horse Guards in a black coat and top hat. Bought by the 2nd Duke. A duplicate was ordered by Queen Victoria. This work brought Glass considerable success.

A sketch is in the Family Collection, and another is in a private collection in Scotland.

GOYA Y LUCIENTES, FRANCISCO DE
1746–1828

Spanish painter. Goya studied in Madrid under Anton Raphael Mengs. In the late 1760s he moved to Rome, but returned to Madrid in about 1772 and married the sister of the painter Francisco Bayeu. He was employed designing tapestries for the Royal Tapestry Factory. In 1789 he was appointed Court Painter to Charles IV and in 1799 he became First Court Painter. The turbulent years of the Peninsular War followed. In 1810 he began his series of prints, *Disasters of War*. Ferdinand VII returned to the throne in 1814 and Goya again received royal commissions, but the political situation became difficult. He left Spain for France in 1824 and died in Bordeaux in 1828.

1. National Gallery, London

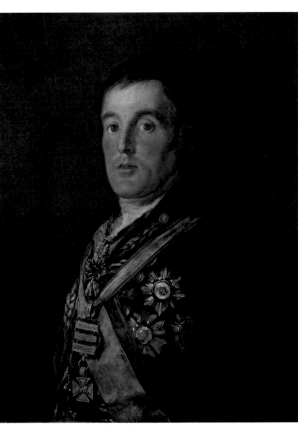

Goya 1 (and see Ill. 29)

Mahogany, 1812–14, 64.3 × 52.4 cm. HL, to the L, in crimson military uniform with various orders and medals. First painted after Wellington's victorious entry into Madrid on 12 August 1812 after the Battle of Salamanca. Modified in 1814 to include the Order of the Bath, the Order of the Golden Fleece, the Army Gold Cross with three clasps, the Portuguese Order of the Tower and Sword, and the Spanish Order of San Fernando. Goya's depiction of the uniform and decorations is not entirely correct. The uniform is not that of a general (1811) or of a field-marshal (1813). The coat should be scarlet, not crimson, and the colours of the sashes have been altered to contrast better with the colour of the coat.

Given by the Duke to Louisa, Lady Hervey-Bathurst, sister of Marianne Patterson. In 1828 she married Lord Carmarthen, who succeeded as Duke of Leeds in 1838. Exh. National Loan Exhibition 1909–10, no. 432, and Guildhall 1915, no. 4. Sold by the 12th Duke of Leeds in 1961. Export was blocked, and it was acquired by the NGL.

2. Wellington Collection, Apsley House

1812, 294 × 421 cm. FL, equestrian, in civilian clothes, riding to the L, face towards the spectator. Head based on the NG portrait (No. 1). Shown at the Real Academia de San Fernando in Madrid on 2 September 1812, a mere twenty-one days after Wellington entered the city.

In an undated letter Goya says: 'Yesterday his Excellency Señor Willington [*sic*], duke of Ciudad Rodrigo, came [to discuss] the question of putting his portrait on public display in the Royal Academy, an idea at which he expressed much satisfaction' (translated from the letter reproduced in facsimile in *La Colección Lázaro*, I, 1926).

The painting was eventually brought to England and to Stratfield Saye. The Duke never liked it. By 1947 it was rolled up, but it was included in the gift to the nation by the 7th Duke of the important pictures at Apsley House. The body is not right, and the horse is not typical of Wellington's horses. All was explained when X-ray examinations (published by Allan Braham in the

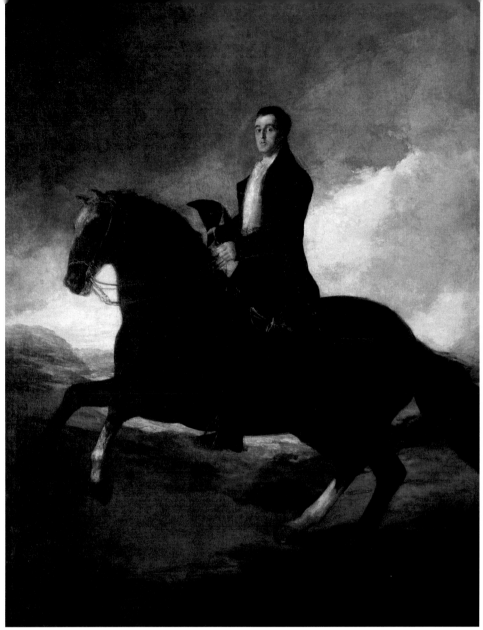

Goya 2 (and see Ill. 30)

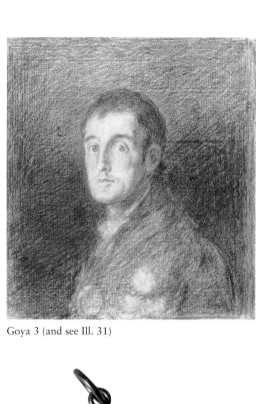

Goya 3 (and see Ill. 31)

Goya 3a

Burlington Magazine, December 1966) showed that the head of Wellington had been painted over that of another sitter, who was much shorter and wore a large curved hat with a cockade – probably Joseph Bonaparte, briefly King of Spain.

3. British Museum, London

Red chalk, 1812, 16 × 14 cm. Head and shoulders to the L, bareheaded, wearing uniform, with the Large Army Gold Medal (3a) and orders lightly sketched. Mistakenly believed by Goya's grandson to have been drawn on 22 July 1812, the day after the Battle of Salamanca. Probably made as the basis for an engraving, in which the orders would have been depicted in detail by the engraver. Bought from Messrs Colnaghi in 1862.

A drawing in pencil, which Manuela Mena of the Prado believes to be autograph, inscribed 'Lord Wellington pr. Goya', is in the Kunsthalle, Hamburg (3b). Wellington is shown wearing the Large Army Gold Medal overlaid by the Order of the Golden Fleece, awarded to him on 8 August 1812. He did not receive the Prince Regent's permission to accept the Golden Fleece until

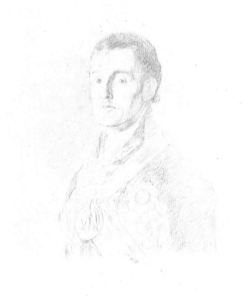

Goya 3b

September, by which time he had left Madrid. The drawing must therefore be later than September 1812, but earlier than 1814, the date when in the oil portrait (No. 1) Goya replaced the Large Army Gold Medal with the Army Gold Cross issued in October 1813. This drawing first appeared in a collection of Spanish drawings formed during the first half of the 19th century by the painter José Echeverria in Mexico. It later belonged to Mr Williams, British Vice-Consul in Seville, and was acquired in 1892/93.

4. National Gallery of Art, Washington, D.C.
c. 1812–14, 105.5 × 83.7 cm. HL, to the L, wearing cocked hat and dark blue coat held across the breast by his right hand. The ribbon of the Order of the Golden Fleece is visible. In the lower L corner is inscribed 'A. W. Terror Gallorum' (A[rthur] W[ellesley] Terror of the French). Generally considered to be by the studio of Goya, it is thought to have belonged originally to General Miguel Álava, from whom it passed through various private hands until it was purchased from a dealer in Spain by Mr and Mrs Havemeyer in 1902. Their daughter, Mrs P. H. B. Frelinghuysen, gifted it to the gallery in 1963.

Goya 4

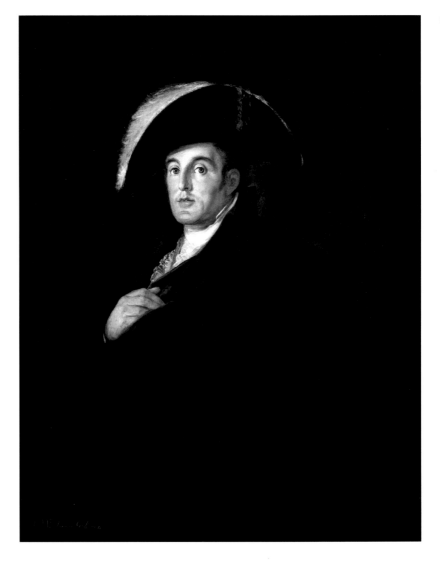

GRIMALDI, WILLIAM
1751–1830

From a Genoese family who settled in England in the 17th century. In 1764 he was bound apprentice to his uncle, the painter and etcher Thomas Worlidge. He exhibited both enamel and watercolour miniatures regularly at the RA between 1786 and 1824. His work attracted the attention of Reynolds, who recommended his work to patrons. In 1790 Grimaldi was appointed Enamel Painter to the Duke of York, in 1791 to the Duchess of York, and in 1804 to the Prince of Wales.

Grimaldi's papers record eleven enamels of Wellington, as well as fourteen watercolour miniatures, and 'out-lines for miniatures' in pencil. Only one watercolour is noted by him as being from life (see No. 2). The remainder are after Nollekens, Turnerelli, and Lawrence, or enamel copies of the original watercolour.

Grimaldi 2

1. Present whereabouts unknown
Miniature, *c.* 1805. Head and shoulders to the R, in major-general's uniform with ribbon and star of the Order of the Bath. Sold at Philips, 2 March 1987, lot 60.

2. Family Collection
Enamel miniature, *c.* 1814–15, 10.5 × 8.2 cm. HL, body slightly to the L and head to the R, right arm extended. In field-marshal's uniform with numerous decorations including the Order of the Garter, Order of the Bath, Order of the Golden Fleece, and Army Gold Cross with four clasps. The enamel is important as showing the Duke's colouring. A note by Grimaldi states that the Duke sat four times for the watercolour miniature from which the enamel was made. Exh. RA 1815, no. 555 (watercolour original), and Victorian Exhibition 1892, no. 432 (enamel). Francis Wellesley sale, Sotheby's, June 1920, lot 406 (enamel). Bought by Lord Beauchamp, who sold it to the 7th Duke in the same year.

Grimaldi 4

3. Present whereabouts unknown
Miniature, signed and dated 1819, h. 11.5 cm. Similar to No. 2, but turned to the R, and left arm extended. Sold at Christie's, 23 May 1989, lot 127.

4. Family Collection
Watercolour miniature, 3.5 × 2.8 cm. Bust in profile to the L on a blue background. Mounted on a circular tortoiseshell box.

5. Ashmolean Museum, Oxford
Enamel miniature, *c.* 1817, h. 5.9 cm (oval, clipped). *Trompe-l'œil* cameo on a reddish-brown background, bust of the Nollekens type in profile to the R.

An identical version is in the Family Collection (5a), inscribed in pencil on the reverse 'Esther Grimaldi/~~LBG BB~~' (*sic*). Esther Grimaldi Dainton was the miniaturist's sister. Purchased at Bonhams, 21 November 2012, lot 79. Another version is in the RCT.

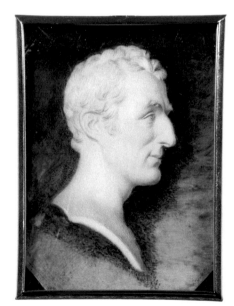

Grimaldi 5a

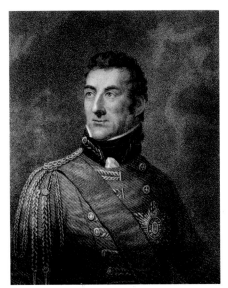

Grimaldi 6

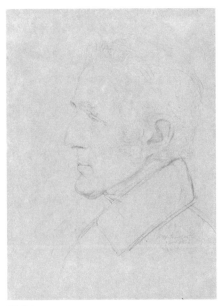

Haines 1a

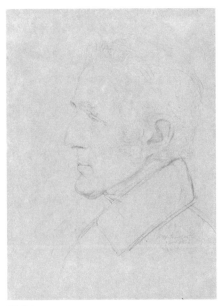

Hall 1a

6. Present whereabouts unknown
Enamel miniature, inscribed 'DUKE OF / WELLINGTON . . . / BY W GRIMALDI / ENAMEL PAINTER TO HIS ROYAL / HIGHNESS THE PRINCE REGENT / 1815', h. 9.8 cm. *Trompe-l'œil* cameo. Sold at Christie's, 5–7 September 2006, lot 62.

A similar miniature, but rectangular, dated 1817, h. 11.3 cm, was sold at Christie's, 23 May 1989, lot 122.

7. Present whereabouts unknown
Enamel miniature after Lawrence, signed and dated 1819, h. 6.4 cm. Head and shoulders, nearly full face. A note by Grimaldi in the catalogue later compiled by A. B. Grimaldi (1873) reads: 'Nineteenth enamel. From my miniature and from Lawrence's picture of the Duke on horseback in the cloak he fought in at Waterloo [Ill. 48]. Finished February 18th, 1819. Plate 2.75 × 2 inches, 0.16.0. Passing fire 15 times. 1.10.0. Labour of 32 days at 0.10.0 per day, 6.0.0. In my hands W.G. 1826.' Sold at Christie's, 23 May 1989, lot 126.

HAINES, WILLIAM
1778–1848

Engraver and miniaturist. He worked on a series of prints for John Boydell's 'Shakespeare Gallery', then exhibited miniatures at the RA between 1808 and 1830, and also showed works at the BI, SBA, and Old Watercolour Society. Many of his subjects were veterans of the Peninsular campaign.

1. Original painting untraced
Miniature, 1812. HL, looking to the L, in military uniform with ribbon and star of the Order of the Bath.

Engraved after Haines by H. R. Cook for the *Military Panorama*, inscribed 'The most Noble Arthur, Marquis of Wellington', 1812. An impression is in the BM (1a).

HALL, JAMES
1800–1854

Son of a well-known geologist, he became a semi-professional artist, chiefly painting Scottish landscapes. For portraits, he relied on the help of the *camera lucida*. He became an assistant to the sculptor Thomas Campbell (q.v.), and accompanied him to sittings with the Duke.

1a, 1b. Scottish National Galleries, Edinburgh
Two sketches in black and white chalk on grey paper, dated 1836, made in connection with the oil portrait (see No. 2).
1a: 46.4 × 35 cm, in profile, inscribed 'Walmer Castle, 1st November, 1836'.
1b: 52.6 × 37.6 cm, full face, bearing the note 'retouched from life'.
Presented in 1919 by General Archibald Stirling of Keir.

2. Family Collection

Signed and dated 1836, 93 × 71 cm. TQL, seated to the L, hands resting on the handle of his stick. Exh. RA 1838. Painted for Colonel John Gurwood, who was the Duke's private secretary and editor of his dispatches. Gurwood's stepdaughter married the 1st Viscount Esher. Bought by the 7th Duke from the Esher collection in 1935. Another version is in an English private collection.

According to letters from the Duke to Lady Burghersh, James Hall was sketching him in November 1836, working as 'draftsman to Mr Campbell' (see 1a and 1b). A note by Miss Gurwood says that the Duke sat for the portrait six times, and that Colonel Gurwood accompanied him to keep him amused.

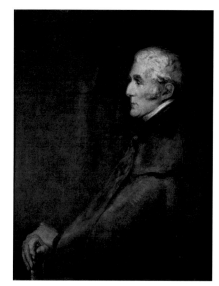

Hall 2 (and see Ill. 77)

3. Family Collection

Bronze cast of the Duke's hands, by Elkington & Co., *c*. 1840. The impression was taken by Hall in November 1836, when he was sketching the Duke. The position of the hands corresponds exactly to those in the finished portrait (No. 2). Another cast is in the NAM, and a copper version is in the RCT.

Hall 3

HARLING, WILLIAM OWEN
1813–79

Painter of portraits and genre scenes. He occasionally worked for the *Illustrated London News*.

1. Family Collection

Ink and pencil, 1852, 12.8 × 10.5 cm. The Duke in old age in profile to the L, stooping slightly. Inscribed on the reverse 'Sketchd by W. O. Harling on the night of the Royal Academy soirée, July 1852'. The party took place on 28 July, so this sketch is probably the last ever made of the Duke.

HAYDON, BENJAMIN ROBERT
1786–1846

Studied Classical art and dissection, then became a painter of narrative and historical scenes. He often clashed with patrons as well as with the RA. Financial problems forced him to undertake several portrait commissions, which he often struggled to complete, but which proved more successful than his history paintings. Having been imprisoned for debt several times, and struggling with his mental health, he eventually committed suicide.

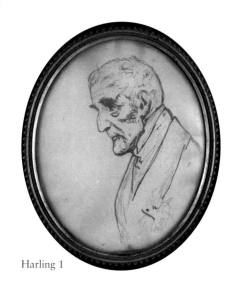

Harling 1

1. Family Collection

1839, 73.5 × 61 cm. HL, seated to the L, wearing black civilian coat and white neckcloth, no orders. Study for the work of the Duke 'musing on the field of Waterloo' (No. 2). A commission for the subject in 1835 from the printseller Boys had ended in failure, but in December 1838 in Liverpool the idea took

shape again. Approached by respectable gentlemen, this time the Duke agreed, and sat to Haydon several times in October 1839 at Walmer Castle. Haydon noted, 'I studied his fine head intensely. . . . his conversation powerful, humorous, witty, argumentative, sound, moral.' He also made quick sketches of the Duke's 'back, his hands, legs, etc.' On the front of the canvas is written 'Esse quam videre' (To be, rather than to seem), and on the back, 'Sketched from the Duke, October 1839, at Walmer, by B. R. Haydon. Never touched since it was left as it is, by desire of Lady Burghersh and Mr Arbuthnot – they thought I had hit the expression.' Purchased by the 2nd Duke of Wellington in 1873.

At the Institute of Directors there is an oil sketch of the head of the Duke with an inscription in pencil on the back attributing it to Haydon. It more closely resembles a portrait by James Hall (q.v.), who was at Walmer Castle at the same time.

2. Walker Art Gallery, National Museums Liverpool

Wellington on the Field of Waterloo, 1839, 317.5 × 254.5 cm. FL, standing, seen from behind, head in profile to the L, wearing blue, holding his hat in his left hand. To the R is Copenhagen, also seen from behind. In the distance is the Butte du Lion, raised in 1826 by the King of the Netherlands as a memorial. On the R is the monument to Lieutenant-Colonel Sir Alexander Gordon. Arms and accoutrements of battle litter the ground. Exh. Derby Fine Arts Exhibition 1877.

Haydon had explored the field of Waterloo in August to prepare 'a background for the Duke'. Copenhagen had died in 1836, and so Haydon used James Ward's image of 1824 (at Alnwick: see Ill. 51). He also did a separate painting of Copenhagen which hangs at Stratfield Saye.

The Duke had been approached about the commission from Liverpool: 'It is the wish of a great number of gentlemen of all shades of political party in this town, that our new public building called the St George's Hall, should be adorned by an historical picture of your Grace by Haydon.' The Duke scribbled on this letter: 'London, Sir I have this day received your letter . . . I am much flattered by the desire of the gentlemen of Liverpool to possess a picture of me by Mr. Haydon.' From St George's Hall the painting subsequently went to Liverpool College. It was presented to the Council in 1958, and transferred to the Gallery in 1969. There is a version of the painting in the NAM. Another, from the collection of the Duke of Sutherland, was sold at Christie's on 27 October 1961 and is now in a private collection in New York. It bears an inscription painted on the canvas, 'Ainsi se couche l'honneur. B.R.H. 1839'.

A sketch for this work, in pen and ink, was sold at Christie's on 18 March 1980, lot 29.

The composition was engraved by Thomas Lupton and published by Thomas McLean in 1843, with the title *The Hero and his Horse on the Field of Waterloo*. The engraver inscribed on a rock in the foreground the names of Wellington's battles.

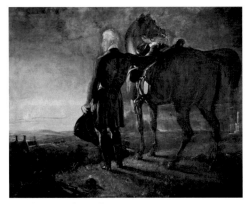

Haydon 1 (and see Ill. 84)

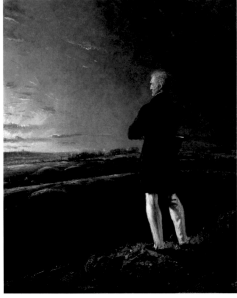

Haydon 2 (and see Ill. 85)

Haydon 3

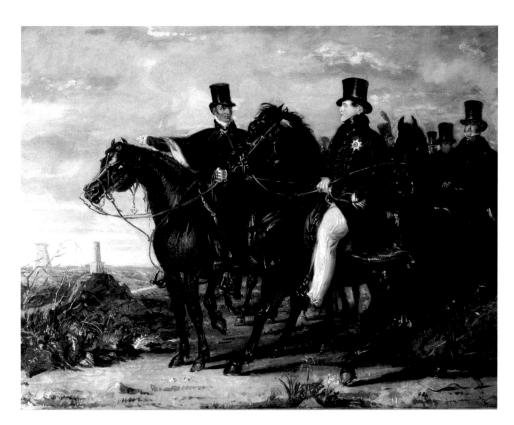

Haydon 4
(and see Ill. 86)

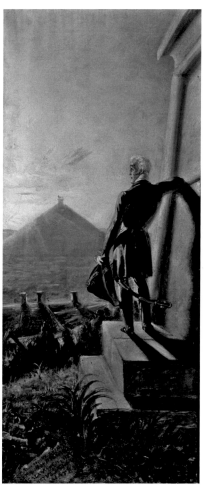

3. National Portrait Gallery, London

1839, 76.2 × 63.5 cm. FL, standing, seen from behind, bareheaded, head turned in profile to the L, arms folded with hat under his right elbow, wearing dark civilian coat and white breeches, helmet and other accoutrements on the ground, sunset in the L distance. Very similar to No. 2, but without the horse and features in the background.

4. Family Collection

The Duke of Wellington describing the Field of Waterloo to George IV, 1840, 68.5 × 89 cm. The Duke on Copenhagen indicating the field of battle with his right hand, George IV on horseback to the R. Other figures on horseback in the background to the R. In the L background the monument to Lieutenant-Colonel Sir Alexander Gordon and to the Hanoverians. The visit had taken place in September 1821. For Copenhagen Haydon again copied Ward's painting.

Another version, 146 × 175 cm, is in the collection of the Royal Hospital Chelsea.

5. Devonshire Collection, Chatsworth, Derbyshire

Panel, 1844, 100.3 × 41.9 cm. FL, in black civilian coat, his hat held in his left hand. Standing on steps, leaning on a Classical building, surveying the field of Waterloo. Butte du Lion in the background. Commissioned by the 6th Duke of Devonshire in December 1844, as a window shutter. Its companion piece depicts Napoleon musing on St Helena.

Haydon 5

Hayter, G. 1 (and see Ill. 52)

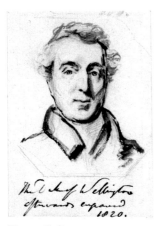

Hayter, G. 2

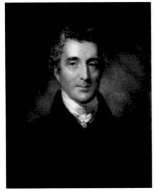

Hayter, G. 3a

Hayter, G. 4

HAYTER, SIR GEORGE
1792–1871

Son of the miniaturist Charles Hayter. Entered the RA Schools in 1808. He studied under Fuseli, and became Painter of Miniatures and Portraits to Princess Charlotte in 1815. Patronized by the 6th Duke of Bedford. In 1816 he studied in Rome, where he met Canova. On the death of Wilkie in 1841 he was made Queen Victoria's Principal Painter in Ordinary. He was knighted in 1842.

1. The Duke of Bedford, Woburn Abbey

1819, 271.8 × 236.2 cm. FL, standing in front of his horse, with his ADC, Lord William Russell. Exh. RA 1820.

A small sketch on canvas for this portrait, 52.7 × 45.1 cm, is in the Family Collection.

2. British Museum, London

Pencil and Indian ink, 1819–20, 10 × 6.5 cm. Head only, full face. Inscribed 'The Duke of Wellington / afterwards engraved / 1820.'

3. Formerly the Duke of Richmond and Gordon, Goodwood House. Present whereabouts unknown

Miniature on ivory, signed and dated 'Geo. Hayter, M.A.S.L. [Member of the Academy of St Luke] 1821'.

Engraved by John Henry Robinson. Impressions are in the NPG and in the BM (3a).

4. Family Collection

Black and white chalk, 36 × 50 cm. Head and shoulders, turned slightly to the L. Inscribed 'retouched at Walmer Castle . . . [illegible] 1836'.

5. Royal Collection Trust

The Coronation of Queen Victoria in Westminster Abbey, 28 June 1838, signed and dated 1839, 255.3 × 381 cm. Wellington is shown standing in uniform to the L of the throne, raising his coronet.

A study for the figure of the Duke is in the BM.

Engraved by Henry Thomas Ryall in 1842.

6. Family Collection

1839, 33.7 × 26 cm. Head and shoulders to the R, wearing black coat, white waistcoat and white neckcloth, with Order of the Golden Fleece. Inscribed 'Sketch at Walmer Castle for C.E.K.' (probably the Rev. Charles Edward Kennaway). A study for the head of the Duke in the picture of *The Reformed House of Commons, 1833*, now in the NPG. According to an inscription by Hayter on the back, 'This study I painted from His Grace at Walmer Castle 1839. For my Great Picture of the House of Commons in 1833 George Hayter'.

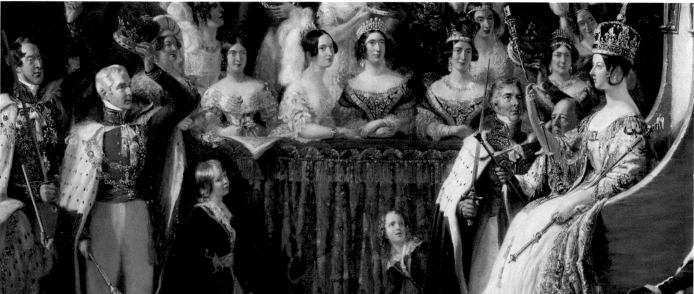

Hayter, G. 5 (complete work and detail)

Hayter, G. 6a

Hayter, G. 6

Writing to Lady Burghersh from Walmer on 29 September 1839, the Duke said: 'I am going to Church and have settled to sit to Mr Hayter at about one o'clock' (*Correspondence of Lady Burghersh with the Duke of Wellington*, p. 114).

Formerly in the collections of Dudley Crichton Stuart and T. K. Mackenzie. Bought by the 7th Duke in May 1935 from a dealer who had acquired it at Mr Mackenzie's death.

There is a related sketch in the Family Collection (6a), bought by the 7th Duke in 1960: black and white chalk on blue paper, 25.4 × 21.6 cm. Inscribed 'Originally for "C.E.K." September 29th 1839'.

7. The Earl of Sandwich, Mapperton, Dorset
1839, 34.3 × 28 cm. Similar to No. 6. Inscribed on a label on the back:
'Field-Marshal his Grace the Duke of Wellington, K.G., etc. etc. etc. This study
I painted from His Grace at Walmer Castle, 1839, for my great picture of the
House of Commons in 1833.'

8. Royal Collection Trust
Sketch for one of Hayter's groups, probably the christening of the Prince of Wales.

9. Present whereabouts unknown
Hayter's diary for 29 September 1839 notes: 'I sketched all afternoon for a fresh
whole length of His Grace as Warden of the Cinque Ports.' It is not clear whether
this painting was ever executed.

Hayter, J. 1

HAYTER, JOHN
1800–1891/95

Brother of Sir George Hayter. In 1815 he entered the RA Schools, and exhibited
annually there from that year. He also exhibited at the BI and the SBA. His
portrait of the Duke established him as an artist in the 1820s. His drawings in
crayon and chalk became particularly successful.

1. Private Collection
76.2 × 63.5 cm. Head and shoulders slightly to the L, wearing plain clothes.

2. Victoria Memorial Hall, Kolkata
1825, 127 × 101.6 cm. TQL, to the L, wearing dark military cloak, holding his
gloves in his right hand. Exh. RA 1826. Formerly Shelley family, Maresfield
Park, Sussex. Sold 23 February 1921, lot 48. Bought in 1924 for Calcutta by
Lord Curzon of Kedleston, then Foreign Secretary.
 The head and shoulders were engraved by W. Sharp and published in 1829.
Impressions are in the Family Collection and the BM.

Hayter, J. 2 (and see Ill. 59)

3. Family Collection
Black and red chalk heightened with white, c. 1825, 50 × 36 cm. Head only,
looking to the L. Although compositionally this sketch relates to No. 2, the
colour of the Duke's hair suggests a possible later date. Bought from the artist
by the 2nd Duke in 1864.
 Engraved after the Duke's death by William Henry Mote, published in 1853.

4. Formerly Sir Claud Russell. Present whereabouts unknown
c. 101.6 × 76.2 cm. Nearly HL, looking to the L, wearing plain clothes with
arms folded. Given by the Duke to Lady George Russell for her son Arthur,
the Duke's godson.
 Engraved by J. H. Robinson.

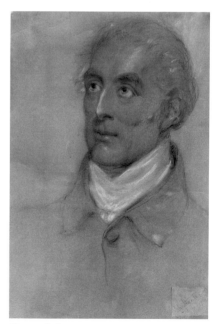

Hayter, J. 3

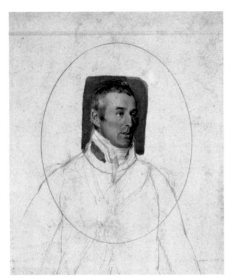

Heaphy 1a (and see Ill. 1)

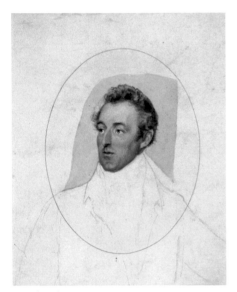

Heaphy 1b

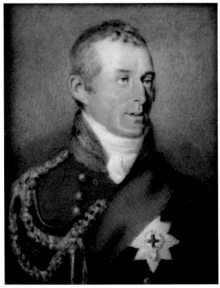

Heaphy 2 (and see Ill. 33)

HEAPHY, THOMAS
1775–1835

Apprenticed to the engraver R. M. Meadows. He first exhibited at the RA in 1797, and became Court Painter to the Princess of Wales. He was invited by Wellington to visit the British Army in northern Spain in October 1813, where he painted portraits of many of the officers as well as Wellington himself.

1a, 1b. National Portrait Gallery, London

Two studies in pencil and watercolour, 1813. Head and shoulders, of which only the heads are finished, the rest being indicated in pencil.
1a: 19 × 16 cm. Head to the R, hair short.
1b: 19.4 × 16 cm. Head to the L, hair noticeably curly.
These sketches form part of a collection of thirty-two studies for the large painting now known only from an engraving (No. 9).

2. Family Collection

Miniature in watercolour, signed and dated 'TH / 1813', 9 × 7.1 cm. Head and shoulders, head to the R, wearing military uniform with ribbon and star of the Order of the Garter. Painted at St-Jean-de-Luz in December 1813, and given by the Duke to his niece Priscilla, Lady Burghersh, who received it at the headquarters of the Allies in France in 1814. Exh. Guelph Exhibition 1891, no. 1181. Bequeathed to the 7th Duke by Rachel Weigall, Lady Burghersh's granddaughter, in 1967.

3. National Portrait Gallery, London

Watercolour, *c.* 1813, 57.2 × 40.6 cm. FL, standing, in dark blue civilian coat, white stock and white breeches, telescope held under his right arm and sword in his left. Fallen tree trunk behind him and landscape in the background. Given to the gallery by Edward Peter Jones in 1960. Another version of this was owned by Q. A. Somerville, signed and dated 1819.

4. The Duke of Buccleuch, Bowhill

Watercolour, after 1813, 65.4 × 51.4 cm. FL, in dark coat and cocked hat, with right arm extended, riding a white horse. The town of San Sebastian and the Pyrenees in the distance, with troops and mounted officers in the midground. This is a sketch for the lost picture which was engraved by Anker Smith and Heaphy (No. 9). Purchased by the 5th Duke of Buccleuch in 1852.

5. Private Collection

Pencil and watercolour, *c.* 1814, 19 × 16.5 cm. HL, to the R, in dark blue coat and white stock, telescope in his right hand and outline of a cloak held in his left. Unfinished. Sold at Christie's, 13 September 2001, lot 6.

6. The Duke of Richmond and Gordon, Goodwood House

Watercolour, 1815, 58.4 × 43.2 cm. FL, standing, head to the L, in dark coat and white breeches, hat in his right hand. Troops are seen in the background. Inscribed on the back: 'Given by Arthur, Duke of Wellington, to Charlotte, Duchess of Richmond, after the Battle of Waterloo. Painted by Heaphy'. In a letter to Lady Georgiana Lennox on 14 August 1815 Wellington writes that Heaphy is doing a picture for the Duchess, her mother.

7. Colstoun House, East Lothian

Watercolour, signed and dated 'Thos. Heaphy 1816', 57.2 × 40.6 cm. FL, head to the R, in dark coat, white stock and black boots, telescope held in his right hand, sword in his left. Standing by a large tree, with large scroll, hat, and flag marked 'N' on the ground to the L. Troops on horseback in the background. Unfinished.

8. Family Collection

Watercolour, dated on frame 1829, 54 × 43.5 cm. FL, standing, pose very similar to that of No. 3. His right hand holding a telescope is held out over the outline of an unfinished cloak on the ground behind him. Sword in his left. Landscape with troops in the background. Formerly Major Maraham, then given to Lady Churchill. It hung in the dining room of the Churchills' house in Hyde Park Gate. After Sir Winston Churchill's death, Lady Churchill sold the painting to the 7th Duke in 1965.

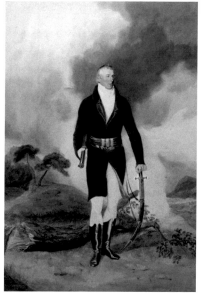

Heaphy 3

Heaphy 5

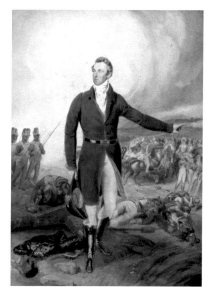

Heaphy 6

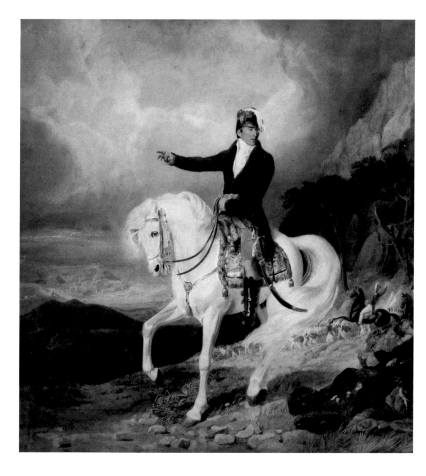

Heaphy 4

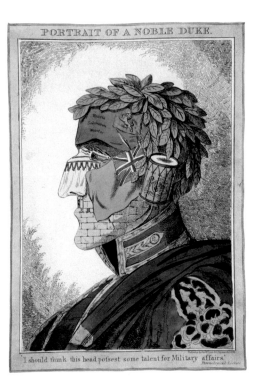

Heaphy 8 (and see Ill. 63)

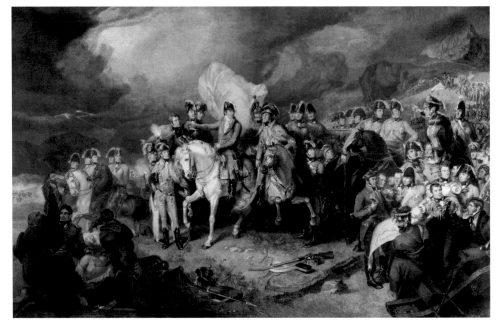

Heaphy 9 (and see Ill. 34)

A copy of this type by Pierre-Jean de Vlaamynck (1795–1850), 37 × 47 cm, was thought to have been signed and dated 1815, drawn in Brussels on the eve of Waterloo. No evidence exists to confirm that, and the current location of the work is not known. Francis Wellesley Sale, Sotheby's, 29 June 1920, lot 217.

9. Original painting untraced
Field Marshall the Duke of Wellington giving Orders to his Staff before a General Engagement. Engraving after Heaphy, begun in 1818 by Anker Smith, completed after his death in 1819 by Heaphy, published in 1822. Wellington in the centre on a white charger, in plain coat and hat, pointing with his right hand. An impression is in the Family Collection.

HEATH, WILLIAM
1795–1840

Painter and illustrator, especially known for his satirical images, sometimes published under the pseudonym 'Paul Pry'. Between 1830 and 1834 he produced a number of political satires for *McLean's Monthly Sheet of Caricatures*.

1. Family Collection
Hand-coloured etching, 1829, 34.6 × 24.7 cm. Entitled 'Portrait of a Noble Duke', and captioned 'I should think this head possest some talent for Military affairs. / Phrenological Lecture.' Head and shoulders to the L, composed of military emblems including laurel leaves, a flag, and a drum. The words 'Vittoria / Salamanca / Waterloo' are seen down the flag which makes up his forehead.

Heath 1

HOME, ROBERT
1752–1834

After training at the RA Schools, Home studied with Angelica Kauffmann in
Rome, then worked in Dublin and London. In 1790 he left for India. In Calcutta
(Kolkata) he first painted Wellington's eldest brother, the Marquess Wellesley,
Governor-General. A total of thirteen portraits of General Wellesley are listed in
Home's account-book (held at the NPG) for 1804–5: in September 1804 one FL
life-size, one small FL, one HL, and three heads, in October 1804 four more, of
which three are heads and one FL 'for Penang', in November 1804 two profile
heads, and in March 1805, a head for 'Col. Malcolm'.

Home 1

1. Royal Collection Trust

1804, 120.5 × 72.5 cm. FL, standing, slightly to the R, wearing the uniform of
a major-general, his right hand inside his coat, his left on the hilt of a sword.
The ribbon and star of the Order of the Bath are shown, but can be seen to have
been added. In the background to the L is a tent, to the R Madras infantry and
cavalry in a landscape.

Formerly owned by the Maharajah of Mysore. Presented to Queen Victoria
in 1862. Another version is in the GAC, and another is reputed to be in the
former Viceroy's Lodge, New Delhi, but it proved impossible to obtain an
image. A version in the Family Collection, which had supposedly belonged to
Lord Farquhar, a Director of the East India Company, was sold by the 7th Duke
in 1948 to his brother-in-law, Mr Bobby James.

Engraved by Charles Turner and published by R. Home in Calcutta,
15 March 1806.

Home 2 (and see Ill. 9)

2. Family Collection

1804–5, 124 × 100 cm. Related to No. 1 but TQL. The Order of the Bath is seen
outside the row of buttons, and appears to be a later addition. Purchased by the
4th Duke from Messrs Colnaghi in 1902. Another version is in the RCT.

3. National Portrait Gallery, London

1804–5, 74.9 × 62.2 cm. Related to No. 1 but nearly HL, and no orders are
shown. Transferred from the Tate Gallery in 1957. Another version of this size,
but with the sash and Order of the Bath, is in the Family Collection.

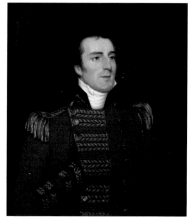

Home 3

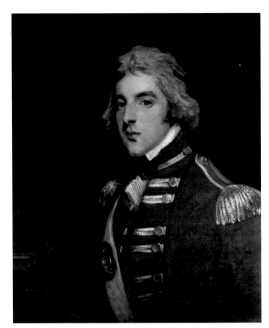

Hoppner 1 (and see Ill. 16)

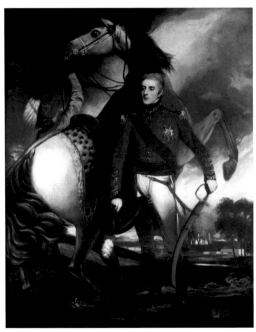

Hoppner 2 (and see Ill. 22)

HOPPNER, JOHN, RA
1758–1810

The son of Bavarian immigrants. He became a chorister in the Chapel Royal, London, and was discovered by George III who gave him an allowance to study to become an artist. He exhibited some 168 pictures between 1780 and 1809, from 1785 exclusively at the RA. In 1789 he was appointed Portrait Painter to the Prince of Wales. He became ARA in 1792 and RA in 1795.

1. Family Collection

c. 1796, 74 × 61.2 cm. Head and shoulders to the L, in the uniform of a lieutenant-colonel of the 33rd Regiment, with powdered wig. Exh. South Kensington 1867, no. 751 (together with portraits by Hoppner of three of Arthur's brothers), and Guelph Exhibition 1891, no. 156.

2. Family Collection

c. 1806–7, 251 × 199 cm. FL, standing, turned slightly to the L, wearing the uniform of a major-general with ribbon and star of the Order of the Bath, holding his hat and sword. The horse, held by an Indian servant, is Diomed, which he had lost at Assaye, but which had been found. Formerly at Government House, Madras (bought by public subscription in 1808), exchanged in 1957 with the Government of India for relics of Tipu Sultan. Two copies are in the RCT, one of which, without the horse, was commissioned by the East India Company.

 Engraved in mezzotint by W. W. Barney in 1808, by Scriven in 1810, and (in colour) by G. Clint in 1814.

ISABEY, JEAN-BAPTISTE
1767–1855

French portrait painter. After studies with François Dumont and Jacques-Louis David he received patronage from the French Imperial and Bourbon courts, and was awarded the Legion of Honour by Napoleon III. A number of copies of his portraits of the Duke were made.

1. Original painting untraced. Print in the Family Collection

The Congress of Vienna, engraving after Isabey by Jean Godefroy, published in Paris in 1819, 61 × 82 cm. Isabey travelled to Vienna in 1814 with the French delegation and made sketches of the participants (see No. 2). His great painting, of which a composition sketch of 1814 exists in the Louvre, showed the Duke along with all the other European leaders attending the Congress. Wellington is standing, far L.

 The Duke subscribed five guineas each for two impressions of the engraving, which were hand-delivered by Isabey to Apsley House in June 1820.

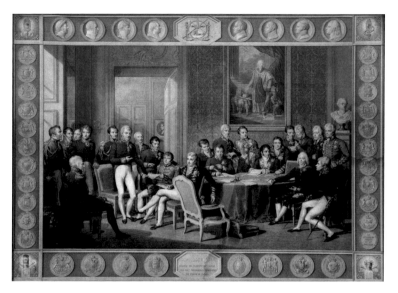

Isabey 1
(and see Ill. 39)

Isabey 2

Isabey 3

Isabey 4

Isabey 5

Isabey 6
(and see Ill. 40)

2. The Ethelston Collection

Sepia and wash, 12 × 19 cm. Head and shoulders to the R, looking straight at the spectator, in military uniform. Thought to be a sketch taken at the Congress of Vienna in 1814–15.

3. Private Collection, England

Miniature, 1816, 13.5 × 9.8 cm. As in No. 2, in red military uniform. Given by the Duke to his friend Lady Frances Wedderburn-Webster. On her death the portrait was left to her husband, who used it as security for a loan which was not repaid. The descendant of the lender still owns the work.

This may be the version that was engraved by André Joseph Mécou in 1817. An engraving by J. Cochran of this type includes a scroll in the right hand. Impressions of both are in the BM.

4. Family Collection

Watercolour miniature, signed and dated 'Isabey 1817', 13.7 × 10.5 cm. Similar to Nos. 2 and 3. Perhaps by Isabey's studio.

5. Wallace Collection, London

Watercolour miniature, signed and dated 'J. Isabey 1818', 14.2 × 10.8 cm. Pose as in Nos. 2–4, wearing a dark grey-blue coat with orders including the Golden Fleece. Bought in Paris in 1852 for the 4th Marquess of Hertford.

A copy showing the Duke in red coat and (wrongly) with brown eyes is also in the Wallace Collection. On the back of it is written: 'Peint par ordre de Sa Majesté pour son Cabinet particulier 1818'.

6. Family Collection

Watercolour miniature, signed and dated 'J. Isabey 1821', h. 13 cm. Similar to No. 5, with the Order of the Golden Fleece. Given by the Duke to the Marquesa de Santa Cruz, wife of the Spanish Ambassador in Paris.

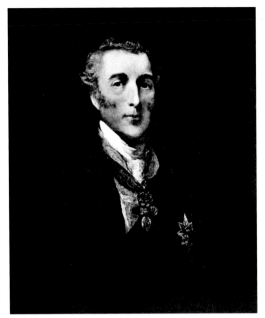

Jackson 1

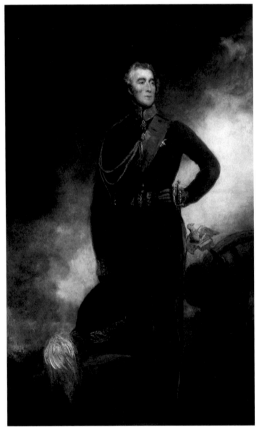

Jackson 3 (and see Ill. 58)

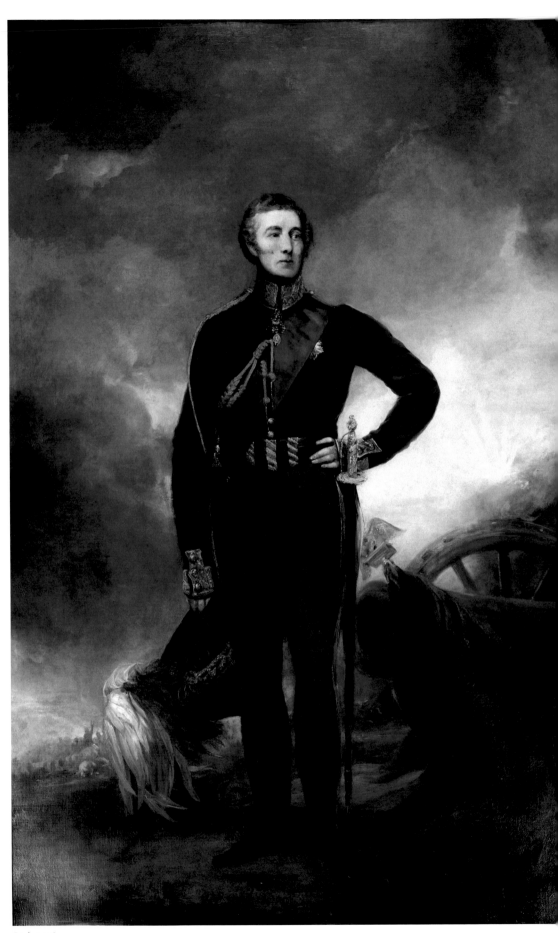

Jackson 2

JACKSON, JOHN, RA
1778–1831

Apprenticed to his father as a tailor, but with the support of patrons he entered the RA Schools in 1804. He became ARA in 1815 and RA in 1817, and a successful portrait painter. He travelled to the Netherlands in 1816 and to Rome with Sir Francis Chantrey in 1819. His friends also included Sir David Wilkie and Benjamin Robert Haydon.

1. The Earl of Jersey, Radier Manor
1824, 76.2 × 63.5 cm. HL, to the R, wearing a dark blue civilian coat with star of the Order of the Garter and Order of the Golden Fleece. Exh. RA 1827. Painted for the Duke's friend Sarah, Countess of Jersey.

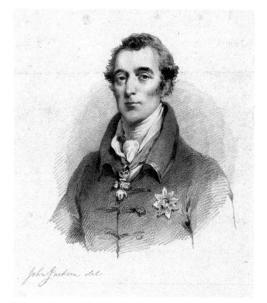

Jackson 4

2. Carlton Club, London
c. 1827, 107.9 × 63.4 cm. FL, standing, with head to the R. In Portuguese field-marshal's uniform, his left hand on his hip and his right holding his hat. Cannon, French standard, and troops in the background. Exh. RA 1827, no. 65.

 A copy of this portrait, attributed to Mrs Dorofield Hardy, is in the Army and Navy Club, London.

3. Chevening House, Kent
c. 1827, 60 × 37 cm. As in No. 2, with ribbon and star of the Order of the Garter. Painted for General the Hon. Edmund Phipps. Bought in 1859 by the 5th Earl Stanhope. Chevening was gifted to the Government in 1967 after the death of the 7th Earl.

4. Original work untraced. Print in the National Portrait Gallery, London
Lithograph after Jackson by R. J. Lane, published by Joseph Dickinson in 1828, 14.2 × 11.9 cm. Head and shoulders slightly to the L, wearing a civilian coat with star of the Order of the Garter and Order of the Golden Fleece. Inscribed 'From a sketch by John Jackson, R.A., in possession of John Jackson, Esq.'

 An oval miniature based on this print, by Johann Baptista Vanacker (1794–1863), was sold at Christie's, 7 November 1988, lot 81.

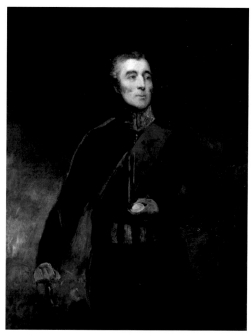

Jackson 5

5. National Portrait Gallery, London
1830–31, 125.7 × 100.3 cm. TQL, head to the R. In Portuguese field-marshal's uniform, with ribbon of the Order of the Garter, his right hand on his sword hilt, his left holding a medal. Unfinished. The portrait was bought in 1911.

Jaquotot 1

Jaquotot 2

Jaquotot 3

JAQUOTOT, MARIE-VICTOIRE
1778–1855

French porcelain painter. She studied under Etienne Charles Le Guay (q.v.) and was employed at the Sèvres factory. Established in her own right, she took private commissions and trained pupils in her Paris studio. She became Painter to Louis XVIII.

1. Royal Collection Trust
Pencil, 1817, h. 14.6 cm. Nearly HL, to the L, bareheaded, wearing military uniform, with the ribbon and star of the Order of the Garter and badge of the Order of the Golden Fleece. The drawing bears a contemporary inscription: 'Wellington d'après nature [from life] fait chez Madame Jaquetot à Paris 1817'.

2. Private Collection, England
Miniature on porcelain, 1817. Head and shoulders, slightly to the L, wearing a dark blue uniform coat with gold epaulettes and red facings. Shown as Colonel of the Royal Horse Guards (the Blues), with ribbon and star of the Order of the Garter and Order of the Golden Fleece. Inscribed on the back: 'Le Duc de Wellington peint sur porcelaine par Madame Jaquotot Peintre du Cabinet Paris 1817'.

3. Family Collection
Miniature on ivory backed on card, after Robert Lefèvre (q.v.), signed with monogram and dated 'J. 1819', h. 7.6 cm. Head and shoulders, to the R, in field-marshal's uniform with sash and Order of the St-Esprit and Order of the Golden Fleece. A tent in the background. Bequeathed to the 7th Duke by Sir Victor Wellesley.

JOSEPH, SAMUEL
1791–1850

A cousin of the portraitist George Francis Joseph and a student of Peter Rouw. He studied at the RA Schools in 1811 and exhibited there from that year until 1846, when he was declared bankrupt.

1. Victoria and Albert Museum, London
Parian porcelain bust made by Minton & Co., Stoke-on-Trent, 1847, h. 36 cm. Looking to the L, in Classical dress.

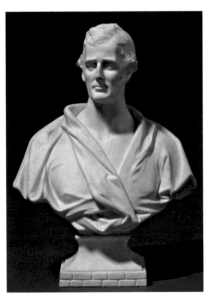

Joseph 1

LANDSEER, SIR EDWIN, RA
1802–73

Best known as a very successful painter of animals. After studying under his father and Benjamin Robert Haydon, he exhibited works at the RA from the age of thirteen. He became ARA at twenty-four and RA in 1831. In 1826 the Duke commissioned *The Illicit Highland Whisky Still*, possibly on the advice of Sir Walter Scott. The painting now hangs at Apsley House. In 1866 Landseer declined the position of President of the Academy. Plagued with mental health problems throughout his adult life, he was declared insane in 1872.

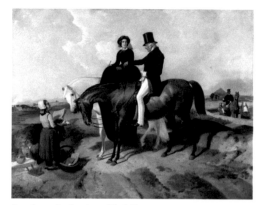

Landseer 1a (and see Ill. 94)

1. Tate Britain, London

A Dialogue at Waterloo, 1837–50, 193.7 × 388 cm. The Duke is shown visiting the battlefield of Waterloo with Lady Douro. Both are on horseback, he in profile to the L, in dark coat and top hat. At the L a small girl offers the pair a souvenir of the battle. Beyond her are her peasant family, paused for lunch, and a farmer with workhorses. The subject is invented, but Landseer visited the battlefield with Charles Dickens in order to make sketches. Exh. RA 1850.

An engraving by T. L. Atkinson was published in 1855.

A copy, omitting the left third, is in the Family Collection (1a).

LAWRENCE, SIR THOMAS, PRA
1769–1830

Initially a child prodigy, largely self-taught, though he studied at the RA Schools in 1787. He received his first royal commission in 1790, when he painted Queen Charlotte. He became the Prince Regent's favourite artist. In 1815 he was knighted, and in 1818 he was sent to Aix-la-Chapelle, where he painted portraits of those attending the Congress. He had become RA in 1794, and on the death of Reynolds in 1820 became President. At his death he left behind a collection of Old Master paintings and drawings, some of which were offered to the nation, but refused.

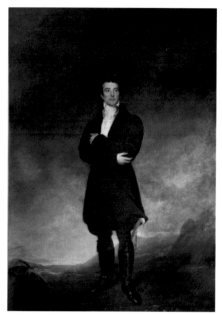

Lawrence 1 (and see Ill. 35)

1. The Marquess of Londonderry, on loan to the Wellington Collection, Apsley House

1814, 266 × 174 cm. FL, standing, to the L, with head slightly to the R, arms folded, wearing a dark uniform. Commissioned by Lord Stewart, later 3rd Marquess of Londonderry.

2. Royal Collection Trust

1814–15, 317.5 × 225.5 cm. FL, nearly full-face, standing in a portico wearing field-marshal's uniform and holding the Sword of State in his right hand and plumed hat in his left. On a ledge below the sword is a letter addressed to him signed 'George P.R.' With the Order of the Golden Fleece, ribbon and collar of the

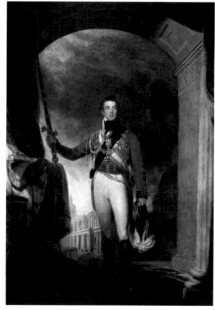

Lawrence 2 (and see Ill. 36)

Lawrence 3 (and see Ill. 45)

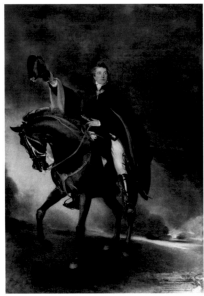

Lawrence 4 (and see Ill. 48)

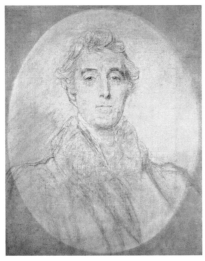

Lawrence 5 (and see Ill. 55)

Order of the Garter, star of the Order of the Tower and Sword of Portugal, ribbon of the Order of Maria Theresa of Austria, and Order of the Sword of Sweden. Commissioned by the Prince Regent. Exh. RA 1815, no. 109, and BI 1830, no. 9.

Engraved by W. Bromley and others.

A small copy of this work, bought by the 7th Duke in 1922, is in the Family Collection.

3. Wellington Collection, Apsley House

1817–18, 91.5 × 71 cm. HL, nearly full-face, with arms folded, wearing field-marshal's uniform, with Order of the Golden Fleece, ribbon and star of the Order of the Garter, and Grand Cross of the Order of the Bath. Exh. South Kensington 1868, no. 199, and NPG 'Sir Thomas Lawrence', 1979, no. 30.

Commissioned by the Duke for Mrs Marianne Patterson, later Marchioness Wellesley, who bequeathed it to the 2nd Duke in 1853. Mrs Patterson's portrait, commissioned at the same time, is still in the Family Collection.

A copy of this type by William Evans, with a clock seen over the R shoulder, was engraved by H. T. Ryall.

4. The Earl Bathurst, Cirencester Park, Gloucestershire

1817–18, 396 × 244 cm. FL, equestrian, riding to the L on his charger Copenhagen. Wearing a cloak and white breeches, holding in his left hand with the reins a telescope, and in his right hand with arm extended a hat. The horse turns his head away to the offside. In the bottom R corner is this inscription: 'HANC / ARTHURI DUCIS DE WELLINGTON / IMAGINEM / QUALEM SESE HABUIT IN PROELIO ISTO / APUD WATERLOO / QUOAD VESTITUM, ARMA, EQUUM, EPHIPPIA / THOMAS LAURENTIUS EQUES / AEVI SUI PICTORUM FACILE PRINCEPS / FIDELITER EXPRESSIT A.S. 1818' (This image of Arthur Duke of Wellington as he appeared at the battle of Waterloo, so far as concerns his clothing, weapons, horse and horse trappings, Thomas Lawrence Knight, easily first among the painters of his time, faithfully represented in the Year of Salvation 1818). Commissioned by Lord Bathurst. Exh. RA 1818, no. 165.

Engraved by W. Bromley.

Replicas were painted by Lawrence for the Grand Duke Michael and J. J. Angerstein. A copy by George Henry Harlow, Lawrence's pupil, was sold at Christie's, 29 September 1977, lot 18.

5. National Portrait Gallery, London

Pencil and chalk, c. 1820, 63.5 × 52 cm. Head and shoulders, full-face, wearing stock and civilian coat. An engraving by Frederick Christian Lewis was published by Hodgson and Graves in 1840. A note on the back of the frame written by Sir Henry Russell, 2nd Bt, records that he bought the drawing from Messrs Graves in 1842, and that 'it must have been made about 1816'. The appearance of the sitter, however, suggests a slightly later date. Formerly Arthur Russell, Swallowfield Park, Reading. Bought by the NPG in 1969.

6. Private Collection, Yorkshire

1820, 76 × 65 cm. Head and shoulders, full-face, wearing a cape round his shoulders with a velvet collar, white stock, and the Order of the Golden Fleece. Exh. RA 1822, BI 1865, and Burlington House 1896.

Painted for Charles and Harriet Arbuthnot, and included in the A. Arbuthnot sale at Christie's, 29 June 1878, lot 88, where it was bought by Archibald Primrose, 5th Earl of Rosebery. Sold at Christie's, 5 May 1939, lot 81, to W. U. Goodbody. By descent until sold at Christie's, 22 November 2006, where it was bought by the current owner. This is one of the most important of all the portraits of the Duke.

Miniature copies by William Essex (q.v.) and by George Raphael Ward (on ivory, signed and dated 1828, 11.5 × 9.8 cm, see Ill. 107) are in the Family Collection .

Prints were made by engravers including E. McInnes, W. Dean Taylor (1827), S. Cousins (mezzotint, 1828), J. R. Jackson, H. T. Ryall, George Raphael Ward and S. F. Smith (1848), H. Robinson, J. Outrim, and William Dean Bromley.

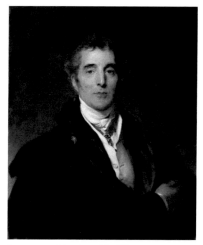

Lawrence 6 (and see Ill. 54)

7. Original work untraced. Print in the Family Collection

Engraving after Lawrence by Frederick Christian Lewis, 59 × 44 cm. Head and shoulders, slightly to the L, in white stock and dark coat. This could be based on a lost earlier sketch.

8. Formerly Lady Lucas, Wrest Park. Present whereabouts unknown

Sketch on canvas, *c.* 1822. Small FL, full-face, wearing military uniform and holding a telescope in his right hand, hat held downwards in his left. Similar to No. 9 but not identical to it. Inscribed on the frame: 'By Lawrence, sketch for portrait of 1822.' Not included in the Wrest sale, 1917. Bought in 1918 by Messrs Leggatt and sold to the collector Kojiro Matsukata of Tokyo. Sold by him in 1928. Illustrated in the *Catalogue of the Matsukata Collection of Western Art* (Kobe City Museum, 1990, p. 245, no. 914).

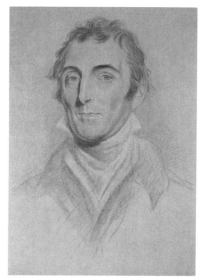

Lawrence 7

9. Wellington College, Berkshire

1824–25, 241 × 140 cm. FL, standing, full-face, wearing black white-lined cape and blue military uniform, arms folded, telescope in his right hand. Painted for Sir Robert Peel, 2nd Bt. Exh. RA 1825, no. 71, BI 1830, no. 53, Victorian Exhibition no. 71, no. 28. Sold by the Peel Trustees at Robinson and Fisher's, 25 November 1909, no. 190. Bought by Wellington College.

Engraved by Samuel Cousins in 1847.

A TQL version is in the Huntington Collection, San Marino, California.

A good copy by Spiridone Gambardella (*c.* 1815–68) was bought from the artist by the 2nd Duke in 1860 and is now in the Wellington Collection, Apsley House.

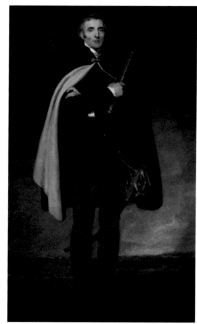

Lawrence 9

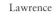

Lawrence

10

Lawrence 11
(and see Ill. 64)

10. Private Collection, Ireland
1829–30, 242 × 157.5 cm. FL, standing, similar to No. 1. Commissioned by
the 1st Duchess of Wellington. Unfinished at Lawrence's death and completed by
his pupil John Simpson (q.v). Lawrence sale, Christie's, 18 June 1831, lot 114.
Sold again at Christie's, 26 November 2002, lot 46.

11. The Clode Collection
c. 1829, 96.5 × 76 cm. HL, only the head completed, slightly to the R. Painted
for Sarah, Countess of Jersey, who, on the death of Lawrence, refused to have
it finished by any other hand. Recently acquired from Lady Jersey's descendants
at Sotheby's, 4 December 2013, lot 42.

12. Wellington Collection, Apsley House

Studio copy, *c.* 1830, 28 × 23 cm. Head and shoulders, slightly to the R. Unfinished. Almost exactly the same composition as No. 11. Formerly attributed to John Simpson (q.v.). On the back is a label reading 'Sir John Beckett, 11 Stratford Place'.

13. The Duke of Buccleuch, Bowhill

62 × 51 cm. Head and shoulders, nearly full-face, wearing brown coat with white neck-cloth. Unfinished. The Bowhill catalogue, no. 677, states that this portrait was painted for Sir Robert Peel, but no authority is given. Close to No. 11. Like No. 12, it appears to be a work of the studio, possibly with the involvement of Simpson (q.v.).

14. Present whereabouts unknown

74 × 62 cm. Head and shoulders, full-face, bareheaded, wearing a dark cloak and white stock. Sold at Sedelmayer, Paris, 1913, no. 85, stated to be from the collections of Colonel Ward and Sir George Donaldson.

LEFÈVRE, ROBERT
1755–1830

Lefèvre studied under Jean-Baptiste Regnault and became one of Napoleon's favourite portrait painters. For a portrait of the restored monarch Louis XVIII he was awarded the Legion of Honour, and became First Painter to the King. His career was ruined by the July Revolution, and he committed suicide by cutting his throat on the night of 2 October 1830.

1. Original painting untraced

Head and shoulders, to the R, in field-marshal's uniform with the Order of the Golden Fleece and the sash and star of the Order of the St-Esprit. Sold at Couturier-Nikolay, Paris, 31 March 1995.

An engraving was produced by Baudran, of which an impression is in the Family Collection (1a). It also served as model for a miniature by Marie-Victoire Jaquotot (q.v.).

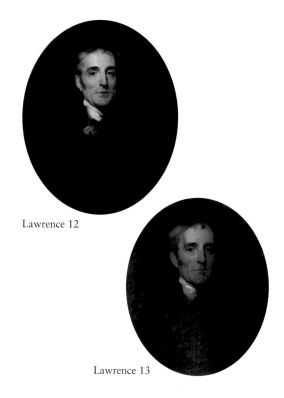

Lawrence 12

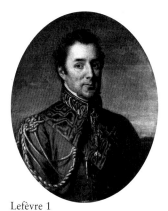

Lawrence 13

Lefèvre 1

Lefèvre 1a

Le Guay 1

LE GUAY, ETIENNE CHARLES
1762–1846

Arguably one of the most important Sèvres porcelain painters of the day.
He worked at the factory, with interruptions, from 1771 to 1840.

1. Private Collection, New York

Miniature on porcelain, 1815, h. 16.7 cm. HL, in profile to the L, in field-marshal's uniform with Order of the Golden Fleece and ribbon and sash of the Order of the Garter. Inscribed on the reverse 'L. GUAY. PXIT. / IER. PEINTRE DE LA MANUFACTURE ROYALE DE SEVRES. / 1815'. Sold at Sotheby's, 9 June 1994, lot 65, and Christie's, 11 March 1996, lot 257, where it was bought by the present owner.

This appears to be after Amatucci (q.v.).

LESLIE, CHARLES ROBERT, RA
1794–1859

Painter of history subjects and portraits, and biographer of John Constable. Born to American parents in London, where he lived until he was five. He was apprenticed to a publisher in Philadelphia. In 1811 the Pennsylvania Academy of Fine Arts raised funds so that he could study in Europe, and he returned to London. In 1813 he entered the Academy Schools. He became ARA in 1821 and RA in 1826, exhibiting 76 works at the RA and 11 at the BI. In 1848 he became Professor of Painting at the RA.

1. Royal Collection Trust

Queen Victoria receiving the Sacrament at her Coronation 28 June 1838, 1838–39, 187.6 × 97 cm. Wellington seen FL to the R of the Queen, in military uniform with with ermine cloak pushed back and baton in R hand. Exh. RA 1843.

2. Royal Collection Trust

The Christening of Victoria, The Princess Royal, 10 February 1841, 1841–42, 129.5 × 184 cm. Wellington is to the L of the Queen, FL, in field-marshal's uniform with Order of the Golden Fleece and the Waterloo Medal. He was standing proxy for the Duke of Saxe-Coburg-Gotha, one of the Princess Royal's royal sponsors. Leslie asked Lord Melbourne if he could paint the scene, and the Queen agreed.

Engraved by Henry Thomas Ryall, 1849. An impression is in the Family Collection.

3. Family Collection

c. 1848, 78.7 × 54.6 cm. FL, full-face, standing with his daughter-in-law, Lady Douro, on the staircase at Buckingham Palace, wearing evening dress, the ribbon of the Order of the Garter and the Order of the Golden Fleece. Originally in the collection of the Baroness Burdett-Coutts. Bought at the Burdett-Coutts sale in 1922 by the 7th Duke.

Leslie 3 (and see Ill. 95)

Leslie 1

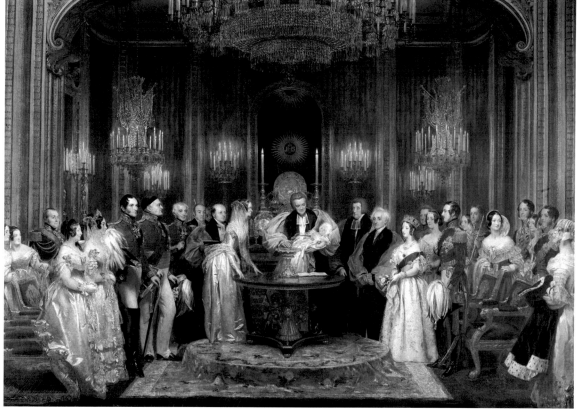

Leslie 2

Leslie 4

Leslie 5

Leslie 6a

4. Wellington Collection, Apsley House

c. 1848, 39.7 × 34.5 cm. FL, standing, to the L, seen partially from behind, wearing evening clothes with star of the Order of the Garter, and ribbon of the Order of the Golden Fleece just visible. The Duke is represented at a party given by the Baroness Burdett-Coutts, looking at a bust of Napoleon. Painted from observation rather than from sittings (see No. 6).

5. Family Collection

c. 1848, 39 × 33 cm. The Duke in a posture identical to No. 4, but looking at a bust of George Washington. More highly finished, this formerly belonged to the Duke's second son, Lord Charles Wellesley.

6. British Museum, London

Watercolour, *c.* 1848, 33 × 17 cm. FL, standing, to the L, seen partially from behind, wearing court dress and holding his hat in his left hand. The pose is similar to that in Nos. 4 and 5. Said to have been painted in the Baroness Burdett-Coutts's house.

Engraved by Paul Gauci. Impressions are in the BM and in the Family Collection (6a).

L'EVÊQUE, HENRI
1769–1832

Born in Geneva, where he became a member of the Academy. From 1812 to 1823 he worked in London, where he was appointed Enamel Painter to Princess Charlotte. In 1812 he published a series of engravings of the Peninsular War battles dedicated to the Earl of Wellington (the title held between February and August 1812).

1. Family Collection
Watercolour, 1814–15, 49 × 42.5 cm. FL, standing, looking to the R, holding a telescope. A tent and fortress in the background.

An engraving by J. Vendramini with a dedication to the Emperor of Russia was published by L'Evêque in 1814. Another was published by Colnaghi in 1815. Impressions of the latter are in the Family Collection and in the BM.

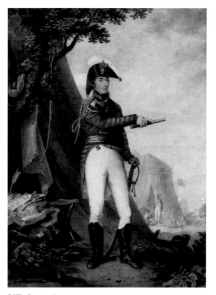

L'Evêque 1

2. Family Collection
Engraving after and by L'Evêque, 1814–15, 41.5 × 31.5 cm. FL, standing, in military uniform, with various orders including the Golden Fleece. Telescope in his right hand, pointing with his left. On the L a tent and tree, hat, maps, and writing materials. A military encampment in the distance. Published by Colnaghi in 1815.

LILLEY, JOHN
1813–1901

Very little about Lilley's artistic life is recorded. He contributed works to the RA from 1834 to 1846.

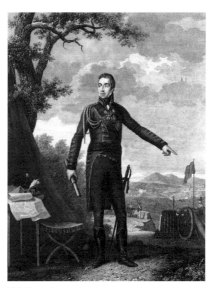

L'Evêque 2

1. Family Collection
Chalk on canvas, 1836, 49.4 × 36.3 cm. Head only, full-face, life-size. A preliminary sketch for the paintings at Dover and Salters' Hall. Formerly the 4th Duke of Wellington at Ewhurst Park, Basingstoke, acquired from Constance Lilley, the artist's daughter, in around 1915.

This sketch was used on the front cover of Christopher Hibbert's *Wellington: A Personal History* (Harper Collins 1997), wrongly attributed to Lawrence.

Similar sketches are in the Shipley Art Gallery in Gateshead and in a private collection in Wales.

2. Family Collection
Pencil on green-tinted paper, 1836, 18.5 × 15.8 cm. TQL, seated to the R, wearing black civilian clothes. Drawn at Walmer in 1836, at the same time as the sketch formerly at Ewhurst (No. 1). Inscribed 'Walmer, 1836'. Formerly in the possession of Constance Lilley, sold in 1933 to the 7th Duke.

Lilley 1 (and see Ill. 75)

Lilley 2

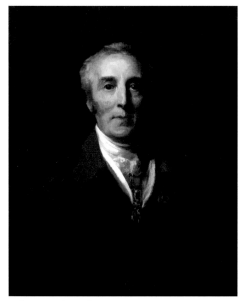

Lilley 3 (and see Ill. 74)

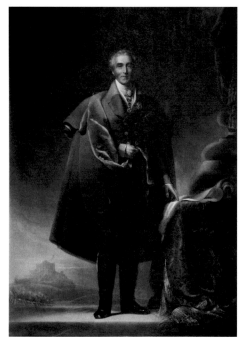

Lilley 3a

3. Town Hall, Dover

1836–37, 75 × 62 cm. Head and shoulders, full-face. Painted for the Mayor and Corporation of Dover. Exh. RA 1837, no. 268. Cut down. Originally 269 × 178 cm, depicting the Duke FL, standing, by a table, wearing a cloak that covered his right arm.

The original composition is recorded in an engraving by James Scott, 1838 (3a).

4. Formerly Salters' Hall, London. Destroyed

c. 1845, c. 335 × 274 cm. Equestrian, riding to the R, facing the spectator, wearing field-marshal's uniform and holding his hat in his right hand. Commissioned by the Salters' Company in 1845. They paid 200 guineas. It is not clear whether the painting was completed from sittings.

It hung above the staircase in the grand Salters' Company Hall in St Swithin's Lane. At the start of the Second World War many of their pictures were removed for safekeeping, but this one was too big to move. It, and the entire building, were destroyed in a fire during the Blitz on 10/11 May 1941. Fortunately an engraving of the painting by James Scott had been published in 1853, of which an impression is in the Family Collection (4a).

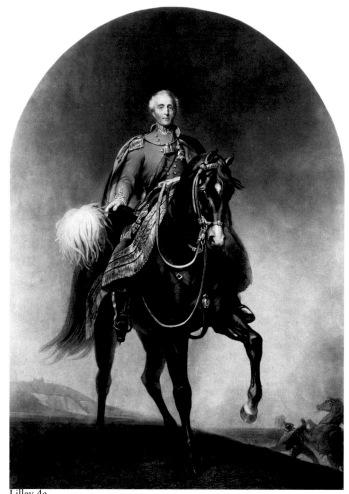

Lilley 4a

LONSDALE, JAMES
1777–1839

Born in Lancaster, studied briefly with George Romney, joined the RA Schools, and became an extremely successful portrait painter. He exhibited regularly at the RA from 1802, and also at the SBA, of which he was involved in the foundation. He became Portrait Painter in Ordinary to the Duke of Sussex and to Queen Caroline.

1. British Embassy, Vienna (Government Art Collection)

1815, 236 × 145 cm. FL, standing, in field-marshal's uniform with orders, right hand extended and left hand holding a telescope in the crook of his arm. Battle scene in the background. Purchased from Legatt Bros, October 1961.

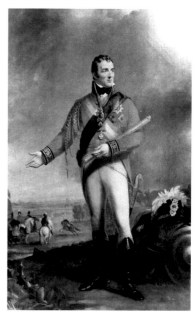

Lonsdale 1

LUCAS, JOHN
1807–74

Began as an apprentice to mezzotint engravers, then became a portrait painter and established a successful practice. He exhibited 96 pictures at the RA between 1828 and 1874, as well as 13 at the BI.

1. Trinity House, London

1839, 238 × 150 cm. FL, standing, slightly to the R, with arms folded. Wearing uniform of the Master of Trinity House, with Star of the Order of the Garter, the Order of the Golden Fleece, and other orders. A table with papers is to the R and the Tower of London seen in the distance to the L. Painted for the Elder Brethren of Trinity House, from sittings given at Walmer Castle. On 2 September 1838 the Duke writes to Lady Burghersh, reporting that Lucas has an order to paint the picture (*Correspondence of Lady Burghersh with the Duke of Wellington*, p. 170).

 Engraved by Henry Cousins.

 A replica of the head and shoulders of this portrait is in the Lady Lever Art Gallery, Port Sunlight (1a). Inscribed on the back of the canvas: 'By permission of the Duke of Wellington this portrait of his Grace was copied by Mr Lucas from the one painted by him for Trinity House, 1839. A. Clare.' On a paper label on the back of the canvas is written: 'The Duke of Wellington; given to Dr Nevins by Lady Clare, at whose request the Duke sat for it. By John Lucas . . .' (The last few words are illegible.) Bought at Christie's, 16 April 1923, lot 103.

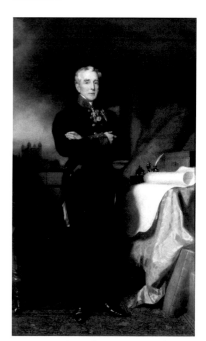

Lucas 1 (and see Ill. 79)

2. Examination Halls, Oxford

1839, 269 × 178 cm. FL, standing, slightly to the R, wearing robes of the Chancellor of the University of Oxford over court dress, with ribbon and star of the Order of the Garter and Order of the Golden Fleece, hat held downward in his left hand. A table to the R and a stained-glass window in the background. Painted at the charge of the Duke in response to a request from the University dated 1835. In a letter to Lady Burghersh in March 1839, from Stratfield Saye,

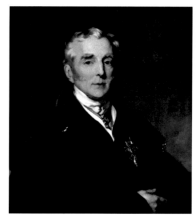

Lucas 1a

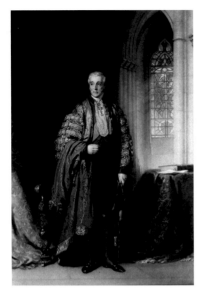

Lucas 2a

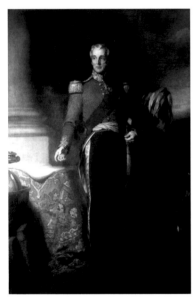

Lucas 3

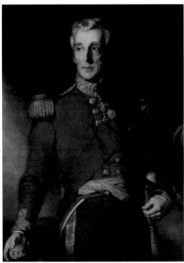

Lucas 4 (and see Ill. 83)

the Duke states that he sat to Lucas. The finished picture was delivered in December 1839. It originally hung in the Bodleian Library.

Engraved by Samuel Cousins, 1841. An impression is in the Family Collection (2a).

3. Hampshire County Council

1839, 230 × 158 cm. FL, standing, to the L, as Lord Lieutenant of Hampshire, wearing ribbon and star of the Order of the Garter and the Waterloo Medal. Painted for the Magistrates of the County of Hampshire. Lucas was working on this at Walmer in October 1839. Exh. RA 1840, no. 307. Formerly on display in the Town Hall in Winchester.

Engraved by John Lucas, 1841.

4. Chevening House, Kent

1839–40, 127 × 101.6 cm. Pose as in No. 3, but TQL. Painted for Lord Mahon, later 5th Earl Stanhope. The canvas bears the date 8 November 1839, thought to be the date of another sitting.

5. Formerly Arthur Somerset, Castle Goring, Sussex. Destroyed

c. 1839, 50 × 38 cm. Head and shoulders, oval, said to have been cut from an unfinished FL. Castle Goring was requisitioned by the army during the Second World War. Its paintings survived the war in a local storage facility, but were destroyed by a fire in 1947.

6. Present whereabouts unknown

A portrait for the Duchess of Cambridge is known to have been painted by Lucas in 1840 (Arthur Lucas, *John Lucas*, p. 35). Efforts to trace this have been unsuccessful.

7. Oxford and Cambridge Club, London

1841, 269 × 178 cm. Nearly identical to the portrait at Oxford (No. 2) but with variations in the background. The Duke gave sittings at Stratfield Saye in 1841.

8. Plas Newydd, Wales (National Trust)

1841–42, 244 × 167.5 cm. FL, standing, slightly to the L, wearing field-marshal's uniform and red-lined cloak, plumed hat held in his left hand, a telescope in his right. Standing in a landscape, a cannon behind him to the L. Painted at the expense of the Duke as a present to the 1st Marquess of Anglesey, for which he paid 200 guineas.

A replica was painted by Lucas for the Drapers' Company in 1851–52.

9. Present whereabouts unknown

A portrait was also commissioned by the Earl of Clare in 1842, a full-length version of the Trinity House portrait (Arthur Lucas, *John Lucas*, p. 28).

**10. Formerly HRH the Duke of Brunswick, Herrenhausen, Hanover.
Presumed destroyed**

1842, 304 × 228.6 cm. FL, equestrian, riding to the R, wearing field-marshal's uniform and blue white-lined cloak, with ribbon and star of the Order of the Garter and Order of the Golden Fleece, hat held in his right hand. Landscape background with a castle on a hill in the distance. Painted for the King of Hanover. Herrenhausen Castle was destroyed by British bombers on 18 October 1943. Some of the works of art in the castle had been removed at the outset of war, but no trace of this painting has been found since the attack.

11. Irish National Portrait Gallery, Dublin

1842, 96.5 × 73.6 cm. HL, nearly full-face, wearing field-marshal's uniform, with plumed hat and ribbon and star of the Order of the Garter and Order of the Golden Fleece. Unfinished. Purchased at the sale of the artist's pictures in 1875 for £20. Catalogued as being either a study for or a replica of the King of Hanover's picture. A similar unfinished sketch of the head and hat only is in the collection of Michael Hulse, Breamore House, Hampshire.

Lucas 7

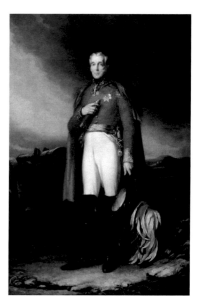

Lucas 8 (and see Ill. 87)

Lucas 11

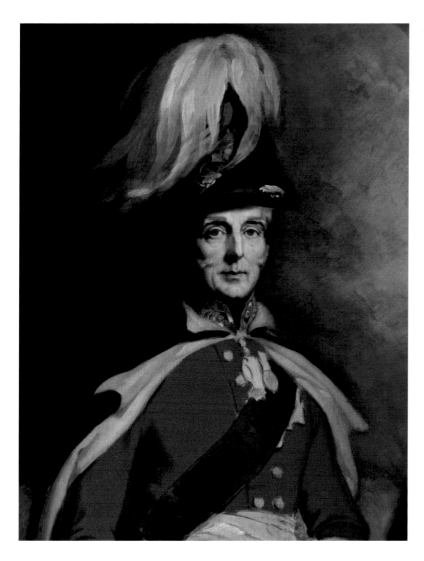

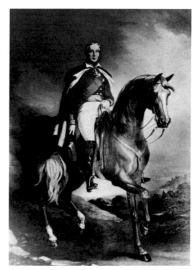

Lucas 10

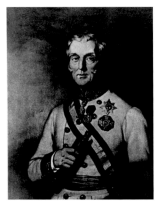

Lucas 12

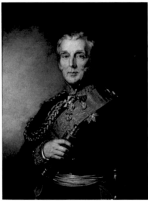

Lucas 13

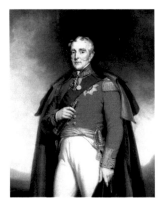

Lucas 14

Lucas 15

12. Formerly Johannisberg-im-Rheingau, Germany. Present whereabouts unknown

1849, 91.4 × 71 cm. HL, slightly to the L, in the uniform of an Austrian field-marshal, with Orders of Maria Theresa and the Golden Fleece. Presented by the Duke to Prince Metternich. See *John Lucas* by the artist's son, Arthur Lucas (p. 64): 'In 1849 we find Wellington again sitting to Lucas for the three Kitcats which his Grace gave respectively to Prince Metternich, to the Austrian Army and to the Military School in Berlin.'

In the account-book of Messrs Draper, the frame makers of Albany Street, is the following entry: '9th August 1849. Making frame for picture of his Grace by Lucas, £4.4s. Making tablet and inscription "Presented to Prince Metternich, etc." £1.1s. Frame and picture conveyed to the Prince in London.'

13. Military-Historical Institute, Prague

1848–49, 91.4 × 71 cm. Similar to Nos. 12 and 14, but wearing the Order of the Garter. As in No. 14, holding a telescope in his right hand. Commissioned by the Duke and presented by him to the Austrian Army (see No. 12), at a cost of 60 guineas plus 4 guineas for the frame.

14. Deutsches Historisches Museum, Berlin

1848–49, 91.4 × 71 cm. Similar to Nos. 12 and 13, but wearing the uniform of a Prussian field-marshal, with the Order of the Black Eagle. Holding a telescope in his right hand. Commissioned by the Duke and presented to the Prussian Army to hang in the Military School, Berlin (see No. 12).

15. Palace of Westminster, London

1851–52, 267 × 175 cm. TQL, to the L, wearing field-marshal's uniform and cloak, with the Order of the Golden Fleece and the Order of the Garter, holding a telescope in his right hand and a hat in his left.

MAROCHETTI, CARLO, BARON, RA
1805–67

Originally from Turin, Marochetti was raised in Paris and became a French citizen. He studied there and in Rome. He was created a Baron by the King of Sardinia and in 1839 was awarded the Legion of Honour. In 1848 he settled in London, where he exhibited at the RA from 1850.

1. Royal Exchange Square, Glasgow

Bronze statue, 1844, life-size. FL, equestrian. The initial movement toward the erection of the statue came from 'a Deputation from the Citizens of Glasgow and the Noblemen and Gentlemen of Counties in the West of Scotland', and subscription lists were opened in February 1840. The Duke told Lady Burghersh he hoped that 'Mr Campbell may yet have the Glasgow statue'. But in the face

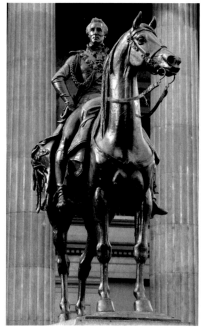

Marochetti 1 (and see Ill. 88) Marochetti 2 Marochetti 4 (and see Ills. 104, 105)

of much competition the commission was awarded to Marochetti. In 1841 he was at Walmer modelling the Duke's head (Arthur Lucas, *John Lucas*, p. 39). The inauguration of the statue took place in October 1844. The Duke is made to appear younger than in Marochetti's two busts (see No. 2) or in other portraits of this date. The work was also produced as a bronze statuette.

A sketch by Marochetti is in the Family Collection, and a statue initialled 'C.M.' and stamped 'FONDU PAR MOREL ET CIE LONDRES' was at the Armoury of St James's, London.

2. Family Collection

Marble bust, signed, 1841, h. 71.5 cm. Probably made from sittings given in 1841. Sold by the artist's grandson, George Marochetti, to the 7th Duke in 1944. There are several repetitions of this bust in bronze, both actual size and reduced.

A similar marble bust dated 1848, h. 76 cm, was at Messrs Tognozzi and Mariotti in London when the *Iconography* was compiled, *c.* 1935.

3. Woodhouse Moor, Leeds

Bronze statue on pedestal, 1854, life-size. To the R in military uniform with various orders and sashes. Right hand on hip, plumed hat held down in his left hand. Originally placed outside Leeds Town Hall, but moved to Woodhouse Moor in 1937.

4. Stratfield Saye, Hampshire

Bronze statue, *c.* 1863, Similar to No. 3. On a plinth supported by a Corinthian column. Inscribed on the base: 'Erected by Arthur Second Duke of Wellington and by the servants and labourers on the estates of his father as a token of their affection and respect 1863'.

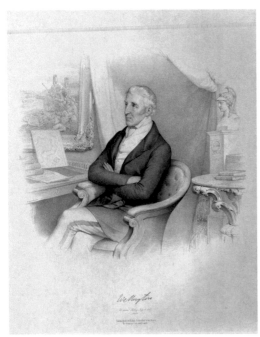

Maurin 1

MAURIN, A., probably ANTOINE
1793–1860

1. British Museum, London
Lithograph after and by A. Maurin, 1841. Nearly FL, seated to the L by a table, arms folded. To his right is a painting of the Napoleonic Wars and to his left a bust of Albion. Inscribed with a facsimile of Wellington's signature and the title 'Woburn Abbey / July 28 1841 / London'. Published by C. E. Baily.

A similar image was engraved by Henry Cook after a painting by S. Diez, and published by A. H. & C. E. Baily in 1843. An impression is in the Family Collection.

MILLIGAN, W.
1812–78

A London-based sculptor, he produced statues of Nelson and Wellington 7 feet (2 m) tall for Southsea Common in 1850. Both have now disappeared, Wellington's being last documented around 1874.

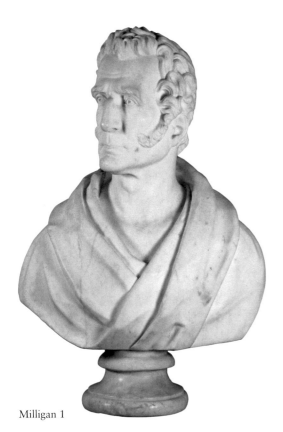

Milligan 1

1. Family Collection
Marble bust, h. 74 cm. To the L in Classical dress. Not believed to be *ad vivum*. Apparently this bust belonged to the Arbuthnot family. It was bought by the 7th Duke at the Woodford Sale in 1963.

MORTON, ANDREW
1802–45

Morton came from Newcastle-on-Tyne to London to study at the RA Schools, where he gained the Silver Medal in 1821. From that date he exhibited frequently at the RA and the BI, developing a large practice.

1. Formerly Royal Naval Club. Present whereabouts unknown
Commissioned by the Royal Naval Club in 1833, sittings given at Walmer and Stratfield Saye. Exh. RA 1835, no. 273. The Royal Naval Club was founded in 1765 as a dining club, and had other paintings by Morton in the dining room. It no longer exists.

2. Lord Carrington, The Manor House, Bledlow
Signed and dated 18 June 1837, 139.7 × 114.3 cm. TQL, full-face, in field-marshal's uniform, holding gloves in his right hand, a plumed cocked hat under his left arm. Wearing sash and Lesser George of the Order of the Garter, the Order of the Golden Fleece and the Waterloo Medal. On the back is an inscription signed by both artist and client, dated 18 June 1837: 'For this picture his Grace the Duke of Wellington at the request of Lord Carrington, whose

property the picture is, gave several sittings at Walmer Castle in the latter part of the month of October and the beginning of November 1836.'

3. Formerly Mrs A. Cross, Wentworth, Virginia Water, Surrey. Present whereabouts unknown

197 × 124.5 cm. Similar to No. 2, TQL. The canvas was was cut down in 1933. It originally measured 256.5 × 177.8 cm and showed the Duke FL. Bought as 'from the life' *c.* 1890 from Craigiehall in Scotland.

A repetition of this, HL only, was in the collection of Alfred Pope of Dorchester (d. 1934), formerly in the collection of John Bridge, of Rundle and Bridge, the Court Jewellers of George IV and William IV.

4. Family Collection

c. 1837, 195.6 × 119.4 cm. Similar to No. 2 but FL, standing, landscape with cannon in the background. Bought by the 7th Duke at Christie's, 2 December 1955, lot 102. Its previous history is not known.

5. Wallace Collection, London

c. 1840, 238.2 × 182.9 cm. FL, sitting in the Library at Apsley House, with Colonel John Gurwood, his private secretary and compiler of his dispatches. A dispatch case, letters, etc., are seen in the foreground. The Duke is shown discussing with Gurwood the dispatch detailing the Battle of Waterloo. Inscribed on the dispatch, held by Gurwood: 'June 1815 / A to E / Bruxelles/~~Waterloo~~ [*sic*] June 19 1815 / To N23 / Lord Bathurst / Report of the Operations / Battle of Waterloo'. This picture or a variant was exhibited at the RA in 1840. The catalogue there said that he was 'explaining to the compiler of his despatches the date of that which describes the details of the Battle of Waterloo: "I began the despatch at Waterloo, and finished it at Bruxelles"'. Bought by the 4th Marquess of Hertford (a friend of Gurwood) from Lord Northwick's collection in 1859, for 200 guineas. A variant (271.8 × 182.9 cm) was sold at Christie's, 18 July 1924, lot 58, for 6 guineas.

NOBLE, MATTHEW
1817–76

Born in Yorkshire, he studied in London under the sculptor John Francis, and exhibited around a hundred works at the RA from 1845, chiefly marble busts.

1. Formerly Army and Navy Club, London. Present whereabouts unknown

Marble bust, dated 1851, life-size. Wearing a cloak and the Waterloo Medal.

The bust currently in the Army and Navy Club is not of this type.

2. Formerly Grocers' Company, London. Destroyed

Marble bust, dated 1852, life-size. Wearing the Waterloo Medal. This or No. 1 exh. RA 1852, no. 1442. Presumed to have been destroyed in a fire at the

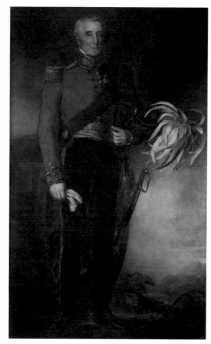

Morton 4 (and see Ill. 4)

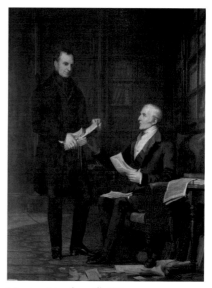

Morton 5 (and see Ill. 72)

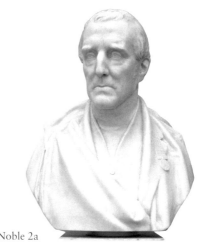

Noble 2a

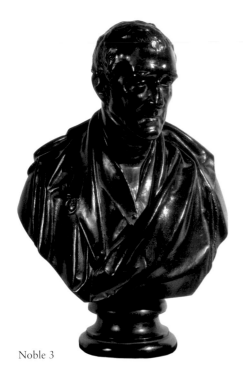

Noble 3

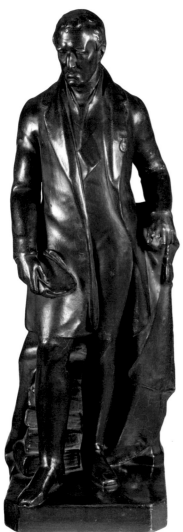

Noble 4a

Grocers' Company in 1965. Examples of this bust are in the Walker Art Gallery, Liverpool, and in the Family Collection (2a), the latter inscribed 'M. Noble. Sc / London / 1852'. Two versions were sold at Christies, one (from Madame Tussaud's) on 24 November 2004, lot 477, and another on 25 September 2012, lot 300.

3. British Embassy, Paris (Government Art Collection)
Bronze bust, 1852, h. 27 cm. To the R with shoulders draped and Waterloo Medal on the L lapel.

4. Piccadilly Gardens, Manchester
Bronze statue, 1856, life-size. FL, standing, in long coat and stock, sash seen under the coat and Waterloo Medal pinned to the L lapel. In his right hand he holds a book. Two seated Classical figures at the base of the monument. Bronze reliefs on the base depict famous battles from the Duke's career. Inscribed 'ERECTED BY PUBLIC SUBSCRIPTION MDCCCLVI WELLINGTON BORN MAY I MDCCLXIX DIED SEPTEMBER XIV MDCCCLII'. The commission was awarded in 1853 and the statue was unveiled on 30 August 1856.

There is a painted plaster statuette of this work, signed, in the Family Collection (4a).

NOLLEKENS, JOSEPH, RA
1737–1823

The son of a painter, Nollekens studied under the sculptor Peter Scheemakers and then in Rome. On returning to London he established a large practice and was patronised by George III. He became the first British sculptor to be known chiefly for portraits, including William Pitt the Younger, Charles James Fox, and the Duke of Bedford. He became ARA in 1771 and RA in the following year. Wellington sat to Nollekens before returning to Portugal in April 1809. He was then in the Peninsula continuously until 1814. From 1813 Nollekens was in poor health, and Wellington never sat to him again.

1. Formerly Philip Guedalla, London. Present whereabouts unknown
Marble bust, signed and dated 'Nollekens fecit 1812', life-size.

The Nollekens bust was considered by the Duke's wife and by the 2nd Duke to be the best ever made of him. A plaster copy is in the Family Collection (1a).

Engravings were produced by H. Meyer from a drawing by John Jackson in 1812, and by Thomas Kelly in 1816, after a drawing by Abraham Wivell.

2. Wellington Collection, Apsley House
Marble bust, signed and dated 'Nollekens fecit 1813', h. 71 cm. Exh. RA 1813, no. 935. Based on No. 1.

Repetitions of this type are very numerous. There is one with an identical signature and date at Woburn Abbey. Another version, dated 1814, is at Castle

Howard. Many versions are unsigned, including those at Welbeck, at Bletchingley, at Apsley House and at Strafield Saye.

Engraved by W. T. Fry in 1814 and by others.

3. Royal College of Defence Studies, London (Government Art Collection)
Marble bust. To the L, with draped shoulders. Incorrectly signed 'NOLEKENS Sculptor', this seems unlikely to be by Nollekens.

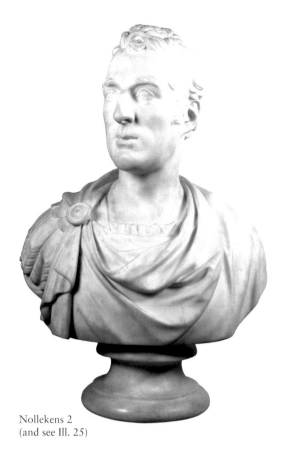

Nollekens 2
(and see Ill. 25)

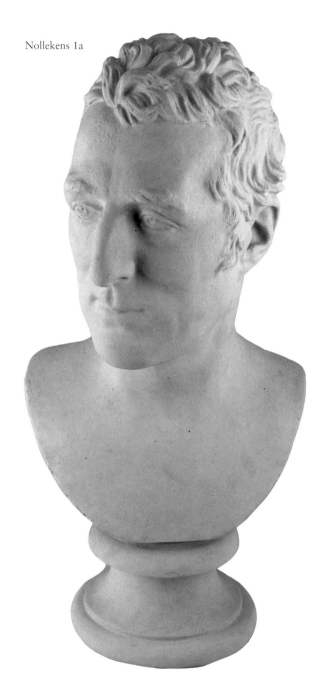

Nollekens 1a

Nollekens 3

Northcote 1

Parent 1

NORTHCOTE, JAMES, RA
1746–1831

Apprenticed to his father, a watchmaker, he ran away from home in 1771 and became an assistant to Sir Joshua Reynolds until 1775. He exhibited his first work at the RA in 1781, became ARA in 1786 and RA in 1787. He produced nine works for John Boydell's 'Shakespeare Gallery'. His memoir of Reynolds (1813) became the foundation for all subsequent biographies of the artist.

1. Exeter Guildhall

1829, *c.* 305 × 180 cm. FL, equestrian, mounted on a white charger, in field-marshal's uniform with star of the Order of the Garter and Order of the Golden Fleece. Troops with a British flag seen in the lower L corner. Recorded in Northcote's manuscript diary as being priced at 150 guineas, and sold to Mr Graves Sawle of Penrice for £320.

 Engraved by S. W. Reynolds. An impression is in the Family Collection.

2. Formerly W. Sidwell, Leicester. Present whereabouts unknown

1829. HL, to the R, in military uniform with the Order of the Golden Fleece and star of the Order of the Garter. Recorded in the Appendix of Northcote's *Memoirs*, in the year 1829, as 'Portrait of the Duke of Wellington' (*Memorials of an Eighteenth-Century Painter*, ed. Stephen Gwyn). In August 1950 it was in the collection of A. J. P. B. Alexander. It was subsequently sold repeatedly at Christie's on 17 March 1967, lot 152, 27 October 1967, lot 177, and 2 February 1968, lot 55.

PARENT, J.
fl. 1814–33

Miniaturist and watercolour painter, working in Paris in the style of Isabey. He painted portraits of Napoleon and his generals, as well as of Wellington during the occupation of France after the Battle of Waterloo.

1. Private Collection, New York

Miniature on ivory, signed and dated 'J. Parent 1816', h. 5.7 cm. Head and shoulders to the R, looking at the spectator, in red military uniform, with badge of the Order of the Golden Fleece, sash and star of the Order of the Garter, cross of Knight Commander of the Order of the Bath, and Military Gold Cross. Bought at Christie's, 2 June 2009, lot 264.

2. Victoria and Albert Museum, London

Miniature, signed 'IP', mounted on a tortoiseshell box inlaid with gold by A. A. Héguin, *c.* 1813–19, 6.6 × 2.3 cm. Head and shoulders to the R, looking at the spectator, in red military uniform with the Order of the Golden Fleece,

two other orders, and an unfinished sash. The miniature is of a type based on a portrait by Isabey (q.v.). Inscribed 'from the Earl of Yarmouth to Dr. Chermside, Paris, Augte, 1823'. Possibly given by the Duke to Richard Seymour-Conway, later Earl of Yarmouth, in 1818 when he was an attaché at the British Embassy in Paris.

Parent 2

PELLEGRINI, DOMENICO
1759–1840

Italian painter of portraits and history paintings. He studied in Venice, and in Rome under Domenico Corvi. In 1792 he moved to London, where Francesco Bartolozzi, an engraver who was a founding member of the RA, became his mentor. Bartolozzi moved to Lisbon in 1804, and at some point Pellegrini also moved to Lisbon.

1. National Museum of Fine Arts, Lisbon
1809, 76.2 × 57.2 cm. HL, to the L, as Viscount Wellington, wearing Portuguese military uniform with ribbon and star of the Order of the Bath. Wellington had agreed to sit to Pellegrini: 'Mr Willien fait ses compliments à Mr Pellegrini il vient de parler à Lord Wellington qui sera bien aise de le voir chez lui demain sur les neuf heures' (Sousa Viterbo, *Noticia de algunes Pintores*, I, 1903, p. 124). 'Willien' was John Villiers, afterwards 3rd Earl of Clarendon, then British Minister at Lisbon.

Prints were produced in great numbers during the Peninsular War, by artists including Francesco Bartolozzi (two, 1810), J. Heath (1811), James Godby (1812 and 1814), and E. Bocquet (1813).

The Pellegrini painting is HL, but one of the Bartolozzi prints (Ill. 26) and both the Godbys are FL. It is not known whether the Pellegrini was cut down or whether there was a FL original which is now lost.

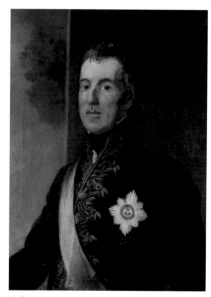

Pellegrini 1

PHILLIPS, THOMAS, RA
1770–1845

Trained as a glass-painter. His work can be seen in the windows of St George's Chapel, Windsor. From 1796 he focused on portrait painting, joining the RA Schools in 1791 and exhibiting there from 1792. In 1804 he became ARA and in 1808 RA. In 1825 he was elected Professor of Painting at the RA.

1. Family Collection
Signed and dated 1814, 75 × 61.5 cm. HL, looking to the R, wearing field-marshal's uniform with Order of the Golden Fleece, star of the Order of the Garter, and other decorations. Recorded in Phillips' diary in 1814 as 'for Lord Talbot'. (In 1815 a copy is recorded, for whom it is not stated.) Bought from

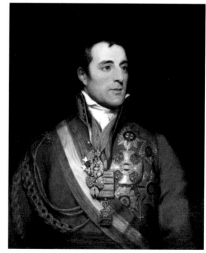

Phillips 1 (and see Ill. 2)

Lord Talbot's descendant, Lord Shrewsbury, at the sale of the contents of Ingestre Hall in December 1960 by the 7th Duke, who noted: 'This portrait is among the early authentic portraits & is therefore very important.'

Engraved by W. Say (an impression is in the Family Collection), and by S. Freeman.

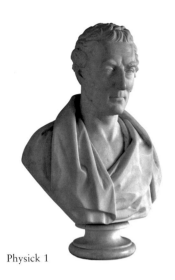

Physick 1

PHYSICK, EDWARD WILLIAM
c. 1774–1862

Sculptor mainly of portrait busts, but also of some ideal subjects and church monuments. He exhibited at the RA between 1810 and 1842 and at the BI between 1824 and 1838. Three of his sons also became sculptors.

1. Family Collection
Marble bust, h. 71.5 cm. To the L, with shoulders draped. Another version, also undated, is in the Merchant Taylors' Hall, London. A marble bust by E. W. Physick was exhibited at the RA in 1843.

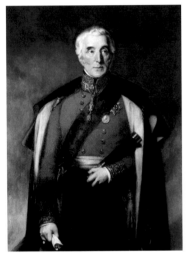

Pickersgill 1 (and see Ill. 71)

PICKERSGILL, HENRY WILLIAM, RA
1782–1875

Trained initially with a silk manufacturer, then studied with George Arnald from 1802 to 1805, when he enrolled at the RA Schools. From 1806 until 1872 he exhibited nearly 400 works at the RA. He became ARA in 1822 and RA in 1826.

1. Oriental Club, London
c. 1834–35, 100 × 127 cm. HL, head slightly to the R, wearing field-marshal's uniform, ribbon and star of the Order of the Garter, and Order of the Golden Fleece, a telescope in his left hand. Commissioned by Sir Pulteney Malcolm, Chairman of the Club, in 1834. Exh. RA 1835, no. 166.

The portrait was cut down when the Club moved to Stratford House in the 1960s, to fit above the fireplace in the library.

The original FL composition, with the head of an Indian servant to the left, is fortunately recorded in an engraving by C. E. Wagstaffe dated 1841, of which there is an impression in the Family Collection (1a).

2. Formerly Mrs Gerald Clegg-Hill, Shropshire. Present whereabouts unknown
c. 1834–35, c. 244 × 152.4 cm. FL, standing, full-face, wearing field-marshal's uniform with cloak, ribbon and star of the Order of the Garter, and Order of the Golden Fleece, in his right hand a telescope. Field-marshal's hat on the table to the R. His right foot rests on a stone. Commissioned by General Lord Hill in 1834. Exh. Manchester 1857, no. 292.

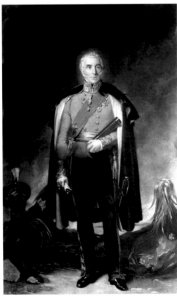

Pickersgill 1a

3. City of London Club, London

1845, 335.3 × 188 cm. FL, equestrian, to the L, wearing blue white-lined cloak,
blue coat, white breeches and cocked hat, holding a telescope. The composition
is based on Lawrence's equestrian portrait of 1817–18 (Lawrence, No. 4).
Exh. RA 1846, no. 145.

4. Army and Navy Club, London

c. 1845, 365.7 × 213.4 cm. As No. 3, but cloak and coat black, not blue.
Purchased through subscription among members of the Club in 1852.

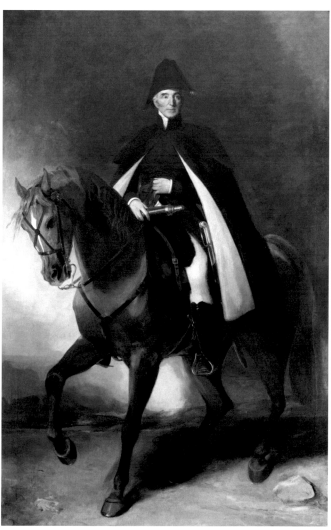

Pickersgill 3

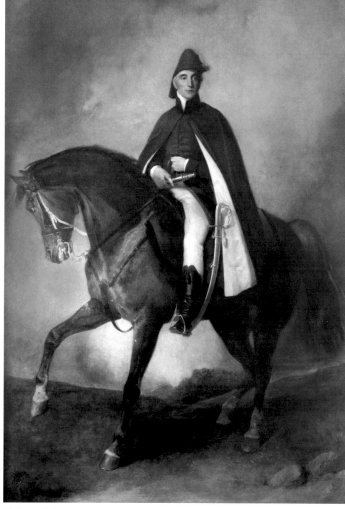

Pickersgill 4

PIENEMAN, JAN WILLEM
1779–1853

Dutch painter. After studies in Amsterdam, in 1805 he was appointed drawing
master to the School of Artillery and Engineering in Amersfoort. In 1815 he
became director of the Royal Collection, in 1820 first President of the Royal

Pieneman 1

Academy of Fine Arts in Amsterdam, and from 1844 to 1847 he was Director of the Rijksmuseum.

1. Rijksmuseum, Amsterdam

Signed and dated 'J. W. Pieneman fecit 1821, Apsley House London', 76 × 63.5 cm. HL, body to the L, head to the R, in dark civilian coat, white stock. The pose is that of the Duke in the large painting of Waterloo (No. 2). Given by the Duke to the 7th Earl of Clancarty. Bought by the Rijksmuseum at Christie's, 19 November 1976, lot 28.

This was probably based by Pieneman on his original sketch for the figure of the Duke in the large painting. A work identified as such by a contemporary Dutch inscription was in the collection of the Duke of Bedford at Woburn Abbey in 1935, but is now untraced.

A copy, bequeathed by James Prendergast to the New Zealand Academy of Fine Arts in 1930, is in the Museum of New Zealand Te Papa Tongarewa, Wellington.

2. Rijksmuseum, Amsterdam

The Battle of Waterloo, 1824, 567 × 823 cm. The scene is the moment during the battle when the Duke learns of the arrival on the field of the Prussian army. Wellington is depicted on Copenhagen, in a dark cloak and white breeches. His pose is that in Pieneman's 1821 portrait (No. 1). The Prince of Orange (later King William II) is being carried on a stretcher in the L foreground. The painting was bought by King William I for 40,000 guilders.

Engraved by R. Craeyvanger, N. Pieneman, and J. A. Daiwaille.

A small version of the painting (54.6 × 76.2 cm) is in the collection of the Earl Bathurst at Cirencester House, Gloucestershire (2a). On the frame is a note in the handwriting of the Duke: 'The painting of the Battle of Waterloo by Pieneman was presented by Arthur, Duke of Wellington, to Henry, Earl Bathurst, K.G. Secretary of State.'

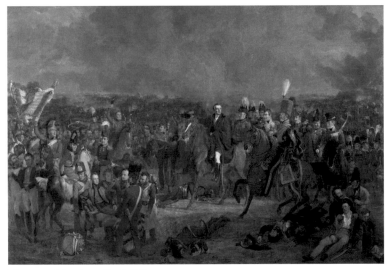

Pieneman 2 (and see Ills. 6, 53)

Pieneman 2a

A small copy is in the Family Collection, and several sketches of officers appearing in the picture, dated 1821, were bought from Pieneman by the Duke for the Striped Drawing Room at Apsley House.

Pistrucci 1

PISTRUCCI, BENEDETTO
1783–1855

Sculptor and medallist. He worked in Rome until 1814, when he moved to Paris and then to London. In 1816 he began work at the Mint, of which Wellington's brother William Wellesley Pole was Master. In 1817 he became Chief Engraver, and produced the design for the new gold sovereign, with St George and the Dragon on the obverse side, still used on that coin today. In 1819 he won the competition to design the large Waterloo Medal, a project that went on until 1849. In 1828 he was appointed Chief Medallist.

1. Wellington Collection, Apsley House
Colossal marble bust, signed and dated 'B. Pistrucci, Royal Mint, 1832', h. 77.5 cm. Sat for by the Duke at the Mint (see p. 72), and bought by him from the sculptor in 1835 for 100 guineas.

Another version is in the Institute of Directors (formerly United Service Club), London, bought by the United Service Club in 1836.

2. Family Collection
Marble bust, 1840s, h. 52 cm. Given by the Duke to his daughter-in-law, Lady Douro. Bequeathed to the 7th Duke by the 3rd Duchess of Wellington in 1939.

Pistrucci 2 (and see Ill. 68)

3. Family Collection, on display at the Wellington Collection, Apsley House
Waterloo Medal, 1817–49, d. 14 cm. On the obverse in the centre, profiles of the Prince Regent, Franz I of Austria, Alexander I of Russia, and Friedrich Wilhelm III of Prussia, surrounded by emblems of peace. On the reverse, Wellington and Blücher on horseback in Classical costume are accompanied by a winged figure of Victory and surrounded by nineteen Titans, symbolizing the nineteen years of the Napoleonic Wars. In 1849 the dies were complete, but the first cast was not made till later.

There are numerous copies.

Pistrucci 3
(and see Ill. 69)

4. Metropolitan Museum of Art, New York
Bronze medal, 1841, d. 6.1 cm. Wellington in profile to the L. Inscribed on the obverse 'FIELD MARSHAL ARTHUR DUKE OF WELLINGTON / PISTRUCCI' and on the reverse 'NOVA CANTAMUS TROPAEA [We sing of new trophies] AUGUST 1841'. Gifted to the gallery in 2001 by Assunta and Romano Peluso.

Many copies were struck, and one is in the Family Collection (4a).

Pistrucci 4a

O.R. 1

Raria 1

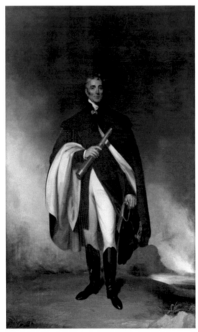

Robinson 1 (and see Ill. 67)

O.R.
Identity and dates unknown

1. Family Collection
Print after O.R. by G. Maile, 1817. HL, in profile to the L, wearing civilian dress with a top hat. Inscribed 'HIS GRACE THE DUKE OF WELLINGTON, / Sketched from the Life'.

RARIA, CAPTAIN
fl. 1800–1811

1. Family Collection
Stipple engraving after Raria by M. Place, 1811, 32 × 24.8 cm. TQL, standing to the L, in general's uniform with ribbon and star of the Order of the Bath, pointing to a map of Spain. Seated statue of Victory in the background. Inscribed 'Drawn by Captain Raria, Lisbon', published by Schiavonetti.

ROBERTSON, ANDREW
1777–1845

Scottish miniature painter, youngest of three painter brothers. He studied medicine, after which he turned to painting. He moved to London in 1801 and joined the RA Schools, and exhibited at the RA from 1802 to 1842. In 1805 he was appointed miniature painter to the Duke of Sussex.

1. Present whereabouts unknown
Miniature on ivory, 1805–6, 7.6 × 5.1 cm. Head and shoulders to the L, wearing cape. Francis Wellesley sale, Sotheby's, 29 June 1920, lot 667.

ROBINSON, WILLIAM
1799–1839

Painter, born in Leeds, apprenticed to a clock-dial enameller. He came to London in 1820 to attend the RA Schools, and worked in the studio of Sir Thomas Lawrence. In 1823 he returned to Leeds, and established a successful practice there.

1. Institute of Directors (formerly United Service Club), London
1831, 271 × 179 cm. FL, standing, wearing black frock-coat and white breeches. Exh. RA 1832, no. 386. Redgrave says that Robinson painted four FLs for the United Service Club, that of Wellington being done from sittings, the other three being copies.

ROCHARD, SIMON JACQUES
1788–1872

Born in Paris, trained at the Ecole des Beaux-Arts, he then moved to Brussels. Soon after the Battle of Waterloo he moved to London, and established a lucrative business painting miniatures. From 1816 to 1845 he exhibited miniatures at the RA, the BI and the SBA. In 1846 he returned to Brussels, where he worked for the rest of his life.

1. Private Collection, New York

Miniature on ivory, signed and dated 'Rochard Bruxelles 1815', h. 8.9 cm. Head and shoulders to the R, wearing scarlet uniform coat, with the star of the Order of the Garter and Order of the Golden Fleece. On the back is written: 'This miniature is an original and was given me by the Duke of Wellington at Brussels on 15 June 1815 [signed] Georgiana de Ros'. Lady Georgiana Lennox, Lady de Ros, in her *Memoirs* refers to a 'Belgian artist' painting a miniature of the Duke in Brussels in 1815.

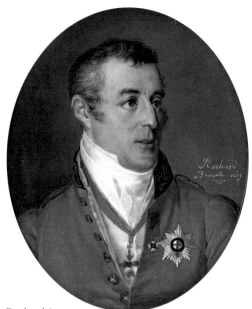

Rochard 1
(and see Ill. 41)

An account of the circumstances of Rochard's portrayal of Wellington was later published in the *Gazette des Beaux-Arts* (1891, VI, pp. 441–65, and 1892, VII, pp. 43–54): 'L'ambassadeur d'Espagne, le général Alava, était chargé par son roi de faire pour lui la miniature du duc de Wellington . . . il consulta le général Daendals qui lui désigna Rochard comme l'artiste le plus capable de répondre au désir de la cour d'Espagne. A la veille de Ligny et de Waterloo le généralissime anglais n'avait guère de temps à donner aux peintres; Rochard dût se contenter, le 13 juin 1815, de saisir rapidement les traits de son modèle pendant que celui-ci, entouré de ses aides-de-camp, leur donnait ses ordres. Cette séance, qui dura à peine une heure, suffit au jeune peintre pour fixer sur le papier, d'une façon définitive, l'originale physionomie de Wellington. . . . Cette aquarelle servit toujours de prototype à Rochard pour les nombreux portraits qu'il eut à faire du vainqueur de Waterloo. Cette aquarelle est pieusement conservée chez M. Garnier-Heldewier.' (M. Garnier-Heldewier was Belgian Minister in Paris in 1891–92, and formed a collection of Rochards.)

A copy is in the Family Collection.

2. Royal Collection Trust

Watercolour miniature on ivory laid on card, signed and dated 1815, h. 8.4 cm. Similar to No. 1. Supposedly given by the Duke to the Comtesse de Chaumont, then left to Sir Hubert Jerningham (1842–1914). First recorded in the RCT during the reign of George V. There are two inscriptions: on the back, 'Rochard Pxt. / 1815', and on the reverse of the frame, 'This miniature by Rochard / signed by him and dated 1815 / was given by the Duke / of Wellington himself to Mlle de Condé (afterwards / Comtesse de Chaumont [. . .]) / at Brussels a few days / before Waterloo. She prized / it very much and dying / in 1879 left it to me in / token of her affection for my / family with whom she was / a refugee after the Revolution. / She was very old when she died. / Hubert E. H. Jerningham.'

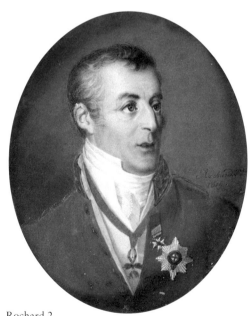

Rochard 2

Rochard 3

Rochard 4

Rochard 5

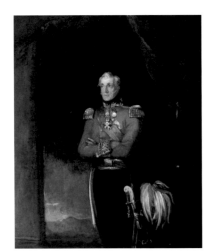

Salter 1

Another version of this miniature, signed and dated 1815, was in the State Museums, Berlin, then in the Krüger Collection, University of Nebraska-Lincoln. It was sold at Sotheby's, 11 December 1978, lot 142. Present whereabouts unknown.

3. The Ethelston Collection

Miniature on ivory, signed and dated 'Rochard / Pinxit 1815' and 'Juin 1815', h. 8.6 cm. Similar to Nos. 1 and 2 but in field-marshal's uniform with the sash and star of the Order of the Garter and Grand Cross of the Order of the Bath. The Order of the Golden Fleece is faintly depicted below the sash of the Garter. Inscribed on the backing paper: 'Portrait de / My Lord Duc / de Wellington / Par Rochard / Peint à Bruxelles / 12 Juin 1815'. Formerly in the collection of Lady Louisa Tighe, daughter of the 4th Duke of Richmond and Gordon. Bought at Christie's, 25 May 2004, lot 189.

4. The Ethelston Collection

Miniature on ivory, signed and dated on the reverse 'Rochard Juin 1815', h. 8.3 cm. Similar to No. 3, but with the Order of the Golden Fleece faintly depicted beside the Grand Cross of the Bath. In original ormolu frame with hook at the base, presumably for the Waterloo Medal. Formerly in the Ullmann and Heckett collections. Bought by the present owner at Bonhams, 5 November 2002, lot 113.

5. Family Collection

Miniature on ivory, signed and dated 'Rochard 1815', h. 6.5 cm. Similar to Nos. 3 and 4 (Order of the Golden Fleece as in No. 4).

SALTER, WILLIAM
1804–75

A pupil of James Northcote in London from 1822 until 1827, he then studied in Europe. In 1833 he returned to England. In 1836 he commenced studies for the vast *Waterloo Banquet* group portrait, completed in 1840 (No. 5). He exhibited mainly at the BI and SBA, becoming a member of the latter in 1846 and later its Vice-President.

1. National Portrait Gallery, London

1839, 61 × 50.7 cm. TQL, to L, in military uniform, arms folded. A study for the *Waterloo Banquet* picture. Bequeathed by W. D. Mackenzie of Fawley Court in 1950.

2. Family Collection

c. 1839, 35 × 37. FL, frontal, head to the L, standing in an archway, wearing military uniform, with sash and star of the Order of the Bath, star of the Order of the Garter, Order of the Golden Fleece, and the Waterloo Medal, holding field-marshal's hat in his right hand. Bought by the 7th Duke in 1931.

Engraved by William Greatbach. An impression is in the Family Collection.

A replica (91.4 × 71 cm) is at Raveningham Hall, Norfolk, purchased in December 1851.

3. Family Collection
c. 1839, 90 × 60 cm. FL, standing, to the L, with arms folded, in dark uniform, possibly that of Lord Warden of the Cinque Ports. Field-marshal's hat and sword held behind. A label on the back reads: 'Study for the fresco in the Houses of Parliament. W. Salter R.A. 1842'. That is a puzzle.

A replica is in the National Maritime Museum, Greenwich.

4. National Museums, Liverpool
After Salter, *c.* 1839, 74.3 × 62.2 cm. Head and shoulders to the L, wearing a dark coat with Order of the Golden Fleece and other orders. Originally in the Town Hall at Liverpool, moved to its current location in 2000.

5. Wellington Collection, Apsley House
The Waterloo Banquet at Apsley House, signed and dated 1840, 333.5 × 189 cm. The Duke is shown standing in the centre, at the dinner given on the anniversary of the Battle of Waterloo. Salter had glimpsed the banquet in 1836, and obtained permission to paint it. Eighty-three figures in total are depicted. Most gave sittings to Salter, whose preparatory works are now in the NPG. Two guests were included posthumously, the Earl Bathurst and Lord Robert Manners. The painting was exhibited at various locations in London. It passed by descent to Major C. Mackenzie of Fawley Court and was presented to the 7th Duke when the house was sold in 1952. It hangs today in the Portico Room at Apsley House.

A popular engraving was produced by William Greatbach and published by F. G. Moon in 1846. A sketch for the work, 81.3 × 137.4 cm, was sold at Christie's, 19 October 2005, lot 173.

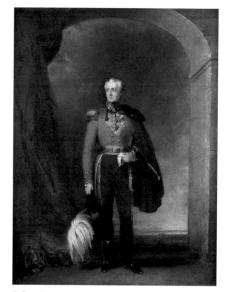

Salter 2

Salter 3

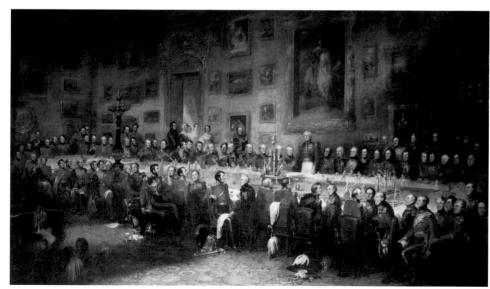

Salter 5 (and see Ill. 73)

Salter 4

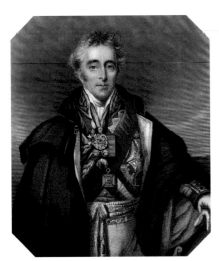

Scanlan 1

Simpson 1

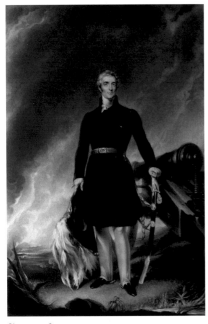

Simpson 2a

SCANLAN, ROBERT RICHARD
1801–76

An Irish artist. Based in Dublin in the 1820s, he exhibited at the Royal Hibernian Academy, and then became Master of the Cork School of Design. He later moved to London, and exhibited works at the RA between 1837 and 1859.

1. Original work untraced. Print in the British Museum, London
Stipple engraving after Scanlan by Henry R. Cook, *c.* 1825, 36.3 × 26 cm. TQL, full face, in military uniform and cloak, with several orders. Another impression is in the National Gallery of Ireland, Dublin.

SIMPSON, JOHN
1782–1847

Born in London and trained at the RA Schools. For some years he was a pupil and assistant of Sir Thomas Lawrence, completing some of his works after Lawrence's death in 1830. From 1807 until his death he was a regular contributor to the RA. In 1834 he worked in Lisbon, where he was appointed Painter to the Queen of Portugal.

1. Society of the Cincinnati, Washington, D.C.
Signed, *c.* 1829, 124 × 99 cm. TQL to the R, in black cloak with fur collar and wearing a field-marshal's hat. Holding a sword in both hands. The signature is almost hidden and is along the scabbard. Originally in the collection of the Duke of Cambridge. Had been attributed to Sir Thomas Lawrence but it is probable that this work was started by Lawrence and finished by Simpson after Lawrence's death. Bought by Larz and Isabel Anderson before 1905, for Anderson House. The house has been the headquarters and museum of the Society of the Cincinnati since 1938.

2. Formerly Junior United Service Club, London. Present whereabouts unknown
1835, *c.* 261 × 173 cm. FL, standing, head slightly to the R, wearing black frock-coat. His left hand on sword hilt, his right hand holding his plumed cocked hat, with the ribbon of the Order of the Golden Fleece. A cannon to the R. Exh. RA 1836, no. 200.

Engraved by G. H. Phillips. Impressions are in the NPG and in the Family Collection (2a).

3. The Earl of Normanton, Somerley, Hampshire
1837, 91.4 × 68.6 cm. Head and shoulders, full-face, wearing military uniform, with a black cape held across with his right hand, and the star of the Order of the Garter. Painted for the 2nd Earl of Normanton, at whose request the Duke gave sittings in 1837. The artist received 70 guineas. The German art historian G. F. Waagen recorded it in his *Treasures of Art in Great Britain* (1854, IV,

p. 372): 'Among the many likenesses of the Duke I have seen, this one is conspicuous for characteristic conception, warm colouring, and careful execution.' It is probably the portrait exhibited at the RA in 1839, no. 186.

4. Royal Hospital Chelsea, London
256 × 175 cm. Similar to the portrait formerly in the Junior United Service Club (No. 2). Presented to the Royal Hospital by Robert Laing in 1881.
 A copy is in the Defence Academy of the United Kingdom.

STEELL, SIR JOHN ROBERT, RSA
1804–91

Sculptor. Born in Aberdeen, he initially trained with his father as a woodcarver, and then studied at the Trustees' Academy and in Rome. He established a large practice in Edinburgh, and in 1838 he was appointed Sculptor in Ordinary for Scotland to Queen Victoria. He exhibited at the Royal Scottish Academy, of which he became a member in 1829, and at the RA, and was knighted in 1876.

1. The Earl Bathurst, Cirencester Park, Gloucestershire
Marble bust, signed and dated 'Jn. Steell. Sculpt., Edin. 1843', h. 75.6 cm. Head to the L, neck bare, shoulders draped.

2. Colstoun House, East Lothian
Marble bust, signed and dated 'Jn Steell Sculpt Edin. 1843', h. 76.2 cm. Head to the L, shoulders draped. Presented to the Earl, later Marquess, of Dalhousie by Edinburgh City Council.

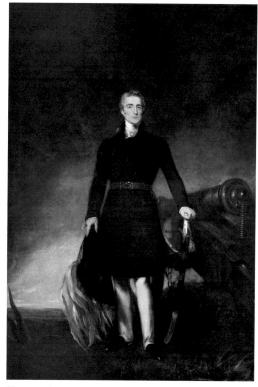

Simpson 4

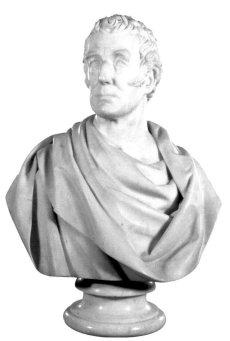

Steell 1 (and see Ill. 89)

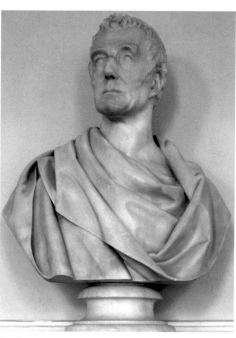

Steell 3

Steell 5 (and see Ill. 90)

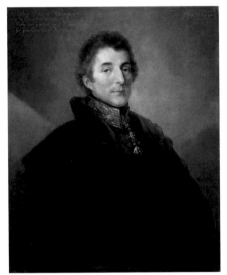

Stroehling 1

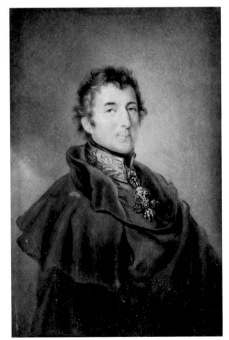

Stroehling 2

3. Eton College, Berkshire

Marble bust, signed and dated 'JN. STEELL. Sculpt / EDINR. 1845', h. 74.9 cm. Head to the L, shoulders draped. A bronze bust of the same date is in the National Galleries of Scotland.

4. Wellington Collection, Apsley House

Marble bust, similar to the preceding, h. 77 cm. Signed and dated 'J Steell, Edin. 1846'.

5. Outside Register House, Princes Street, Edinburgh

Bronze statue, 1840–52, life-size. FL, equestrian, in cloak, right hand pointing. Commissioned by the Committee of the National Wellington Testimonial in Scotland in 1840.

STROEHLING, PETER EDWARD
1768–c. 1826

Of German or Russian extraction, Stroehling travelled to St Petersburg in 1796, where he remained until 1801. In 1803–7 and again in 1819–26 he worked in London, where he painted portraits of George III and Queen Charlotte. He exhibited at the RA between 1803 and 1826. Two group portraits which include George IV and the Duke are in the National Trust Collection at Plas Newydd, Wales.

1. National Army Museum, London

c. 1820, 90.5 × 71.2 cm. HL, to the R, wrapped in a black cloak, with Order of the Golden Fleece visible. An inscription in the upper L corner refers to Wellington wearing the cloak he wore at Waterloo for the sitting he gave to the artist. Painted for Jane, Countess of Harrington.

2. Family Collection

Miniature, c. 1820, 17 × 11 cm. Composition similar to No. 1. Acquired in 1948 by the 7th Duke from Lady Eva Wemyss (née Wellesley), daughter of the 2nd Earl Cowley.

THORBURN, ROBERT
1818–85

Known for producing large miniatures on ivory. He studied drawing in
Edinburgh and then came to London to attend classes at the RA. He received
the patronage of the Duke of Buccleuch, and in 1846 his first commission from
Queen Victoria. He became ARA in 1848. In 1855 he won a gold medal at the
Paris International Exhibition.

Thorburn 1 (and see Ill. 97)

1. Family Collection

Large watercolour miniature on ivory, 1852, 45 × 65 cm. FL, seated to the L.,
with Henry, Mary, Arthur and Victoria, children of Lord Charles Wellesley, in
the library at Stratfield Saye. Formerly Baroness Burdett-Coutts, for whom it
was painted. Exh. Guelph Exhibition 1891, no. 1158, Victorian Exhibition 1892,
no. 443, and Lansdowne House 1929, no. 380. This was the last portrait painted
of the Duke in his lifetime. Purchased by the 7th Duke at the Burdett-Coutts sale,
Christie's, 9 May 1922, lot 9.

A watercolour sketch of the library for the picture is in the Family Collection.

2. Private Collection

A miniature of the Duke's head and shoulders, similar to No. 1, was exhibited
at the Royal Military Exhibition, 1890. It was sold in the same Burdett-Coutts
sale, as lot 401. Bought at Bonhams, 21 November 2012, lot 127.

TOWNE, JOSEPH
1808–79

Thorburn 2

A scientific modeller who also trained as a sculptor. From 1826 he worked at
Guy's Hospital, constructing over a thousand anatomical models in wax for
teaching purposes. At the same time he sculpted portraits, and produced an
equestrian statue of the Duke of Kent for Buckingham Palace.

1. Present whereabouts unknown

Marble statue, exh. RA 1835, no. 1073. See Whitley, *Art in England*, pp. 301–2,
where this statue is stated to have been made from sittings.

2. Formerly Junior United Service Club, London.
Present whereabouts unknown

Marble bust, life-size, executed for the Junior United Service Club. Exh. RA
1838, no. 1368.

3. Formerly Guy's Hospital, London. Present whereabouts unknown

Bust to the L., with draped shoulders.

Turnerelli 1a

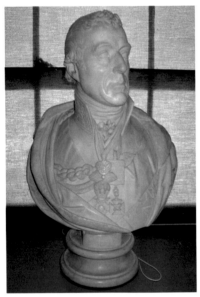

Turnerelli 2

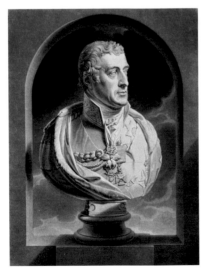

Turnerelli 2a

TURNERELLI, PETER
1774–1839

Born in Belfast, where his father practised as a modeller. He studied at the RA Schools, and in 1797 he was appointed Sculptor in Ordinary to Queen Charlotte. Twice in his career he turned down a knighthood. He exhibited continuously at the RA from 1802 until his death, when most of his models and moulds were purchased by Manzoni, who reproduced them in vast numbers. In July 1813 Farington recorded in his *Diary* (VII, p. 194): 'Nollekens complained much of the conduct of Turnerelli, the sculptor, who he said copied his bust of Lord Wellington [Nollekens, No 2] and now sold it as his own performance.'

1. Ipswich Town Hall

Marble bust, 1813, h. 70 cm. Inscribed 'P. Turnerelli Fecit 1813'. To the R, with sash over military uniform and two stars, Order of the Golden Fleece suspended from a chain. Exh. RA 1813, no. 920, described as having been executed for the Marquess Wellesley. An unsigned version is in the Army and Navy Club, London.

An engraving by Henry Cook was published on 10 September 1813. An impression is in the BM (1a).

An inscription on an undated engraving by J. Chapman says that the bust was taken from the life, but the Duke wrote to Turnerelli in 1819 refuting this.

2. Walmer Castle, on loan from the Royal Collection Trust

Marble bust, signed and dated 1814, h. 75 cm. To the R, in fur-lined cloak over field-marshal's uniform, with various orders including the Golden Fleece and the Army Gold Cross with four clasps. Purchased by the Prince of Wales for Carlton House in 1815, for £159.10. On loan to Walmer Castle since 1905. This or another version exh. RA 1816, no. 954.

An engraving by Charles Turner was published on 21 June 1815 by permission of the sculptor. An impression is in the BM (2a). Also engraved by T. Burke after a drawing by Burney, 1815.

3. National Gallery of Ireland, Dublin

Marble bust, signed 'P. TURNERELLI FECIT 1816', h. 74 cm. As No. 2. Purchased by the Gallery in 1984.

Other examples are in the collection of the Duke of Richmond and Gordon, Goodwood House, inscribed 'P. Turnerelli fecit 1817', Blair Castle, Perthshire, and the Guildhall, London (exh. Guelph Exhibition 1891).

4. Victoria Memorial Hall, Kolkata
Marble bust, h. 30.5 cm. As No. 2.

5. Family Collection
Granite bust, h. 76 cm. Similar to No. 2. Currently in the garden at Stratfield Saye.

Turnerelli 3

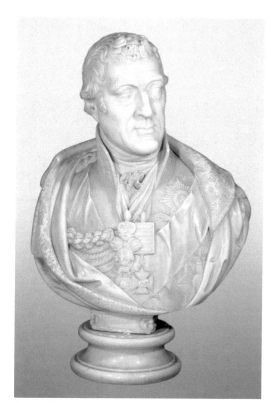

Turnerelli 4

Turnerelli 5

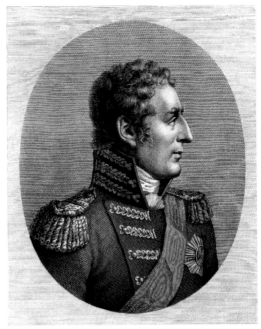

Vauthier 1

VAUTHIER, JULES ANTOINE
1774–1832

History painter, born in Paris. He studied under Jean-Baptiste Regnault, and was known to produce lithographs of his own works.

1. Family Collection

Etching and engraving after Vauthier by P. Audouin, 21 × 15.5 cm. Head and shoulders to the R, in profile, bareheaded, wearing field-marshal's uniform with ribbon and star of the Order of the Garter. Captioned 'Le Feld-Maréchal DUC de WELLINGTON / Prince de Waterloo.' The Order of the St-Esprit, awarded in July 1815, is not shown.

WARD, JAMES, RA
1769–1859

Best known for his paintings of animals, he also produced portraits and mezzotints. He studied engraving and painting under his elder brother, William,

Ward 1 (and see Ill. 49)

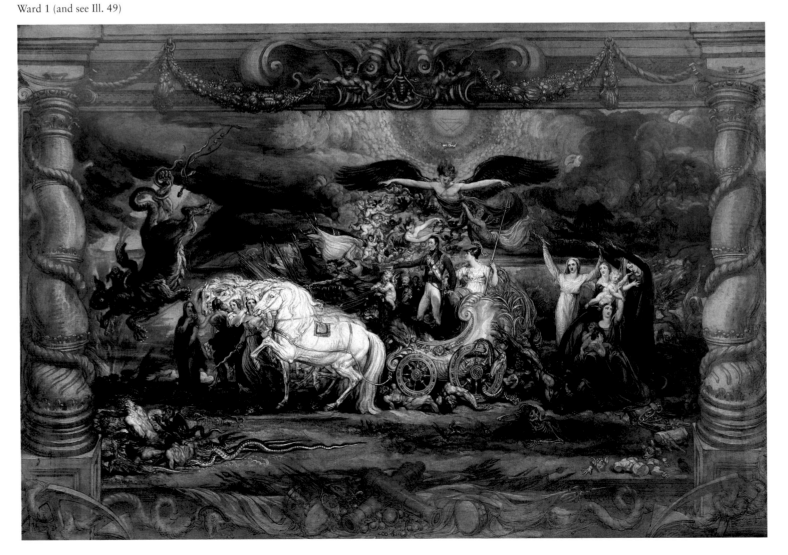

and in 1794 was appointed Painter and Mezzotint Engraver to the Prince of Wales. He was elected ARA in 1807 and RA in 1811. Between 1792 and 1855 he exhibited 298 works at the RA. His fine paintings of Copenhagen, the Duke's horse, and Marengo, Napoleon's horse, hang at Alnwick (see Ills. 50 and 51).

1. Royal Hospital Chelsea, London

The Triumph of the Duke of Wellington, 90 × 132 cm. A study for the *Allegory of Waterloo*, now lost. A sketch had been shown at the BI in 1816, prompting the directors to commission a giant canvas 6.7 × 10.7 m. That was displayed in the Egyptian Hall, Piccadilly, in 1821, with a pamphlet in which Ward explained that it depicted 'The Genius of Wellington on the Car of War, supported by Britannia and attended by the Seven Cardinal Virtues, commanding away the Demons, Anarchy, Rebellion and Discord, with the Horrors of War'. It then went to the Royal Hospital Chelsea (presented by the BI, or, according to the Hospital records and a letter from the artist's son, George Raphael Ward, by the artist himself). At the Hospital it was hung in the hall without stretcher or frame. In 1837 it was taken down and rolled up, offered to the Crystal Palace but declined on account of its size, and in 1879 handed over to Ward's son.

2. Formerly Philip Guedalla, London. Present whereabouts unknown

c. 1819, 63.5 × 50.8 cm. Head and shoulders in profile to the R, wearing a fur collar. Unfinished. Published as the frontispiece of Guedalla's biography of Wellington, *The Duke* (1930).

3. Family Collection, on loan to No. 10 Downing Street, London

Signed and dated 1829, 73.5 × 63 cm. Head and shoulders, in profile to the L, in field-marshal's uniform with sash and star of the Order of the Garter and Order of the Golden Fleece. Painted for the Royal Female Orphanage in Surrey, of which the Duke was a Patron. It descended to the Shaftesbury Homes, was sold at Sotheby's, 20 November 1969, lot 86, and bought by the 7th Duke.

A copy of the painting hangs at the family's house in Spain.

WATSON, MUSGRAVE LEWTHWAITE
1804–47

Sculptor. Trained as a solicitor. On the death of his father in 1823 he moved to London to become an artist. He met John Flaxman and joined the RA Schools. After some years in Europe he returned to London in 1828 and exhibited at the RA from that year. He worked for a brief time in the studios of Sir Francis Chantrey, William Behnes, and E. H. Baily.

1. British Embassy, Paris (Government Art Collection)

Marble bust, inscribed 'M. L. WATSON F.', *c.* 1825, h. 69 cm. Bare-chested, to the L. Purchased in Paris, August 1971.

Ward 2

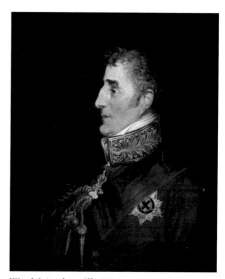

Ward 3 (and see Ill. 62)

Watson 1

Weigall Sen. 1a

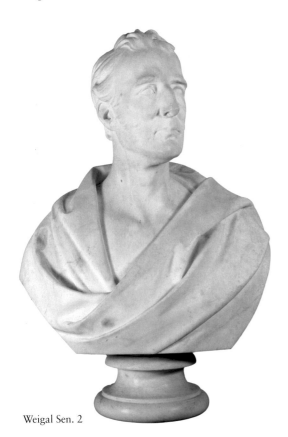

Weigal Sen. 2

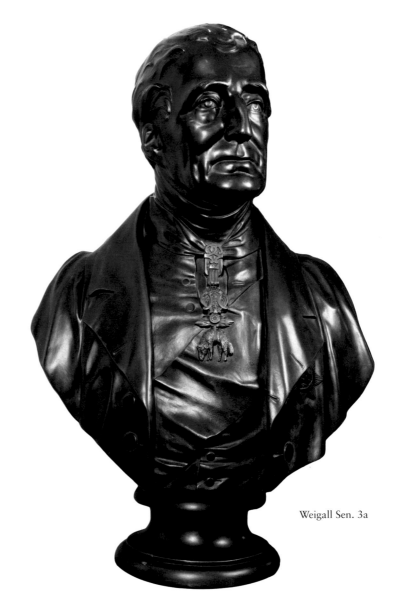

Weigall Sen. 3a

WEIGALL, HENRY (SENIOR)
c. 1800–1882

Initially a gem-engraver and medallist, he became a sculptor of portraits. He exhibited busts and reliefs at the RA, the SBA and the Royal Hibernian Society between 1829 and 1852. In 1856 he and his wife emigrated to Australia, where he stayed until his death.

1. Original work untraced
Small bronze bust, incised 'Published by J. Blashfield, 1829'.

An engraving after Weigall by A. R. Freebairn was published by H. Moseley in 1838. An impression is in the Family Collection (1a).

2. Family Collection
Marble bust, h. 76.5 cm. To the R, in Classical dress. This appears to date from the late 1820s or early 1830s. It could possibly be the basis for the engraving

published in 1838 (see No. 1). Bequeathed to the 7th Duke by Rupert Gunnis in December 1963.

A marble bust by Weigall was exhibited at the RA in 1849, no. 1306.

3. Present whereabouts unknown
Bronze bust, 1851, h. 77 cm, cast by Elkington & Co. To the R, with sash and star of the Order of the Garter and Order of the Golden Fleece. Exh. RA 1852, no. 1049. The Duke sat for this bust at the same time as sitting to Henry Weigall Jun. (q.v.) for a painted portrait.

Multiple editions in bronze and in plaster, inscribed on the back 'Modelled from sittings taken on Aug 6, 9, 11 and Nov 18 1851, H. Weigall, 27 Somerset St, Published Oct 10 1852'. Examples in bronze are in the V&A and in the Institute of Directors, London, formerly the United Service Club (3a). A plaster version is in the Family Collection.

4. Present whereabouts unknown
Bronze bust, *c*. 1853. Described as done 'from sittings'. Exh. RA 1853, no. 1398. A bronze bust by Weigall of 1853 was sold at Philips, 18 February 1997 (lot number not known).

WEIGALL, HENRY (JUNIOR)
1829–1925

Painter, son of the sculptor Henry Weigall. In 1866 he married Lady Rose Fane, daughter of Wellington's favourite niece, Lady (Priscilla) Burghersh, Countess of Westmorland. Through his wife's connections he received many commissions from prominent families, and went on to paint both the Prince and Princess of Wales.

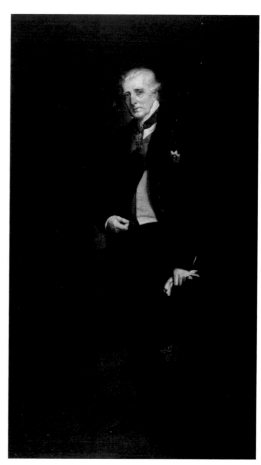

Weigall Jun. 1 (and see Ill. 100)

1. Family Collection, on loan to the Foreign Office, London
1851, 213.4 × 124.5 cm. FL, standing, slightly to the L, wearing court dress with ribbon and star of the Order of the Garter and badge of the Order of the Golden Fleece. Painted from sittings given in August and November 1851. Exh. RA 1852, no. 919, South Kensington 1866, no. 462 (lent by the Dowager Countess of Westmorland), and Guelph Exhibition 1891, no. 157. Sold to the 7th Duke by Rachel Weigall in 1955.

Engraved by S. W. Reynolds.

Copies are in the RCT, and in the Weymouth Museum, formerly in the collection of Sir John Hesketh Lethbridge. A version by an unidentified British artist is in the collection of Llyfrgell Genedlaethol Cymru, The National Library of Wales.

2. Family Collection
Miniature, *c*. 1851, 26 × 17 cm. TQL, similar to the preceding but with hat held under his right arm. Acquired in 1977.

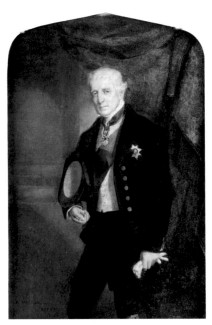

Weigall Jun. 2

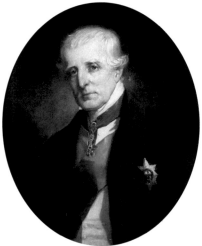

Weigall Jun. 3

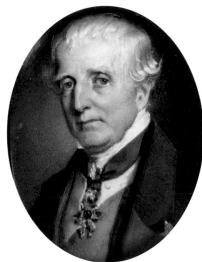

Weigall Jun. 4

3. British Embassy, Madrid (Government Art Collection)

1851, 76.7 × 64 cm. Head and shoulders to the L, with ribbon and star of the Order of the Garter and Order of the Golden Fleece. Derived from the FL in the Family Collection (No. 1).

4. Royal Collection Trust

Watercolour miniature on ivory laid on card, signed 'H. WEIGALL', *c.* 1851–52, 4.2 × 3.5 cm. Also derived from No. 1. First recorded in the RCT during the reign of Edward VII.

5. Family Collection

Miniature, signed 'H. Weigall. Sep. 1851', 4 × 3 cm. Like Nos. 3 and 4, but set in a bracelet given to the Duke's granddaughter Victoria, who was the Queen's goddaughter, after the Duke's death.

Weigall Jun. 5
(and see Ill. 98)

WILKIE, SIR DAVID, RA

1785–1841

Chiefly known as a genre painter. Born in Fife, he studied at the Trustees Academy of Design in Edinburgh. In 1805 he went to London and enrolled at the RA Schools. He became ARA in 1809 and RA in 1811. In 1816 he was commissioned by the Duke to paint *Chelsea Pensioners Reading the Gazette of the Battle of Waterloo*, for which he was paid 1,200 guineas. In 1830 he succeeded Sir Thomas Lawrence as Painter in Ordinary to the King. He was knighted in 1836.

1. Merchant Taylors' Hall, London

1832–33/34, 269 × 118 cm. FL, standing to the R by his horse Copenhagen. Wearing uniform of the Constable of the Tower of London, with sash of the Order of the Garter and other orders, cocked hat in his left hand. A figure can be seen in the far L. This portrait was commissioned for the Merchant Taylors by Sir Claudius Stephen Hunter, and executed at Stratfield Saye in October and November 1832, with further sittings in September 1833 (Cunningham, *Life of Wilkie*, III, p. 62).

There is a study for this picture in the Family Collection, 90 × 70 cm, bought by the 7th Duke in 1922 (1a). Another sketch is in a private collection. A drawing is in the BM.

2. British Museum, London
Sketch made during the installation of the Duke as Chancellor of the University of Oxford in 1834. If this led to a finished painting, it is now lost.

3. The Marquess of Salisbury, Hatfield House
1833–35, 238.8 × 147.3 cm. FL, standing, slightly to the L, wearing dark coat and cloak and red and gold belt, with badge of the Order of the Golden Fleece and Waterloo Medal, and both hands on his sword-hilt. Exh. RA 1835, no. 112. A preliminary sketch, in pen and bistre, signed and dated 1833, is in the BM.

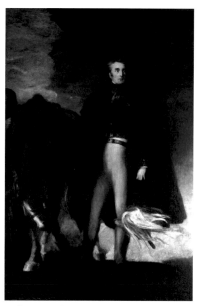

Wilkie 1 (and see Ill. 43)

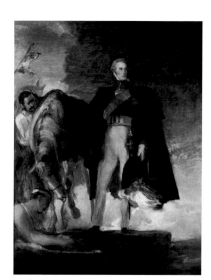

Wilkie 1a

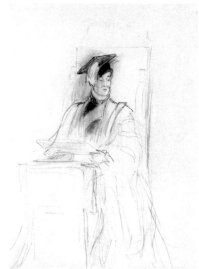

Wilkie 2

Wilkie 3
(and see Ill. 70)

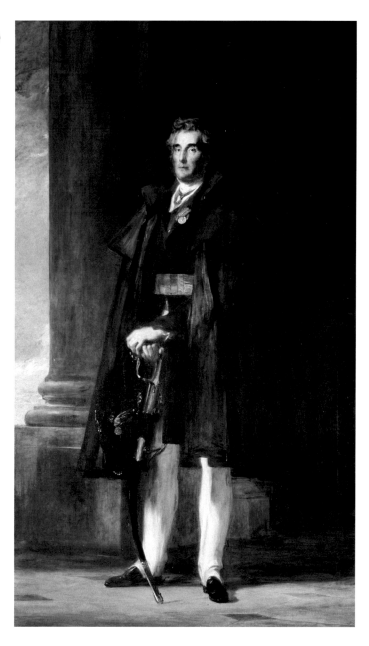

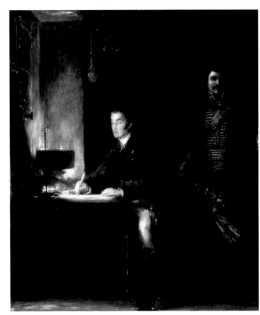

Wilkie 4 (and see Ill. 65)

4. Aberdeen Art Gallery and Museum

The Duke of Wellington writing Dispatches, 1836, 64.6 × 55.2 cm. FL, to the L, seated at his writing desk, his face lit by a gas lamp. A soldier stands to attention in the background. He is writing to the Duc de Berri in the early morning on the day of the Battle of Waterloo. Exh. RA 1836. Supposedly commissioned by Sir James Willoughby Gordon.

A sketch for this work dated 1829 is also in the Aberdeen Art Gallery and Museum. Another, undated, is in the Family Collection, bought by the 7th Duke in 1930.

WINTERHALTER, FRANZ XAVER
1806–73

German painter. The son of a farmer, he achieved international fame as a portraitist at the courts of Bavaria, England, France, Spain, Russia, Portugal, Mexico and Belgium. His first visit to England was in 1842, and he returned several times to receive sittings from Queen Victoria and her family. He painted at least 120 portraits for the British Royal Family.

Winterhalter 1 (and see Ill. 3)

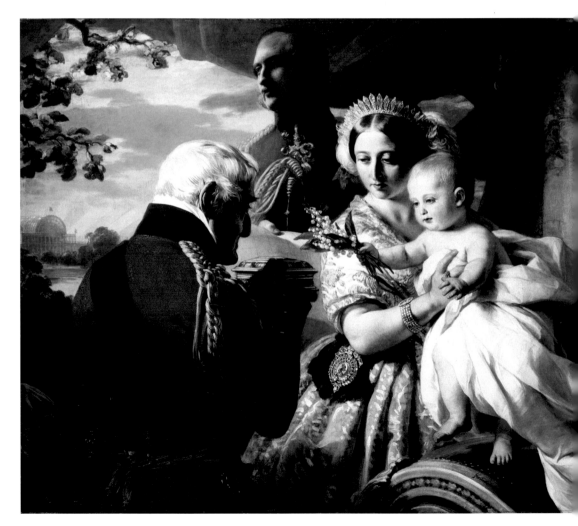

Winterhalter 2

1. Royal Collection Trust

Signed 'F Winterhalter', 1844, 149.5 × 97.8 cm. FL, standing, in profile to the R, wearing the Windsor uniform, with Sir Robert Peel. Painted for Queen Victoria. Inscribed as a study for a detail in a picture of the reception of King Louis Philippe, but such a picture has not been traced.

2. Royal Collection Trust

The First of May 1851, 1851, 130 × 107 cm. HL, in profile to the R, in field-marshal's uniform, giving a christening present to his godson, Prince Arthur, on his first birthday. The Queen holds the baby and the Prince Consort is in the background. Commissioned by Queen Victoria.

Witzleben 1

WITZLEBEN, BARON FRIEDRICH HARTMANN VON
1802–73

Amateur portraitist. Thuringian nobleman and landowner. He was Chamberlain to Princess Augusta of Prussia, later Empress.

1. Royal Collection Trust

Pencil, signed and dated 'F. Witzleben, Windsor Castel, 25 Sept. 1846', 20.7 × 15 cm. Head and shoulders in profile to the L, wearing civilian dress and the Order of the Red Eagle.

Wivell 1

WIVELL, ABRAHAM
1786–1849

Wigmaker-become-portraitist. Drawings exhibited in his shop window attracted the attention of Caroline of Brunswick, the estranged wife of George IV, and her patronage helped him become a successful portrait painter. In later life he developed one of the first effective methods of evacuating people from burning buildings.

1. British Museum, London

Stipple engraving after a drawing by Wivell of 1814–16 by W. T. Fry, published by Thomas Kelly on 14 September 1816, 26.3 × 19 cm. The inscription says that it was engraved after a drawing by Wivell of the bust by Nollekens (see Nollekens, No. 1).

2. Family Collection

Pencil and grey wash, signed and dated 1818, 11.4 × 9 cm. Bust in profile to the L, bare-chested.

Engraved by M. Gauci.

Wivell 2

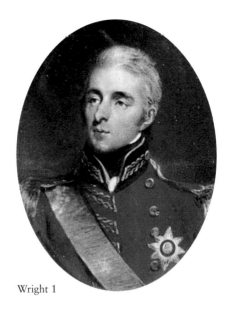

Wright 1

WRIGHT, JOHN WILLIAM
1802–48

Painter in watercolours and miniaturist, the son of miniaturists. He studied under Thomas Phillips, and exhibited at the RA from 1825. In 1831 he became an Associate of the Old Watercolour Society, in 1842 a full member, and in 1844 the Society's Secretary. Many of his works were reproduced in engravings.

1. Levens Hall, Cumbria

Miniature by Wright after Hoppner (see Hoppner, No. 2), signed and dated 1808, h. 9 cm. Head and shoulders to the L, in lieutenant-general's uniform, with sash and ribbon and star of the Order of the Bath. Exh. Chaumet International SA, Paris, 2004–5.

WYATT, MATTHEW COTES
1777–1862

Chiefly known as a sculptor. Son of the architect James Wyatt, he was educated at Eton and the RA Schools. He initially found employment at Windsor Castle. Between 1803 and 1814 he exhibited several portraits and historical subject paintings and one bust at the RA. In 1832 he produced the equestrian statue of George III that stands on Cockspur Street, London.

1. Round Hill, Aldershot, Hampshire

Monumental bronze statue, 1846, h. *c.* 9 m. FL, equestrian, in field-marshal's uniform and cloak, right arm extended with baton. Originally sited on Decimus Burton's triumphal arch opposite Apsley House (see Ill. 81). The idea originated in 1837, when a committee decided that a 'National Memorial' should be erected 'by general Subscription'. The Duke is said to have given sittings for the head. The horse is not Copenhagen, dead by then. The statue was not considered a success, and many wanted it removed in the Duke's lifetime. After the redesign of Hyde Park Corner for traffic and the re-siting of the arch in 1882, the statue was moved to Aldershot and installed in 1885.

An account of the casting and original placing in position of the statue is given in the *Illustrated London News*, 1846–47, p. 213. See also *Correspondence of Lady Burghersh with the Duke of Wellington*, p. 178.

2. Formerly United Service Club, London. Present whereabouts unknown

Marble bust, signed and dated 1848, life-size. There is no evidence that the Duke gave sittings to Wyatt other than those said to have been given in 1846. This bust is not recorded as being in the club after 1935.

Wyatt 4 (and see Ill. 82)

Acknowledgments for Photographs

For photographs not © Stratfield Saye Preservation Trust, the author and publisher would like to thank the following individuals, collections, photographic libraries, museums and galleries. Any errors or omissions are entirely unintentional, and the publisher will, if informed, make amendments in future editions of this book.

3 © Royal Collection Trust – 5 © Heckscher Museum of Art, Huntington, N.Y. – 6 © Rijksmuseum, Amsterdam – 7 *top row* Cosway see below, 20 • *second row* Goya see below, 31 • *third row* Chantrey see below, 38; Hayter see below, 52; Lawrence see below, 55 • *fourth row* Lawrence see below, 64; Campbell see below, 76 • *bottom row* Morton see below, 72 – 20 © Victoria and Albert Museum, London – 24 © Trustees of the British Museum – 29 © The National Gallery, London Bought with aid from the Wolfson Foundation and a special Exchequer grant, 1961 – 31 © Trustees of the British Museum – 36 © Royal Collection Trust – 37 © The State Hermitage Museum, St Petersburg, Photo by Inna Regentova, Natalia Antonova – 38 © Ashmolean Museum, University of Oxford – 41 © Christie's Images, 2013 – 49 © Royal Hospital Chelsea – 50, 51 © Collection of the Duke of Northumberland – 52 © The Duke of Bedford and the Trustees of the Bedford Estates – 53 © Rijksmuseum, Amsterdam – 54 © Christie's Images 2006 – 55 © National Portrait Gallery, London – 58 © National Portrait Gallery, London – 59 © Victoria Memorial Hall, Kolkata – 60 © By Permission of the Trustees of the Goodwood Collection – 62 © Crown copyright: UK Government Art Collection, on loan from the Family Collection – 64 © Sotheby's Images 2013 – 65 © Aberdeen Art Gallery & Museums Collections – 66 © The Duke of Bedford and the Trustees of the Bedford Estates – 70 © The Marquess of Salisbury, Hatfield House – 71 © The Oriental Club, London – 72 © By kind permission of the Trustees of the Wallace Collection – 74 © Town Hall, Dover – 76 © By kind permission of the Duke of Buccleuch & Queensberry KBE – 78 © Charterhouse, London – 83 © Chevening House, Kent – 85 PCF, Supplied courtesy of National Museums Liverpool – 87 ©National Trust Images/John Hammond – 88 © Glasgow City Council – 90 © PMSA (Dianne King) Licensor www.rcahms.gov.uk – 92 © National Portrait Gallery, London – 98 © UK Art Collection, on loan from the Family Collection – 101 © Trustees of the British Museum – 102 © Cpl Mark Larner RY – 106 © The Chapter of St Paul's Cathedral

CATALOGUE

Adams 2 © Cpl Mark Larner RY; 4 © Crown copyright: UK Government Art Collection – Baily 1 © Palace of Westminster Collection, WOA S90 www.parliament.uk/art; 2 © Tate Britain, London 2014 – Barker 5 © Joint Services Command and Staff College, Shrivenham – Bauzil 2 © National Portrait Gallery, London; 4 © The Duke of Beaufort, Badminton – Beechey 1b © Heckscher Museum of Art, Huntington, N.Y. – Behnes 2 © Hampshire County Council, Winchester – Bone 1 © The Ethelston Collection – Briggs 1 © Charterhouse, London – Buck 1 © National Portrait Gallery, London – Burney 1 © Christie's 2008 – Campbell 2 © By kind permission of the Duke of

of the British Museum – Morton 5 © By kind permission of the Trustees of the Wallace Collection – Noble 3 © Crown copyright: UK Government Art Collection – Nollekens 3 © Crown copyright: UK Government Art Collection – Northcote 1 © Exeter Guildhall – Parent 1 © Private Collection, New York; 2 © Victoria and Albert Museum, London – Pellegrini 1 © National Museum of Fine Arts, Lisbon – Pickersgill 1 © Oriental Club, London – Pieneman 1, 2 © Rijksmuseum, Amsterdam – Rochard 1 © Christie's Images, 2013; 2 © Royal Collection Trust/© Her Majesty Queen Elizabeth II 2014; 3, 4 © The Ethelston Collection – Salter 1 © National Portrait Gallery, London; 4 © Image by PCF, Supplied Courtesy of National Museums Liverpool – Scanlan 1 © Trustees of the British Museum – Simpson 1 The Society of the Cincinnati, Anderson House, Washington, D.C.; 4 © Royal Hospital Chelsea – Steell 3 © Eton College, Berkshire; 5 © PMSA (Dianne King) Licensor www.rcahms.gov.uk – Stroehling 1 © National Army Museum, London – Thorburn 2 © Bonhams Images 2012 – Turnerelli 1a © Trustees of the British Museum; 2 © Royal Collection Trust/© Her Majesty Queen Elizabeth II 2014; 2a © Trustees of the British Museum; 3 © Photograph courtesy of the National Gallery of Ireland, Dublin; 4 © Victoria Memorial Hall, Kolkata – Ward 1 © Royal Hospital Chelsea; 3 © Crown copyright: UK Government Art Collection, work on loan from the Family Collection – Watson 1 © Crown copyright: UK Government Art Collection – Weigall Jun. 1 © Crown copyright: UK Government Art Collection, work on loan from the Family Collection; 3 © Crown copyright: UK Government Art Collection; 4 Royal Collection Trust/© Her Majesty Queen Elizabeth II 2014 – Wilkie 2 © Trustees of the British Museum; 3 © The Marquess of Salisbury, Hatfield House; 4 © Aberdeen Art Gallery & Museums Collections – Winterhalter 1, 2 Royal Collection Trust/ © Her Majesty Queen Elizabeth II 2014 – Wivell 1 © Trustees of the British Museum – Wright 1 © Hal Bagot, Levens Hall

Bibliography and Recommended Reading

Andreeva, G., *Geniuses of War, Weal and Beauty: George Dawe, RA Pinx* (Moscow 2012)

Archer, M., *India and British Portraiture 1770–1825* (Oxford 1979)

Braham, A., 'Goya's Equestrian Portrait of the Duke of Wellington', *Burlington Magazine*, vol. 108, no. 765 (December 1966), pp. 618–21

— , 'Portrait of the Duke of Wellington in the National Gallery', *Burlington Magazine*, vol. 108, no. 755 (February 1966), pp. 78–83

Bryant, M., and S. Heneage, *Dictionary of British Cartoonists and Caricaturists 1730–1980* (Aldershot 1994)

Burghersh, P., Lady, *Correspondence of Lady Burghersh with the Duke of Wellington*, ed. Lady R. Weigall (London 1903)

Du Cann, E., *The Duke of Wellington and his Political Career after Waterloo – the Caricaturists' View* (Woodbridge 2000)

Cotton, H. E., *Robert Home* (Calcutta 1928)

Eimer, C., *Medallic Portraits of the Duke of Wellington* (London 1994)

Foulkes, N., *Last of the Dandies: The Scandalous Life and Escapades of Count d'Orsay* (London 2003)

Garlick, K., *Sir Thomas Lawrence: A Complete Catalogue of the Oil Paintings* (London 1989)

Glover, G., *Wellington's Voice: The Candid Letters of Lieutenant Colonel John Fremantle, Coldstream Guards, 1808–1837* (London 2012)

Glover, M., *A Gentleman Volunteer: The Letters of George Hennell from the Peninsular War 1812–1813* (London 1979)

Gordon, E., *The Royal Scottish Academy of Painting, Sculpture and Architecture 1826–1976* (Edinburgh 1976)

Gunnis, R., *Dictionary of British Sculptors 1660–1851* (London 1951)

Haydon, B. R., *The Autobiography and Memoirs of Benjamin Robert Haydon (1786–1846)*, ed. T. Taylor (London 1926)

Hayward, J., D. Birch and R. Bishop, eds, *British Battles and Medals*, 7th edn (London 2006)

Healey, E., Lady Unknown: *The Life of Angela Burdett-Coutts* (London 1978)

Kauffmann, C. M., rev. S. Jenkins, *Catalogue of Paintings in the Wellington Museum, Apsley House* (London 2009)

Lawrence, T., *Sir Thomas Lawrence's Letter-Bag*, ed. G. S. Layard (London 1906)

Levey, M., *Sir Thomas Lawrence* (New Haven and London 2005)

Longford, E., *Wellington, The Years of the Sword* (London 1969)

— *Wellington, Pillar of State* (London 1972)

Lucas, A., John Lucas, *Portrait Painter, 1828–1874. A Memoir of his Life Mainly Deduced from the Correspondence of his Sitters* (London 1910)

Millar, O., *The Later Georgian Pictures in the Collection of Her Majesty The Queen* (London 1969)

— *The Victorian Pictures in the Collection of Her Majesty The Queen* (Cambridge 1992)

O'Keeffe, P., *A Genius for Failure, The Life of Benjamin Robert Haydon* (London 2009)

Oman, C., *The Gascoyne Heiress: The Life and Diaries of Frances Mary Gascoyne-Cecil, 1802–39* (London 1968)

Percival, V., *The Duke of Wellington: A Pictorial Survey of his Life (1769–1852)* (London 1969)

Physick, J., *The Duke of Wellington in Caricature* (London 1965)

Prown, J., *John Singleton Copley. In America, 1738–1774. (In England, 1774–1815)* (Cambridge, Mass., 1966)

Remington, V., *Victorian Miniatures in the Collection of Her Majesty the Queen* (London 2010)

Roscoe, I., E. Hardy and M. G. Sullivan, *A Biographical Dictionary of Sculptors in Britain 1660–1851* (New Haven and London 2009)

Shelley, F., Lady, *The Diary of Frances, Lady Shelley, 1787–1817*, ed. R. Edgcumbe (London 1912)

— *The Diary of Frances Lady Shelley 1818–1871*, ed. R. Edgcumbe (London 1913)

Smailes, H., 'Thomas Campbell and the "camera lucida": the Buccleuch Statue of the 1st Duke of Wellington', *Burlington Magazine*, vol. 129, no. 1016 (November 1987), pp. 709–14

Stewart, B., and M. Cutten, *A Dictionary of Portrait Painters in Britain up to 1920* (Woodbridge 1997)

Wake, J., *Sisters of Fortune: The First American Heiresses to take England by Storm* (London 2010)

Walker, R., *Regency Portraits* (London 1985)

Ward-Jackson, P., 'Carlo Marochetti and the Glasgow Wellington Memorial', *Burlington Magazine*, vol. 132, no. 1053 (December 1990), pp. 851–62

Wellesley, G., and J. Steegmann, *The Iconography of the First Duke of Wellington* (London 1935)

Wellington, 1st Duke of, *The Dispatches of Field Marshal the Duke of Wellington, during his Various Campaigns in India, Denmark, Portugal, Spain, the Low Countries, and France, from 1794–1818*, ed. J. Gurwood (London 1837). There were further editions between 1844 and 1852

— , *The Private Correspondence of the First Duke of Wellington*, ed. the 7th Duke of Wellington (London 1952)

— , *Supplementary Despatches and Memoranda of Field Marshal Arthur Duke of Wellington, K.G.*, ed. the 2nd Duke of Wellington (London 1858–72)

Wellington, 3rd Duchess of, *A Descriptive and Historical Catalogue of the Collection of Pictures and Sculptures at Apsley House* (New York and London 1901)

Wellington, 7th Duke of, and F. Bamford, *The Journal of Mrs. Arbuthnot, 1820–1832* (London 1950)

— *A Selection from the Private Correspondence of the First Duke of Wellington* (London 1950)

Whitley, W. T., *Art in England* (New York 1973)

Williams, D. E., *The Life and Correspondence of Sir Thomas Lawrence* (London 1831)

Wilson, J., *A Soldier's Wife: Wellington's Marriage* (London 1987)

Index